Wisdom With Understanding is Better Than Rubies

Lurine Karon Greenberg Fine Arts Collection

The Shock of the Real

The Shock of the Real
Romanticism and
Visual Culture, 1760–1860

Gillen D'Arcy Wood

palgrave

First published 2001 by
PALGRAVE™
175 Fifth Avenue, New York, N.Y. 10010 and
Houndmills, Basingstoke, Hampshire, England RG21 6XS.
Companies and representatives throughout the world.

PALGRAVE™ is the new global publishing imprint of St. Martin's Press LLC Scholarly and Reference Division and Palgrave Publishers Ltd (formerly Macmillan Press Ltd).

ISBN 0-312-22654-3 hardback

Library of Congress Cataloging-in-Publication Data

Wood, Gillen D'Arcy.
 The shock of the real : romanticism and visual culture, 1760–1860 / Gillen D'Arcy Wood.
 p. cm.
 Includes bibliographical references and index.
 ISBN 0-312-22654-3
 1. Romanticism in art. 2. Arts, Modern—18th century. 3. Arts, Modern—19th century. I. Title.

NX452.5.R64 W66 2001
709'.03'42—dc21 00-051483

A catalogue record for this book is available from the British Library.

Design by Westchester Book Composition

First edition: January 2001

10 9 8 7 6 5 4 3 2 1

Printed in the United States of America.

CONTENTS ⟿

ILLUSTRATIONS ✺

ACKNOWLEDGMENTS ∽

Many people aided me in the writing of this book. Marilyn Gaull, in her editorial role, offered tireless support and showed infinite patience in bringing it to press. My sincere thanks are due also to Karl Kroeber and David Simpson for their great encouragement, careful reading (and re-reading) of the manuscript, and always pertinent advice. Others who read part or all of the manuscript in draft versions, and offered indispensable help, were Martin Meisel, Jonathan Crary, William Galperin, Nick Roe, Anna Brickhouse, and Laura Engel. I likewise owe a debt of gratitude to David Ferris and Andreas Huyssen, whose inspiration was critical to my development of this study at its embryonic stages. At Palgrave, my thanks go to Kristi Long; her enthusiasm and professional acuity has made the road to publication mercifully smooth. On a personal note, I am deeply grateful to my family in Australia for their unstinting support, and to my wife, Nancy Castro, without whom I could never have enjoyed the requisite good health, of both body and mind, to finish this book. My debts to her are beyond measure.

To Nancy
. . . happy changes in emphatic dreams

an Imperial City stood,
With Towers and Temples proudly elevate . . .
By what strange Parallax or Optic skill
Of vision multiplyed through air, or glass
Of telescope, were curious to enquire:
And now the Tempter thus his silence broke . . .

—Milton, *Paradise Regained* IV.33-34, 40-43

Introduction ↬

BELZONI'S TOMB

In Regency London, the south side of Piccadilly near Old Bond Street was known for a particularly gaudy edifice. The building, covered in pseudo-hieroglyphic script, recalled the recently excavated temple at Dendera in Egypt. Sphinxes presided over the entrance above giant, lurid statues of Isis and Osiris. To Leigh Hunt's fastidious eye, this faux-Egyptian erection distinguished itself amongst the red-brick boutiques of Piccadilly as an "uncouth anomaly," a "practical joke."[1] The fact that William Bullock, a showman and collector of curiosities from Liverpool, had given his new premises the grandiose title "London Museum" only compounded the jarring effect. Two hundred years on, the unblushing nature of the building's Egyptian references would suggest less fraternity with a museum than a Las Vegas theme hotel. Regency Londoners were similarly skeptical about the establishment's self-description. Bullock's lowbrow answer to the British Museum soon gained the nickname "The Egyptian Hall," a title that captured both the orientalist motifs of its outside and the miscellaneous entertainment to be found within.[2] In 1811, Jane Austen wandered through rooms filled with stuffed birds, boa constrictors, giraffes and bears. Bullock maintained this permanent collection of natural curiosities and exotica, but cannily reserved other rooms to rotating exhibitions. In the following decades, his West End emporium hosted art shows, panoramas and dioramas, pseudo-scientific demonstrations, Napoleon's carriage, and gala appearances by Tom Thumb.

Most fitted to Bullock's venue, however, was the exhibition advertised in the summer of 1821 as "The Egyptian Tomb" or "Belzoni's Tomb." The Bartholomew Fair strongman-turned-archaeologist, Giovanni Belzoni, had recently returned from the Valley of the Kings with a spectacular booty.

Before opening negotiations with the British Museum for purchase of his treasures, Belzoni struck a deal with Bullock to exploit the collection as a popular entertainment.[3] He filled the entire upper floor of the London Museum with reconstructions of archaeological sites as he had found them. The result was more an "installment" than a typical museum exhibition: a veritable dreamscape of mocked-up tombs, statues, and sarcophagi, with the tomb of Seti as the exhibit's crowning glory. Patrons ascended the stairs into a sideshow world of Egyptiana enhanced by the lugubrious illumination of torches. "Every eye," reported *The Times,* "must be gratified by this singular combination and skilful arrangement of objects so new and in themselves so striking."[4] The appeal of Belzoni's exhibition, unlike the recently opened Elgin Marbles Gallery at the British Museum, was not determined by its aesthetic value; it derived, rather, from the exotic novelty of his treasures and the "striking" effect he produced in recreating their discovery. The British Museum offered highbrow antiquity. The Elgin gallery space—with its bare walls, open floors, and decorous silence—invited a disinterested, intellectual contemplation of the Parthenon sculptures *ex-situ,* divorced from their historical context. At the down-market Egyptian Hall, by contrast, Belzoni "gratified the eye" with an extravagant and thrilling simulacrum: a presentation of the artefacts on display not as art but as real.

Roland Barthes has defined the "real" as a sign that "is assumed not to need any independent justification. It is powerful enough to negate any notion of 'function,' it can be expressed without there being any need for it to be integrated into a structure, and the *having-been-there* of things is a sufficient reason for speaking of them."[5] The apparently gratuitous descriptive details in a Flaubert story, to take Barthes' literary example, are not integrated into the structural realm of narrative, theme, or symbol; they resist interpretation or idealization of any kind. The most one can say, argues Barthes, is that the minutely rendered texture of Flaubert's visual description, through its sheer density of insignificance, produces a particular aesthetic effect, namely the "real." The same might be said of Balzac's novels, in which a host of supernumerary characters appear and disappear without development or any direct relation to the plot. Like the descriptive details in a Flaubert story, it is the very fact of their presence that lends the narrative a self-authenticating quality, a more vivid sense of real, lived experience.

Transferring Barthes' literary notion of the "real" to the visual arts, we encounter more than the sub-tradition of illusionist chicanery in Western painting from Zeuxis' grapes to baroque trompe l'oeil.[6] In the visual entertainment marketplace of late Georgian London, Belzoni's 1821 exhibition,

with its warren of dimly lit rooms imitating an Egyptian tomb and gaudy facsimiles side by side with original sarcophagi, clearly relied on the effect of the real for its appeal. Likewise did Bullock's principle competitors, the panoramas of Leicester Square and the Strand, which offered the life-like recreation of famous sights and scenes on a giant 360° canvas. Visiting the panorama on a visit to London, the poet Wordsworth was struck by the exhibit's accumulation of apparently gratuitous realistic detail:

> every tree
> Through all the landscape, tuft, stone, scratch minute
> And every cottage, lurking in the rocks—
> All that the traveller sees when he is there. (276-80)

To Wordsworth, the fastidiously realized trees, tufts, and stones of the panorama—like Flaubert's descriptively dense style for Barthes—served no aesthetic function beyond the effect of similitude. The pictorial objective of the panorama was what is now called "virtual reality": where, through a technologically contrived illusion, be it of an Alpine prospect, the city of London, or the Battle of Waterloo, the viewer is presented with a breath-takingly accurate simulation of "all that the traveller sees when he is there." The marriage of documentary representation and touristic curiosity at the panorama not only mirrors its contemporary, "Belzoni's Tomb," but fore-shadows a sequence of developments in modern visual culture leading to photography and film, media that embody, in Barthes' words, "the Real in its indefatigable expression."[7] The "reality effect" of these nineteenth-cen-tury West End entertainments was not, of course, real; nor should they be confused with a Flaubertian real*ism*. "Belzoni's Tomb" and Robert Barker's panorama belonged to a different order of the imaginary: to an idea of simulated experience that, as Barthes claims, "forms the aesthetic of all the standard works of modernity."[8] The "real" is, in this sense, a production: in the case of "Belzoni's Tomb," the production of archaeological adventure in the Orient.[9]

Exhibitions devoted to the spectacle of the "real" were wildly popular—Belzoni attracted almost two thousand visitors on opening day and extended his exhibit through the autumn season—but they were not uni-versally approved. Samuel Taylor Coleridge, for example, considered the reality effect irredeemably vulgar. "Simulations of nature," he protested, are "loathsome" and "disgusting."[10] Coleridge's repudiation of mimetic repre-sentation echoes a recurrent theme of his lectures on aesthetics, which continually reiterate a distinction between the imitation of reality achieved

by a work of art and a mere "copy" of nature. In the above-quoted lecture from his 1818 season at the London Philosophical Society, Coleridge explains that the viewer of a portrait in the conventional academic style begins with the presupposition of difference between art and nature. The pleasure of viewing the painting consequently lies in the appreciation of resemblances the artist has worked to achieve: in "a work of genuine imitation, you begin with an acknowledged total difference, and then every touch of nature gives you the pleasure of an approximation to truth." By contrast, the "simulations of nature"—Coleridge mentions waxworks museums, to which I would add "Belzoni's Tomb" and the panorama—that is, visual representations intended to deceive the viewer into mistaking them for the real thing, are not pleasurable but "disagreeable." The reason for the disparity in aesthetic effect between an imitation and copy is that the viewer of the copy, expecting nature itself, is "disappointed and disgusted with the deception," rather than pleasantly surprised at the picture's artful effects of similitude. "A good Portrait" Coleridge argues, is "a Work of Art—while a real *Copy,* a Fac Simile, ends in shocking us." A facsimile of nature is only as good as the mimetic fidelity of its details and yet, paradoxically, it is the presence of this very detail that establishes expectations in the viewer that can only be disappointed: "Not finding the motion and the life which we expected, we are *shocked* as by a falsehood, every circumstance of detail, which before induced us to be interested, making the distance from truth more palpable" (my emphasis). In short, the same pictorial effects of similitude produce pleasure in a work of art, but shock and disgust in a sub-artistic "real Copy."

The notion of a "real copy" is a seeming contradiction in terms, and yet it describes most pointedly the emerging class of popular visual media in late Georgian England to which "Belzoni's Tomb" and the panorama belonged. Panoramas were no less popular in Paris than in London, and the disapproval of the literary elite no less decided. Five years after Coleridge's London lecture, the French critic Quatremère de Quincy deplored "the popularity of shows flocked to by the vulgar crowd," and delivered a warning about the cultural effects of popular mimetic media such as the panorama: "If the artist substitutes the real for the fictive . . . if he abandons, for example, all the poetic figuration with which art is dressed for a positivist language, what will we find? The disenchanting effect of reality [*le désenchantement de la réalité*] substituted for the charm of imitation."[11] The shock of the real discloses its double value: for the "vulgar crowd" it represents a thrilling novelty, while to the discerning eyes of the cultural elite it effects a "disenchantment"—an experience that, for Baudelaire, in

the case of photography, will signal nothing less than the death of the Romantic imagination. For all their misgivings, some French critics were nevertheless sufficiently impressed by the international popularity of the panorama to engage in comparative analyses of local work in the medium with examples from abroad. In 1829, Johann Hittorf visited London to report on the opening of James Horner's sensational "Panorama of London" (see cover illustration) at the city's luxurious new entertainment emporium, Regent's Colosseum. Comparing Horner's painting unfavorably to the work of the Parisian panoramist, Pierre Prévost, Hittorf explained its success with the British public in highly revealing (if clearly parochial) terms. According to Hittorf's account, "the bulk of the London public [was] still unfamiliar with the sensation of the real in art [*au sentiment du vrai*]," and Horner's painting, unlike the work of Prévost, succeeded only in "delighting the eyes of most of the spectators most of the time, but without *shocking* the mind [*choquer la raison*] of a single one" (my emphasis).[12] Echoing Coleridge and Quatremère de Quincy quite precisely, Hittorf links the pictorial representation of unmediated reality with an experience of shock in the viewer. The putative failure of Horner's picture only underlines what is, for Hittorf, the definitive effect of the genre to which the panorama belonged: the shock of the "real."

Whatever Hittorf's opinion, Horner's London panorama is a landmark in the visual culture of modernity. It combined technological engineering and visual spectacle on a scale never before seen, and, as a part of the ambitious Regent's Colosseum, belonged to a vision of multi-purpose recreational space that prefigured the contemporary Disney-style theme park. At Horner's show, patrons ascended to its viewing platform in London's first hydraulic lift, and were provided with telescopes to view the smallest and most "distant" aspects of the view of London, thus anticipating the latter-day urban panoramic experience offered by such iconic pillars of modernity as the Eiffel Tower and Empire State Building. At the genesis of this book lies my desire to explore prefigurations of modernity, such as "Belzoni's Tomb" and the panorama, in the visual culture of the Romantic period. In doing so, I will be guided by the connection Coleridge and his French counterparts insist upon between these new visual media purveyors of the "real" and the effect of disenchantment or "shock." Are there reasons, beyond the philosophical argument Coleridge presents, why the link between "shock" and the "real" should be so necessary in his mind? What are the historical and cultural contexts of Coleridge's 1818 lecture and its impassioned, even violent rejection of "simulations of nature"?

I have borrowed from Roland Barthes for my exposition of the reality

effect Coleridge deplores. But for the student of twentieth-century critical theory, in particular those writings on the culture and aesthetics of modernity associated with the Frankfurt School, Coleridge's characterization of the reality effect of new visual media as "shocking" is likewise familiar, albeit chronologically disorienting. In his celebrated essay on mechanical reproduction (1936), Walter Benjamin has described the "sight of immediate reality" at the cinema as a "shock" experience endemic to twentieth-century visual technology.[13] In another canonical essay, on Baudelaire (1939), Benjamin identifies the origins of the "shock" experience of visual-cultural modernity in Second Empire Paris in the individual city-dweller's experience of an intimidating variety of visual and bodily stimulation, from shop windows, to photographs, to city crowds. Coleridge's use of the very term "shock" to describe the aesthetic response elicited by new visual media in London in 1818 suggests, however, that Benjamin's historical timeline may be misleadingly foreshortened. As Jonathan Arac has observed, "the same conditions of urban mass society that Wordsworth identified in 1800 acted crucially upon the poetic practice of Baudelaire."[14] Pursuing Arac's suggestion, my purpose in this study is to extend the historical scope of Benjamin's analysis, to examine the embryonic forms of the "shock" aesthetic of modernity that Coleridge identifies in Regency London a full generation before Baudelaire in Paris.

The gratification experienced by *The Times* reviewer at "Belzoni's Tomb" represents the positive appeal of that show's "reality effect," and we must assume that his approval was typical of the "vulgar crowd" at large (how else to account for Belzoni's success, or the panorama's?). My interest, however, lies in the consistently negative response evinced by those authors we identify most closely with the Romantic canon, exemplified by Coleridge's "shock" and "disgust" at sub-artistic "simulations." The fact that Coleridge's opinion of waxworks and other "simulations of nature" was probably not shared by the majority of his audience at the 1818 lecture leads to a fundamental question entertained by this book: Why were Romantic writers so prominently represented among the minority opinion that disdained the rise of popular visual media in late Georgian England? What stake did the Romantics have in actively, often virulently opposing new forms and forums of visual representation? In 1800, Wordsworth complained of the modern urban craving for "outrageous stimulation," which he, in publishing the *Lyrical Ballads,* sought to counteract through a new poetics of "common life" focused on "the essential passions of the heart."[15] But as this study will show, the late Georgian public's appetite was less for revolutions in lyric poetry than for the "outrageous stimulations" of

the new visual entertainment culture. The response of the literary elite mingles apprehension and contempt. Lamb disdains theatrical spectacle, as does Wordsworth the "mimic sights" of the panorama, while both decry the illustration of books. Hazlitt experiences a depression of spirits at a printshop, Keats a "dizzy pain" at the British Museum, and Baudelaire "trepidation" in Nadar's photography studio. In examining these mostly neglected encounters between canonical Romantic writers and the visual culture they inhabited, *The Shock of the Real* uncovers an ideologically grounded reaction of—in Coleridge's terms—shock, disenchantment, and disgust directed toward the emerging visual media and entertainment industry we so closely associate with our own modernity.

Much recent critical work has explored the neglected relation between canonical Romantic literature (the six great poets) and commercial, sub-literary forms of Romanticism: gothic novels, travel journals, diaries, memoirs, and the periodical press. Much less scholarly attention, however, has been devoted to the relation of Romantic literary culture to the emerging commercial *visual* culture I am describing here: from domestic collectibles such as prints, illustrated books, and, later, photographs, to the public sphere of theaters, art exhibitions, museums, popular entertainments like "Belzoni's Tomb" and the panorama, and picturesque tours. To redress that neglect, this study places fundamental aesthetic categories of Romanticism—imagination, original genius, Hellenism, the gothic, picturesque landscape, and the sublime—in the often hostile territory of late Georgian visual culture. By this means, I suggest ways in which Romantic ideology was constructed not in opposition to the enlightenment rationalism of the eighteenth century, but as a reaction to the visual culture of modernity being born. Put another way, the conflict addressed in *The Shock of the Real* is not between M. H. Abrams' mirror and lamp, but between the lamp and the magic lantern: between Romantic, expressive theories of artistic production emphasizing original genius and the idealizing imagination, and a new visual-cultural industry of mass reproduction, spectacle, and simulation.

My methodological approach is interrogatory. Each chapter will address questions, contradictions, or simply oddities in the visual culture of the period 1760-1860. For example: What was Lamb's objection to Garrick's statue in Westminster Abbey? Why did the Royal Academy exclude engravers? Why were Benjamin Haydon's paintings so huge? How did the panorama's representation of landscape impress Wordsworth, the quintessential Romantic poet of landscape? What metaphor of Greece did the Elgin Marbles produce: truth and beauty, or psychosis and death? How did

Turner's illustrations of Scott succeed where the photographer Fox Talbot failed? And why did Baudelaire consider photography the death of Romantic genius? Taking the long view of Romanticism as an historical period, *The Shock of the Real* finds answers to each of these questions in a century-long conflict between the literary elite of late Georgian England (and, briefly, France) and a booming recreational industry in visual media.

In chapter 1, I begin with an inquiry into the formation of modern celebrity culture in the career of David Garrick. The origins of Garrick's unprecedented fame in the late eighteenth century lay, I argue, in the peculiarly *visual* nature of his onstage technique—pauses, starts, pantomimic expressions, etc.—the psychological credibility of which has led to his canonization as the first "realist" stage actor. I am interested in the link, embodied by Garrick and insisted on by Coleridge, between the visual and the "real," but also with the means by which popular fascination for Garrick's physical presence onstage was sustained by sophisticated promotional merchandizing, evident in the plethora of paintings, prints, souvenirs, and memorabilia bearing his image. A study of Garrick belongs in a book on the Romantic period because the legacy both of Garrick's realism and his fame proved abhorrent to the critic Charles Lamb, whose 1811 essay "On Garrick, and Acting; and the Plays of Shakespeare, considered with Reference to their Fitness for Stage Representation" sets the stage, as it were, for the Romantic anti-visual culture prejudice I will be examining throughout the book. Lamb laments the loss of the "literary" stage, and blames Garrick for the triumph of dramatic performance and scene painting over poetic genius. The second part of the chapter examines comparable machinations of fame in the career of comic actress Frances Abington, in particular the role of her portraitist Joshua Reynolds, whose many images of her functioned less as conventional portraits than as glamour publicity shots that merged her real-world identity with an onstage persona. In my reading of Reynolds' *Portrait of Mrs. Abington as 'Miss Prue'* with which the chapter concludes, I attempt to revivify the stale and all-too-often general association of eighteenth-century culture with tropes of theatricality and masquerade by situating the Georgian stage and its players within an emerging celebrity culture.

While chapter 1 attempts to explain Lamb's seemingly aberrant expression of antitheatrical prejudice in 1811 through a backward look at Garrick's career, chapter 2 draws the same contextual analysis for Hazlitt's 1824 essay "On the Principal Art Galleries of England," in which he denigrates engraving and the popular fashion for mass-produced prints. As all roads in early nineteenth-century theater lead to Garrick, so all roads in Regency

painting lead to Sir Joshua Reynolds and the enduring influence of his academic lectures, the so-called *Discourses on Art*. The first part of chapter 2 finds in the *Discourses* a sub-textual argument against the art of engraving that, as a form of industrialized *mimesis*, Reynolds perceived to be antithetical to the ideals of the newly founded Royal Academy. This academic rejection of the print trade (engravers were excluded from the Academy) runs directly counter, however, to Reynolds' practical management of his own career, for which he, like all Georgian painters, depended on the successful commercial marketing of prints. As in my study of Lamb's reaction against the Regency culture of celebrity in chapter 1, the highbrow, literary idealism of the English cultural elite, represented in this case by Reynolds' *Discourses,* confronts an emerging market for visual media whose appetite for "real copies" it is unable to control. The second section of the chapter moves from the miniature to the gigantic, and the private to the public sphere, to examine the new trend for public exhibition of academic paintings, characterized by immense canvasses, which literally did not "fit" the increasingly domestic-bourgeois spaces and tastes in British painting. The popularity of public exhibitions unregulated by the Academy was, like the print market, a source of serious concern to the cultural establishment. Examining the career of one of the new breed of commercial academic painters, Benjamin Haydon, I trace a growing popular taste for what I term "spectacular realism." Haydon's paintings, as part of a school that included John Singleton Copley, Benjamin West, and John Martin, offered a combination of spectacle and verisimilitude that heralded the radical divergence of popular visual media from the idealist principles and "grand style" that had governed conventional academic painting since the Renaissance.

As I have already outlined, the apotheosis of "spectacular realism" in the first half of the nineteenth century was achieved at the panoramas of the West End. These enormous circumferential paintings, hung in specially designed rotundas, appropriated the elite academic genres of landscape and history painting to create a spectacular new form of visual entertainment for a mass audience. The inclusive nature of the panorama itself, which designated no privileged viewpoint, foreshadowed modern cinematic culture, and embodied the increasingly democratic, collective nature of visual recreation in the Romantic period. Chapter 3 analyzes Wordsworth's description of a panorama in Book Seven of *The Prelude,* where the poet of nature confronts the commodification of natural landscape in a popular *visual* form. In particular, I examine how Wordsworth's poetics of the sublime in nature are repudiated by the panorama's attention to a documentary recreation of the visible world. Wordsworth's subsequent rejection of the

panorama's "lifelike mockery" represents an emblematic crisis of Romantic idealism in the emergent visual culture of modernity—the subject of this book as a whole.

Chapter 4 shifts from the popular visual entertainment venues of the West End to their highbrow counterpart in Bloomsbury, the British Museum, with a special view to its status as symbol and repository of Hellenic ideals. In the first section, I examine the origins of eighteenth-century Hellenism as a strictly idealized, predominantly text-based phenomenon. I then argue that the critical strategies and presumptions of literary Hellenism—what I identify in Schiller, Winckelmann, and Diderot as "sentimental distancing"—were overthrown by the installation of the Elgin Marbles in the British Museum in 1816. In the same way that the verisimilitude of the panorama offended Wordsworth's relation to landscape as a notional, poetic ideal, the Marbles represented the visual-material "real" of antiquity come to shake the idealist foundations of literary Hellenism. In my analysis of the new archaeological Hellenism in section two, I read Keats' British Museum poems as unique illuminations on the instability, both political and aesthetic, of the Elgin Marbles' first arrival at the British Museum. A central purpose of this section is to present Keats' two *Hyperion* poems as a critique of the nationalist ideology under which the British Parliament justified acquisition of the marbles. At the British Museum, the nation's imperial destiny assumed the symbolic form of Athenian glory, but Keats' traumatic allegory of the museum-going experience in "The Fall of Hyperion" places this transaction under the threat of a "curse." Pursuing this notion of the "curse" of imperialism, the chapter concludes with a biographical study of Lord Elgin's unhappy career through the suggestive imagery of Byron's anti-Elgin poem, "The Curse of Minerva." Elgin becomes, in this reading, the anti-type of sentimental distancing. Through his fixation on the literal (as opposed to literary) object of antiquity, Elgin's antiquarian passion collapses into the very forms of psychological breakdown and personal disaster that Schiller, Winckelmann, and Diderot intuited, flirted with in the form of critical writing, but ultimately avoided through the defensive power of idealization. To this extent, Elgin's disputed legacy represents a profound irony. His acquisition of the Parthenon marbles was not a natural outcome of Romantic Hellenism but a transgression of its established parameters. Making Hellenism "real" had dire consequences for Elgin's career no less than his judgment, and the crises and contradictions of his story, I suggest, foreshadow the seemingly intractable outrage and political anxiety that continue to surround the Marbles. In Elgin's personal history, and Keats' poems, we find the origins of the Mar-

bles' construction as intensely politicized, rather than merely conventionally idealized, antique remains.

The first part of chapter 5 returns from the public spaces of early nineteenth-century visual culture—the art gallery, panorama, and museum—to the domestic sphere, first examined in my discussion of collectible prints in chapters 1 and 2. This chapter compares the aesthetics of book illustration—a popular and lucrative industry since the 1770s that reached an artistic apogee with Turner in the 1830s—and the emergent medium of photography. The fact that both Turner and the photographic pioneer Fox Talbot illustrated the works of Sir Walter Scott within a decade of Victoria's coming to the throne presents an extraordinarily instructive opportunity, never before grasped, to uncover the tensions between the two visual media and their relation to *literary* Romanticism. Framing my discussion of Turner and Fox Talbot is a dramatized account of their trips to the Highlands, through which I explore the emerging Scottish tourist industry that Turner's illustrations both drew upon and helped to promote. The increasing commercial importance of the new tourism is suggested by the fact that both Turner's engraved designs and Fox Talbot's photographs do less to actually *illustrate* Scott's literary narratives than document their respective tours, thus anticipating a twentieth-century souvenir tourist culture centered around the camera and photo album. That said, while Turner's illustrations contain a trademark visual rhetoric indissociable from British Romanticism, Fox Talbot's "Scott" photographs refuse to romanticize their subject, insisting on a putatively objectivist account of the Highland landscape. The second part of the chapter examines the Romantic backlash against the supposed "realism" of the photographic image with a reading of Baudelaire's jeremiad against photography in his 1859 *Salon*. I conclude with a consideration of Félix Nadar's nostalgic Second Empire portraits of aging Parisian bohemians (including Baudelaire), and his mock-Gothic study of the Paris Catacombs in 1861. Both these photographic projects suggest that Baudelaire's reports of the death of Romantic idealism, implicit already in the 1818 Coleridge lecture with which I began this study, were no longer exaggerated or premature.

As is evident from this brief synopsis, my use of the term the "real" will not be strictly Barthesian, but serve rather as a generous catch-all. In the course of this book, the "real" will describe variously a style of stage acting; a type of pictorial scenic effect; a form of social identity; mass-produced prints (i.e. copies of a "real" original); Greek statues; book illustrations; and photographs. Each subject will bear its own particularly inflected definition of

the "real," which I will be careful to introduce in a timely way. Against the charge that such a catholic application of the term necessarily compromises theoretical probity, I present no defense except that I have used the idea of the "real" only insofar as it is useful, and have otherwise preferred a historically descriptive, even at times anecdotal approach, to a densely theorized study. My purpose, in the most general terms, is to both adhere to and seek to verify Benjamin's dictum that "the [modern] theory of 'progress' in the arts is bound up with the idea of the imitation of nature, and must be discussed in the context of this idea."[16] By "progressive" art, Benjamin does not mean the modern avant-garde but rather its nemesis: a technology-driven popular market for visual entertainment, the prime currency of which is not any conventional (or, for that matter, radical) ideal of beauty but rather novelty and the shock effect of visual similitude, of the "real." In my efforts to represent what Bernard Comment has identified in the era of the panorama as "the beginnings of a new logic . . . of surrogate experience," I employ the broad and familiar vocabulary of visual-culture studies, including "mass media," "visual technology," "spectacle," "simulacrum," "celebrity," "entertainment," and "popular culture."[17] My purpose in employing free use of a critical language associated with Benjamin, Barthes, Debord, Adorno, and others without engaging in detailed analysis of these theorists is to maintain focus on the historicist task at hand: to establish a deep connection between the visual culture of the Romantic period and later nineteenth and twentieth-century modernity, a link that, as I have suggested, has hitherto been obscured by Benjamin's foreshortened historical paradigm.

In his editor's introduction to *The Visual Culture Reader* (Routledge, 1998), Nicholas Mirzoeff describes how "visual culture has gone from being a useful phrase for people working in art history, film and media studies, sociology and other aspects of the visual to a fashionable, if controversial new means of doing interdisciplinary work."[18] The "controversy" Mirzoeff refers to is the institutional guerilla war currently being waged within art history departments by proponents of a popular media and theory-oriented visual studies curriculum (see *October*'s special issue on the subject, Summer 1996). My interdisciplinary approach to "visual culture," however, does not accord with its role in this debate, either as a substitute for the now stale concept of postmodernism ("Postmodernism is visual culture," declares Mirzoeff), or as an "academic clearing-house of cultural studies."[19] This book owes far more to recent cultural historians of the Georgian period: to the encyclopedic archival studies of Richard Altick,

John Brewer, and Timothy Clayton, and to the groundbreaking interdisci-
plinary work of John Barrell, Morris Eaves, and Shearer West. My aim is to
continue the efforts of these scholars in drawing the history of visual
media within the orbit of a literary culture from which, at least since Less-
ing's *Laocoön* (1766), it has been resolutely exiled. To this extent, *The Shock
of the Real* helps illuminate our millennial anxieties over the aesthetic values
of text and image through a study of their original estrangement in the
century after Lessing's unilateral declaration of the superiority of the word.
By dramatizing this estrangement as a kind of Georgian "culture war," my
study of Romantic visual culture adopts James Heffernan's model of verbal-
visual inquiry, which "treats the relation between literature and the visual
arts as essentially *paragonal,* a struggle for dominance between the image
and the word."[20]

Aside from its purpose in broadening the historical terms currently
applied to our understanding of visual-cultural modernity, this book inter-
sects also with debates over Romantic ideology. My principal concern is
with issues of class, specifically the inseparability of Romantic sensibility
from the self-constituting presumptions of a cultural elite. Lady Blessington
called the crowds at Belzoni's exhibition "intolerably vulgar," while her
friend Lord Byron derided the company at Elgin's gallery of antiquities as
"brawny brutes [who] in stupid wonder stare/And marvel at his Lordship's
'stoneshop' there."[21] A generation earlier, Reynolds' *Discourses* had likewise
attempted to distance the ideals of the elite Royal Academy from the new
commercial market in prints, while Wordsworth and later Baudelaire, adrift
in the spectacular *fourmillante cités* of London and Paris, feared for the priv-
ileges of poetic imagination. In each case, we find an educated literary sen-
sibility outraged by the spectacle of bourgeois consumption of art, and by
the increasing influence of a decidedly middle-class taste for visual novelty
and the "real." This conflict has consolidated itself in the twentieth century
in a high culture/low culture divide, and the seemingly permanent resent-
ment of an educated elite toward the visual mass media. To take a recent
compelling example: in 1997, the highest grossing film of all time, James
Cameron's *Titanic,* first excited public fascination with its staggeringly lit-
eral recreation of the doomed liner. Aside from the costs of the meticu-
lously rendered period *décor,* the overwhelming majority of the film's
record budget was spent on a historically exact and extraordinarily realistic
cinematic staging—almost in real time—of the ship's sinking. In the phe-
nomenal success of *Titanic,* popular appetite for the "shock" of verisimili-
tude showed itself to be as strong at the turn of the twenty-first century as

at the turn of the nineteenth. While Cameron's film swept the middlebrow, popularity-conscious Academy Awards, in particular the technical achievement categories, highbrow critics ridiculed the inanities of his script. The disputed aesthetic merits of *Titanic,* as much as its fascination for the "real," suggest that the Romantic era conflict between the literary-cultural elite and popular visual media casts long shadows over our own.

Further to this point: It is a commonplace to describe millennial culture as "visual" rather than "literary." An evolutionary trajectory of commercial visual media—from photography to the cinema, through television, and now the post-photographic era of computer-imaging technology and the "virtual reality" arcade—has, it is routinely said, asserted an increasingly dominant role in Western and now global culture. As I have suggested earlier, one inspiration for this study lies in the misleading placement of photography as a point of origin in both academic and popular versions of this historical narrative. Walter Benjamin considered photography and later the cinema the principle emblems of the new mass culture, with Baudelaire, a contemporary of pioneer photography, as a representative urban poet on the cusp of modernity. In *The Shock of the Real,* however, we will find that the *literati* of Regency London were already immersed in a proto-cinematic urban culture of panoramas, printshops, galleries, and spectacular theatricals.

A more recent example of the characteristic foreshortening of modern visual-cultural history was the 1999 exhibition, "Fame After Photography," at the Museum of Modern Art in New York, which represented 1839, the year of the camera's invention, as the moment of our "self-expulsion from a pre-photographic Eden."[22] As a corrective to this critical myth of origins, my readings here are intended to demonstrate that the social and techno-logical foundations for twentieth-century visual culture were set in the century *preceding* photography's emergence as a mass medium circa 1860. The rush to develop new commercial visual media in the pre-photographic era—from prints to panoramic illusions, from book illustrations to "Bel-zoni's Tomb"—prefigures the twentieth-century enthrallment with recre-ational visual technology no less than the invention of photography itself. This is not to read visual-cultural history deterministically, but as a sequence of evolutionary accidents. Daguerre, for example, a one-time pupil of the great panoramist, Prévost, created the Daguerrotype while experimenting with illusional effects for his famous diorama—an estab-lished visual entertainment that provided the commercial and technologi-cal impetus for his invention. In the more agonistic terms suggested by Marshall McLuhan, Daguerre's new photographic technology cannibalized

the media that preceded it.[23] It is thus by specific design that this revision-
ist study of Romanticism and visual culture chronologically *ends* with Sec-
ond Empire Paris and photography, where surveys of visual-cultural
modernity from Benjamin to MoMA have begun: the better to illuminate
the largely unwritten pre-history of our millennial visual age.

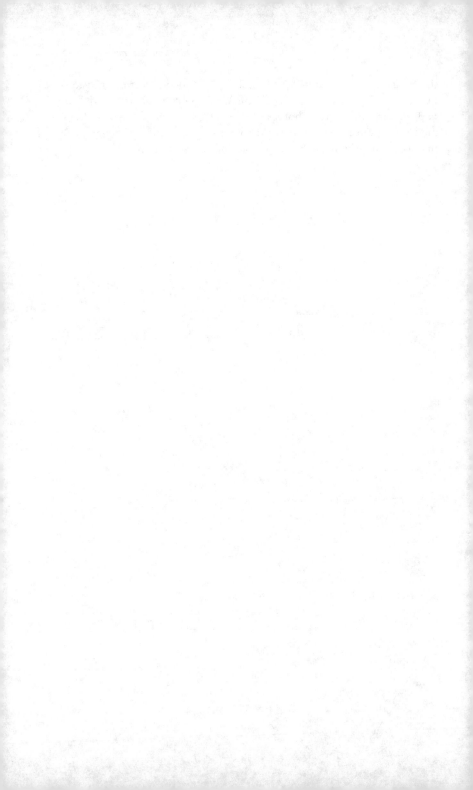

Chapter 1 ∾

THEATER AND PAINTING

The Legible Face:
Romantic Antitheatricality and the Legacy of Garrick

The shock experience of modernity, as defined in my introduction, derives from the perceived realism of popular visual-cultural phenomenon. Such a phenomenon was David Garrick. His first biographer, Thomas Davies, relates the impression Garrick made on his stage debut in October 1741:

> Mr. Garrick's easy and familiar, yet forcible style in speaking and acting, at first threw the critics into some hesitation concerning the novelty as well as propriety of his manner. . . . But after he had gone through a variety of scenes, in which he gave evident proofs of consummate art, and perfect knowledge of character, their doubts were turned into surprise and astonishment, from which they relieved themselves by loud and reiterated applause.[1]

The audience's response to Garrick anticipates the psychological phases of the sublime later described by Kant. The spectators move, by collective degrees, from an initial negative moment of "hesitation" and "doubt," to a pitch of "astonishment," to the psychical "relief" of approbation. The object of wonder in this case is not the natural sublime, but Garrick's *naturalistic* style. Although no conclusive visual evidence of his stage technique is available, first-hand accounts attest to the reality effect integral to a Garrick performance:

> So when great Shakespeare to his Garrick join's,
> With mutual aid conspire to rouse the mind,

'Tis not a scene of idle mimickry,
"Tis Lear's, Hamlet's, Richard's self we see. [2]

Garrick's friend, Samuel Johnson, marveled at his *complete* impersonation of a role, and explored further the critical distinction between "mimickry," represented in this case by the comic actor Samuel Foote, and Garrick's new standard of psychological realism:

> Foote was even no mimic. He went out of himself, it is true, but without going into another man. He was excelled by Garrick even in this, which is considered as Foote's greatest excellence. Garrick, besides his exact imitation of the voice and gesture of his original, to a degree of refinement of which Foote had no conception, exhibited the mind and mode of thinking of the person imitated.[3]

In short, the attraction of a Garrick performance lay not merely in his ability to suspend the disbelief of his audience, as Coleridge would later define the effect, but to defy disbelief altogether in his adoption of a persona not his own.

Although their individual styles differed markedly from each other, the great actors of the generation after Garrick—Kemble, Siddons, and later Kean—shared a common inheritance in Garrick's natural technique and emphasis on psychological depth.[4] Like Garrick before her, Sarah Siddons did not seem to "act" when onstage, but to be in "downright earnest."[5] But this association of the theater with psychological realism disturbed many of the early nineteenth-century writers who make up the Romantic canon. Wordsworth, for example, felt his imaginative powers "languish" at the theater's "gross realities" (*The Prelude* VII.509). Even for so influential a promoter of the Regency stage as William Hazlitt, a Shakespearean hero— a sublime, infinitely rich character on the page—could become an "unmanageable reality" when impersonated on the stage.[6] The positive appeal of the reality effect, on which purveyors of visual entertainment from Garrick to Belzoni depended for their door receipts, was the thrilling shock it provided the spectator. But Charles Lamb, watching Edmund Kean play Macbeth, felt his literary sensibility suffocate under "the too close pressing semblance of reality." Instead of thrill, Lamb experienced a "pain and an uneasiness" at Kean's performance of Shakespeare's text, "which totally destroy[ed] all the delight which the words in the book convey."[7]

In addition to the disturbing effects of naturalistic acting, the new fashion for visual spectacle on the London stage threatened the theater's tradi-

tional status as a forum for poetic drama. The most popular theatrical entertainment of the eighteenth century, the pantomime, with its love of stage tricks and spectacular scenic innovations, had long been criticized for "preferr[ing] shew to sentiment." Critics complained of the ruinous effect of the pantomime on public taste, an effect that was to cultivate the audience's vulgar "desire to behold a glittering pageant, which, by filling the imagination, prevented the toil of thinking."[8] Beginning in the 1780s, such criticism came increasingly to be leveled against more traditional drama as well. In Coleridge's nostalgic view, the doyen of playwrights, Shakespeare, had written for an Elizabethan stage of bare scenery and largely anonymous players: "The stage had nothing but curtains for its scenes, and the Actor as well as the author were obliged to appeal to the imagination & not to the senses."[9] Coleridge's language is imprecise but his meaning clear: an audience's imagination is awakened by the literary/aural experience of Shakespeare's text—whose "words . . . enchain the mind, and carry on the attention from scene to scene"—but dulled by the visible "outward action" of the performance.[10] Visuality, in this case, bears the full brunt of the time-honored philosophical denigration of sensory experience. Coleridge mourns the passing of an Elizabethan golden age in which poetic "recitation" rather than dramatic action was paramount.[11] Likewise Shelley declared that "the corruption which has been imputed to the drama begins when the poetry employed in its constitution ends."[12] The actor Macready—the model of the new nineteenth-century theater professional—fit Shelley's description of a stage inimical to poetic inspiration. He adopted the technique of translating his verse lines into prose as an aid to preparation. Stage managers too—and this trend was first established by Garrick himself—had long been wary of highbrow "literary" scripts. In short, when Coleridge delivered his first series of lectures on Shakespeare in 1808, "the connection between the theatre and literature was," in Raymond Williams' words, "virtually lost."[13] Due, in large degree, to the chilling effects of the Licensing Act of 1737, no writer of the first rank, save perhaps Sheridan, had written consistently for the stage in more than a century (Fielding, for example, abandoned playwriting for the novel).[14] Theater managers compounded the disincentives for serious verse dramatists by focusing increasingly on the commercial possibilities of scenic spectacle. With a regular schedule of pageants, pantomimes, and spectacular new stage sets and effects, the focus of London's theaters shifted pronouncedly through the late Georgian period to "visual as opposed to verbal presentation," as Marilyn Gaull has described it, to spectacle rather than poetry.[15]

As even the most casual student of the period will immediately realize, the foregoing account of the Romantics' negative attitude to stage representation contradicts the plain fact of their enthusiastic attendance at and voluminous commentary upon the theater of the early nineteenth century. Hazlitt and Lamb, for example—so often produced to buttress arguments for so-called Romantic antitheatricality (as they will be, in a qualified manner, in this chapter)—were among the most articulate and influential champions of the English theater in its history. Through his impassioned critical commitment to the career of Edmund Kean in the pages of the *Times* and the *Examiner* in the years 1814-17, Hazlitt acted as a de facto publicity agent for Kean's controversial challenge to the reign of the Kembles. That is, Hazlitt was definitely a player in the theater world, in the modern sense, whatever his doubts on the artistic merit of stage representation in general. To illuminate these contradictions inherent in Romantic antitheatricality is, I suggest, a more productive critical strategy than to attempt to resolve them on the basis of selective readings. Indeed, contradiction is, of itself, illuminating in this case. The relationship of Romantic authors to the Regency stage describes a pattern of ambivalence we will observe repeatedly throughout the course of this book. It signifies the literary elite's attitude of fascinated distrust toward the variegated and spectacular forms of visual culture emerging around them.

One thing is certain: as would-be playwrights, the Romantics had a difficult and distant relationship with the commercial theater. Their attempts to have plays accepted at the patent theaters constitute, in Timothy Webb's somber phrase, "a short, sad history."[16] The most marketable dramas, including Shelley's *The Cenci* and Keats' *Otho the Great,* were rejected, and only one script by a first-generation Romantic poet, Coleridge's *Remorse,* actually made it to the boards.[17] The Romantics' retreat into "closet drama" has been well documented and regularly maligned.[18] Wordsworth's *The Borderers,* Shelley's *Prometheus Unbound,* and Byron's *Manfred* belong to the repertoire of what Byron called "mental theatre": highly literary, psychophilosophical dramas "rendered . . . quite impossible for the stage."[19] The experience of serving on the board at Drury Lane had left Byron with the "greatest contempt" for the commercial theater, to the point of taking legal action to prevent his tragedy *Marino Faliero* from ever reaching the stage. In a letter to John Murray from 1821 regarding its proposed production, Byron protested that "I have never written but for the solitary *reader*— and require no experiments for applause beyond his silent approbation. . . . I claim my right as an author to prevent what I have written from being turned into a Stage-play."[20] Sir Walter Scott summed up the frustrations of

a generation of would-be verse dramatists when he complained that, in the modern commercial theater, "the author is compelled to address himself to the eyes, not to the understanding or feelings of the spectators."[21] With dramatic poetry and the psychological complexities of tragedy in increasing bad odor among the theatergoing public, scenic spectacle and the formulaic emotional conflicts of melodrama took center stage in the early nineteenth century.

In addition to the Romantics' benighted attempts at writing plays, a strain of antitheatricality in their dramatic criticism reinforces our sense of their love-hate attitude toward the stage. Certainly, a perennial scandal to the Romantics' reputation as critics of Shakespeare is Coleridge's admission that he never attended a Shakespeare play "but with a degree of pain, disgust and indignation." The leading Shakespearean commentator of the age was a churlish theatergoer, dissatisfied even with the artistry of Mrs. Siddons and John Kemble: "these might be the Macbeths of the Kembles, but they were not the Macbeths of Shakespeare." For Coleridge, Shakespeare didn't belong in the theater at all, but "in the heart and in the closet . . . with Milton."[22] A Hamlet or King Lear was an essentially ideal creation, produced not by the poet's "observation," but "his inward eye of meditation."[23] Shakespeare's characters were not, Coleridge insisted, mere "portraits." They possessed greater depth and psychological nuance than the visual arts and their shallow realities could possibly endow them with. In a similar vein, Byron held that stage productions "sacrifice character to the personating of it," while Lamb declared that the "greatness of Lear is not in corporal dimension, but in intellectual"; and, as such, he "cannot be acted."[24] Keats accordingly heard the call of the muse upon reading *King Lear,* not on seeing it performed. The Romantic Shakespeare was a reader's Shakespeare, and the reader, according to Hazlitt, "is almost always disappointed in seeing [the plays] acted." Even a consummate performer such as Mrs. Siddons—whom Hazlitt called "tragedy personified"—communicated no more than the "*pantomime* part of tragedy," the "exhibition of immediate and physical distress," at the expense of the "poetical beauties and minuter strokes of character" found in Shakespeare's text. Only the reader, in the privacy of his study, shared the "profounder feelings" of the Shakespearean hero.[25] Lady Macbeth in the flesh-and-blood form of Mrs. Siddons was inimical to the character's idealization in the imaginative act of reading. Antitheatricality, like much else in Romantic ideology, thus presumed a fundamental distinction between the ideal or sublime—symbolized here by the private interior of the reader's closet and, by extension, the interiority of the mind—and an external, sensory world of "reality" embodied, in

this case, by the stage. "The boards of a theater and the regions of fancy," Hazlitt concluded, "are not the same thing."[26]

The most comprehensively argued statement of Romantic antitheatrical prejudice came, ironically, from perhaps the most enthusiastic theatergoer of the age, Charles Lamb. Published in Leigh Hunt's journal *Reflector* in 1811, the original title of Lamb's essay reads "On Garrick, and Acting; and the Plays of Shakespeare, considered with reference to their fitness for Stage Representation" (in subsequent reprints, the initial reference to Garrick has often been elided—a significant and misleading omission).[27] In the essay, Lamb echoes Coleridge and Hazlitt's antitheatrical sentiments, the origins of which lie in classical iconophobia. The theater is an inferior medium, Lamb contends, for the simple reason that it is a visual medium. A theater audience cannot appreciate Shakespeare as a closet reader does: "What we see upon a stage is body and bodily action; what we are conscious of in reading is almost exclusively the mind, and its movements." As a visual medium, the theater excites the senses but not the mind; the subtle delineation of substantial feelings and ideas in Shakespeare's text lies beyond its scope. The art of the actor, Lamb insists, is limited to the "signs" of feeling. When it comes to "the motives and grounds of the passion," that is, the essence of dramatic character, "the actor can give no more idea by his face or gesture than the eye (without a metaphor) can speak, or the muscles utter intelligible sounds." Because the player's aim is "to arrest the spectator's eye upon the form and the gesture," Lamb argues, he will only distract his audience from the lyrical and psychological profundity of Shakespeare's verse. The result is a dramatic medium that represents "not what the character is, but how he looks; not what he says but how he speaks it." The actor, he concludes, is capable of communicating passion but not motive, feeling but not thought.

Literary critics have generally downplayed the importance of Lamb's *Reflector* essay on Garrick and Shakespeare. Its antitheatrical polemic, apparently so at odds with Lamb's lifelong passion for the stage, has been called "notorious," "weak," "eccentric," and a "glaring aberration" in his oeuvre.[28] For Jonathan Arac, however, the essay marks "an important moment in the history of the comparative valuation of media," a precursor to Benjamin's seminal "Work of Art in the Age of Mechanical Reproduction." Further to its significance for twentieth-century critical theory, Janet Heller has pointed to echoes of Lamb's devaluation of theatrical representation in contemporary film theory.[29] Considered as a reaction against Garrick and his legacy as a visual artist and theatrical celebrity, Lamb's essay assumes central importance in the argument of this book. Writers of the Romantic canon perceived the emerging visual media of the late Georgian age as

a threat to the traditional authority of the written word, and hence literature. The early nineteenth-century theater, as a forum for the visual art of dramatic performance, a purveyor of scenic visual spectacle, and a source of celebrity actors whose images were popularized in paintings, prints, and numerous other merchandised forms, played a vital role in the visual culture the Romantics so resented.

At the opening of his *Reflector* essay, Lamb recalls his outrage at coming across a statue of Garrick in Westminster Abbey:[30]

> [T]he reflection it led me into was a kind of wonder, how, from the days of the actor here celebrated to our own, it should have been the fashion to compliment every performer in his turn, that has had the luck to please the town in any of the great characters of Shakespeare, with the notion of possessing a *mind congenial with the poet's.* (italics in original)

Both Lamb and Coleridge regularly expressed their contempt for Garrick's editorial desecration of Shakespeare's texts. As the all-powerful manager of Drury Lane between 1747 and 1776, Garrick interpolated scenes in Richard III, cut the gravediggers from *Hamlet,* permitted Romeo a moment in Juliet's arms before dying and, most scurrilous of all, composed a new death speech for Macbeth—the better, it was said, to exhibit his mastery of protracted mortal convulsions. This alone does not explain, however, why Lamb, an ardent lover of both Shakespeare and theatergoing, would seek to belittle the man principally responsible for the bard's revival on the eighteenth-century stage. After all, almost one-third of the plays produced during Garrick's tenure at Drury Lane were by Shakespeare, while he himself performed no less than eighteen Shakespearean roles. He championed Shakespeare's genius against the carping of the French classicists, and rescued *Romeo and Juliet* from a century's obscurity. In the hagiographic account of the Abbey statue's inscription, at a time when Shakespeare's plays were neglected, "Immortal Garrick call'd them back to day." But despite this impressive record, Lamb is sufficiently resentful of his legacy even "to deny to Garrick the merit of being an admirer of Shakespeare."

The popularity of Garrick had spurred an enormous increase in theater attendance and excited great popular interest in its performers. Theophilus Cibber attested in 1759 that "on a moderate computation, the number of play-going people is now twenty to one compared with [some years ago]."[31] This new theater public demanded advance publicity for productions, reviews of performances they had seen, and gossip about the players. Grub Street obliged, transforming the hitherto humble players of the stage

into public celebrities. Groping for superlatives to describe Garrick's effect on the public imagination, the critic Benjamin Victor labeled him a "star," the first recorded use of the now ubiquitous epithet of fame. "There appeared a bright Luminary in the Theatrical Hemisphere," he wrote in 1761, "and the Fame of his extraordinary Performance reached St. James' End of the Town when Coaches and Chariots with Coronets, soon surrounded that remote Theatre. That Luminary soon after became a Star of the first Magnitude, and was called Garrick."[32] Before Garrick's debut in 1741, theater criticism in England reached a relatively small audience. But in the years following his first descent on the London stage "like a Theatrical Newton," events at Drury Lane became " a topic of almost universal conversation," and theater journalism blossomed.[33] A "little legion" of critics and admirers subjected Garrick's performances to intense scrutiny and comparison.[34] "Who are the objects of admiration among us now?" cried the literary-minded *Herald* in 1757, appalled at the popular craze for all things Garrick: "the estimator of the manners and principles of the times, is pleased to single out a player for the glory of our degenerate age."[35] The great Shakespearean actors of Lamb's generation—Sarah Siddons, her brother John Kemble, and Edmund Kean—subsequently became, according to the Garrick model, major cultural figures at their peak and national treasures in their decline.[36]

In Lamb's view, the increase in the popularity of actors and critical attention to the art of performance—a cultural phenomenon for which Garrick was largely responsible—had come at the expense of dramatic text. At the Regency theater, the celebrity power of the actor's performance shattered Lamb's literary ideal of Shakespeare's characters. "It is difficult for a frequent playgoer to disembarrass the idea of Hamlet from the person and voice of Mr. K[emble]," he complained, "we speak of Lady Macbeth while we are in reality thinking of Mrs. S[iddons]."[37] Accordingly, in his *Reflector* essay, Lamb does not perceive the Garrick statue in Westminster Abbey as a tribute to Shakespeare, but a symbol of the poet's fall from popular regard in favor of the player. The insidious effect of Garrick's unprecedented fame as a stage performer, Lamb suggests, was to subordinate Shakespeare's *poetic* genius to the actor's art of dramatic interpretation. Most provoking was the statue inscription, which exalted Garrick as Shakespeare's "twin star." For Lamb, the Westminster Abbey statue embodied Garrick's odious legacy to the Regency stage: the actor as celebrity icon.

The Abbey statue was not the only sanctifying tribute to England's first star of the stage. On Garrick's death in 1780, the painter George Carter

produced an extraordinary allegory, *The Apotheosis of Garrick* (figure 1.1), in which the actor's deathbed doubles as the altar of his canonization. Set in a Claudean arcadia, the painting depicts seventeen of Garrick's fellow actors, in Shakespearean costume, forming a mournful retinue at his bedside. Above their heads, two angels escort Garrick's earthly shape toward the slopes of Mount Parnassus and the welcoming arms of Shakespeare himself accompanied by the Muses. Carter's homage is the pictorial accomplishment of the Abbey statue inscription: the painting represents Garrick as Shakespeare's equal in the English cultural firmament. For Lamb, the heretical conceit of both the Abbey statue and Carter's painting—namely, the apotheosis of the actor—overturned the orthodox hierarchy of the arts, in which poetry reigned supreme over painting and music, and acting barely made the scale. "What connection," he demanded, does "that absolute mastery over the heart and soul of man which a great dramatic poet possesses, ha[ve] with those low tricks upon the eye and ear, which a player . . . can so easily compass?" Garrick's presence in Westminster Abbey as the popular emblem of Shakespeare's dramas, together with the notion that his "genius bade them breathe anew," was, for Lamb, a "scandal" and an "insult."

Notwithstanding Lamb's discomfort under the loom of Garrick's statue, however, the actor's presence in the national pantheon was what early nineteenth-century celebrity culture—the age of Siddons and Kean—demanded. But how did Garrick first create this market for fame? How did he construct his unprecedented celebrity? "To be considered 'famous' and praiseworthy in modern mass societies," Richard Brilliant has observed, "ha[s] less to do with a person's achievements than with a mechanism for distributing images, abundantly present in the public eye."[38] Garrick's close association with the world of reproductive visual media—with the marketing of paintings, prints, and all manner of sub-artistic merchandise—exemplifies the close connection Brilliant describes between modern visual culture and the phenomenon of modern celebrity. In the first part of this chapter, I argue that Garrick's unique marketability in the emergent visual culture of late eighteenth-century England began with his radical innovations in acting technique: his *visual,* as opposed to oratorical style. The intensely visible nature of his dramatic performances in turn transformed Garrick's person, particularly his face, into a marketable "image" able to be reproduced and sold through a multitude of subsidiary visual media. This ubiquity of Garrick's image laid the foundation for his fame, in the modern sense of the instantly familiar, iconic public figure. The careers of actors such as Garrick, Siddons, and Frances Abington bear out the direct connection Guy Debord has drawn between the modern "society of spec-

Figure 1.1 George Carter, *The Apotheosis of David Garrick* (1780). From the RSC Collection with the permission of the Governors of the Royal Shakespeare Theatre.

tacle" and the phenomenon of media fame: "Media stars are spectacular representations of living human beings, distilling the essence of the spectacle's banality into images of possible roles."[39] The first section of this chapter explores the connection between theatrical spectacle and media celebrity, while the second part, focusing on Sir Joshua Reynolds and Mrs. Abington, inquires further into Debord's understanding of the nature of modern celebrity itself, as the diversification of individual identity "into images of possible roles"—in my terms, fame as masquerade.

A Hazlitt piece from 1826, "Persons One Would Wish to Have Seen," alludes to Charles Lamb's abiding dissatisfaction with the new celebrity theater culture. The essay remembers a lively parlor game at which Hazlitt's guests nominated famous figures they would most like to see return from the grave. After consideration of Shakespeare, Milton, and Cromwell, the conversation turned to the performing arts. "Of all persons near our own time," Hazlitt recalls, "Garrick's name was received with the greatest enthusiasm." But the proposal of Garrick did not meet with unanimous approval. "A grumbler in a corner," Hazlitt writes, "declared it was a shame to make

all this rout about a mere player and farce-writer, to the neglect and exclusion of the fine old dramatists, the contemporaries and rivals of Shakespear[e]."[40] The curmudgeon of the party could only have been Charles Lamb, who evinces characteristic indignation at the new celebrity stage, and at the passion for fame that the evening's discussion in itself symbolized. In the conversation at Hazlitt's dinner table, the Elizabethan stage conjured images of the poets Shakespeare and Jonson, but the Georgian theater belonged to the actor Garrick. With Lamb's *Reflector* essay as its backdrop, this chapter explores how material, specifically *visual,* aspects of the Drury Lane Theater under Garrick—his natural, physiognomic style, spectacular scenery, and the "celebritization" of its actors through subsidiary commercial arts—came to define the theater of the late eighteenth and early nineteenth centuries far more than the literary merit of the scripts performed.

Garrick's "ruling passion," according to his first biographer, was not for the English dramatic tradition but "the love of fame."[41] Even in Lamb's time, a generation after his retirement from the stage, Garrick's image might be found everywhere: from Byron's rooms at Cambridge, to playing cards in London taverns, to the hallowed aisles of Westminster Abbey. As a drama critic and would-be poet of the stage, Lamb resisted this transformation of the English theater from a forum for poets of genius to a producer of celebrity actors. His resentment of Garrick's self-created, multi-media "stardom" exemplifies the resistance of the Romantic literary elite to the increasingly visible spirit of the age.

At the most general level, Garrick's stylistic innovations for the stage belong to the new naturalism in eighteenth-century visual arts and taste. The "naturalness" of Garrick's performances corresponds, for example, to the relative informality and freshness of portraits by Reynolds and Gainsborough, and anticipates the overthrow of Palladian stiffness in the Apollo Belvedere by the life-like charisma of the Elgin Marbles. That said, it is impossible to know how natural a Garrick performance would be judged today, when even the once-vaunted informality of 1950s film acting—Marlon Brando, James Dean, etc.—already appears idiosyncratic and contrived. Naturalism is a relative term and, furthermore, not the main point. The significance of Garrick's revolution in stage performance lies not in his naturalness per se but, as Diderot perceived in his essay *The Paradox of Acting* (ca.1773), in the technique that produced the *effect* of nature in his art. The essence of that reality effect lay in the visual elements of his style.

In the first decade of the eighteenth century, the premier actor of the London stage, James Betterton, had described himself as a "speaker" and

based his technique on the teachings of ancient rhetoricians. [42] Betterton had "fat, short arms," according to one critic, "which he rarely lifted higher than his stomach." His performances consisted of senatorial declamations, with "his left hand frequently lodged in his breast, between his coat and waistcoat, while, with his right he prepared his speech."[43] James Quin, the leading player at the time of Garrick's debut, continued the tradition of declamatory acting. As a 1747 review described, "he recited, rather than acted. In this indeed he resembled his predecessor Booth; and in my opinion he still retains too much of the deep rotundity of his pronunciation, and the formal deliberate sway of his motion."[44] Beginning in the 1730s, commentators on the theater began to express contempt for the classical, oratorical style Quin embodied, and advertised the need for naturalistic innovation:

> The most universal complaint among good judges of the stage is that players are shockingly unnatural . . . if we miss nature, we miss pleasure, our whole expectation from the theatre being that deception which arises from *appearance* mistaken for *reality*. (emphasis in original)[45]

A market demand for the "pleasure" of "reality" is already evident here and within a decade, by virtue of Garrick's radical modernization of acting technique, the theater had caught up with its audience's changing tastes. Contemporary eyewitnesses perceived Garrick's revolutionary impact on English theater as clearly as the historians who have come after them. At a 1740s production of Rowe's *Fair Penitent* in which both Quin and Garrick appeared, the writer Richard Cumberland described the birth of a new era:

> Quin presented himself . . . with very little variation of cadence, and in a deep full tone, accompanied by a sawing kind of action, which had more of the senate than of the stage in it . . . but when after long and eager anticipation I first beheld little Garrick, then young and light and alive in every muscle and in every feature, come bounding on the stage, and point at the wittol Altamont and heavy-paced Horatio—heavens, what a transition—it seemed as if a whole century had been stept over in the transition of a single scene! Old things were done away, and a new order at once brought forward, bright and luminous, and clearly destined to dispel the barbarisms and bigotry of a tasteless age, too long attached to the prejudices of custom, and superstitiously devoted to the illusions of imposing declamation.[46]

After seeing Garrick in the role of Richard III, Quin himself appreciated the significance of Garrick's vivid and psychologically complete represen-

tation of the villain King. "If the young fellow was right," he reportedly conceded, "he, and the rest of the players, had been all wrong."[47]

Garrick was not naturally equipped for oratory. He was "no declaimer," observed Johnson, ". . . there was not one of his own scene shifters who could not have spoken 'to be or not to be' better than he did."[48] Intent on making a virtue of his verbal shortcomings, Garrick built his technique around a *visual* concept of characterization. Consequently, throughout his career Garrick "disliked to perform any part whatever, where expression of countenance was not more necessary than recitation of sentiment."[49] Eye-witness accounts invariably focus on Garrick's representation of character through non-verbal means: facial expression, gesture, and elaborate stage business. Through Garrick's influence, it became commonplace among critics to imagine an actor's effect on a deaf or foreign-speaking spectator. "Garrick," reported Georg Lichtenberg, "contrives that every gesture would make even a deaf spectator aware of the gravity and importance of the words which they accompany."[50] In the case of an Italian attending a performance of *Macbeth* at Drury Lane, Garrick passed the new visual standard of dramatic interpretation with honors: the foreign visitor collapsed from his seat in horror during the dagger scene.[51] Likewise Diderot, fascinated by the new "English" style, took to blocking his ears during performances, the better to judge the actors' command of a purely visual rhetoric of the passions.[52] The oratorical poses of seventeenth-century classicism rapidly fell into disrepute. The cult of sensibility had made it to the stage, with Garrick as the consummate man of feeling. From the night of his debut in 1741, Garrick added a physiognomic and gestural vocabulary of emotion to the representation of character, a revolution in acting technique that critics, in innumerable handbooks and reviews, began to consolidate in a body of dramatic theory from the 1750s on.

The architecture of the Drury Lane theater was ideally suited to Garrick's intimate style. Built by Christopher Wren in the reign of Charles II, the interior remained largely unchanged until the eve of Garrick's retirement. The audience, numbering considerably under a thousand at full capacity, circled about the performers in boxes along the sides of the stage, and loomed above them in galleries overhanging the pit. This proximity allowed for a physical rapport between the actors and audience that would be lost in the vastly expanded theaters of Lamb's day. Garrick was, by all accounts, an extraordinarily nimble and dynamic performer who moved about the Drury Lane stage with reckless confidence. He captivated his audience, as the young Laurence Olivier would two centuries later, with a combination of natural charisma and heedless athleticism. The essence of a

Garrick performance lay not in physical gesture, however, but the preternatural mobility and expressiveness of his face. Taking advantage of the intimacy of the theater, his performance of Hamlet, for example, would begin with a physiognomic representation of the Prince's mood. Garrick's "look" established his character in the audience's mind so vividly that his articulated thoughts, when they did come, seemed almost superfluous:

> When he entered the scene, his look spoke the character, a mind weighed down with apprehension and grief. He moved slowly, and when he paused he remained fixed in a melancholy attitude; such was the expression of his countenance, that the spectator could not mistake the sentiment to which he was about to give utterance.[53]

Likewise, John Genest reported how from Garrick's first entrance onstage as Hamlet "the character he assumed was visible in his countenance."[54] Variations of this critique abound. The attraction of Garrick's mercurial face even induced some gentlemen enthusiasts of the theater to eschew the comfort of their boxes and mix in with the rowdy groundlings of the pit. The critic and poet, Charles Churchill, fixed his admiring gaze on Garrick from the first row of benches where he joined the painter Henry Fuseli, who treated Garrick's performances as a master-class in the facial contours of dramatic passion.[55]

Fuseli's interest in Garrick points to the fact that Georgian fascination with the dramatic possibilities of physiognomy began with painting, not the theater. Charles Le Brun's influential guidebook for painters on facial expression, *Méthode pour apprendre à dessiner les passions* (1698), sought to systematize the human passions into generic physiognomic types. It is symptomatic of our distant remove from eighteenth-century naturalism that Le Brun's *Méthode,* based on the mechanistic dualism of Descartes, now appears reductive at best and at worst grotesque. The book's influence on the eighteenth-century visual arts, however, was profound. After publication of an English edition in 1734, denizens of the theater adapted Le Brun's system to the stage as a visual directory of the passions an actor might consult and imitate. Aaron Hill, the first English theorist of dramatic technique, outlined the new Le Brunian science of acting in his groundbreaking 1730s theater journal *The Prompter.*[56] "Every passion," he wrote, "has its peculiar and appropriate look . . . and which, intermingling their differences on the visage, give us all the soul-moving variety of pain, pleasure, or suspension which the heart can be strikingly touched by."[57]

Whether by deliberate study or intuition, Garrick was already master of the new technique by the time of his debut. According to Hill's prescription, he transformed Le Brun's empirical psychology of the passions into dramatic art. Critics, used to the stiff-armed oratory of Booth and Quin, marveled at Garrick's *physiognomic* approach to characterization: "Mr. Garrick . . . is indebted to nature for an almost matchless significance of feature, enlivened with eyes particularly brilliant; from an amazing flexibility of countenance, he can express the most contrast[ing] feelings: simplicity, mirth, rage, grief, despair, and horror, with nearly equal excellence."[58] Garrick's technique emphasized the communicative power of facial expression, whereby "the passions rose in rapid succession, and, before he uttered a word, were legible in every feature of that various face."[59] Employing a similar figure, Garrick's friend and admirer Hannah More recalled "the *handwriting* of the passions in [his] features" (my emphasis).[60]

The metaphor of physiognomic "legibility"—a silent "handwriting" of the actor's face that discloses psychological meaning—illuminates the larger image-text conflicts evident in Lamb's 1811 essay. Because Garrick's onstage character is already "legible" in his face, the spoken text becomes, if not dispensable, then at the least secondary. Joseph Pittard, for example, found in Garrick "a player who personates in every part the living manners of a superior character, [and] manifests beyond contradiction, that he has conceived the true idea of the author."[61] Another contemporary critic, John Hill, argued that the actor's interpretation of a role, far from a vulgarization of the poet's intent as Lamb would later suggest, was in fact indispensable to the experience of poetic drama. What the author has "left deficient," he states, "the actor must supply, not in words of his own adding, but by the silent eloquence of gestures, looks and pauses."[62] Thomas Wilkes ventured even further, beyond the idea of dramatic action that merely supplements the spoken word. "There is something," he suggests, "inexpressibly eloquent in a proper and just action, which *words can never describe:* it is the language spoken by the soul, which penetrates directly into the heart, and that undisguised, natural eloquence which only is universally intelligible" (my emphasis).[63] To these critics, Garrick did not simply declaim or represent a role; he enlarged and enriched the dramatic text through a "legible" rhetoric of facial expression and gesture.

As we have seen, Hazlitt echoed Lamb's distrust of stage representations of Shakespeare, observing that an actor's interpretation of a tragic hero offered only "the pantomime part of tragedy, the exhibitions of immediate and physical distress."[64] In the case of Garrick, Hazlitt's charge of "pan-

tomime" was not simply rhetorical. The popular pantomimes, at the low end of the theater marketplace, had exerted a profound influence on Garrick's Shakespeare revivals at the putative top end. Garrick's style, with its emphasis on pauses, starts and "speaking looks," was itself highly pantomimic. As a budding player, Garrick learned the elements of pantomime from the famous Covent Garden Harlequin, John Rich. Innumerable accounts testify to Garrick's putting this training to use as a parlor-trick, where he would perform a virtuosic dumb show of characters to the delight of his audience. The most famous of these private improvisations took place in the presence of Diderot, during Garrick's triumphant visit to Paris in 1763:

> Garrick put his head between two folding doors, and in the course of five or six seconds his expression changed successively from wild delight to temperate pleasure, from this to tranquility, from tranquility to surprise, from surprise to blank astonishment, from that to sorrow, from sorrow to the air of one overwhelmed, from that to fright, from fright to horror, from horror to despair, and thence went up again to the point from which he started.[65]

Difficult as it is to believe that even Garrick could accomplish the complete gamut Diderot describes in only six seconds, the nature of the exhibition is itself revealing. Called upon to entertain an after-dinner company, Garrick chooses to perform not a soliloquy from Shakespeare, but a Le Brunian pantomime of the passions. Furthermore, he limits the scope of his performance by offering only his face to the assembly, keeping his body hidden behind the folding doors. What Diderot observed was, in fact, the core of the Garrick technique: the poetry of the "legible" face.

To recapitulate: Contemporary accounts agree that Garrick's finest moments on the stage lay in the visual representation of character. According to Thomas Davies, a Garrick performance defied verbal description; to capture it "would call for the pencil of a Raphael or a Reynolds."[66] Rare is the reference to his memorable enunciation of a line. In a Garrick performance, the deliberate, protracted absence of his voice—in a pause, start, or facial movement—drew the audience's focus away from his recitation of the dramatic text to the complex visuality of his style. These innovations set a new standard in the dramatic representation of character that demanded, in turn, a significant change in audience perception. True dramatic feeling, it was increasingly suggested, lay beyond the reach of words, to be communicated only by silent gesture. Theatergoers soon discovered that the most electrifying moments at the theater were not to be had in the

os rotundum of declamation, but in the dramatic suspense of silences. In a tribute to Garrick on his retirement, Thomas Bowdler's sister recalled how

> Oft, when his eye, with more than magic pow'r,
> Gave life to thoughts, which words could ne'er reveal,
> The voice of praise awhile was heard no more;
> All gaz'd in silence, and could only feel![67]

In a similar vein, Davies remarked how the expressive glances exchanged between Garrick and Mrs. Pritchard, not their recitation of Shakespeare's lines, communicated the emotional meaning of the murder scene in *Macbeth:* "their looks and action supplied the place of words. You heard what they spoke, but you learned more from the agitation of mind displayed in their action and deportment."[68] Garrick's performance of this scene, like his famous "start" upon seeing Hamlet's Ghost, was considered a *tour de force,* and exemplary of the new style. The painter Johann Zoffany recorded the *Macbeth* scene, after which a popular print was made (figure 1.2), in which the physical and verbal urgency, as in Shakespeare's text, is all Lady Macbeth's. Garrick's Macbeth meanwhile is frozen in a helpless gesture of shock and incipient remorse. His glazed eyes are fixed on a point above the heads of the audience in the pit, and his lips parted in soundless horror. In the days of Betterton and Quin, such a pose would be premeditated and held indefinitely in the expectation of applause. As Garrick's faraway gaze in the Zoffany image suggests, however, the effect of his (undoubtedly) rehearsed attitude is built upon a pretended denial of the audience's presence, at the same time that he invites them to experience his reaction to the murder of Duncan as psychologically real and truly felt. "It is impossible," marveled Thomas Wilkes on witnessing the scene, "to convey an adequate idea of the horror of his looks."[69]

The dramatic pause was the particular signature of Garrick's style. In his repertoire of stage effects, the Garrick pause served to heighten dramatic tension in ways that the most nuanced delivery of lines could not. According to his keenest commentator, Georg Lichtenberg, Garrick's performance of a Hamlet soliloquy might simply trail off into silence, the last words entirely lost to the audience.[70] With the example of Garrick vividly in mind, Aaron Hill theorized the dramatic effects of the pause in his influential 1745 *Essay on the Art of Acting:* "Beautiful and pensive pausing places will . . . appear to an audience but the strong and natural attitudes of thinking; and the inward agitations of a heart, that is, in truth, disturb'd and shaken."[71] Where Lamb will later see only the empty "signs" of passion in

Figure 1.2 Johann Zoffany, *Mr. Garrick and Mrs. Pritchard in the Tragedy of Macbeth,* engraving by Valentine Green, for John Boydell (1776). By permission of the Folger Shakespeare Library.

the silent play of an actor's features, Hill perceives a language of genuine psychological depth. Some contemporaries indeed saw low trickery in Garrick's starts and pauses, but for most spectators the effect was profoundly emotive.[72] In his 1761 satire of the stage, "The Rosciad," Charles Churchill upholds Garrick's use of the pause as essential to the emotional intensity and psychological truth of his performances:

When reason yields to passion's wild alarms,
And the whole state of man is up in arms,
What but a critic could condemn the player
For *pausing* here, when cool sense pauses there?
Whilst, working from the heart, the fire I trace,
And mark it strongly flaming to the *face;*
Whilst in each sound I hear the very man,
I can't catch words, and pity those who can.[73]

Further evidence of Garrick's commitment to visual realism was his determination, not hitherto witnessed on the English stage, to stay conscientiously "in character" throughout a performance, rather than only when speaking his lines. Soon after his debut, the *Gentleman's Magazine* related how "when three or four are on the Stage with him, he is attentive to whatever is spoke, and never drops his Character, when he has finished a Speech." Garrick's devotion to character was in stark contrast to the habits of his compeers, who distinguished their non-speaking moments onstage by either "looking contemptibly on an inferior performer, unnecessary spitting, or suffering [their] Eyes to wander thro' the whole Circle of Spectators."[74] Garrick's consistent representation of character, independent of his delivery of actual lines, marks the beginnings of modern "fourth wall" technique. In short, the visual emphases of Garrick's style—pauses, starts, and staying "in character"—do more than convey his particular strengths as an actor. They imply the modern concept of stage performance itself: as not merely the recitation of a speaking part, but a rich, psychologically credible impersonation of the dramatic role, as if real.

The visual realism of Garrick's acting style, particularly the mesmerizing effects of his facial expression, was decisive in the creation of his fame. The emphasis on Garrick's physical appearance led to the successful marketing of his "image," in the commercial sense, a half-century long publicity campaign consummated by the erection of his visible shape in Westminster Abbey in 1797. As our millennial culture of celebrity dictates, it is through visual, not print media, that an ordinary individual is transformed into a public "personality." Garrick intuited this new cultural order, and expanded his promotional influence beyond merely bribing puffs in the press. He was the first public figure to employ mass-market strategies of self-promotion, and "belongs beside Josiah Wedgwood and Hogarth among the most astute eighteenth-century entrepreneurs of culture."[75] Garrick developed close relationships, both personal and professional, with the major painters of the

age: Hogarth, Wilson, Hayman, Reynolds, and Zoffany. As a consequence, there are more portraits of Garrick than any other eighteenth-century figure excepting George III. Almost no public art exhibition in England from the 1760s until his death was without a painting or statue of Garrick.[76] This unprecedented collaboration between the visual and performing arts in England spawned its own genre: the theatrical conversation painting.[77] But Garrick's marketing genius saw that genuine fame, in the modern sense he helped to create, lay not in the paintings themselves but the sale of engraved reproductions, such as Valentine Green's print of Zoffany's "Macbeth" picture. For example, Garrick's interest in Hogarth's commemoration of his sensational debut as Richard III centered on the potential marketability of an engraving. "Pray, does Hogarth go on with my picture," he asked in a letter from 1745, "and does he intend a print from it?"[78] Even during his European tour of 1764-65, a supposed vacation from the stage, Garrick's mind ran very much on publicity. In a letter to his brother George (his de facto personal assistant), Garrick sent an urgent call for fresh supplies of prints to distribute to his Continental admirers: "I must desire you to send me by the first opportunity six prints from Reynolds' picture. You may apply to the engraver he lives in Leicester Fields, & his name is Fisher, he will give you good ones, if he knows they are for Me—You must likewise send me a *King Lear* by Wilson, *Hamlet, Jaffier* & Belv[idera] by *Zoffani* [sic] . . ."[79] According to his biographer, Davies, Garrick's house at Hampton was itself a kind of shop window display, adorned "with multiplied paintings and engravings of himself, in various characters."[80]

In *British Theatre and the Other Arts* (1984), Shirley Kenny points out that Garrick's self-promoting merchandise extended far beyond the baseline media of paintings and engravings:

> Garrick's likeness appeared in terra cotta, cast busts, watercolors, etchings, pencil, pen and ink, and wash pictures, as well as on medals (mulberry wood, copper gilt), wall hangings, Wedgwood jasperware, a hair picture, Liverpool Delft tiles, playing cards, and refreshments tokens for the Jubilee at Stratford. . . . Garrick pieces sold.[81]

Prints of Garrick and other well-known actors appeared also in book form either as self-sufficient collectibles or illustrations to drama anthologies. The amount of financial stake Garrick had in the various sub-artistic commodity forms of "Garrickmania" is unclear. Regardless, the principal reward for his marketing of souvenirs bearing his image was not financial (although he became a very wealthy man), but an unprecedented celebrity

in his lifetime and apotheosis afterward. On a visit to England in 1775, Lichtenberg admitted to being "dazzled . . . by his fame."[82] A product of the new commercial culture of the eighteenth century, Garrick was a cultural icon in the very modern sense, a merchandized brand name, a proto-movie star. His effect on popular culture was such that, in the early nineteenth century, Lamb confronted his legacy not merely in the fashion for natural acting and visual spectacle, but in a comprehensively merchandized celebrity theater industry—a Hollywood *in embryo.*

To successfully sell a brand name, one must flood the market with a range of products from which the consumer may choose but cannot escape. Garrick's strategies for self-promotion thus anticipated the golden rules of modern mass media advertising: saturation and diversity. His image, unlike King George's, was not reserved for the walls of the gentry and state buildings; it was public property in the commercial sense: a mass-produced commodity accessible to all social levels in a multiplicity of forms. The Garrick statue in Westminster Abbey should thus not be seen in isolation, but as a posthumous manifestation of the Garrick industry, as one of more than 450 individual likenesses produced over half a century.[83] These images of Garrick—from portraits to playing cards, etchings to decorative tiles—spanned the full spectrum of Georgian visual culture, high and low. The academic pretensions of the Abbey statue and Carter's bombastic allegorical painting were, in fact, the exception rather than the rule. Garrick certainly enjoyed the respect, even the awe of the cultural elite. "Poussin is considered the painter of men of taste," adjudged Joseph Pittard, "so in like manner Mr. Garrick is the player."[84] In an obituary, Edmund Burke likewise credited Garrick with elevating acting to the status of a liberal art. Nothing in Garrick's career or writings, however, suggests that the achievements of art were his foremost concern. If he did ennoble acting, it was by virtue of sheer talent, not conscious design. True fame, Garrick knew, required not the imprimatur of the cultural elite, but the adoration of the masses. His prime motive was always, in Reynolds' words, a "passion for fame," and that passion was requited.[85] The proof of Garrick's amazingly successful career in self-promotion lies in his permanent place in the foreground of Georgian cultural history—the equal of Johnson, Reynolds, and George III—so long after living memory of his actual performances has expired.

The multitude and intensity of Garrick's collaborations with painters, engravers, and other visual media merchandisers came at the expense of his relationship to writers. In the new era of visual entertainment after 1760, where the public might as soon attend an art exhibition, museum, or eclec-

tic West End emporium as read poetic drama in their closet, Garrick held
no illusions about the viability of a progressive "literary" theater in the
Elizabethan style. In a letter he wrote, in essence, dozens of times in his
career, Garrick diplomatically informed James Boswell in the spring of
1772 that he could not accept his friend's script because it offered too little
scope for spectacular adaptation:

> Mr. Mickle whom you so warmly recommended is a most ingenious man
> but I fear, from what I have seen, that his talents will not shine in the
> Drama—his play before the alteration was not in the least calculated for rep-
> resentation—there were good passages; but speeches & mere poetry will no
> more make a play, than planks & timbers in the dock-yard can be call'd a
> ship—It is fable, passion & action which constitute a Tragedy, & without
> them, we might as well exhibit one of Tillotson's Sermons.[86]

Because it consists principally of "speeches & *mere* poetry," Garrick deems
Mickle's play too literary for Drury Lane. He perceives that in the compet-
itive West End entertainment market, the successful management of a the-
ater lies in a preponderance of visible "passion & action," not poeticizing
and oratory. Thus while scene painters, set designers and a multitude of
visual media merchandisers established ever more lucrative connections
with the theater under Garrick's tenure, would-be successors to Shake-
speare and Jonson found themselves out in the cold.[87] Garrick was severe
on unsolicited scripts and, as in the case of the unfortunate Mickle, his
resistance to all recommendation beyond his personal interest earned him
the enmity of an entire generation of English playwrights. Frustration cen-
tered also on Garrick's perennial revivals of Elizabethan and Restoration
plays at the expense of new material. Even when a new play debuted, very
often Garrick himself or one of his cronies had written it. After a decade
of Garrick's hostile regime at Drury Lane, the literati's rage bubbled over.
In *The Case of the Authors Stated* (1758), James Ralph blamed the two-
theater Licensing Act of 1737 that reserved power in the hands of actor-
managers like Garrick for the drought in dramatic genius: "The dramatical
muse is the coyest of the choir . . . but in our days, all access to her is in a
manner cut off. Those who have the custody of the stage claim also the
custody of the muse." Ralph's complaint anticipates, in its essence, Lamb's
antitheatrical critique of a half-century later: that the actor-manager had
arrogated for himself the glory due to the playwright. I have described
how the early nineteenth-century stage inherited the Georgian apotheosis
of the actor. The eighteenth century likewise bequeathed to them, in a

very practical sense, the death of the dramatic author. "On the stage," states Ralph, "exhibition stands in place of composition: the Manager, whether player or harlequin, must be the sole pivot on which the whole machine is both to move and rest."[88]

The pseudonymous "Stentor Telltruth" of the *Herald* also anticipates Lamb's concern, in the post-Garrick era, for the relative cultural status of actor and author: "All merits of the actor, it must be allowed, are local and temporary, while those of the author are universal and immortal." But under Garrick's influence, Telltruth complains, "the orders of society have been suffered . . . to be reversed." Actors find fame and fortune, while writers starve in their garrets:

> [T]he dramatic poets even of the very last age appeared . . . as far above actors in rank and esteem, as they at present do in fame. But such is the altered state of things, in our days, that it will be found, on talking with one manager, that he considers all living authors to be ignorant, presumptuous and despicable creatures; while another arrogantly treats them as dependents and hangers-on; nay draws characters of them for the stage, as ragged, shoeless mendicants, and writes letters for them, dated from Moor Fields, full of abject representations of their vile condition, and of his own glory and conscious preheminence [sic] . . . such has become the case to a daring and even to a dangerous degree; dangerous, I mean, to literature and genius, and consequently, if not to the propriety, at least to the reputation of the age.[89]

Another anti-Garrick diatribe from 1758, by William Shirley, abandons the high-handed indignation of Ralph and Telltruth in favor of old-fashioned bile. In a dozen pages of libelous heroic couplets, Shirley accuses Garrick of manipulating public opinion against writers, and encouraging the mob's "infatuation" with him:

> If e'er 'tis observed that good writers are few,
> The want, by no means, they'll attribute to you:
> But deem it an evil, for errors or crimes,
> That's fated to curse or to scandal the times:
> Your reports they rely on, your conduct excuse,
> Nor e'er wish to examine the works you refuse . . .
> Nay, there are who have thought, that, instead of a farce,
> Should you print your intention to shew them your A__e,
> The Design all Reward would of Novelty reap,
> For they'd hurry, and cluster, and pay for a peep.[90]

This marked hostility of writers toward Garrick's management at Drury Lane illuminates an important context for Lamb's 1811 *Reflector* essay. Considered in the tradition of Ralph, Telltruth, and Shirley, Lamb's unusually intense resentment of Garrick stands at the end of a half-century long decline in relations between the Georgian theater and the literary elite. His so-called antitheatricality is, in this sense, the product of an entrenched antagonism between those devoted to the preservation of theater as a forum for dramatic poetry, in which writers are the pre-eminent talent, and those in the business of creating the modern theater culture of spectacle and celebrity. Echoing his Augustan predecessor Stentor Telltruth, Lamb is thus concerned less with the aesthetic limits of dramatic representation per se, than the fate of literature on the modern stage and with it "the reputation of the age." What kind of culture, they ask—and the question is ours still today—venerates actors over writers?

We have seen that the visual rather than oratorical emphases of Garrick's onstage technique reflected the broader impact of his career, which witnessed the progressive estrangement of authors from the stage and an inversely proportional boom in the theater's relationship with the commercial visual arts. But Garrick's most direct impact on the new visual-culture industry lay in his hiring innovative scene painters and designers to satisfy the public's appetite for spectacular effects. Already in the late 1750s, Garrick was attracting criticism for producing pantomimes and after-piece pageants designed purely for the visual delectation of his audience. Theophilus Cibber complained "of these unmeaning fopperies, miscalled entertainments . . . these mockeries of sense, these larger kind of puppet shows—these idle amusements for children and holiday fools, as ridiculously gaudy as the glittering pageantry of a pastry cook's shop on a Twelfth Night."[91] But these "fopperies," as Garrick well knew, were enormously popular with the public. Through the succeeding decade and a half, Garrick set about a series of innovations at Drury Lane intended to integrate the visual spectacle associated with opera and pantomime into legitimate theater.

First, in 1763, Garrick removed spectators from the sides and rear of the stage to which the public had hitherto conceived a natural right. This promoted the audience's perception of the stage as, in Christopher Baugh's words, "a harmonious and completed vision."[92] Experiments in stage lighting reinforced the new emphasis on visual and spectacular elements of the theater experience. On his return from Europe in 1765, Garrick got rid of the low-hung chandeliers that obtruded upon the Drury Lane stage, and

introduced rudimentary footlights. With the sight-lines of the audience cleared and their focus on the performance aided by direct illumination, the stage was now literally set for innovations in scenic design. For these, Garrick hired Philippe De Loutherbourg, a young French academician known for his eclectic talents in pastorale, battle-scenes, and Romantic landscape à la Salvator Rosa. De Loutherbourg had no previous theater experience, but impressed Garrick with his knowledge of technological advances in French set design.

Before De Loutherbourg's arrival at Drury Lane in 1771, scenery had played a minimal role in mainstream English theater. Stock sets, consisting usually of a single uniform backdrop and/or proscenium decoration, were shunted out year after year. Over the next decade, De Loutherbourg created a stunning new inventory of scenic properties and technologies, bringing the glamour of the Romantic picturesque to the aging pastoral backdrops of the Augustan stage. He specialized in mountainous vistas, exotic scenery, and the engineered effects—through light, sound, and moveable sets—of natural cataclysm. He introduced back-lit silk transparencies, graduated scenic flats to give the illusion of depth, rapid changes of scene, and even mechanically operated puppets. The first sign of change at Drury Lane was De Loutherbourg's salary. Five hundred pounds a year was an unheard-of sum for a scene painter, and an indication of Garrick's commitment to spectacular innovations. For De Loutherbourg's second production, *The Maid of the Oaks* in 1774, Garrick invested 1500 pounds on the set: a "prodigious sum," declared the *London Magazine,* "yet it will not appear extravagant to anyone who sees it." In a fourteen-year association with Drury Lane, De Loutherbourg designed sets for pantomimes but also serious dramatic productions such as *The Tempest.* His crossover to legitimate drama excited anxiety in the literary press, which complained that he had "turned the stage of Shakespeare into an exhibition of scene painting."[93] But for the theater managers of the Regency period, Garrick's successful collaboration with De Loutherbourg reinforced the indispensability of visual spectacle to a successful new production.

A review of De Loutherbourg's design for Mrs. Cowley's *The Runaway* (1776) indicates that his principal achievement in scenic design was the effect of verisimilitude:

> The piece was decorated by an excellent garden scene painted by that great master Louterbourg [sic], who has the honor of being the first artist who showed our theatre directors, that by a just position of light and shade, and

a critical preservation of perspective, the eye of the spectator might be so effectually deceived in the playhouse, as to be induced to mistake the produce of art for pure nature.[94]

De Loutherbourg's innovations in spectacular realism were a crucial technological and aesthetic precursor not only to the Regency stage, but also the hugely successful panoramas and dioramas of the West End. A further example of De Loutherbourg's singular importance in the modern history of mimetic media was his experimental Eidophusikon, an independently produced "theater without actors" of the mid-1780s. With houselights dimmed, and a display of moving figures and changing lights orchestrated from behind the proscenium, the Eidophusikon offered Londoners the first identifiably proto-cinematic entertainment.[95] At the Eidophusikon, as at the panoramas where many Drury Lane scene painters later found employment, the combination of spectacle and verisimilitude proved enormously lucrative and perennially popular.

Garrick's hiring of De Loutherbourg thus shared with his innovations in stage performance a common aesthetic purpose: the effect of the real. That is, Garrick's promotion of verisimilitude in stage production should be seen as a logical extension of the psychological realism he introduced to stage performance. Predictably, Lamb, Coleridge, and other Romantic writers were as disenchanted with De Loutherbourg's legacy as with Garrick's, for both contributed to the transformation of English theater from an Elizabethan, essentially literary medium, to a modern, predominantly visual medium. A satirical print by Matthew Darly from 1772 (figure 1.3) anticipates Romantic disaffection with the growing emphasis on theatrical "show." Employing the iconography from Reynolds' celebrated tribute painting, *Garrick between Tragedy and Comedy* (1761), Darly places Garrick between the poetic muses and his production staff of set builders and costume designers. Where Reynolds' painting suggested that Garrick favored comedy over tragedy, Darly makes clear through his caption that Garrick's principle loyalty is to spectacle rather than dramatic texts of either genre: "Behold the Muses Roscius sue in Vain/Taylors & Carpenters usurp their Reign."[96]

Further to this trend toward spectacle, theaters were progressively enlarged after 1780, partly to accommodate the extravagant visions of set designers like De Loutherbourg, to the point where Sarah Siddons deliberately altered her onstage technique, "fearful that the power of my voice was not equal to filling a London theater."[97] Leigh Hunt later decried the renovations as a further lapse in taste from the Romantic ideal of an intimate

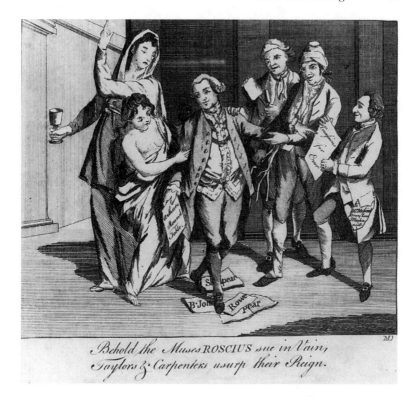

Figure 1.3 Matthew Darly, "Caricature of Reynolds' 'Garrick Between Tragedy and Comedy'," title page engraving to *The Theatres: A Poetical Dissection* by Sir Nicholas Nipclose [pseud.] (1772). General Research Division, The New York Public Library, Astor, Lenox, and Tilden Foundations.

Elizabethan theater. "The managers and the public thus corrupt each other," Hunt charged, "but it is the former who begin the infection by building these enormous theatres in which a great part of the spectators must have noise and shew before they can hear or see what is going for-wards. In time these spectators learn to like nothing else; and then the man-agers must administer to their depraved appetite, or they cannot get rich."[98] Coleridge likewise complained that "in the glare of the scenes, with every wished-for object industriously realized, the mind becomes bewildered in surrounding attractions," while Scott agreed that "show and machin-ery have . . . usurped the place of tragic poetry."[99] Lamb too, in his never-performed prologue to Coleridge's *Remorse,* contrasted the text-oriented

austerity of the Shakespearean stage with the De Loutherbourgian visual
effects in vogue at the Regency theater:

> The very use, since so essential grown,
> Of painted scenes, was to his stage unknown.
> The air-blest castle, round whose wholesome crest,
> The martlet, guest of summer, chose her nest—
> The forest walks of Arden's fair domain,
> Where Jacques fed his solitary vein—
> No pencil's aid as yet had dared supply,
> Seen only by the intellectual eye.
> Those scenic helps, denied to Shakespeare's page,
> Our Author owes to a more liberal age.[100]

Lamb's antitheatrical critique reads more gently here than in his *Reflector*
essay, but he nevertheless betrays a quiet contempt for the gaudy "liberality"
of the Regency stage, and nostalgia for the "intellectual" theater of the
Elizabethans. Garrick's legacy, both as a realist actor and a managerial archi-
tect of stage spectacle, was a theater where "no attention is paid any more
to good dialogue; [where] effect is all that is demanded. One goes to the
theater to see, scarcely any longer to hear."[101] Given Lamb's antispectacular
prejudices, it is little wonder his prologue was rejected; although, caught in
a love-hate relation to the Regency stage, he appears to have been disap-
pointed that it was.

In his antitheatrical manifesto of 1811, "On Garrick and Acting . . . ,"
Lamb attempted to reassert the ideal experience of reading Shakespeare
over its visual realization at the theater. His argument for closet reading
hangs on the issue of the psychological depth of Shakespeare's characters,
which, he believed, could not satisfactorily be represented onstage. But the
conflict between the late Georgian theater and the literary elite runs deeper
than the question of dramatic character. Already in 1770, Oliver Goldsmith
complained that only "old pieces are revived, and scarcely any new ones
admitted. The actor is ever in our eye, and the poet seldom permitted to
appear."[102] The same paucity of quality new drama was true of the
Romantic period. The fame of Siddons, Kemble, and Kean, which so over-
shadowed the dramatists of the early nineteenth century, perpetuated a the-
atrical culture of celebrity that had originated in Goldsmith's time with
Garrick. Through Garrick's influence, the English stage had transformed

from a forum for the acted recitation of dramatic poetry to a celebrity theater where the most famous people in London appeared nightly, in a limited range of roles, to satisfy the public's craving simply for the sight of them.

If Garrick's celebritization of Drury Lane alienated authors, his intensely visual, physiognomic acting style marginalized the text itself. This supersession of text by spectacle lies at the heart of Lamb's antitheatricality. As quoted earlier, Lamb rejected the Garrickian metaphor of the "legible" face. "Of the motives and grounds of the passion," he insisted, "the actor can give no more idea by his face or gesture than the eye (*without a metaphor*) can speak, or the muscles utter intelligible sounds" (my emphasis). Lamb is consequently impatient with shopworn articles of the Garrick legend: "those who tell me of him, speak of his eye, of the magic of his eye . . . but what have they to do with Hamlet? What have they to do with intellect?" However skilled the actor, Lamb contends, his face cannot become text. One cannot "read" into his opaque expression the legible passions of the poet. But Lamb's was a minority opinion. The historical significance of Garrick's acting style is not that he introduced visuality to the eighteenth-century stage—critics had long complained of the theater's debasement by pantomime, opera, musical entr'actes, and Bartholomew Fair style entertainments—but that he brought a realistic visual technique to literary drama, hitherto reserved for an oratorical, "poetic" style. With his highly visual approach to dramatic performance, Garrick first made a spectacle of himself then turned to technological innovations in scenery. And it was against this theater of spectacle, both human and mechanical, that Lamb and other Romantic writers revolted.

The implications of the Garrick revolution extend further than the nineteenth century. In Garrick's signature "physiognomic" style lies a Georgian embryo of the cinematic close-up. His intimate technique invited the kind of ritual rapt attention the camera now pays to film and TV actors, to create an atmosphere of meaning at climactic moments in the plot and a suggestion of psychological depth. Further anticipating twentieth-century celebrity culture, Garrick intuited the natural link Debord has observed between visual spectacle and the parasitic media of celebrity self-promotion. Having created a public fascination for his face through his onstage performances, he took direct control over marketing his image in myriad merchandized forms. The booming popularity of souvenirs bearing his "close-up" image shows the marketability of his visual style beyond the theater itself. Whether exhibited onstage at Drury Lane, in a printshop window, or a decorative screen in a drawing room, Garrick's

image seduced the public gaze to fascinated scrutiny of his changeable features. The ubiquity of his image in Georgian London prefigures the post-modern cult of media stardom whereby an individual's fame—be it a newscaster, sporting hero, or movie star—is judged according to market recognition of his or her face on a TV screen, magazine cover, or billboard. That recognition then becomes the basis of the uniquely modern career of the celebrity, who is famous simply for being famous.[103]

Lamb was a devotee of the theater, whatever his reservations about the popularity of its actors. But he nevertheless longed for a return to the Elizabethan stage where, according to his friend Coleridge, "the idea of the poet was always present, not of the actors, not of the thing to be represented. It was at that time more a delight and employment for the intellect, than an amusement for the senses."[104] But between Lamb, Coleridge, and the Elizabethans lay the Restoration and the theater-crazed Georgian age. This century and a half witnessed the birth of opera and pantomime, the enlargement of theaters from intimate boxes to cavernous auditoria, the rise of the scene painter, the corresponding demise of the dramatist, and the institution of Garrick's visual style as the summit of dramatic stage performance. Sarah Siddons, for example, supreme icon of the Romantic stage, inherited the lineaments of a realistic, visual style from the master Garrick. Her facial expression, like Garrick's, appeared to the spectator "so full of information, that the passion is told from her look before she speaks."[105] Frustrated by Garrick's enduring influence on acting style, Shelley ultimately called for a return to the masks of Greek tradition, to rid the stage of the "partial and inharmonious effect" of the physiognomic style and its "master[s] of ideal mimicry."[106] In short, the Romantic age inherited from Garrick a drama of the eye, not the ear, a theater of spectacle not poetry. Critics and would-be poets of the stage, such as Charles Lamb, were hostile to the popular aura surrounding the visual art of the actor and the notion of theater-as-spectacle. The cultural agenda of Lamb's essay for Hunt's *Reflector* was thus not antitheatrical in any absolute sense, but an effort to reclaim the theater for literature and literary genius. Considered in this light, Lamb's "On Garrick and Acting . . ." appears not as "a glaring aberration" in Romantic theater criticism but a deliberate, ideologically grounded counter-attack in the culture war between England's literary elite and the new celebrity-based visual entertainment industry.

Performing the Real:
Reynolds, Mrs. Abington, and Celebrity as Masquerade

"On the stage he was natural, simple, affecting;
T'was only that when he was off he was acting"
—Goldsmith on Garrick

By all accounts, Garrick's acting technique centered on perfectly controlled, rapid transitions in feeling. Lichtenberg marveled at Garrick's "gift for changing expression," while Frances Abington, a long-time leading lady at Drury Lane, specified that his unique "excellence lay in the bursts and quick transitions of passion."[107] This critical rhetoric applied to Garrick's mercurial performances echoes David Hume's skeptical description of human identity in his *Treatise of Human Nature,* published on the eve of Garrick's stage debut in 1740. In the section entitled "Of Personal Identity," Hume describes the self as "a bundle or collection of different perceptions, which succeed each other with inconceivable rapidity, and are in a perpetual flux and movement." Onstage, Garrick mastered the creation of just such a plausible chain of related impressions in his representation of dramatic character. His portrayal of, say, Hamlet, conveyed to his rapt audiences exactly the "smooth and uninterrupted progress of the thought along a train of connected ideas" that Hume insists positivist philosophy has wrongly defined in terms of "identity." According to Hume's celebrated figure, the human mind is not a single, unified vessel but "a kind of theatre, where several perceptions successively make their appearance."[108] If the mind is a "kind of theatre" and the fount of our essential character, then Garrick in the role of Hamlet, with his seamless control of dramatic appearances, offered as convincing an account of human identity as was possible in a Humean world.

The Georgians explored the possibilities of a theatrical, Humean identity for themselves in their enthusiasm for masquerades. These events included lavish, often decadent affairs at the homes of the elite, but also public masquerades that attracted thousands of people to venues like the Vauxhall Gardens, creating a de facto outdoor theater for what Terry Castle has called a "shimmering liquid play on the themes of self-presentation and self-concealment."[109] At the height of masquerade mania, in 1743, Fielding invoked the masquerade as a synecdoche for society as a whole, which he called "a vast masquerade, where the greatest Part appear disguised."[110] Sixty years later, when the popularity of masquerades had terminally declined, Charles Lamb continued to make use of the metaphor, describing life in London to

Wordsworth as "a pantomime and a masquerade."[111] The Georgians were fascinated with the theatrical nature of the newly teeming streets of urban England, and enjoyed dressing to deceive. At Garrick's spectacular Shakespeare Jubilee at Stratford in 1769, not a word of Shakespeare's plays was read or performed, but thousands attended the masquerade balls nominally in his honor. The guests apparently felt little obligation to Shakespeare's texts: James Boswell appeared as a Corsican chief. Garrick himself, a quintessential theater professional and notoriously jealous of his own pre-eminence, disliked masquerades, in which everyone assumed the aura of theatricality. As Goldsmith wittily observed, Garrick was already "in character" as a public celebrity: "On the stage he was natural, simple, affecting / T'was only that when he was off he was acting."[112] Accordingly, Garrick almost invariably went as himself.

A close and conscious connection existed in the eighteenth-century imagination between painting, masquerade, and the theater. The visual and verbal rhetoric of all three phenomena frequently overlapped. For example, criticism of the morally pernicious illusions of theatrical performance, mostly from the clergy, was often indistinguishable from charges brought against the masquerade.[113] In another cross-fertilization of art and entertainment, women attended masquerades as characters from the court portraiture of Van Dyck and Holbein. Likewise, as we have seen in the career of Garrick, the Georgian actor, no less than the masquerade maven, "became an image responded to, interpreted and analyzed like a work of art."[114] The inverse also held true. Garrick's friend and mentor, William Hogarth, saw painting as a form of theater: "my picture was my stage, and men and women my players, who were by means of certain actions and expressions to exhibit a dumb show."[115] Bearing out Hogarth's point, his *Beggar's Opera,* a painting of the theater, is barely distinguishable in compositional terms from his *Marriage à la Mode* or *A Harlot's Progress,* with their theatrical view of real life. These works also contained literal references to the new Georgian entertainment culture. In the second plate of *A Harlot's Progress,* Moll Hackabout has recently enjoyed a fancy-dress entertainment. Her mask lies by the table and, as evidence of the masquerade's reputation as a scene of sexual intrigue, she is in the process of concealing the departure of a lover. In Hogarth's comedic vision of Georgian London, one masquerade led naturally to another.

In a culture fascinated by the ambiguous sign of the mask, the line dividing life-like theater and theatricalized real life could on occasion be literally crossed. In one Garrick-produced stage pageant of London life, the rear wall of Drury Lane was opened to a view of passers-by on the street, creating a seamless link between the real London and its theatrical simula-

tion. A generation later on the same stage, in the winter of 1815-16, a popular Drury Lane pantomime recreated a famous actual masquerade from the previous social season. The result was a masquerade of a masquerade, produced as a form of commercial entertainment. Compounding the delicious ironies of this production, Byron attended both "the *real* masquerade" (emphasis in original) and its stage re-creation. He ended up onstage with a friend, cavorting "amongst the figuranti" who "were puzzled to find out who we were."[116] In the unscripted intrusion of Lord Byron from the pit onto the stage, the pantomime crossed the threshold of the "real." Just as guests at the original masquerade had no doubt sought to guess his identity through his costume, so the Drury Lane company, assuming the *roles* of the same guests, are left to wonder at the mysterious new arrival.

As the most fashionable portraitist of the age, Garrick's friend Sir Joshua Reynolds was naturally attuned to the Georgian love of playacting, both public and private. From the 1760s on, he began to incorporate the booming unofficial drama industry of amateur theatricals, tableaux vivants, and masquerade parties into his pictorial repertoire. In his so-called historical portraits, which represented aristocratic women as characters from classical mythology, Reynolds "moved the contemporary love for masquerades from the assembly room to the studio."[117] These portraits featured prominently at Royal Academy exhibitions. They excited popular comment and reviews, and often found mass-market distribution in the form of prints. The second section of this chapter on theater, art, and celebrity shows how Reynolds' career converges with Garrick's not only as his occasional portraitist and an eminent visual artist in his own right, but as stage manager of a fashionable new London theater: the portrait studio. Richard Wendorf has drawn attention to the theatrical quality of Reynolds' studio methods and "the dramatic nature of the sitting itself." In this context, Wendorf suggests, we might usefully consider Reynolds' studio as "a carefully contrived stage," and Reynolds himself "a theatrical manager." Wendorf is indebted for this insight to David Piper, who has argued that Reynolds conceived the challenge of portraiture as "not merely that of recording an individual facial likeness, but of *producing*—with all the theatrical implications of that word—a convincing, coherent character in action."[118]

Reynolds' famous theatrical portraits of Garrick, Siddons, and Frances Abington played a crucial role—both as original, exhibited artworks and as mass produced prints—in constructing an aura of celebrity around the late eighteenth-century theater and its performers. During her career, Sarah Siddons cultivated an image of regal disinterestedness, but in retirement she was candid about the lure of fame for actresses and the necessity of mar-

keting oneself through paintings and prints: "I was, as I have confess'd, an ambitious candidate for Fame. . . . As much of my time as could now be stol'n from imperious affairs, was employ'd in sitting for various Pictures."[119] The most successful stage performer of the Romantic age, like Garrick before her, recognized the dependence of performing artists on subsidiary visual media to promote them. But the aura of performance in Reynolds' art extended beyond the players of Drury Lane and Covent Garden. As we shall discover in his so-called historical portraits, Reynolds' aristocratic female subjects embraced, no less enthusiastically than his professional sitters, the theatrical possibilities of personal identity bequeathed by Hume, Garrick, and the age of masquerade.

In the second half of the eighteenth century, Garrick and Reynolds transformed the visual rhetoric of the theater and portrait painting respectively. The personable and relaxed manner of Reynolds' portraits replaced the stiff profiles of Godfrey Kneller, while Garrick's natural ease onstage usurped the mummified posturing of Booth and Quin.[120] But for both Reynolds and Garrick, "naturalism" was a production, an aesthetic effect, a relative truth: what appeared real onstage or in a portrait would be "ridiculous" in ordinary life. Diderot, in his *Paradox of Acting* (ca.1773), had argued for the essential artificiality of "natural" acting. In a conversation between Johnson and Gibbon that Reynolds went to the unusual effort to transcribe, Johnson insisted, following Diderot, that the impression of reality in a Garrick performance was an elaborate fiction for which dramatic technique and preparation beforehand far outweighed an emotional commitment to the role onstage. To Gibbon's objection that Garrick "surely feels the passion at the moment he is representing it," Johnson asked derisively whether Reynolds likewise experienced the emotions of his subject while painting. "It is amazing," he continues,

> that any one should be so ignorant as to think that an actor will risk his reputation by depending on the feelings that shall be excited in the presence of two hundred people, on the repetition of certain words which he has repeated two hundred times before in what actors call their study. No, Sir. Garrick left nothing to chance. Every gesture, every expression of countenance and variation of voice, was settled in his closet before he set his foot upon the stage.[121]

Conscious planning and artistic technique were equally indispensable, Johnson asserts, to Garrick rehearsing a role in his study as to Reynolds conceiving a portrait's composition in his studio.

Reynolds chose the discussion between Johnson and Gibbon as one of two dialogues "illustrating Johnson's manner of conversation" to record for posterity, suggesting that, like Johnson (and, later, Coleridge), Reynolds despised the fashion for confusing "nature" in art with literal truth. In his presidential lecture to the Royal Academy in 1786, he made a deliberate effort to distance the higher branches of drama and art—namely tragedy and history painting—from sensory illusion. To Reynolds, a player such as Garrick appeared

> to aim no more at imitation, so far as it belongs to anything like deception, or to expect that the spectators should think that the events there represented are really passing before them, than Raffaelle in his Cartoons, or Poussin in his Sacraments, expected it to be believed, even for a moment, that what they exhibited were real figures.[122]

To illustrate his analogy between theater and painting, Reynolds emphasized the pragmatic responsibilities of the actor, who was required to communicate intimate psychological truths before a large auditorium of people. However immersed in his role, the actor, like the painter at his canvas, must remain aware

> that everything should be raised and enlarged beyond its natural state; that the full effect may come home to the spectator, which otherwise would be lost in the comparatively extensive space of the Theatre . . . All this unnaturalness, though right and proper in its place, would appear affected and ridiculous in a private room.[123]

In short, Reynolds agrees with Johnson and Diderot that the effect of the real, in theater as in painting, is a stylized production. Just as the actor never fully deludes his audience, but rather participates in a mutual understanding of the codes—physiognomic, gestural, and scenic—exclusive to stage performance, so the portrait artist employs exaggeration and "art" to *stage* naturalistic visual effects in his paintings. At the same time, however, the apparently parallel relation between Garrick and Reynolds was, in an important respect, a mirror image. While Garrick's radically "natural" style brought theatrical performance closer to real life, Reynolds' historical portraits bestowed on his real-life subjects the aura of the theater.

The figural use of the theater to describe eighteenth-century social phenomena, particularly (following Burke) episodes in the French Revolution, is pandemic. Marc Baer has rightly warned that, "as with many unex-

amined metaphors, theatre may be in danger of becoming too all-encompassing."[124] I wish to avoid the more fanciful critical applications of "theatricality" by adhering to literal references to the theater in Reynolds' paintings, and only then proceeding to speculative inferences about theatricality at the social level. Like any critic who attempts to conjoin painting and theatricality, I am indebted to Michael Fried's pioneering work on the subject, which illuminates how certain eighteenth-century portraits and genre paintings are built upon a relative awareness of the spectator. Rather than focusing on the subject's deliberate recognition or self-absorbed neglect of the viewer's presence, however, my analysis of Reynolds' historical portraits suggests that the pose, dress, and setting of these subjects imply a theatrical self-consciousness whether they are looking at us or not. Certainly, neither Reynolds nor his subjects communicate what Fried has identified in French portraiture as a "desire to escape the theatricalizing consequences of the beholder's presence."[125]

Women are the exclusive subjects of Reynolds' historical portraits because it was the domestic sphere that played host to Georgian allegorical imaginings and heroic fantasy.[126] As such, these paintings reinforce the impression that, for a Georgian woman of a certain class, personal identity could be more fluid than for her male counterpart, who was rigidly defined by birth, profession, and his standing in the wider world. As Gill Perry has observed, "although many middle and upper class women in the eighteenth century had access to learning and education, without comparable profession, political or military roles through which they could be publicly identified, they were more easily transformed into seductive allegorical images than their male counterparts."[127] Mistress of the self-sufficient, isolated realm of a county seat, any woman of rank was free to imagine herself a nymph or goddess. It is the activity of this restless, housebound female imagining that these Reynolds paintings record. In addition, from the 1770s on, prominent landed gentry such as the Duke of Marlborough and the Duke of Richmond began to erect theaters on their estates to satisfy the general lust for performance and show. Full-fledged productions at these private theaters attracted audiences in the hundreds.[128] Many of Reynolds' female subjects were regular performers on this unofficial private theater circuit, and would have perceived their sitting for Reynolds as an extension of their careers as amateur actresses. These private theatricals, as well as after-dinner tableaux vivants and "attitudes" (à la Lady Hamilton), drew on the pictorial iconography of ancient statuary and Old Master paintings. The interior of the Greek Revival home—dotted with classical busts, tapestries, and ceramics featuring allegorical scenes—provided the

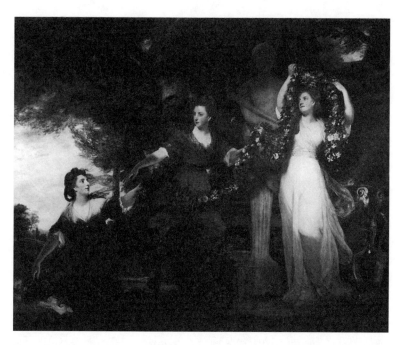

Figure 1.4 Sir Joshua Reynolds, *Three Ladies Adorning a Term of Hymen* (1773). Tate Gallery, London/Art Resource, New York.

perfect setting for these impromptu performances, and the intriguing image of the Georgians imitating their furniture. On such occasions, the boundaries between pictorial and performance art were crossed, a theatrical transgression clearly visible in Reynolds' historical portraits.

In *Three Ladies Adorning a Term of Hymen* (1773, figure 1.4), the Montgomery sisters, nicknamed "the Irish Graces," dress up as nymphs and form a fanciful tableau about a statue of the Roman god of marriage. The setting is local and contemporary—the Montgomery estate in Ireland, aflame in glorious autumnal color—but the drama performed, a rambunctious fertility rite, is wholly pagan. The seasonal wind is a decisive pictorial element. It flaps at the women's dresses and hair, and wraps an enormous crimson curtain around a tree behind them. The breeze communicates its spirit to the sisters themselves: the eldest, Anne, dressed in a long white robe, dances on one foot while next to her Elizabeth, in a sprinter's pose, accepts a floral baton from Barbara, who is on her haunches. Reynolds' references to the Grand Style emerge here from the coloristic and compositional sub-text of

his conventional portraits to a dazzling combination of explicit motifs: diaphanous classical clothing, mythological characters, and Dionysian dance-steps. Elements of Poussin pastorale and Watteau *fête galante* are apparent, but the picture possesses a theatrical composition and energy unique to Reynolds. The Montgomery sisters were well-known amateur actresses, and the foreground of Reynolds' painting, entirely filled by the cavorting women, resembles a stage. Reynolds also includes an abundance of props: Barbara's basket of flowers; a rug-covered table behind Elizabeth; a gold pitcher and chair with a ram's head molding (emblematic of the grooms-to-be) on the right; and, of course, the antiquary statue of Hymen presiding. The billowing curtain at the rear makes for a serviceable back-drop to the scene: we can even see where it has been tied to the tree. "At any moment the curtain may fall," Ernst Gombrich observes, whereupon "three smiling amateur actresses will resume their social duties."[129]

Stylistically, *Three Ladies Adorning a Term of Hymen* represents an adventurous compromise in Reynolds' oeuvre between the real and the ideal. "When a portrait is painted in the Historical Style," he explained in his Fifth Discourse (written at the time he painted the Montgomery sisters), "it is neither an exact minute representation of an individual, nor completely ideal."[130] One thing is sure: *Three Ladies* could never be confused with a dry neo-classical allegory. Reynolds has not removed the Montgomery sisters to antiquity, but has brought the Georgian fantasy of antiquity brilliantly to life. These aristocratic women, however idealized, are palpably real in their enthusiasm for playing the Graces. Reynolds has made his canvas a stage, and invites us to enjoy an impromptu performance at the Montgomery estate. As with many of his historical portraits, Reynolds received his commission for *Three Ladies* from one of his subjects' future husbands, who wished to commemorate his impending nuptials in the form of a unique and permanent display of his bride. "It was the very instability produced by the irresolvable tension of portrait and allegory," remarks Marcia Pointon, "that made this format [the historical portrait] peculiarly appropriate for the representation of young women—marriageable, recently married, or about to be married."[131] Reynolds' female subjects assumed their roles as part of a transaction conducted between men, and for the delectation of the male eye, but the paintings arguably do more to liberate than exploit them. To participate in a fanciful allegory, full of fun, theater, and sexual energy, was a singular opportunity in an aristocratic woman's life. In the case of the Montgomery sisters, the Reynolds painting depicts a rare moment of euphoric self-creation for brides-to-be in a transitional period

between two households and identities, between childhood subordination to their parents and assumption of their husband's name.[132]

The fanciful portrait of Lady Sarah Bunbury (like the Montgomery sisters, an enthusiastic amateur actress) likewise exemplifies Reynolds' increasingly comedic vision of portraiture after 1760. *Lady Sarah Bunbury Sacrificing to the Graces* (1765, figure 1.5) lacks the dynamism of *Three Ladies,* but shares the same elaborate theatricality. We are in a portico of the Bunbury residence converted for an after-dinner *tableau.* The scene is filled with the decorative flowers, props, and statuary we saw in *Three Ladies.* Lady Sarah wears an entirely fictitious classical robe, and her attitude of supplication is pure melodrama. A younger member of the family cast in the role of servant girl sits at the right, dressed in Lincoln green with gold trim, pouring a libation. At the very bottom of the painting, a straight black line indicates the foreground termination of Lady Sarah's stage (a blue coverlet hangs over its edge); we observe her from a front row seat. Lady Bunbury later left her husband, who had commissioned the portrait, in scandalous circumstances. Lord Bunbury nevertheless insisted on keeping the painting, presumably to taste the extremity of masquerade in his ex-wife's attitude of virtuous servility.

A less solemn historical portrait from the following year, *Mrs. Hale as Euphrosyne* (figure 1.6), owes its reputation to the svelte beauty of the principal subject and Reynolds' successful realization of her allegorical identity, "Good Cheer." Mary Chaloner, soon to be Mrs. Hale (and eventually a mother of twenty), makes a spectacular entrance from stage right, her dark hair trailing from where she has come. She wears the customary classical robe but with her waist and bodice flatteringly articulated. She also shares the anatomically impossible features of Reynolds' classicized women: extraordinarily long legs, a truncated torso and, in place of shoulders, a swanlike neck that declines gently into her upper arms. She performs in the late afternoon light to the accompaniment of two bare-shouldered nymphs on flute and cymbals and a boy playing the triangle, who is distracted by the entrance of two cherubic children. They have come onstage when they ought not and look out at us, the audience, with mischievous glee. One lifts a finger conspiratorially to his lips: we are not to tell Mrs. Hale she has been upstaged. The musical ensemble scene (commissioned for the Robert Adam music room at Harewood House) is not "orgiastic," as Pointon's overheated reading has suggested, but a playful mock-Bacchanal. Despite suggestions of sexual display in Mrs. Hale's diaphanous garment and the bare shoulders of her musicians, decorum is preserved through the self-

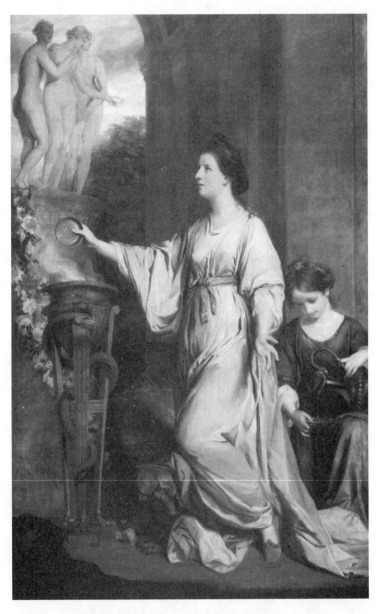

Figure 1.5 Reynolds, *Lady Sarah Bunbury Sacrificing to the Graces* (1763–65). Oil on canvas, 242.6x151.5 cm, Mr. and Mrs. W. W. Kimball Collection. Photograph courtesy of The Art Institute of Chicago.

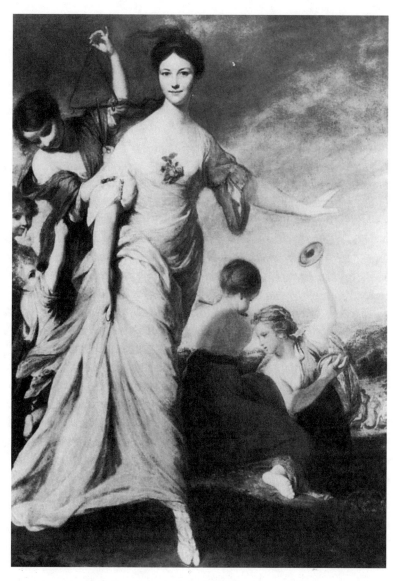

Figure 1.6 Reynolds, *Mrs. Hale as Euphrosyne* (1766). Reproduced by the kind permission of the Earl and Countess of Harewood and Trustees of the Harewood House Trust.

conscious theatricality of the subject.[133] Mrs. Hale is *playing* a Bacchante, not embodying one. Portrayed as one of the mythical Graces, she is available as an object of male fantasy, but her expression of confidence and "good humor" means that she controls the terms of that fantasy and thwarts subjugation. No contemporary review of the painting suggests that Mrs. Hale either compromised her respectability through her public exhibition as a follower of Bacchus, or exposed herself to the contempt of the mere voyeur.

Further to the relation of Reynolds' historical portraits to the public, the identity of his female subjects becomes more complex than the simple adoption of an allegorical persona. Protocol disallowed the inclusion of a lady's name in exhibition catalogues, because of the good chance her portrait might find itself hung next to that of a famous courtesan or actress (a characteristically English laxity in class distinctions that scandalized French visitors). *Mrs. Hale as Euphrosyne,* for example, appeared at the Society of Artists Exhibition in 1766 entitled simply *A Lady; whole length.* In 1773, a Reynolds portrait of Mrs. Hartley with her child was listed as *A Nymph with a Young Bacchus,* even though its real-life subject was widely known. Likewise, the sentimental title of the 1769 painting, *Hope Nursing Love,* fooled nobody that Reynolds' subject was a certain Miss Morris. As Martin Postle has pointed out, although the painting is now usually referred to as *Miss Morris as Hope Nursing Love,* Reynolds himself never gave it that name.[134] These shifting descriptions signify more than an art-historical curiosity. The anxiety of connoisseurs and art historians to make a clear distinction between portraiture and history painting—between the real identity of Reynolds' subjects and their ideal persona—suggests a teasing ambiguity in his historical portraits. Whether Reynolds' subject is Mrs. Hale or Euphrosyne or an anonymous lady remains undetermined in the painting itself. Certainly Reynolds never clarified the issue. The identity of his female subject shifts in the viewer's mind according to the changing caption beneath her. With their emphasis on role-playing, these portraits invoke Hume's skeptical definition of the self in his *Treatise on Human Nature.* In Reynolds' allegorizing vision, personal identity has become a kind of theater and a chance at masquerade.

When done satisfying the theatrical fantasies of his aristocratic clients, Reynolds' favorite "fanciful" subjects were courtesans and actresses. These two classes of women, closely associated and often confused, shared a liminal and highly mobile status in Georgian society, circulating with unusual freedom through its various classes. As models for historical subjects, they

highlighted the purely theatrical nature of Reynolds' enterprise, reducing the allegorical remoteness of the paintings. One favorite Reynolds model, the renowned beauty Kitty Fisher, was an eighteenth-century Marilyn Monroe, a celebrity *avant la lettre*. She began her career apprenticed to a milliner, spent six years in the *beau monde* as mistress to the rich and famous, posed for Reynolds as Cleopatra, then fell ill from over-use of noxious cosmetics, married into obscurity, and died. All before the age of thirty. That Reynolds, the consummate art professional, painted her so often without commission is as convincing a proof of her charismatic appeal as her string of celebrated lovers.[135] Reynolds' association with Kitty Fisher was not without commercial interest, however. Her portraits were promptly engraved and made available for mass consumption in the form of prints.

In a manner similar to the salons of the aristocracy, the Georgian theater also served as a "showcase for women who had that autonomous characteristic called beauty," and as a talent pool for ambitious society portrait painters like Reynolds.[136] Ironically, the most famous of English theatrical portraits, the darkly melodramatic *Mrs. Siddons as the Tragic Muse* (1784), is an anomaly in Reynolds' oeuvre. Few of his paintings aspire to such serious sublimity. Just as Garrick, in Reynolds' famous theatrical portrait from 1761, appears to choose the buxom charms of Comedy over the severity of Tragedy, Reynolds was most drawn to the whimsical, mercurial possibilities of playacting. His taste in actresses lay not, in fact, with the celebrated tragedian Sarah Siddons, whom he found cold onstage, but with the comic genius of Frances Abington: he painted her more often than Garrick and Siddons combined.[137]

In life, Mrs. Abington was not considered a genuine beauty in the mold of Kitty Fisher, but onstage she was a siren of the quicksilver, impish kind. Georg Lichtenberg was particularly alive to her charms, describing with relish her unorthodox habit of walking upstage with her back to the audience. "I wish you might have seen," he wrote home to Germany, "the propriety with which she swayed her hips, with each step evincing a mischievous desire to aggravate the glances of imitative envy and admiration with which a thousand pairs of eyes followed her."[138] Sexual charisma, Lichtenberg implies, won her the admiration of the men, while her "exquisite taste" in dress excited the "imitative envy" of female spectators. According to nineteenth-century accounts of her life (biography would be too dignified a name for the published innuendo that perpetuated her memory), Mrs. Abington's acting talent served her offstage as well as on. After an unpromising childhood as a cobbler's daughter turned teenage prostitute in Covent Garden, her liaison with the actor and reprobate

Theophilus Cibber gave young Frances Barton (as she then was) her first opportunity on stage.[139] Once established as a rising star of the theater, she embarked on a social and sexual career worthy of the Restoration comedy heroines she impersonated onstage. She married for form's sake, but soon attached herself to a prominent parliamentarian when touring in Dublin. On the death of her lover, she invested the generous benefits of his will in a consortium of London residences. These she selected according to a simple criterion: her own satisfaction and convenience. "Conversant in amours," reported John Haslewood, in his salacious *Secret History of the Green Room* (1795),

> she now resolved to separate her lovers into two different classes: the first, those whose liberality might enable her to live in splendour; and the second, those whom her humour pitched upon. For this purpose, she had various houses in town for her various admirers; her assignation with Mr. Jefferson, formerly of Drury Lane, were made at a house near Tottenham Court Road; while my Lord Shelburne, now Marquis of Lansdown, allowed her fifty pounds per week, gave her an elegant house, the corner of Clarges street, Piccadilly, and continued this generosity until he married. Mr. Dundas succeeded his Lordship as her humble servant.[140]

With these unusual domestic arrangements, Mrs. Abington effectively reversed the terms of sexual exchange of her youth. She now "kept" men in addition to being kept, and visited houses according to her whim, as a gentleman might take his choice of bordellos. The freedom aristocratic Georgian women found, transiently, in attending masquerades or posing for historical portraits, Mrs. Abington discovered as a permanent way of life. Shearer West has said of Sarah Siddons that "her private life, as much as her stage roles, was a kind of performance, enacted with the knowledge that she was constantly being observed, admired, or envied."[141] Frances Abington's career demonstrates, however, that Mrs. Siddons marked the zenith rather than the origin of celebrityhood among Georgian actresses. Like Siddons, who combined stardom with a carefully crafted persona of idealized maternity, Mrs. Abington play-acted, performed, and improvised her way from humble beginnings to the very heights of Georgian society, taking on the roles of expensive courtesan, high-society lady, and theater diva with equal relish and conviction as and when they arose.

Mrs. Abington was the model of the modern entertainment celebrity in several respects. The scandal of her private life served only to increase her

fame, and the glamour of her personality alone, independent of her professional identity, became the object of popular fantasy and emulation. As Kimberley Crouch has pointed out, Mrs. Abington belonged to that select band of "actresses so successful at taking on the characteristics of their wealthiest and most socially secure patrons that they became worthy of imitation."[142] Mrs. Abington's first appearance on stage in any given year was a sure "harbinger of the reigning fashion for the season."[143] In 1759, appearing in Garrick's play *High Life Below Stairs,* she debuted a particularly fetching cap that soon sprang up in millinery windows all over Britain and Ireland as "Abington's Cap." It was perhaps the first celebrity-endorsed product. Later, in the 1776 season, she chose to make "a very beautiful style of petticoat, of Persian origin," her trademark. "It was no sooner seen," Haslewood relates, "than it was imitated in the politest circles."

As a performer, Mrs. Abington belonged to the new natural school of acting. Her ability to *be* rather than merely perform a role reminded contemporaries of Garrick. Lichtenberg speaks of her "talent for convincing the innermost heart of the spectators that she does not feel herself to be acting a part, but presenting reality in all its bitter truth."[144] Exclusively a comedienne, her most famous role was the social-climbing Lady Teazle in Sheridan's *The School for Scandal,* in which she represented a perfect combination of "*artificial* refinement and *natural* vivacity" (my emphases).[145] The irony that her own fortune-hunting career so closely resembled Lady Teazle's did not disable her performance; indeed it energized the public response in her favor. In the epilogue to *The School for Scandal,* written for Mrs. Abington in the character of Lady Teazle, the tantalizing paradox of her artifice and naturalness comes to a head. The epilogue's theme is Lady Teazle's renunciation of her glittering London social life for retirement to the country. But as she relates a conversation with Sheridan (the "bard") about the necessity of a tragic sequel to the play, theatrical metaphors invade the language of the epilogue, to the point where the role of "Lady Teazle" herself becomes indistinguishable from the actress who plays her:

> Farewell! Your revels I partake no more,
> And Lady Teazle's occupation's o'er!
> All this I told our bard; he smiled and said 'twas clear,
> I ought to play deep tragedy next year.
> Meanwhile he drew wise morals from his play,
> And in these solemn periods stalked away: —
> "Blessed were the fair like you, her faults who stopped,

> And closed her follies when the curtain dropped!
> No more in vice or error to engage
> Or play the fool at large on life's great stage."

The puzzle of this speech surrounds the shifting referent of the "I" (later "you"). Who, for instance, is "play[ing] the fool," Mrs. Abington or Lady Teazle? Is Lady Teazle's "occupation" her own as a misbehaving wife, or Mrs. Abington's, who performs her? When the metaphor turns to the curtain dropping on "life's great stage," are we to imagine the conclusion of Lady Teazle's social career or Mrs. Abington's at the theater, to resume her role as real-life celebrity? The passage is confounding to us on the page but must not have been to Sheridan's audience, who had the benefit of Mrs. Abington herself to give shape to the ironies. Perhaps it was Mrs. Abington's performance of this epilogue that prompted Lichtenberg to observe "that the cardboard world of Drury Lane is too restricted for her," and allude mysteriously to the common surmise that she would soon "play her part in the greater sphere it reflects."[146] Like her manager Garrick, Mrs. Abington embodied the new theater culture of celebrity in which the aura of onstage performance merged with the aura of popular fame. For the Georgian public as for our postmodern age, celebrity culture implies a breakdown between public persona and personal identity, between the theatrical and the real.

While her excellence in the role of the parvenue was undisputed, Mrs. Abington never suffered the indignity of typecasting. "So various and unlimited are her talents," enthused Thomas Davies, "that she is not confined to females of a superior class; she can descend occasionally to the country girl, the romp, the hoyden, and the chambermaid, and put on the various humours, airs, and whimsical peculiarities of these under parts."[147] Paradoxically, Mrs. Abington appeared most natural to Davies when playing "females of a superior class," but had to "descend" to the level of "hoyden" and "chambermaid" from where she did, in reality, originate. The relation between her theatrical and real identity has been entirely inverted in his mind. Playing host to Mrs. Abington after her retirement, Henry Crabb Robinson makes an ambiguous observation that strikes at the heart of the Abington mystique: "Mrs. Abington would not have led me to suppose she had been on the stage by either her manner or the substance of her conversation. She speaks with the ease of a person used to good society, rather than with the assurance of one whose business it was to imitate that case."[148] First, Crabb Robinson is surprised by Mrs. Abington's lack of theatrical airs. He then makes a highly nuanced contrast between her manifest

"ease" in fashionable circles and celebrated "assurance" as a professional actress impersonating high born ladies. The distinction between Mrs. Abington's true identity and her theatrical aristocratic persona crumbles under the weight of Crabb Robinson's indeterminate language. Whose business is it to "imitate" the ease of social privilege: Mrs. Abington in real life, or onstage? Is Crabb Robinson complimenting Mrs. Abington's comfort at his dinner table, or her performance of it? The eighteenth-century love of the theater and theatrical metaphors reaches an acme of confusion in the figure of Mrs. Abington. Wherever she went, Mrs. Abington impressed her admirers with her plausibility. Be it at the theater or the dining tables of the cultural elite, Mrs. Abington came across as "real," whatever mask she happened to be wearing.

Reynolds captures the complex imbrication of Mrs. Abington's life and art in his celebrated portrait of her as Miss Prue in Congreve's *Love for Love* (figure 1.7). *Mrs. Abington as 'Miss Prue'* is an intriguing tribute to the actress Garrick himself despised for her caprice and vanity but critics lauded as their "theatrical Euphrosyne."[149] In Reynolds' painterly vision of Mrs. Abington, celebrity and masquerade went hand in hand. Aside from her immortalization as Miss Prue, she posed for Reynolds as the Comic Muse, as Thais, as Roxalana in *The Sultan,* but never as herself. No hard evidence exists to support the suggestion that the two were lovers, except Reynolds' painting her so often, and buying forty tickets for her benefit night—an act of almost unparalleled liberality for the miserly painter. Reynolds' nineteenth-century biographers, Leslie and Taylor, admit that Mrs. Abington "seems to have been a special favourite with Reynolds," and that he painted her "*con amore,*" but, with the bleak naiveté that gave the Victorian age its reputation, they still wonder why "Sir Joshua should have wasted so much regard on such a woman."[150]

Mrs. Siddons as the Tragic Muse won fame for the grandiose manner of Sarah Siddons' pose. So much so, that a debate arose over whether Reynolds or his subject was responsible for its celebrated indices of pathos: the languid tilt of Siddon's head and exhausted waft of her hand. *Mrs. Abington as 'Miss Prue'* is no less a masterpiece of attitude, but here the Comic Muse presides. Where Mrs. Siddons impressed with her gravity, Mrs. Abington startles with a presumptuous candor, sitting sidesaddle on a Chippendale chair, leaning on its back. She pays no attention to the small Pomeranian in her lap, but instead looks at us with an air of distracted curiosity. Her hair is drawn back dramatically from her brow in an elaborate coiffure, but her pose is disarmingly girlish. In a painting that combines

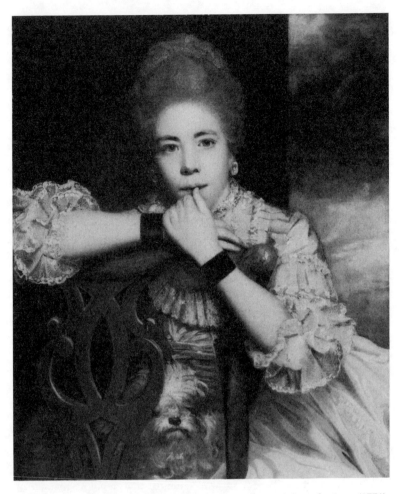

Figure 1.7 Reynolds, *Mrs. Abington as Miss Prue in Congreve's* Love for Love (1771). Yale Center for British Art, Paul Mellon Collection.

ambitious structure with the tenderest detail, the *punctum* is Mrs. Abington's left thumb, which plays at her lower lip. The character of Miss Prue in Congreve's comedy is a sexually precocious ingénue, one of Mrs. Abing-ton's most famous roles, which she reportedly played with a combination of "childish simplicity and playful awkwardness."[151] In Reynolds' painting, however, her child-like innocence is less plausible than the sensual pressure

of her thumb on her mouth. With the black silk bands about her wrists, it forms a triangle of erotic suggestion at the precise center of the painting.

Mrs. Abington's dress, an extravagant rush of pink and white silk, is a visual sensation, but presents a problem for critics. Congreve's character, Miss Prue, is an unsophisticated country girl from the 1690s, whereas the gown in Reynolds' painting suggests the height of 1770s' society fashion. Mrs. Abington's piled-up hair, lace trimmings, and silk wristbands were the latest imports from Paris. "Reynolds seems to have been bewitched by the woman herself," suggests Robert Halsband, "and to have forgotten the part she is playing."[152] Eighteenth-century actresses habitually dressed onstage according to fashion irrespective of the role (Mrs. Abington enjoyed a large clothing allowance from Garrick's coffers), but this fact does not resolve the ambiguity of the painting's setting: is it a stage or a private boudoir? The background—a dark flat or curtain with a sliver of scudding clouds to the right—is equally suggestive of the theater and portrait studio. Joseph Musser asks the obvious question, namely "How much of the portrait is Mrs. Abington the woman? How much the public figure, the actress? How much Miss Prue?"[153] The theatrical suggestion of the painting's title comes up against the personal intimacy of the pose. Is this a Restoration comedy, or a private audience with Mrs. Abington? The portrait embraces both possibilities at once. As an actress "in character," Reynolds' Mrs. Abington visually encodes the new informality of stage acting in the age of Garrick. As a woman, she embodies the theatrical "ease" of the Georgian career celebrity, at home across all levels of society. Mrs. Abington plays the role of Miss Prue for us, but the finery of her dress more suggests her role in real life, as a cobbler's daughter and child prostitute turned darling and fashion plate of the *beau monde*. The slipperiness of the painting's title reinforces this essential instability of the image: as a masquerade that assumes the aura of reality. *Mrs. Abington as 'Miss Prue'* resembles Reynolds' allegorical portraits of Georgian women in seeking to elevate the art of portraiture from the tradesman's task of taking a likeness into a pictorial Human Comedy. The painting shows that while Reynolds' ambitions for portraiture were academic in theory, they were theatrical in practice. Just as Crabb Robinson became lost in the ironies of Mrs. Abington's "assurance" of gentility—is it performed, he wondered, or a "natural ease"?—so in his portrait of Mrs. Abington, Reynolds opened his art to the Georgian world of masquerade, with no distinction made between theater and reality, between the face and the mask it wears.

Reynolds' sustained fascination with Mrs. Abington as a theatrical model suggests the role of Miss Prue he chose for her may also have served

a personal end: as an image of his own wishful projections. The painting's title denotes a theatrical portrait—a public figure depicted in her professional role—but the picture itself hums with the contradictory suggestion of very private longing (the impression of Mrs. Abington's figure is rendered with the utmost care). Contradiction being the language of desire, *Mrs. Abington as 'Miss Prue'* reveals as much about the painter as his subject. Reynolds composes Mrs. Abington as "Miss Prue" as he would have her pose for him in his dreams: younger than she actually was (at least 33 when the portrait was done, possibly as old as 40), knowing and yet innocent, with an expression of sexual wonder directed openly toward him. Viewed more largely, Reynolds' seemingly compulsive need to paint Mrs. Abington makes him a forefather of the modern *paparazzi,* a cog in the increasingly powerful machine of popular celebrity, indentured to perpetual reproduction of the faces of the stars. Thanks in part to the exposure brought by publication of Reynolds' paintings, Mrs. Abington's fame, like Garrick's, extended far beyond the Drury Lane stage. Through the reproduction of her image in paintings and prints, and the imitation of her taste in seasonal fashions, her personal aura reached into the shop windows, drawing rooms, and wardrobes of the nation at large. As her admirer Georg Lichtenberg prophesied, Mrs. Abington's professional prominence as an actress launched her from the "cardboard world" of the theater to a celebrity status in "the greater sphere" of public imagination. In this light, *Mrs. Abington as 'Miss Prue'* appears as a carefully orchestrated publicity shot, an eighteenth-century "glossy" combining sexual allure, high fashion, and the tantalizing promise of intimacy. In Reynolds' worshipful portrait, Mrs. Abington is both impossibly glamorous and casually familiar, both remote and available. The painting is an archival image from the pioneer days of an entertainment celebrity culture we have inherited from the Georgians, and that the Romantic literary elite was first to despise.

Chapter 2 ～

PRINTS AND EXHIBITIONS

Reynolds and Hazlitt: Between the Royal Academy and the Print Trade

"The disadvantage of pictures is that they cannot be multiplied to any extent, like books or prints."
—William Hazlitt, "Sketches of the Principal Picture Galleries of England" (1824)

In an 1814 letter to the comic actor Charles Mathews, Coleridge makes a careful distinction between theatrical naturalism and literal truth: "A great Actor, comic or tragic, is not to be a mere *Copy,* a *facsimile,* but an *imitation,* of Nature. Now an *Imitation* differs from a Copy in this, that it of necessity implies & demands *difference*—whereas a Copy aims at *identity.*"[1] As I described in my introduction, the language of this distinction between acting and mere mimicry—modeled on that between imitation and copy—constitutes an *idée fixe* of Coleridge's lectures on aesthetics. For example, he counseled would-be dramatic poets with the same terms he applied to the actor Mathews, that is, "not to present a *copy,* but an *imitation* of real life." Whether watching a play or reading it in one's study, Coleridge states, "the mind of the spectator, or the reader, therefore, is not to be deceived into any idea of reality."[2] Coleridge's carefully reiterated distinction between the imitative genius of art and the technique of merely "copying" reality illuminates and protects the idealist impulse integral to Romantic poetics. Clarifying his position in the *Biographia Literaria,* Coleridge stipulates that images of nature, "however beautiful, though faithfully copied from nature," do not constitute art unless "they are modified by a predominant passion."[3] The shaping sensibility of the artist, actor, or poet must "modify" reality in

the service of an ideal. In the early nineteenth century—the age of "Belzoni's Tomb," spectacular realism at the patent theaters, and the panoramas of the West End—Coleridge's need to assert an idealist aesthetic over the fashion for "facsimile" acquired new urgency. The theatrical and panoramic spectacles of the Regency age aimed at unmediated reproduction of the external world, and thus lacked all "modifying" sensibility. Coleridge's apparently universal statements on the aesthetic difference between imitation and copy may accordingly be historicized as a reaction against the early nineteenth-century proliferation of new visual media devoted to mimetic reproduction of reality. For Coleridge, the terms "copy," "facsimile," and "simulation" made up a single, composite bogey, a menace of popular taste that threatened the hegemony of elite, idealist principles in art.

In his 1824 essay, "Sketches of the Principal Picture Galleries of England," William Hazlitt extends Coleridge's definition of the "copy" from the effect of verisimilitude at the theater to the mechanical reproduction of paintings in the form of prints. For Hazlitt, an engraving of a painting by Reynolds, for example, was another potentially obnoxious form of facsimile. Consequently, his essay makes pains to distinguish between a visit to a print shop and a "pilgrimage" to a collection of original paintings. The first constitutes no more than "a point to aim at in a morning's walk," while the latter is "an act of devotion performed at the shrine of Art!" For Hazlitt, the commercial printshop was a "mean, cold, meagre, petty" establishment when compared to the cathedral-like galleries of a private collector. According to the same hierarchical order, the engraved image itself was far inferior to the original painting. Whereas an original painting allowed Hazlitt to "enter into the minds of Raphael, of Titian, of Poussin, of the Caracci, and look at nature with their eyes," a print signified only "hints, loose memorandums, outlines in little of what the painter has done."[4] Despite Hazlitt's confident dismissal of the artistic claims of engraving, his very argument for the superiority of original painting over its engraved reproductions suggests a significant concession to the influence of the print trade.[5] In short, Hazlitt perceives printshops as a threat to the role of picture galleries in English culture and, by implication, to the status of his own connoisseurship. The Romantic view of art, Walter Benjamin has stated, places "the whole sphere of authenticity outside . . . technical reproducibility . . . the technique of reproduction detaches the reproduced object from the domain of tradition."[6] Engraving, as a commercial product, was crucial to the success of the new British school of painting that emerged in the late eighteenth century. As a technical process, however—whereby the image was copied and mass-produced—printmaking contra-

dicted Romantic ideals of authenticity, original genius, and the *beau ideal.*
The Romantic repudiation of technical reproduction Benjamin postulates
is clearly evident in Hazlitt's essay. Following Shaftesbury, he likens the
effect of engraving on art to that of the printing press on literature.[7] Mass
production, Hazlitt predicts, will reduce art to the "cheap and vulgar" state
of popular literature, dictated to by the gross tastes of the "public" rather
than the enlightened sensibilities of the elite.

The terms of both Coleridge's theoretical contempt for "copying" real-
ity in art and the theater and Hazlitt's prejudice against printshops may be
traced back to Sir Joshua Reynolds' influential lectures to the Royal Acad-
emy (1769-90; first published collectively in 1791 as *Discourses on Art*), a key
reference text for Romantic antimimetic prejudice. As David Solkin has
explained, as a rising artist in the 1750s, Reynolds found himself at
ground-zero of the new commercial art culture: "Up until the middle of
the eighteenth century, artists had typically worked on commission for
individual patrons, in a manner that could at least be represented or imag-
ined as a close collaboration between spiritual equals. But all this changed
dramatically with the advent of the exhibitions, which encouraged painters
and sculptors to exchange a traditional form of clientage for the pitfalls of
a competitive free-for-all fueled by anonymous and impersonal commer-
cial demands."[8] The principal market demand Solkin alludes to was the sale
of print reproductions, which followed the exhibition of a painting if it
was sufficiently successful in attracting public notice. In my first chapter,
I sought to explain the resentment of Charles Lamb toward the early
nineteenth-century stage through an examination of the radical changes in
the character and social role of the theater wrought by Garrick in the sec-
ond half of the eighteenth century. This chapter adopts a similar strategy,
first sketching the historical background to Hazlitt's concern over the pro-
liferation of art as "copies" through an examination of the late eighteenth-
century print market, then, in the second section, addressing establishment
anxiety over the commercial exhibition of art through a study of the
history painter Benjamin Haydon. As in my analysis of Romantic anti-
theatricality, this chapter looks back to late eighteenth-century Britain,
specifically to the two principal agencies of the new commercial art mar-
ket—print reproduction and public exhibition—with a view to explaining
the anxieties that the marriage of art, *mimesis,* and the marketplace inspired
among the Romantic literary elite.

Whatever their unconscious susceptibility to his influence, the Romantics
largely resented Reynolds. Blake scribbled scornful notes in the margins of

his copy of the *Discourses,* while Hazlitt used his position as art critic for *The Champion* to attack the legacy of Reynolds' conservative idealism.[9] Throughout his long career as tastemaker and theoretician of painting, Reynolds, like Coleridge after him, fought strenuously against the notion "that objects are represented *naturally* when they have such relief that they seem real." Nature in art, he argued, should never be confused with the replication of material reality, as it had been by the painters of the Dutch Baroque. The stakes for Reynolds, as a painter, were even higher than for Coleridge. If painters were to condescend to the "real," they must necessarily abdicate their hard-won "rank . . . as a liberal art, and sister to poetry." Reynolds makes a clear opposition between the eye and the intellect, between the merely visible and the poetically imagined. "What pretence," he asks, "has the art [of painting] to claim kindred with poetry, but by its powers over the imagination?"[10] As we shall see, this question will be taken up, with increasing rhetorical urgency, by Romantic idealists from Wordsworth and Coleridge to Charles Baudelaire. But simply to place Reynolds' *Discourses* on the fault line between classicist orthodoxy and Romantic reaction is to miss the greater conflict the lectures represent, namely that between the Georgian academic elite and the commercial art trade.

As Richard Wendorf has stated, "Britain's gradual evolution from a 'client' to a 'market' economy affected painters and writers no less than it did the average merchant or shopkeeper."[11] Responding to the threat of commercialization, Reynolds, in his role as President of the Royal Academy, continually reminded his students of the disinterested, intellectual nature of the artist's vocation: "the industry which I principally recommended, is not the industry of the *hands,* but of the mind. As our art is not a divine *gift,* so neither is it a mechanical *trade.*"[12] Whatever he preached from the podium of the Royal Academy, however, in the management of his own career Reynolds showed a keen awareness of the commercial imperatives facing artists, namely as purveyors of mass produced engraved copies of original paintings. It is this seeming disparity between Reynolds' theory and practice, his finessed distinction between "copying" as art and as business, that provoked Blake to condemn the *Discourses* as "the Simulations of the Hypocrite who smiles particularly where he means to Betray" (as we shall see, Blake was not the only engraver to show bitterness toward Reynolds). [13] But if they are not quite the work of a hypocrite, Reynolds' lectures do betray some telling prejudices. Anticipating Hazlitt's 1824 essay on picture galleries, Reynolds' sub-textual argument against engraving in

his *Discourses* depends upon the transfer of conventional academic antipathy toward copying nature to the facsimile process of mechanical reproduction associated with the print trade. This hidden politics of the *Discourses,* I will seek to show, points to Reynolds' difficult dual role in the late Georgian art world: as President of the conservative Royal Academy on one hand and, on the other, a conspicuous beneficiary of the booming commercial print trade to which the Academy was ideologically opposed.

The work of engraving being so laborious and time-consuming, and the taste of the market so fickle, print-selling required an appetite for high-risk speculation. A print merchant managed the commercial relationship between the painter and engraver, and offset risk by raising a subscription for the engraving at the time of the painting's first exhibition. Confidence in the marketability of an elite painter such as Reynolds was sufficiently high that an engraving might be commissioned without subscription so as to appear simultaneously with the painting (just as museum exhibitions today are invariably accompanied—some would say overwhelmed—by merchandizing in the form of catalogues for serious connoisseurs, and posters, t-shirts and coffee mugs for the rest). In 1762, Reynolds published his celebrated allegory, *Garrick between Comedy and Tragedy,* in this manner. Reproductions of the painting, including many pirated variants, were soon for sale in printshops and on street corners throughout Europe.

The bullish and self-confident English print industry Reynolds enjoyed was a recent phenomenon. In the early eighteenth century the workshops of Paris and Amsterdam dominated the international print market. Connoisseurs and collectors in England were obliged to order their reproductions of Old Masters and keep up with new trends via continental agents. Remarkably, the direction of this traffic was almost completely reversed in less than fifty years. William Hogarth first proved the commercial viability of well-made English prints with his *Harlot's Progress* series (1732). A decade later, Arthur Pond's Claude engravings demonstrated that fine art prints were capable of comparable appeal. These prints established a whole new standard in reproductive quality, and Pond followed them with a series of equally fetching picturesque scenes of Roman antiquities. Between them, Hogarth and Pond opened up a middle-class market for art with a sales logic that was simple and effective: "Both produced sets containing four to eight prints unified by theme and composition, relevant to contemporary interests, large and rich enough to decorate the walls of a Georgian-scale room, after known original paintings by name artists."[14] The print industry targeted new bourgeois consumers. Its products, both in size and

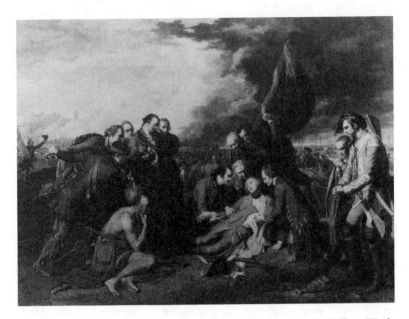

Figure 2.1 Benjamin West, *The Death of General Wolfe,* engraving by William Wool-lett, for John Boydell (1776). © The British Museum.

subject, were consequently designed to appeal less to the artistic sensibility of their clientele than their practical need to decorate domestic wall space.

As important as Hogarth and Pond's ventures were to the development of skilled local engravers, it was the printselling magnate John Boydell who transformed the native industry into a powerhouse on the European and colonial art markets. Borrowing from the commercial techniques of book-sellers, Boydell established a network of continental buyers to supplement his local trade. His 1763 subscription series, *A Collection of Prints, Engraved from the Most Capital Paintings in England,* subsequently attracted 173 initial subscribers of whom more than a third were foreigners.[15] Boydell first established his market share through the technical excellence of these Old Master reproductions, but his increasing dominance over the international print trade in the following decade had important consequences for the British art scene. Prints of paintings by British artists, such as West's Romantic battle scene *The Death of General Wolfe* (figure 2.1), achieved great celebrity and sold in the thousands. Likewise, prints featuring local subjects—quintessentially English prospect views and picturesque land-

scapes—rode the wave of fashion for English engraving to create new tastes on the continent. In an important sense, late eighteenth-century British art was the age of Boydell, not Reynolds or Gainsborough. As corporate owner of an international network of printshops, Boydell enjoyed more power, if not prestige, than the President of the Royal Academy. It is no surprise then that Reynolds, despite his indebtedness to the flourishing English print trade for his own professional success, had "mixed feelings" for the man principally responsible for creating it.[16]

Indeed, in Reynolds' twenty years of presidential lectures to the Royal Academy, engraving barely rates a mention, let alone the actual trade in prints. The *Discourses* refer to engraved reproductions only as a means by which academy students "may now avail [themselves] of the inventions of antiquity."[17] Pond published his popular series of Roman ruins in 1746, and James "Athenian" Stuart's prints of Greek architecture excited great interest in 1762. Notwithstanding these publications, the "inventions of antiquity" represented only a tiny portion of the booming market in fine art prints. This, in turn, was only part of a much larger print market, which offered middle-class consumers everything from maps and landscape views to satirical prints, decorative designs, and illustrated books.[18] What Reynolds' *Discourses* never acknowledge is that, already by the time of the Academy's founding in 1768, career success as an artist depended on the commercial reproduction of paintings in miniaturized print form, to be mass produced up to a thousand copies and sold in print shops in England and abroad.[19]

Although Reynolds was conspicuously reticent on the subject, academy students attending his inaugural lecture as president in 1769 did not have far to look for evidence of the close relationship between high art and the print trade. An embossed sign at the entrance to the lecture hall in Pall Mall declared it the Royal Academy, but without entirely obscuring the somewhat plainer inscription above the lintel, which advertised a print warehouse. As the engraver Robert Strange relates, "Part of the rooms only were appropriated for the purposes of the royal academy; the rest, for the farther benefit of [the engraver] Mr. Dalton, were occasionally let out to auctioneers."[20] Nor did the Academy's presence curtail commercial activity on the site, which continued side by side with academic instruction for years afterward. The fact of academy students sharing the Pall Mall premises with engravers and art auctioneers raised more problems for Reynolds than the danger of double-booking. The shared tenancy symbolized the dynamic kinship of art and commerce in the late Georgian period,

in which painters and engravers did, in fact, share in the manufacture of the new, much-heralded British school of art. Timothy Clayton has summed up the centrality of the engraving industry to the artists of Reynolds' generation: "Engravings served to legitimize paintings by authenticating their provenance and attribution. They brought additional renown to the painting and to the collector. It was to be expected that these factors would increase the sale value of the paintings at auction."[21] In a counterintuitive reversal of value, the copy "legitimizes" and "authenticates" the original. That is, an artist such as Reynolds stood to gain financially not only from a share of print sales, but also from the value accrued to his original painting through the public exposure that sale brought. The worth of the painting, it seems, was not intrinsic to an academic standard of aesthetic merit but a function of the quality and number of its reproductions.

The foundation of a Royal Academy in 1768 had ended a decade-long internecine struggle in the art community that reflected the greater class divisions of Georgian England. The denizens of the new Royal Academy represented aristocratic, Tory interests, and, in its neo-classicist curriculum and elitist system of self-governance, looked to the continental academies, particularly the French, for its model. By contrast its rival, the Society for the Encouragement of Arts, Manufactures, and Commerce (known as the "Society of Artists"), more resembled a trade union of artists: aggressively egalitarian, nationalist, and Wilkite.[22] This ideological conflict is reflected in the strong anticommercial rhetoric of Reynolds' *Discourses*. The Society included merchants and manufacturers among its members as well as artists and connoisseurs. It awarded annual prizes not only for painting and drawing but also for the industrial genres of design, engraving, and papermaking. In so doing, it sought to emphasize a natural kinship between industry and the fine arts. By the mid-1760s, a group of elite painters, including Richard Wilson, Benjamin West, and Angelica Kauffman (although not Reynolds initially), had become sufficiently dissatisfied with the commercial principles and democratic political structure of the Society to apply to the King to found an Academy. By resorting to Royal auspices to solve their factional conflicts, Britain's new academicians committed themselves to an institution-based, conservative ideology of art antithetical to the commercial codes of the expanding print market. In direct opposition to the Society's policy, the Academy reserved membership for painters and sculptors, excluding engravers and all others associated with "trade."[23] Thus in its very charter, the Academy stood to embody an aristocratic model of patronage, not a popular market; to serve the tastes of a (self-described) noble and civic-minded elite, not the bourgeoisie; to promote original works of genius, not

the mass reproduction of prints; in short, to pursue a disinterested and cultivated, rather than commercial, career in the arts. The supersession of the Society of Artists by the Royal Academy in the late 1760s thus represented the end of a brief but troubled interregnum of pro-commercialism in the Georgian republic of taste. The democratic unionization of British artists failed, giving way to a continental, absolutist model of state art.

But for all these political struggles at the institutional level, the art market itself did not change. The popular audience for fine art prints continued to expand rapidly. By the beginning of the Academy's second decade, the British export market in prints was worth two hundred thousand pounds a year.[24] Increasingly therefore, the Royal Academy came to embody an ideal of state patronage entirely at odds with the realities of the new bourgeois market for fine art. Furthermore, the opening of this market was due less to English artists themselves than to those engravers and print-sellers who had improved their skills and adapted workshop technologies to better compete internationally. But it was precisely this group to which the doors of the Royal Academy, flagship of the British Art Renaissance, were now to be shut.

Anticipating Coleridge's distinction between imitation and copy, Reynoldsian theory divides "imitation" into two categories. The sixth *Discourse* (1774) defines the "*liberal* style of imitation" as a selective, analytical study of the Old Masters through which "what is learned . . . from the works of others really becomes our own."[25] Reynolds here effectively integrates imitation, as a species of academic instruction, into an enlarged notion of originality. This is in contrast, however, to another class of imitators for whom Reynolds reserves an unusually harsh string of epithets. Those painters who treat "strict imitation" or "copying" as an end in itself, says Reynolds—he specifically nominates the despised underclass of journeyman portraitists or "face painters"—are not liberal artists but rather the "narrow, confined, *illiberal,* and servile kind of imitators." These are the villains of the *Discourses,* who would reduce painting to a mere craft, genius to talent, and art to a merely sordid trade in likenesses:

> When I speak of the habitual *imitation* and continued study of masters, it is not to be understood, that I advise any endeavour to copy the exact peculiar colour and complexion of another man's mind; the success of such an attempt must always be like his, who imitates exactly the air, manner, and gestures, of him whom he admires. His model may be excellent but the *copy* will be ridiculous. (my emphasis)[26]

Reynolds' explicit reason for clearly distinguishing imitation and copy is to assert the Academy's allegiance to the Italian grand style of the Renaissance and Baroque over the pernicious influence of Dutch realism and, worse still, journeyman portraiture. Placed in a more immediate context, however, Reynolds' disapproval of copying as a means of instruction at the Academy reveals much that is *implicit* about his attitude toward engraving. In a polemical pamphlet highly critical of Reynolds, published the year following Reynolds' delivery of his sixth discourse, Robert Strange relates the gossip surrounding the exclusion of engravers from the Academy: "they said,—that engravers were men of no genius,—*servile copiers,*—and consequently not fit to instruct in a royal academy. This too, I am sorry to say it, was the language, as I was informed, held by their president" (my emphasis).[27] Strange's anecdote reveals two things: first, that in Reynolds' mind, "servile copying" applied equally to poorly trained painters and to engravers; second, that Reynolds was reluctant, nevertheless, to publicly denigrate those artisans with whom he had so crucial a business association. His contempt for the servility of engraving circulates at the level of rumor, not official pronouncement. In light of this evidence, Strange's accusation that Reynolds' *Discourses* and the institutional policies they dignified amounted to "an attack upon the art of engraving" seems justified, despite the fact there is no direct expression of this prejudice in the lectures themselves.[28]

Sources for Reynolds' rhetoric of servility to describe engraving may be found in his extensive library of French academic theory.[29] In 1699, Roger de Piles stipulated that "un habile Peintre ne doit point être *esclave* de la Nature, il en doit être Arbitre."[30] Two decades later, Jean-Baptiste Dubos laid down the precise language for Reynolds' rejection of engraving: "il faut savoir faire quelquechose de plus que *copier servilement* la nature, pour donner à chaque passion son caractère convenable" (my emphasis).[31] Given the reputation of these precedents, Reynolds' description of engraving as "servile copying" was a rebuke that carried with it the full weight of academic scorn: hence Strange's pointed sense of injury. But Strange was perhaps more perplexed than angry. The elitist attitudes of the Academy seemed an act of self-sabotage: "I appeal to their understandings, whether perpetuating the merit of their works to posterity, supposing them to be men of abilities, must not, in a great measure, depend upon the perfection of engraving, an art which they meant to disgrace by this exclusion?" Reynolds' apparent disdain for engravers was particularly perverse, Strange contended, because "I know no painter, the remembrance of whose works will depend more on the art of engraving than that of Sir Joshua."[32] In pri-

vate, Reynolds acknowledged this. Looking over a set of prints by the gifted engraver James McArdell, he reportedly exclaimed, "By this man, I shall be immortalized!"[33]

Reynolds was playing a deep game. As Strange points out, his lectures to the Royal Academy effectively denied the existence of the print trade, while from the outset of his own artistic career he demonstrated an acute awareness of its importance. Immediately on his return to England from study in Rome in 1752, Reynolds undertook an engraving of his portrait of Lady Charlotte Fitzwilliam for promotional purposes. From that moment on, he constructed a prototypically modern career as an artist, utilizing the print medium to multiply the commercial value of his paintings and promote his name. Among Reynolds' engravers were the leading men of the emerging English school: Valentine Green, William Wynne Ryland, James McArdell, and John Raphael Smith. He cultivated business relationships with both Boydell and Ryland & Bryer, the largest print merchants of the day. Through these commercial initiatives, Reynolds became the first truly "famous" English artist. He published more of his paintings, in more copies, than any other artist of the period. Furthermore, Nicholas Penny has pointed to the significant number of Reynolds' portraits, particularly of celebrities such as Mrs. Abington, that he undertook without commission, speculating that "Reynolds' chief reason for making the paintings was in order that prints could be made of them."[34] Evidence also exists that Reynolds'"predilection for broad effects of light and shade" was a deliberate attempt to render his paintings conducive to mezzotint reproduction.[35] In this light, the idealist dogma of Reynolds' *Discourses,* in which he barely refers to the print trade and characterizes art as the disinterested practice of imaginative genius entirely removed from the common world of capital and industry, bears little connection to realities of his own career. Indeed, for Valentine Green (himself, ironically, an engraver), Reynolds exemplified the parlous effects of the new commercial art culture, which was "making *Marchands d'Estampes* [printsellers] of our first men of genius, and reducing the study of their professions to connoisseurship in proof impressions from engravings."[36] In the diary of his journey to Flanders and Holland, Reynolds showed clear evidence of such expertise. His description of engravings done under the supervision of Rubens displays a sophisticated understanding of the translation of painting to miniature, black-and-white form. He observes, for example, that Rubens' engravers "always gave more light than they were warranted by the picture," and offers this technique as an example "which may merit the attention of [English] engravers." Unlike

his principal rival, Thomas Gainsborough, who never showed the slightest interest in engraving either as a technique or commercial opportunity, Reynolds, in his more ingenuous moments, considered it a "science" very much worthy of his study.[37]

As a successful engraver, Robert Strange considered the marriage of art and commerce a natural union in modern, industrial Britain: "The progress of the fine arts cannot but attract the attention of every lover of his country. Connected with various branches of manufactures, they became objects of importance in a commercial kingdom."[38] He perceived his duty as an artist and "lover of his country" to aggrandize the prosperity of a mercantile, commercial empire. The fine arts, engraving among them, served to adorn and inspire its progress. But Reynolds saw his patriotic mission entirely differently. The Royal Academy, as he conceived it, was an Augustan institution, designed to evoke the role of the great oligarchic orders of antiquity and the Renaissance. The Academy's concern for the state was moral and intellectual rather than economic: "An institution like this has often been recommended upon considerations merely mercantile; but an Academy, founded upon such principles, can never effect even its own narrow purposes."[39] This brand of disinterested elitism was a political necessity for the Academy because, as Clayton puts it, "exaltation of genius at the expense of craftsmanship attracted painters who sought an intellectual foundation for their profession . . . the cultural current favoured originality and genius."[40] It was in order to protect (or, in fact, create) an aura of exalted disinterestedness about the artist's vocation that Reynolds' lectures are full of high-sounding blandishments about genius, imagination, and the Grand Style, but entirely empty of references to the practical demands of the Georgian art market. Implicit in the Royal Academy charter was the need to rise above the servility associated with the portrait and print trades. At an institution where imagination and invention were privileged, and only the most "liberal" style of imitation permitted, the "narrow" and "servile" art of the engraver was therefore anathema.

In light of their sub-textual hostility toward engraving, Reynolds' *Discourses* constitute not merely a Johnsonian summation of three centuries of European art theory, but a concerted attempt to reinvigorate academic principles in a visual culture increasingly governed by commercial investment in mechanical reproduction. A Royal Academy answered the pressing need, shared among Britain's elite artists, to preserve painting from too close a connection to the commercial world and middle-class taste. Founded a hundred years after the French Academy and centuries after its

Italian models, the Royal Academy thus represented less a consolidation of the Renaissance culture of art in Britain than a circling of the wagons against the encroaching commercialization and industrialization of painting. British academic painters of the late eighteenth century found themselves in a quandary. They depended on the print trade for their income and celebrity, but to be guaranteed the elite social standing they desired (as the equals of poets), they could never concede engraving, a form of industrialized *mimesis,* to be anything but a sin against art. Given this, it is no surprise that the *Discourses* are so strangely dissonant to their times. Reynolds' lectures ignore engraving in the midst of a boom in English prints, preach artistic disinterestedness in a competitive commercial art market, and champion history painting in the great age of British landscape and portraiture. From our viewpoint, the *Discourses* appear as they did to Blake: a monument of denial and disingenuousness. The Academy building in which Reynolds delivered the greater part of his lectures—with its echoes of artists, engravers, and auctioneers working in adjacent rooms—is the more faithful image of the English art world in the age of Reynolds.

For all the contradictions between Reynolds' public statements and private career management, the historical question remains: Did the Royal Academy ultimately succeed in giving birth to the longed-for British School of painting? And to what extent did the officially maligned print industry determine the outcome of that mission?

A key principle of Reynolds' *Discourses* is the so-called "hierarchy of genres," in which history painting serves the artist's impulses to the sublime, with landscape, portraiture, and still life accorded humble minority status. To champion the cause of history painting was an obvious course. The heroic moments of Scripture and Antiquity dominated the Italian Renaissance canon to which the eighteenth-century European academies continued to look for their model of excellence. Moreover, to its powerful sponsors in Britain, history painting answered the pressing need for a national school of art that would reflect the grandeur of her expanding empire. As Benjamin Haydon declaimed, it was the duty of British history painters to "adapt[] to great national work, to illustrate national triumph." As such, the Royal Academy and its signature heroic style constituted a nationalist project in the arts. To Reynolds, the Academy represented a natural and long-overdue consummation of art and national destiny. "It is indeed difficult," he maintained, "to give any other reason why an empire like that of Britain, should so long have wanted an ornament so suitable to

its greatness, than that slow progression of things, which naturally makes elegance and refinement the last effect of opulence and power."[41] For Reynolds, the grand style, embodied in history painting, adorned the State as an "ornament" to its power.

To succeed as such in the British context, however, required the Anglicization of history painting. Benjamin West's *Death of General Wolfe* (1771) spawned a generation of patriotic, contemporary history paintings that reached its zenith in the Napoleonic Wars. The British Institution, founded in 1806 as a forum for academic painting, devoted prizes not to traditional religious and mythological subjects but the celebration of British Naval victories. Haydon's response to Waterloo shows this imbrication in the academic mind of the political, the martial-imperial, and the grand style: "'Have not the efforts of the nation,' I asked myself, 'been gigantic?' To such glories she only wants to add the glories of my noble art to make her the grandest nation in the world."[42] The patriotic hope at the Royal Academy and British Institution was that the encouragement of history painting might overturn a pernicious continental heresy. To its critics in Europe, the meagerness of British painterly achievement, when compared to the country's rich literary heritage, was due to the poor climate. The perennial mediocrity of the British school was the symptom of a psycho-cultural disability attending the lack of sun:

> Abbé du Bos, president Montesquieu, and Abbé Winckelmann have followed one another in assigning limits to the genius of the English . . . that we are eternally incapacitated by the clouds that hang over our heads . . . that our climate is so distempered, that we disrelish everything, nay even life itself; that we are naturally and constitutionally addicted to suicide; that it is a consequence of the filtration of our nervous juices; that it is in consequence of a north-east wind.[43]

In the half-century after the founding of the Academy, however—with the septuagenarian Benjamin West still, in Byron's unpatriotic assessment, "Europe's worst dauber, and poor Britain's best"—James Barry's skeptical defiance gives way to a chorus of bitter self-loathing among the art establishment.[44] For Prince Hoare, even John Boydell's ambitious Shakespeare Gallery project had been insufficient to "remove the charge brought against us by other nations, of deficiency in history painting. It cannot be denied . . . that works in the higher provinces of this class do not constitute the prominent feature of our school."[45] The Shakespeare Gallery—the most systematic and well-funded attempt to nationalize history painting in

Britain (beyond the Academy itself)—was offered to public lottery in 1805, closing down after barely a decade (see chapter 3).[46]

Reflections on British art in the reformist, inquisitional mode extend as far back as James Barry's "Inquiry into the Real and Imaginary Obstructions to the Acquisition of the Arts in England," published only six years after the Academy's founding.[47] Some half-century later, Haydon's "Enquiry into the Causes which have Obstructed the Advance of Historical Painting for the Last Seventy Years in England" (1829) was still flogging the same horse. Significantly, Haydon dates the period of crisis in English art from the decade of the Royal Academy's founding, as if the Academy had brought only a greater visibility to the absence of a British school rather than actually producing it as was intended. Likewise Hazlitt, always an enemy of the Academy, argued that the institutionalization of art under royal patronage had done nothing to improve the degraded reputation of British painting: "What extraordinary advances have we made in our own country in consequence of the establishment of the Royal Academy? What greater names has the British School to boast than those of Hogarth, Reynolds, and Wilson, who owed nothing to it?"[48] In short, the cause of history painting came to be seen, for all Reynolds' mission statements from the Academy, as next to hopeless. As John Brewer relates, "collectors and critics who had been on the Grand Tour compared the art they had seen with the work of contemporary British painters and found the latter lacking in technical skill and, above all, nobility of conception."[49]

But these negative accounts do not give us the full picture. The success of the British print trade in this period contradicts the academic consensus surrounding the new British school of painting. By the mid-1780s England was supplying the Continent with prints in an export industry worth almost a quarter-million pounds a year, the majority of earnings generated by Boydell's thriving conglomerate of printshops.[50] Copies of Old Masters made up a sizeable proportion of British engravings flooding the European market, but an increasing number were works by local artists. Until the continental upheavals of the 1790s, contemporary British art enjoyed great success in Germany, Holland, France and Italy. West, Copley, Barry, Wilson, and Reynolds were, in art circles at least, household names. From the German point of view, where anglophilia was particularly strong, London had displaced Paris and Amsterdam as the art capital of Europe. New engravings of British paintings were regularly reviewed in French and German publications, and agents for British printsellers trafficked busily on the Continent. In short, while academic connoisseurs and artists at home reflected despondently on the apparent failure of the Royal Academy to

produce artists of international standard, the view from the Continent was of a British School in the process of spectacular parturition:

> Barely out of the cradle it has announced itself through its great success, and is the more deserving of applause and even of exciting the emulation of its elders since the aspects which make it distinctive are the noblest aspects of the art; soundness of composition, beauty of form, loftiness of idea, and truth of expression. The school is only known to us through prints.[51]

Claude-Henri Watelet published this encomium to British painting in the French Academy's monumental *Dictionnaire des Arts* (1792). Periodicals and sales catalogues throughout Europe quoted his rave review, helping to define popular continental opinion of British painting well into the nineteenth century. So: why bouquets for British artists abroad, and brickbats at home?

Watelet's admission that the British school "is known to us only through prints" has significant ramifications for our understanding of art, commerce, and print technology in the late Georgian period. First of all, the international success of the British School appears to contradict Benjamin's influential notion of the decay of the Romantic "aura" under the conditions of mechanical reproduction. For connoisseurs on the Continent, the print *was* the British school, but whatever incipient aura surrounded British painting did not "decay" on this account. The mass production of copies of British paintings served, in fact, to create a fashion for British art inspired not by the originals themselves, but a cult of prints only. Second, and more importantly, late Georgian painting now assumes its proper form as an unstable art-historical phenomenon. By 1824, Hazlitt perceived the dual identity of modern European art: as a set of original paintings housed in private galleries on the one hand and, on the other, an industry of miniaturized commercial print copies circulated by an international network of shops, agents, and buyers for a bourgeois market. Hazlitt feared for the fate of original painting and its aura in the new age of mechanical reproduction. Paintings were at a colossal "disadvantage" in the new art marketplace, he noted, because unlike prints "they cannot be multiplied to any extent." As Reynolds' career exemplifies, academic painters sought exposure and profits in the print trade, but were forced to compete with the vulgar ephemera of satirical prints, trade advertising, book illustration, and decorative designs for their corner of the expanding print market. Lost in the shuffle, Hazlitt implies, was the visibility of the original works themselves.

The aura of disinterested genius surrounding academic art, so resolutely

upheld by Reynolds and Hazlitt, showed signs of terminal decay in the half-century that followed the founding of the Royal Academy in 1768. By the time Benjamin Haydon entered the scene in the new century with his atavistic notions of state patronage, the art market had expanded far beyond its traditional audience of connoisseurs and aristocrats. Fine art in the Regency period became accessible to a broad and voracious middle-class whose investment in public exhibitions and print reproductions amounted to hundreds of thousands of pounds a year. Having examined the print industry, I turn now to what Reynolds' principal engraver, Valentine Green, called the "humiliating practice" of exhibiting art to the general public. For the academic establishment, it marked another disastrous step toward the vulgarization of British art when her most talented painters opened their doors to the masses, requiring no proof of their new patrons' taste beyond a capacity to advance the shilling's admission.

Contracted Optics:
Benjamin Haydon and the Cult of Immensity

"Some people prefer to look at paintings with closed eyes, so as not to disturb their imagination."

—A. W. Schlegel

In the *Poetics,* a widely read text in the eighteenth century, Aristotle describes an elemental relation between the human desire for knowledge and the pleasure derived from imitative reproduction of the visible world. We enjoy mimetic art, he says, because "we enjoy looking at the most accurate representations of things." But even Aristotle's definition, less hostile toward *mimesis* than Plato's, is inflected by social distinctions. Not only do "philosophers" derive pleasure from the mimetic arts but so do "other people as well, however limited their capacity may be."[52] For Sir Joshua Reynolds, it was only a half-step from Aristotle's idea of a universally pleasurable art object to its rejection on the basis of that universal appeal:

> Painting is not only to be considered as an imitation, operating by *deception,* but it is, and ought to be, in many points of view, and strictly speaking, no imitation at all of external nature. Perhaps it ought to be as far removed from the *vulgar idea of imitation,* as the refined civilized state in which we live, is removed from a gross state of nature; and those who have not cultivated their *imaginations,* which the majority of mankind certainly have not, may be said, in regard to arts, to continue in this state of nature.[53] (my emphases)

For example, the likeness of a portrait to its subject offers a thrill only to those languishing in "the gross state of nature," a lower class of sensibility. Eschewing *mimesis,* argues Reynolds, the Academy must nourish the subtle "imaginations" of the cultural elite, and oppose the fashion for imitative visual media so fascinating to "the majority of mankind."[54] Certainly, Reynolds' portraits conformed to this principle. They were notoriously unlike their subjects.

A decade prior to the founding of the Royal Academy, in three letters to Johnson's *The Idler,* Reynolds had warned of the potential for untutored art commentary to promulgate an unwanted narrow concentration on likeness and detail. Reynolds' fears were dramatically realized in the explosion of art reviews in the years following the Society of Artists' first public exhibition in 1761. A principal motive for Reynolds' legislative, at times dogmatic, tone in his *Discourses* was thus to correct what he perceived as the tendency in the new art press to apply merely vulgar mimetic standards to the appreciation of art. "With hardly any exceptions," David Solkin points out, "the art criticism published in the 1760s was not sophisticated. . . . As the contrast with Reynolds suggests, this endeavor to free the discussion of works of art from its prestigious social origins not only challenged the hegemony of the connoisseurs, but also revealed a growing divide separating the ambitions of the artistic intelligentsia from the more catholic tastes of the general viewing audience."[55] Certainly the stakes of the debate were high. An entire class of Britons, never before exposed to high art or questions of pictorial aesthetics, constituted a cultural tabula rasa, and sought a template for their opinions. Moreover, the emergence of public exhibitions in Britain signified not only a sea-change in the production, consumption, and cultural profile of the visual arts, but, in the manner of the Parisian *Salons,* were themselves barely controlled experiments in social mixing.[56] The spectacle of artisans rubbing shoulders with ladies of fashion, and the clerisy with the demi-monde, became, in its turn, a rich subject for commercial art, taking the form of bawdy satirical prints by Rowlandson, Gilray, and others. In short, the emergence of public art in Britain post-1761 puts the elitist rhetoric of Reynolds' *Discourses* in its proper context. Unwilling to expose his work before an unfiltered market of viewers, Reynolds first withdrew his work from the Society of Artists' exhibitions after 1766, and later instituted admission charges to Royal Academy shows. Both moves were an attempt to regain some measure of control over the constitution of the new British art public.[57]

As is evident from the above-quoted passage from his *Discourses on Art,* Reynolds' argument for class distinctions in visual taste—between the truly

educated, the merely polite, and the irredeemably common—doubles as an anticommercial argument. For Reynolds, relative proximity to the commercial sphere of life determined a person's susceptibility to vulgar representations of the "real." The genteel connoisseur, safely removed from commercial interest, has learned the skill of "looking upon objects at large, and observing the effect which they have on the eye when it is *dilated,* and employed upon the whole, without seeing any of the parts distinctly." By contrast, the common unsophisticated eye sees only a painting's detail, and judges its parts according to their fidelity to everyday life as he knows it. To illustrate his point, Reynolds draws on Pliny's tale of the shoemaker, whose sole response to a sculpture by Apelles was to question the correctness of the sandal.[58] The anecdote, says Reynolds, illustrates how a viewer's concern for the reproduction of reality in a work of art is the "observation of a very narrow mind; a mind that is confined to the mere object of *commerce,* that sees with a *microscopic* eye but a part of the great machine of the economy of life, and thinks that small part which he sees to be the whole" (my emphasis).[59] Reynolds here makes an important connection between realism and commercialism, a kinship we have observed in the remarkable career of the actor Garrick. Equally revealingly, Reynolds' anticommercial rhetoric relies on metaphors of size to describe inherent class differences in art appreciation. Proportional to a painting's "grandeur," the eye of the connoisseur "dilates" in order to embrace its ideal pictorial content. By contrast, the poor dullard tradesman "sees with a microscopic eye" and, as such, really doesn't see anything of importance at all. Reynolds' engraver Valentine Green draws on the same optical metaphor to make the same distinction, but in a way that combines an academic notion of the educated or "dilated" eye with a contempt, not unmixed with fear, for the new market power of popular taste:

> more than the virtue of economy is sometimes necessary to the attainment of riches; arithmetical calculations are never more uncertain, than when applied to matters of taste, and works of superior genius, which are influenced by causes far beyond their *contracted optics* to account for, with all their feebleness of foresight, and miserable contrivance.[60] (my emphasis)

Both the physical and legal-financial meanings of the word "contracted" are in play here. For Green, commercially produced paintings appeal only to a "contracted" view of artistic representation. The commercial eye of popular taste is consequently blind to the heroic themes and moral depth of the academic grand style, demanding instead the pictorial replication of

the familiar contemporary world, the "miserably contriv[ed]" realm of the "real."

Green's figure of "contracted optics" links two themes I wish to examine in the career of the history painter Benjamin Haydon: commercial exhibition and size. In the 1760s, one critical point of dispute between the Society of Artists' leadership and its disgruntled elite members was the issue of charging admission to its shows. As I have described, Reynolds recoiled at the prospect of the Society's commercialization, refusing to exhibit there because, in his opinion, the open admission policy attracted a "company [which] was far from being select, or suited to the wishes of the exhibitors."[61] Despite Reynolds' scruples, however, a succession of post-1760s British history painters, frustrated at a lack of private patronage for their work, took the radical step of introducing their heroic scenes to the general public outside of the Academy's annual public exhibitions. In so doing, these painters, including John Singleton Copley, John Martin, and Haydon, effectively reversed Reynolds' strategic withdrawal from the pro-commercial Society of Artists in 1766. To the dismay of the Academy, these artists chose to compete in the Georgian visual entertainment market alongside a gaudy assortment of popular theaters, West End shows, and fairground-style recreations. For reasons that demand investigation, this populist academic art was invariably huge. T. S. R. Boase has called it the "cult of immensity" in British Art.[62] The success of many of these commercial exhibitions by academic painters would seem to suggest that Reynolds underestimated the level of cultivation among the hoi-polloi: that there was indeed a popular audience for art in the grand style. But, as I shall argue, in an important sense Reynolds and Green were right to suspect the essentially populist appeal of these painterly "spectacles."

Haydon took the grand injunctions of Reynolds' *Discourses* literally, and aspired to be the English Raphael. But as Gainsborough once remarked, the worst painters choose the grandest subjects, and it would be difficult to find a better proof of this maxim than Haydon: in Marilyn Gaull's words, the "exemplary failure" of British history painting.[63] He was always an unlikely painter given the astigmatic condition he suffered since childhood. His strategies for compensating for this disability, as recorded by his son, would strain credulity were it not for the evidence of Haydon's often confused paintings themselves. According to Frederick Haydon's account, Reynolds' figure of the dilated eye was a literal condition of his father's work:

> His method of painting was his own. His natural sight was of little or no use to him at any distance, and he would wear, one pair over the other, some-

times two or three pairs of large round concave spectacles, so powerful as greatly to diminish objects. . . . How he contrived to paint a head or a limb in proportion is a mystery to me, for it is clear that he had lost his natural sight in boyhood. He is, as he said, the first blind man who ever successfully painted pictures.[64]

We have seen that, for Reynolds, a "dilated eye" represented the exercise of the imaginative faculty in appreciation of the ideal in art. Green's "contracted optics," conversely, implied the deliberate and cynical concentration of the eye on visual detail—on the "real." Haydon's own optical pathology of dilation and contraction, and his uneasy balance of natural sight with artificial projection, is an instructive metaphor for his crossover role between the Royal Academy and the commercial art marketplace. Like Reynolds before him, Haydon painted (as best he could) according to the "dilated" prescriptions of academic art, but with an eye nevertheless "contracted" to popular taste.

It was as would-be leader of a British art renaissance that Haydon embarked on his first major work, *The Death of Dentatus* (1808), a subject appropriately drawn from Hooke's triumphalist history of imperial Rome. "Dentatus" was the first of Haydon's many attempts to invest British painting with the grandeur and authority of the Continental masters. Its exhibition at the British Institution won Haydon minor acclaim, but he took five years over his next painting, accumulating debts from which he would never subsequently escape. Whatever the privileges accorded to history painting by the conservative Royal Academy, Haydon had chosen a precarious living in the real world of the Regency art market. Even before arriving in London from Plymouth, he had been warned away from a career as a history painter: "Why, yee'll starve with a bundle of straw under ye'er head," was the extent of James Northcote's encouragement.[65] Sure enough, Haydon soon discovered that the Academy's attempt to recreate an aristocratic system of patronage for history painting had been a rank failure. Probably only Benjamin West, with a fifteen hundred pound annuity from George III, could be said to have earned a satisfactory living from history painting according to the traditional client model. The church's doctrinal antipathy toward religious art and the downturn in construction of large country estate houses further compounded the budding history painter's problems in this period.[66] Private patrons were few simply because there was precious little space for these huge paintings, which could be years in the making, to be hung (in Goldsmith's *The Vicar of Wakefield,* the

Vicar's "large historical family piece" ends up in the kitchen because it won't fit through any of the doors). The new bourgeois market for original paintings and print reproductions demanded a domestic economy of size, and accordingly preferred anecdotal or decorative themes. With private commissions so rare, the only answer for an ambitious history painter was to rent rooms in the West End and rely on income and publicity from door receipts. Haydon's subsequent adventures as a purveyor of high art in the marketplace of London's popular entertainments constitute the most fascinating phase of his career.

In March 1820, Haydon advertised the commercial premiere of his enormous *Christ's Entry into Jerusalem* (figure 2.2), with its famous heads of Keats, Wordsworth, and Voltaire in the crowd. His unlikely choice of venue was none other than William Bullock's "Egyptian Hall," site of Belzoni's sensational "Egyptian Tomb" the following year. After years of disappointment seeking commissions for his work, launching *Christ's Entry* at Bullock's museum was Haydon's first serious venture as a commercial artist. To improve his takings, he borrowed marketing techniques from the panoramists of nearby Leicester Square, selling programs and a key to aid his patrons in plotting the figural elements of the painting. Desperate for money, but anxious to preserve the academic aura of his enterprise, Haydon was careful not to encourage the "intolerably vulgar" company Lady Blessington would complain of the following summer at "Belzoni's Tomb," but issued his invitations first to the Royal Academy men and the denizens of polite society.[67] In 1820, the luster had not yet worn off Haydon's frequent proclamations of his own genius and, with Géricault's *The Raft of the "Medusa"* setting the tone next door, the exhibition was a triumph. Mrs. Siddons' breathless approbation of the work generated a buzz, as did the sight of Sir Walter Scott waiting on the steps the following morning. Haydon made a dizzy profit from this first speculative venture, but impatient creditors impounded his next offering at Bullock's museum and his luck ran out.

Richard Altick has described how Haydon attracted vitriolic abuse for his relentless self-promotion: "His fellow artists as well as the critics had plenty of other objections to him, but the one they most relied upon throughout their long-running quarrel was that he had degraded Art by the vulgarities of the raree showman."[68] With his Celliniesque charisma, the business of marketing his paintings came naturally to Haydon. His journals provided ready copy for promotional advertising and, while the aura of novelty lasted, the public came to his shows in droves. But indefatigable optimist though he was, Haydon had to admit that his messianic

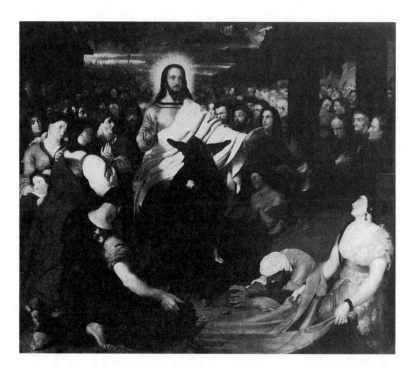

Figure 2.2 Benjamin Robert Haydon, *Christ's Entry into Jerusalem* (1820). Reprinted by courtesy of the Athenaeum of Ohio/Mount St. Mary's Seminary, Cincinnati, Ohio.

ambitions for painting were not necessarily served by his resemblance to a Bartholomew Fair hawker: "Is it not a disgrace to this country that the leading historical painters should be obliged to exhibit their works like wild beasts, and advertise them like quack doctors?"[69] The reference to "quack doctors" suggests that Haydon was only too aware of his negative press in academic circles. In January 1819, his exhibition of copies of the Raphael Cartoons and the Elgin Marbles inspired the circulation of a biting satirical print. "St. James Street in Uproar, or the Quack Artist and his Assailants" depicts a thickly bespectacled Haydon, ledger under his arm, under attack from an academician in the guise of an angry goose. A malformed dwarf, similarly endangered by fowl, barks the show before an unruly crowd of swells. Haydon described the event in his *Diary* in typical fashion—"The impression was deep! The glory of old England lasting! It struck a blow that will sound for ever!"—but the reaction of his critics

suggests that Haydon's famous ebullience was especially misplaced in this instance.[70] The connoisseur William Carey attacked Haydon for his bald presumption in demanding sixpence for a catalogue on top of the shilling's admission (and this for a show consisting of only eight chalk drawings).[71] A writer for the *Examiner,* identifying himself as the "Castigator," vilified Haydon in similar strains:"he has got himself puffed and quacked in all the public prints where his servile adulation could introduce him."[72] In the career of Benjamin Haydon,"quack" artist extraordinaire, the Royal Academy's fears of the degrading effects of commercialization on British painting were spectacularly realized.

Increasingly through the 1820s and 30s, Haydon turned to blaming his failures on his enemies at the Royal Academy, many of whom he had gained through his controversial role as antagonist to Richard Payne Knight in the Elgin Marbles affair of 1815-16. Unfortunately for the dignity of his memory, Haydon's final nemesis in a long and tumultuous public career was none so estimable as Payne Knight or the Royal Academy, but instead the freak-show merchant P. T. Barnum and his inimitable dwarf, Tom Thumb. The last in a long string of career setbacks for Haydon was his failure to win a commission to decorate the new House of Lords in 1843. The new Fine Arts Commission overlooked him in favor of younger artists. Infuriated at the snub, Haydon determined, with typically reckless defiance, to complete the historical series he had proposed and exhibit it at the Egyptian Hall at his own cost. The hordes flocking to his show would both rescue him from his creditors and embarrass the government into employing him at Westminster. The hordes did come, but only to see Tom Thumb perform in the upstairs room. To the luckless Haydon, it seemed that all of London rushed past his door—without a thought for the colossal gravity of his "Nero" and "Aristides," blissfully unconcerned with the moral benefits of the grand style they embodied, and indifferent to the artist who had so devoted himself to their edification:

> They push, they fight, they scream, they faint, they cry help and murder! and oh! and ah! They see my bills, my boards, my caravans, and don't read them. Their eyes are open, but their sense is shut. It is an insanity, a rabies, a madness, a furor, a dream . . . Tom Thumb had 12,000 people last week, B. R. Haydon 133 1/2 (the half a little girl). Exquisite taste of the English people![73]

Four weeks later Haydon was dead. After years of battling creditors, the Academy, the government, his long-suffering patrons and, most unbearable of all, public indifference, Haydon cut his throat after ineffectually directing

a bullet into his brain. From the *Death of Dentatus* to his self-portrait as *Curtius Leaping into the Gulf* (1843), Haydon had frequently projected his own very real suicidal tendencies onto idealized images of Roman self-sacrifice. The unexpectedly large outpouring of public sentiment at his death suggests that, in his final tribute to that heroic example, Haydon the man had at last achieved the recognition he had always sought for his paintings—albeit through an unrepeatable act of self-destruction. Ironically, the project of decorating the new House of Lords in the grand historical style was an abysmal failure, with barely half the panels completed and few of any merit. The entire scheme, into which the Fine Arts Commission had, at Prince Albert's behest, poured improbable amounts of money and effort, was finally abandoned in 1863. Almost a hundred years after Sir Joshua Reynolds introduced the grand style as a nationalist project in the arts, the era of state-sponsored history painting was over. So too all serious endeavors, Haydon's conspicuous among them, to recreate the European Art Renaissance on English soil.

It is the central irony of Haydon's career, and of British history painting in general, that while institutionalized by the Academy as the most highbrow of artistic genres, it found so profitable an audience among the "intolerably vulgar" patrons of establishments such as the Egyptian Hall. Benjamin West and John Singleton Copley, a generation before Haydon, had first begun the drift from the Academy and private patronage to these commercial venues. Both West's *Death of General Wolfe* (1771) and Copley's *Death of the Earl of Chatham* (1781) were hugely successful commercial ventures. Copley's painting attracted twenty thousand patrons in just six weeks to the Great Rooms in Pall Mall.[74] The fact that West's "Death of Wolfe," after earning a small fortune in door receipts, went on to make in excess of fifteen thousand pounds in print sales for John Boydell is an example of how interdependent the various commercial branches of British art had become in the late eighteenth century. Indeed, the prospect of print sales was key to the commercial viability of history painting exhibitions. As Valentine Green explains, West and Copley's paintings were "works of speculation, begun by the artists themselves, without commission, or the least dependence of their ever being disposed of."[75] The worth of the painting itself was nominal; the artist did not expect to sell it. That is, the true cash value of commercial history painting lay not in the painting itself but in exhibition receipts and print sales, not in the material oil and canvas of the painting but its spectacular, reproducible *image*.

As I have mentioned, a prerequisite for the commercial history paintings

of Haydon's type was their enormous size. Richard Altick points out that "immensity was an important attribute of romantic art. Sheer magnitude, combined with the powerful feeling inherent in the subject and amplified by the artist, was intended to overwhelm the spectator."[76] English history painters had certainly become obsessed with the aesthetic effects of size. "What are . . . small pictures to me?" demanded Haydon, "disgusting!" His account of the genesis of *Christ's Entry into Jerusalem* is illustrative of Regency fashion:

> I always filled my painting-room to its full extent; and had I possessed a room 400 feet long, and 200 feet high, and 400 feet wide, I would have ordered a canvas 399-6 long by 199-6 high, and so have been encumbered for want of room, as if it had been my pleasure to be so. My room was 30 feet long, 20 wide, 15 high. So I ordered a canvas 19 long by 15 high, and dashed in my conception, the Christ being nine feet high.[77]

Reviewing *Christ's Entry* for the *London Magazine* (May 1821), Hazlitt satirized Haydon's apparent compulsion for extremities of size and gesture. "Reduce him within narrow limits," Hazlitt wrote, "and you cut off half his resources. His genius is gigantic. He is of the race of Brobdignag, and not of Lilliput. . . . He does not concentrate his powers in a single point, but expands them to the utmost circumference of his subject." Haydon's inspiration for this gigantist impulse may be blamed on his competition: West's *Christ Rejected by Caiaphas* (1814) measured an almost unimaginable 34 by 16 feet, and Copley's *Siege of Gibralter* (exhibited 1791, the same year Robert Barker's enormous "panorama" first opened its doors) had been offered for public perusal in a huge mobile tent in Green Park. For all the gargantuan efforts of West and Copley, however, the title "King of the Vast" went to John Martin, whose apocalyptic themes combined with the daunting scale of his paintings doubly indulged the public's love for the Romantic sublime. His *Belshazzar's Feast* (figure 2.3), which in 1821 competed with "Belzoni's Tomb" for public patronage, had to be roped off from enthusiastic crowds. Subsequent Martin paintings on Biblical themes—*The Fall of Nineveh* (1829) and *The Last Judgement* (1853)—both measuring almost 100 square feet, enjoyed comparable success. The "vastness" of Martin's paintings—actually somewhat smaller than the standard set by West and Copley—refers to more than simply the physical dimensions of his canvasses. Martin's trademark sublimity, like De Loutherbourg's stage sets at Drury Lane, relied on the exaggeratedly disproportionate relation in his paintings between the human figures and their setting, typically depicted on the verge of cataclysm.

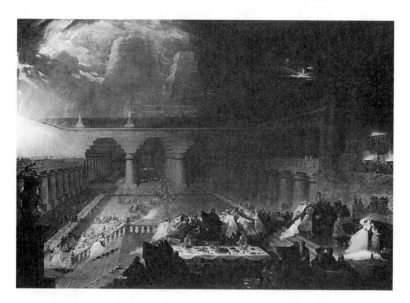

Figure 2.3 John Martin, *Belshazzar's Feast* (1820). Yale Center for British Art, Paul Mellon Collection.

Without ever seriously investigating the causes of this fashion for huge paintings, Altick makes a persuasive case for the meeting of Georgian high art and popular culture in a shared fascination with "pictorial spectacle." Whether attending the annual Royal Academy exhibition, the Egyptian Hall, a West End theater, or the Panorama of Leicester Square, one was likely, argues Altick, to encounter similar visual phenomena: some combination of vast crowds, colossal architectural structures and sweeping topographies, all set against backdrops of unprecedented magnitude—what Charles Lamb disparagingly called "the material sublime."[78] Describing the commercial ventures of the immensity "school," Altick proposes that

> the demarcation between such exhibitions and those of panoramas was hardly perceptible. Was a painting occupying say, three or four hundred square feet of canvas an object of fine art or a small-scale panorama? The charge made to see it was the same at least. The relationship between the panorama and products of the cult of immensity deserves to be looked into.[79]

There was certainly ample precedent in the work of the Renaissance masters for paintings on a large scale, but the reasons for the unheard-of dimensions of British history painting have never been properly examined. Reynolds' *Discourses*—in which Haydon and his fellow Academy students were so thoroughly schooled—never mentions the actual size of canvasses. Reynolds' idea of the heroic dimensions of history painting was clearly rhetorical: the "grandeur" and "greatness" he so often alludes to are figures for dramatic impact and moral scope. Somewhere in the course of the transmission of his teachings, however, or perhaps for reasons entirely unrelated to Reynolds, British artists came to interpret his principle of "grandeur" very literally indeed.

Notwithstanding Reynolds, theorization of painting size has a singularly important critical precedent. In the most notorious opinion on art in the Western canon, Plato's reasons for advocating the expulsion of artists from the Republic rest on the falsifying proportions of painted figures. Painting, states Socrates in the tenth book of *The Republic,* appeals to the base, "ordinary" affections of human nature:

> Haven't measuring, counting, and weighing come to light as most charming helpers in these cases? As a result of them, we are not ruled by a thing's looking bigger or smaller or more or heavier; rather we are ruled by that which has calculated, measured or, if you please, weighed. . . . And further, the part which trusts measure and calculation would be the best part of the soul.
> - Of course.
> - Therefore, the part opposed to it would be one of the ordinary things in us.
> - Necessarily.
> - Well, then, it was this I wanted agreed to when I said that painting and imitation as a whole are far from the truth when they produce their work; and that, moreover, imitation keeps company with the part in us that is far from prudence, and is not comrade and friend for any healthy or true purpose.[80]

Socrates argues that painting, as an art of illusion, degrades our rational faculty by upsetting perception of the relative scale of things. The penalty for this deception was severe: as an impediment to Reason, painting must be outlawed. It was the difficult task of promoters of the visual arts in the eighteenth century to reject the conclusion of Plato's argument while preserving its premises. "When such a man as Plato speaks of painting as only an imitative art, and that our pleasure proceeds from observing and acknowledging the truth of the imitation," Reynolds explained, "I think he misleads us by a partial theory."[81] For Reynolds, artists must reject the imitation of

nature in favor of a genre of artistic expression presumably beyond Plato's conceptual grasp, namely the idealist grand style of the Renaissance. This epic genre was in turn, as a kind of compensation to the father of civic humanism, to embody the very principles of virtue and heroism necessary to the renewal of the British "republic," and so redeem art.

It is my argument here, however, that this Georgian compromise with Platonism over the relation between art and the state was purely academic (in all senses of the word). Reynolds' *Discourses* stipulated that the viewer's visual perception of an artwork was secondary to, or merely facilitated, intuition of its intellectual content. The ideal setting for such critical viewing was the private gallery of a collector, as Hazlitt describes in his "Sketches of the Principal Picture Galleries of England," where we "enter into the minds of Raphael, of Titian" But by the time Hazlitt wrote these words in 1824, visual culture in Regency London had already ventured well beyond the enjoyment of private collections reserved for the privileged few. Hazlitt blamed the ubiquitous vulgarity of prints for the decline of art's aura, while experiments in virtual reality such as the panorama and "Belzoni's Tomb" represented an even more radical departure from the academic model of aesthetic visual experience. Most disturbing for the Academy, however, was the influence of these commercial shows on their own artists. The paintings of Haydon and Martin, in terms of their venues, clientele, and aesthetic effects, had at least as much in common with the pictorial spectacles of Drury Lane and the Egyptian Hall as the Royal Academy exhibitions to which they nominally belonged. These commercial Romantic painters thought "big" for the same reasons movie houses today advertise the size of their screens. For the curious Londoner, just stepped off the street and lighter by a shilling, what about these paintings could have made greater impact than their sheer size? Immensity, in this case, produced in the patron the necessary (and lucrative) effect of "shock."

Commercial history painting in the Romantic period sought not simply the shock effect of pictorial spectacle, however, but a new verisimilitude in the approximation of natural size. At these fine-art-meets-the-West-End exhibitions, Plato's rejection of the distortions of natural measurement in painting returned in the Regency public's demand for life-size verisimilitude. The question of size raised by Boase and Altick thus goes beyond the effects of sublime magnitude. That is, the cult of immensity in British history painting, from Copley to Haydon, involved not an open-ended trajectory toward spectacular vastness per se, where bigger was necessarily better, but toward life-size, or the illusion of natural size. With the approximation

of natural size in Regency history painting came an exaggerated attention to realistic detail. In an essay entitled "The Barrenness of the Imaginative Faculty in the Productions of Modern Art," Lamb criticized Martin's *Belshazzar's Feast* for its presentation of "all that is optically possible to be seen."[82] Just as he rejected the spectacles of the post-De Loutherbourgian stage, Lamb finds fault with Martin's gaudy realism. A treatment of the same subject by Titian or Veronese, Lamb contends, would convey the cataclysmic terror of the moment "in masses and indistinction." By representing "all that was to be seen at any given moment by an indifferent eye," modern artists such as Martin and Haydon had abandoned the true sublimity of history painting, in its transmission of grand themes, for the shock effect of visual realism. For Lamb, the Regency imagination remained "barren," while the commercially driven reproduction of life-sized reality spawned room after room of monster paintings.

To conclude, the colossal early nineteenth-century paintings of Benjamin Haydon transgressed the Augustan, academic definition of art, abandoning the idealist pictorial grammar and production model of aristocratic patronage set by Reynolds' *Discourses* for the world of West End popular entertainment. This movement was characterized by a shift away, aesthetically speaking, from the academic principle of ideal beauty toward the shock of the real, from heroic themes and the pure forms of nature toward spectacle and the techniques of optical illusion. Unfortunately for Haydon, his paintings only partially satisfied the public appetite for spectacle and verisimilitude. Born showman though he was, Haydon soon fell out of step not only with the art establishment but also popular taste. His paintings were spectacular enough in their own way, but Haydon's dogmatic devotion to basic elements of academic practice—classical subject matter, a slow production schedule—put him fatally at odds with the major imperatives of the visual entertainment marketplace. While Haydon spent years conceiving the head of Dentatus, the scene painters and panoramists of the West End were experimenting with visual technologies that would ultimately exaggerate and transform the effects of pictorial spectacle beyond recognition. The fact that Haydon struggled to find buyers for his paintings was the first suggestion that the literal immensity of his painterly ambitions had led him beyond the codes of the new art market, increasingly defined by anecdotal and decorative subjects designed for display in modestly-sized bourgeois dwellings. Blind to this reality, Haydon in vain sought a living under the traditional auspices of private patronage. What popular success Haydon subsequently enjoyed as a public exhibitor of enormous history paintings marks a brief transitional coincidence of the Augustan "high art"

aesthetics he championed with an emergent pre-cinematic visual culture he failed to understand. Like the print industry, which effectively industrialized *mimesis,* the commercial art exhibitions of the late Georgian period represented a challenge to academic idealism from a new, popular regime of taste in visual culture. Haydon intuited this at some level, but faced a crowded market in "pictorial spectacles." From the viewpoint of our own highly sophisticated visual culture, it cannot surprise us that Haydon's bombastic paintings slid rapidly down the list of the average Londoner's recreational priorities. The hordes storming past Haydon's door at the Egyptian Hall in 1846 are the same that, a century and a half later, bypass theaters and art galleries for the latest Hollywood blockbuster. But, as I have already intimated, Tom Thumb was hardly Haydon's most serious competitor. By the time he launched his career in the first decade of the nineteenth century, the influence of academic art on English visual culture was already overshadowed by a more populist painterly medium, a veritable "spectacle within doors" that offered a life-like texture of detail and the illusion of three-dimensional space. My next chapter examines how the public taste for spectacular realism, which first inspired the cult of immensity in British history painting in the generation after 1770, assumed its proto-cinematic, mass-market form at the Panorama of Leicester Square.

Chapter 3 ⌀

THE PANORAMA

The Anti-Sublime:
Wordsworth and the Virtual Landscapes of Leicester Square

In the late 1780s, printselling magnate John Boydell launched his Shakespeare Gallery project as a commercially viable forum for British history painting. By employing native painters such as Reynolds, Opie, and Northcote to illustrate scenes from the plays of the national bard, Boydell hoped to engineer a renaissance in British art. He commissioned a suitably august, neo-classical home for the proposed collection of nationalist painting: a "mock-public building" complete with Grecian columns and decorative statuary.[1] The true engine-room of Boydell's operation, the printshop, was discretely sequestered next door. The iconography of the Shakespeare Gallery's façade was a far cry from the gaudy monoliths of the Egyptian Hall that Leigh Hunt would later find so "uncouth." Unlike Bullock's downmarket museum, the marble entablature of the Gallery advertised a commitment to highbrow neo-classical academic principles: it depicted Shakespeare himself, reclining languidly on a rock (in Georgian breeches), receiving the attentions of the Muses of poetry and painting. These attendant figures marked the Gallery's consecration of poetry and painting as "sister arts."

Kinship between the visual and verbal arts in the eighteenth century was genre specific. Academic theory stipulated that history painting only—not landscape, still life, or portraiture—commanded the intellectual scope and moral depth of poetry. As James Barry, history painter and future president of the Royal Academy, wrote in 1783, "The principal merit of [history] painting, as well as of poetry, is its address to the mind; here it is those

arts are sisters, the fable or subject, both of the one and the other, being but a vehicle in which are conveyed those sentiments by which the mind is elevated, the understanding improved, and the heart softened."[2] As we saw in chapter 2, the Georgian cultural elite considered history painting the pictorial equivalent to epic poetry and, through its institutionalization at the Royal Academy, encouraged its status as the national genre. But for all the Academy's efforts, the public market for history painting evaporated during the 1790s. The closure of the Shakespeare Gallery in 1805 with Croesus himself, John Boydell, on the verge of bankruptcy, came as a further devastating blow to the art establishment. The union of poetry and painting was a keynote of the Academy curriculum, but the general public effectively voted history painting out of the market. Even with the combined imprimatur of Shakespeare and Boydell, the grand style demonstrated little commercial appeal.

Boydell blamed the Gallery's failure on the collapse of the continental print market during the revolutionary upheavals of the 1790s. But the fact that Robert Barker's sensational new 360° painting medium, the "panorama" (figure 3.1), opened in Leicester Square the same year as the Shakespeare Gallery is a historical coincidence that suggests an alternative to Boydell's explanation. Where the demand for academic paintings and prints stagnated during the Napoleonic wars, the market for middlebrow visual entertainment boomed. The Shakespeare Gallery languished with patchy attendance and few subscriptions, but the panorama thrived on the war: dramatic recreations of major battles on the Continent were a staple feature of Barker's shows. The panorama's "all-embracing view" transformed the epic themes of academic history painting into epic size, offering a combination of spectacle and verisimilitude Boydell's artists in Pall Mall could not hope to match. A further problem for Boydell was the glacial speed of the Shakespeare Gallery's commercial production. Painters were slow to fulfill their commissions, and the engravers even slower. When the Gallery doors finally opened in 1791, the subsidiary print merchandising through which Boydell hoped to make his profits was already hopelessly backed up. In short, by the time of his Shakespeare Gallery project, Boydell had lost touch with the machinations of the popular market. His vision of the Shakespeare Gallery as a commercial forum for academic painting was outmoded in both its themes and technologies. Barker's panorama, by contrast, represented the new generation in popular visual culture: a very modern marriage of entrepreneurship, visual technology, and the craze for picturesque landscape. His anonymous team of painters eschewed academic composition and finish in favor of topicality and a high turnover of pic-

tures. If a painting failed to excite attention and receipts, it was swiftly replaced. As a medium of current events, the panorama anticipated the early twentieth-century newsreel. In commercial terms, it operated more like the contemporary movie industry than the traditional art market of Boydell's generation. The respective fates of the middlebrow panorama and its high art contemporary, the Shakespeare Gallery, reveal much about popular taste in visual entertainment around 1800. The popularity of the panorama at the expense of Boydell's Gallery marked a further blow to the dominance of academic taste in favor of what I have called, in chapters 1 and 2, "spectacular realism": that is, the novelty of specially engineered visual spectacles and simulacra.

The thrill of the panorama's all-embracing view was, from the first, an international phenomenon. Barker filed a patent for his invention in 1787, and the technology crossed the Atlantic as early as 1794, when a "Panorama of London and Westminster" opened in New York City. Panoramas were likewise a sensation in Napoleon's Paris, and in the northern cities of Amsterdam and The Hague were still making money into the twentieth century. Despite the importance of panoramas as a landmark in the technology of pictorial representation, and enduring popularity in the entertainment districts of the great European cities, they have until recently received little attention from art historians. No examples of British or French panoramas survived their heyday of 1790-1840, thus obscuring them from traditional art-historical view.[3] It has been left to cultural historians such as Richard Altick and Stephan Oettermann to call attention to the panorama's definitive importance in early nineteenth-century visual culture.[4]

Most panoramas were, at least nominally, cityscapes: these included Constantinople, Naples, Milan, Rio de Janeiro, Sydney, Rome, Florence, Genoa, and Edinburgh (the Panorama of London of 1791 is a special case I will treat separately). But these metropolitan titles were, in a sense, misleading. At the panorama, as Walter Benjamin later observed, "the city dilates to become landscape."[5] The distant, elevated vantage of the panoramic view ensured that the landscape environs—the hills surrounding Rome, the bay at Genoa, etc.—dominated the urban areas of the scene. As a hybrid urban-pastorale, the panoramic formula invoked the Italian landscape tradition. In a Poussin painting, for example, one customarily finds the middle ground of the canvas filled out with an architectural feature: from a bridge or Doric temple to an entire city. Another important precursor to the panorama was the picturesque tour book, as popularized by William Gilpin. With precise mimetic fidelity to the actual scene, program

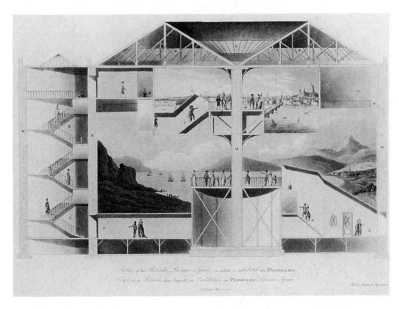

Figure 3.1 Cross section of Robert Barker's two-level Panorama in Leicester Square. Robert Mitchell, *Plans and View in Perspective of Buildings Erected in England and Scotland* (1798). Yale Center for British Art, Paul Mellon Collection.

notes to provide background information on its history and landmarks, and a key to points of interest, the panorama supplied the would-be picturesque traveler with all the additions of a Grand Tour.[6] Above all else, the "reality effect" was paramount. For Benjamin, the panorama was a windowless room from which one saw "the true."[7] As Barker himself outlined in his 1787 patent: "By the invention . . . is intended, by drawing and painting and a proper disposition of the whole, to perfect an entire view of any country or situation as it appears to an observer turning quite round."[8] To one such observer, William Wordsworth, the panorama satisfied the would-be picturesque tourist by its conscientious reproduction of "All that the traveller sees when he is there" (*The Prelude* VII.280).

Barker deliberately integrated a "shock" effect into the panorama experience. The spectator entered from the street, navigating a narrow and ill-lit hallway leading under a large dome, before ascending a flight of circular stairs (or in the 1830s at Regent's Colosseum, in London's first hydraulic lift). These preliminaries served to disorient the spectator, who arrived at last on a central viewing platform. Set at a distance of thirty feet, and with

the limits of the canvas obscured, the panorama deprived the viewer of all scale by which to determine the painting's actual size. According to contemporary accounts, the thrill of the effect lay not only in the picture's uncanny verisimilitude but its dizzy sense of elevation. Charles Leslie described an "unpleasant," vertiginous sensation, and Queen Charlotte declared herself seasick at a showing of Barker's "The Grand Fleet Anchored at Spithead" in 1791.[9] Such were the physical symptoms of the panorama's "shock" effect.

Despite the guaranteed popular appeal of a realistic medium given to generically picturesque vistas, Barker initially harbored aspirations for the panorama that went beyond its money-making potential. He conceived it as an epochal breakthrough in the technology of artistic representation worthy of the Royal Academy's attention. His first appeal for subscription was to none other than Sir Joshua Reynolds himself who, somewhat surprisingly, agreed that the new invention was "capable of producing effects and representing nature in a manner far superior to the limited scale of pictures in general."[10] What soon became clear, however, was that the future of the panoramas lay not with the patronage of the academic establishment but the middle-class who, wary of the increasing disreputability of London's theaters, flocked to Barker's educational, family-friendly show. Most importantly, at the panorama the Georgian elite's love affair with the visual poetry of landscape reached the urban middle-class. The emerging bourgeoisie had been largely excluded from picturesque sightseeing and the Grand Tour, but found their craving for exotic sights and breath-taking scenery cheaply and conveniently satisfied at the panorama. As Quatremère de Quincy said of Pierre Prévost's Panorama of Athens, shown in Paris in 1821, "the precious remains of antiquity of the city were rendered with a verisimilitude that seemed to dispense with the need to actually see the originals."[11] As unlikely as it might seem to us in the age of international air travel, the experience of the panorama as an actual substitute for tourism was a selling point aggressively highlighted by its promoters. Barker's invention represented a radical democratization of landscape art not only by virtue of its subject matter, however, but its very form. Unlike a conventional gallery painting, which presupposed a single optimum viewing-point, the circular panorama offered no privileged vantage and invited a collective circulation by the spectators. In this way, as Stephan Oettermann has suggested, the panorama anticipated the inclusive visual structures of twentieth-century mass media: "the pictorial expression or 'symbolic form' of a specifically modern, bourgeois view of nature and the world . . . [the panorama] represents the first true visual 'mass medium.'"[12]

While an academic painting by Reynolds or Haydon implied an exclusive observer, the panorama literally embraced the masses.

The panorama may have been a thrilling novelty in landscape art to the average Londoner, but what did it represent to the cultural elite of Regency England, to the artists and connoisseurs trained in appreciation of the Claudean pastorale and its amateurist offspring, the English picturesque? The consensus in the art establishment was that panoramas were somehow vulgar. The art patron, Sir George Beaumont, lamented that "the effect of panorama painting has been injurious to the taste, both of the artists and the public, in landscape."[13] Constable was similarly disappointed with Richard Reinagle's Panorama of Rome, which he visited in the Strand in the spring of 1803. The terms of his criticism invoked the academic precepts set forward a generation before in Reynolds' *Discourses:* "great principles are neither expected nor looked for in this mode of describing nature. [The panorama painter] views Nature minutely and cunningly, but with no greatness or breadth. The defects of the picture at present are a profusion of high lights, and too great a number of abrupt patches of shadow. But it is not to be considered as a whole . . ."[14] Constable does not finish the thought, or even the sentence. The judgment implied by the ellipsis is that the panorama, in its "minute" and "cunning" view of nature, marks a regression to a purely mechanical style of painting governed by principles of *mimesis*. We saw in chapter 2 that Reynolds' idealist academic program directed the aspiring painter not to "amuse mankind with the minute neatness of his imitations . . . [but] improve them by the grandeur of his ideas."[15] Likewise for Coleridge, echoing Reynolds, the duty of the painter was to represent "the figured language of thought . . . distinguished from nature by the unity of all the parts in one thought or idea." By contrast, "simulations of nature," Coleridge averred, were "disgusting" and "loathsome."[16] Given these conventionally idealist precepts, distaste for the panorama among the elite was automatic. Aside from its "loathsome" verisimilitude, the 360° picture denied Constable the advantage of a privileged station at which he might feel himself, most fundamentally, to be actually *in front of* the painting. Denied also therefore was the opportunity, through the intuition of the painting's ideal form, to *interiorize* the image as a "figuration of thought" rather than a mere view or "sight." At the Rome panorama, Constable perceived no animating harmony by which the painting might produce an effect of "greatness," or by its literal size convey a figurative "breadth." According to these terms, there was a failure of meaning as well as taste at the panorama.

A landscape artist's opinion of the panorama is revealing, albeit predictable. But what about a Romantic landscape poet? What happens when the Wordsworthian imagination, for example, encounters the scene of its "unfather'd" creation—natural landscape—in the form of a commodified simulacrum? It is tempting to believe that Wordsworth, while in London in the autumn of 1802, saw the same panorama of Rome Constable visited the following spring. This would account for the Miltonic echoes in Book Seven of *The Prelude*. To a literary mind such as Wordsworth's, parallels between the panoramic spectacles of the West End and the machinery of demonic temptation in Book 4 of *Paradise Regained* would be inevitable and determining. We know that Milton was much on Wordsworth's mind at that time. The contemporaneous sonnet, "London 1802," begins "Milton! Thou shouldst be living at this hour," employing Milton as the symbol of an English cultural legacy at risk in the maelstrom of modern London. In short, if Wordsworth—preoccupied with Milton—did visit Reinagle's Panorama of Rome in September 1802, the spectacle could not have failed to recall the lines from Milton's poem where Satan engineers a vision of Rome from a lofty cliff-top:

> an Imperial City stood,
> With Towers and Temples proudly elevate
> On seven small Hills, with Palaces adorn'd,
> Porches and Theatres, Baths, Aqueducts,
> Statues and Trophees, and Triumphal Arcs,
> Gardens and Groves presented to his eyes,
> Above the highth of Mountains interpos'd.
> By what strange Parallax or Optic skill
> Of vision multiplyed through air, or glass
> Of telescope, were curious to enquire:
> And now the Tempter thus his silence broke. . . . (IV.33-43)

The sumptuous list of Roman landmarks available to Christ's gaze in this passage underscores the essentially sensual nature of the temptation. Just such a listing technique was adopted in promotional brochures for the panoramas, which proudly itemized the visual details of the painting on display. Furthermore, Milton's reference to the technological wizardry at work in the Satanic vision—the "strange Parallax or Optic skill . . . or glass of telescope"—is likewise uncannily prescient of the panorama's self-conscious technological modernity. Milton's "Rome," like Reinagle's, invites the awe of the beholder not only at the content of image itself, but

at the sheer wonder of its production. That is, the panorama patron, like the poet of *Paradise Regained,* is naturally "curious to enquire" of the engineering behind the spectacle. In the text of Luke on which Milton's passage is based, Satan, we are told, "showed [Jesus] in an instant all the kingdoms of the world" (IV.5). Similarly, the shock effect of the panoramas lay not with the scope and variety of their marvelous scenes—which could, conceivably, be experienced by a conscientious traveler over time—but with their instantaneous viewability. The panorama's much-promoted power to display the sights of the world "at a glance," in Barker's words, was the unequivocal sign of its artifice. In short, if the panorama in Book Seven of *The Prelude* is indeed Rome, Wordsworth's reaction to Reinagle's picture has already been scripted by Milton (after Luke). Assuming the role of Milton's Christ, Wordsworth perceives the panoramic spectacle as both a devilish ruse and a temptation to be resisted.

Rome or not, Wordsworth's description of a panorama in Book Seven of *The Prelude* resembles Constable's in its emphasis on the picture's unsettlingly literal representation of nature, and his strong reaction against this mimetic effect. For the young poet, the panorama was the most memorable of London's "spectacles / Within doors," with their

> mimic sights that ape
> The absolute presence of reality,
> Expressing as in mirror sea and land,
> And what earth is, and what she hath to shew—
> I do not here allude to subtlest craft,
> By means refined attaining purest ends.
> But imitations fondly made in plain
> Confession of man's weakness and his loves. (248-55)

Following Constable, the terms of Wordsworth's reaction to the panorama rely on the orthodox academic principles embodied in Reynolds' *Discourses.* For Wordsworth, the "subtlest" craft of art is learned at the Royal Academy, where aspiring painters pursue the "purest ends" of ideal form in study of the Old Masters. Wordsworth elevates this idealist doctrine above the "mimic sights" of the West End where sub-artistic visual entertainments "ape the absolute presence of reality." At the panorama, the "subtlety" and "purity" of academic art is replaced by the vulgar thrill of "imitation" (here synonymous with Coleridge's "copy"). The concluding lines of the passage adhere equally to academic rhetoric. The panorama's excitement of man's "loves" recalls the elemental pleasure Burke, following

Aristotle, had discovered in those arts devoted purely to mimetic imitation of nature, which for Wordsworth, following Plato, constitutes rather a "weakness" in our aesthetic faculty:[17]

> the painter—fashioning a work
> To Nature's circumambient scenery,
> And with his greedy pencil taking in
> A horizon on all sides—with power
> Like that of angels or commissioned spirits,
> Plant us upon some lofty pinnacle
> Or in a ship on waters, with a world
> Of life and lifelike mockery to east,
> To west, beneath, behind us, and before (256-65)

Contrary to what some critics have suggested therefore, Wordsworth clearly does not like what he sees at the panorama.[18] He does not intend "ape" and "fondly" (read "stupidly") as complimentary descriptions of the panoramist's art, whose "greedy pencil" produces a "lifelike mockery" of nature.

Wordsworth's negative response to the panorama is not, like Constable's, derived only from orthodox pictorial considerations, but also his poetical investment in the panorama's particular point of view—the elevated view or "prospect." In first undertaking his poetic autobiography in *The Prelude,* Wordsworth had drawn upon recollections of his "elevated" experiences of nature as a child:

> among the hills I sat
> Alone, upon some jutting eminence
> At the first hour of morning . . .
> Oft in those moments such a holy calm
> Did overspread my soul, that I forgot
> That I had bodily eyes, and what I saw
> Appear'd like something in myself, a dream,
> A prospect in my mind. (II.361-712)

It was from such an elevated station, William Gilpin advised his readers, that the imagination might "dilate itself in vast ideas of space."[19] After 1798, Wordsworth's poetry transformed the clichés of Gilpin's tour guides into a Romantic metaphysics of being. For example, the mountain peak or hilltop is the natural locus for the idealizing progress of these lines from the

1805 *Prelude*. The poet rehearses the figurative journey of intellectual and spiritual ascent in the act of climbing "among the hills," from where the particulars of topography give way to the generalities of air. What was picturesque is now sublime: the visual field no longer describes an inventory of objects in determined spatial relation to each other—a tree, ruins, a lake—but is unbounded and becomes a pure function of space and distance. What Wordsworth literally saw with "bodily eyes" from the "jutting eminence" is "forgotten," and the view, now dissolved, becomes a sublime image of his own inchoate self-awareness, a "prospect in my mind."

Similarly, in a celebrated passage from Book Thirteen, Wordsworth relives his ascent of Mt. Snowdon during a walking tour of Wales in 1792. At the summit, the "universal spectacle" of misty mountain peaks appears to him "The Perfect image of a mighty mind," as much through what he cannot see as what he can. In "a blue chasm, a fracture of the vapour," Wordsworth perceives a sublime reflection of his own nascent imaginative power:

> In that breach
> Through which the homeless voice of waters rose,
> That dark deep thoroughfare, had Nature lodged
> The soul, the imagination of the whole. (62-65)

Later, at the very end of *The Prelude*, the prospect view becomes a metaphor of self-understanding through autobiography. Wordsworth's past self becomes a panoramic vista over which the living narrator hovers:

> Anon I rose
> As if on wings, and saw beneath me stretched
> Vast prospect of the world which I had been
> And was; and hence this song. (XIII.377-80)

Here at *The Prelude*'s conclusion, *spatial* distance compounds the effect of temporal differentiation between the poet and his past, a rhetorical device consistent with the prospect poem tradition in which the figure of space is at least as important as the actual landscape in view. The inaugural poem of the "prospect" genre, Sir John Denham's *Cooper's Hill* (1642), utilized a prospect view of London to choreograph an imaginary pageant of British history. A century and a half later, Wordsworth's reiterated prospect views in *The Prelude*—from the Lake District in Book Two to the Alps in Book

Six to Mt. Snowdon in Book Thirteen—clear a figurative stage for him to re-enact his own personal history.

Given the importance of the prospect view throughout *The Prelude,* Wordsworth's outrage at its commodification by the panorama comes as no surprise to the reader of Book Seven. Wordsworth confronts in Barker's pictorial spectacle a landscape idiom that threatens the intensely personal, agonistic relation with the natural world he memorializes in his poetry. The exhilarating sense Wordsworth enjoyed "among the hills" in Book Two—a visual experience solemnly re-dedicated as the figurative space of his imagination—is in stark contrast to the simple accumulation of visual detail at the panorama. In Book Thirteen, Mt. Snowdon's misty chasms and abyssal depths give rise to "circumstance most awful and sublime." The panorama, by contrast, offers merely a "lifelike mockery" of *visible* nature. The principle concern for Wordsworth, then, is not that panoramic technology usurps his privileged poetic elevation and hence his expressive power, but that it re-defines the experience of the prospect view altogether. At the panorama, the landscape view is wholly externalized. There is no escape from the "profanity" of form and image to a more "elevated mood" inspired by actual nature. For Wordsworth, the paradox of the panorama's reality effect is that the virtual landscape affords precisely the opposite of the comforts of actual nature. What is restorative or revelatory on Mt. Snowdon is an oppressive burden on the spirit in Leicester Square or the Strand.

For Wordsworth, the panorama belonged to London's "unmanageable sights," one of the "gross and violent stimulants" he associated in his 1800 *Preface* with "the increasing accumulation of men in cities." In providing, among other things, a medium for the "rapid communication of intelligence," the panorama, like the growing rash of London newspapers, gratified the city-dweller's distracted "craving for extraordinary incident." An agent of the city's "blank confusion," the panorama was (as photography would later prove for Baudelaire) an enemy to "imaginative power."[20] At a panorama of Rome, or the Swiss Alps, there was no determinable scale or natural station from which the pictorial view might be composed; and yet neither was the eye relieved, by virtue of that unboundedness, from the burden of topographical detail. We recall that on the summit of Mt. Snowdon, Wordsworth experienced "The sense of God . . . most awful and sublime" at a double remove from the actual view. First, the revelation occurred in a recollective meditation; second, Wordsworth describes the essential power of the experience through a rhetoric of absence. The

"chasm," "fracture," and "breach" of the misty cloud supplied the "Perfect image of the mighty mind." At the panorama of Book Seven, however, no such negative space is available to Wordsworth. Unlike the Mt. Snowdon epiphany, or the "prospect in my mind" he intuited from his "jutting eminence" in Book Two, no part of the panorama can be "forgotten" or sublimated into the ideal. Its visual field resists interiorization and remains immediately and relentlessly visible. Through a virtual representation of natural landscape in which the spectator never loses the conscious wonder of that virtuality, the panorama reproduces the topography of the sublime but not the experience. It is the anti-sublime.

As I suggested earlier, Barker's original shorthand name for his invention, View-at-a-Glance (used before the catchier, pseudo-Greek coinage "panorama"), reveals much about the aesthetic experience of the panorama. A landscape designed to be "viewed-at-a-glance," no matter how elevated the station, cannot fulfill the role of a Wordsworthian prospect view. First of all, the term "at-a-glance," with its echoes of Satan's conjured vision in the desert in *Luke* and *Paradise Regained,* suggests instantaneity. The effects of Barker's panorama were immediate and comprehensive. By contrast, the Romantic poet of nature seeks, in Karl Kroeber's memorable phrase, to "make place embody time." In "Tintern Abbey," for example, Wordsworth distinguishes between the "dizzy raptures" of his youth inspired by a purely visual "appetite" for cataracts and mountains, and his more mature connection, "unborrowed from the eye," to "something far more deeply interfused" in nature. This distinction is possible through the intrusion of temporal difference into Wordsworth's experience of the Wye Valley: the poet is now "changed, no doubt, from what I was when first / I came among these hills." For Wordsworth above Tintern Abbey, there is no immediate gratification of the kind Barker promises at the panorama. The essence of the poem lies rather in "the temporal movement of the ratiocinative and ruminative syntax."[21] Wordsworth's relation to the Wye River landscape is not what he sees, but his act of return, which invests significance in the visible scene from its specific association to his personal history. Through projection of his memories, hopes, beliefs, and desires, Wordsworth effectively humanizes the landscape, making "history out of nature."[22] The panorama, by contrast, is topical without being "historical" in the Wordsworthian sense. It resists humanization in the permanent immediacy of its picture. Wordsworth's anxiety throughout the London Book of *The Prelude* is rooted in the city's restriction of the generous spatial field available in the Lake District or the Alps, whose open horizons he had found so congenial to unhurried wandering and meditation in Book

Six and elsewhere. The object of the panorama, in one sense, was to bring just such an exhilarating experience of visual and ambulatory freedom characteristic of the countryside *into* the crowded metropolis. "Such was the paradoxical status of the panorama," Bernard Comment has observed: "an enclosed area open to a representation free of all worldly restrictions."[23] But in its essence, Barker's invention embodied the contraction of spatio-temporal possibility in the city by offering only a single frozen moment in time, and literally enclosing the viewer in a non-negotiable space within which one might wander at will, but through or beyond which one could not pass into a new space. In David Simpson's words, the panoramic "subject is cast as the consumer of an already prefigured way of seeing."[24] The effects of that prefiguration are still felt today. Stephan Oettermann has pointed out that the word "panorama" is now most commonly taken to describe a broad and elevated landscape view rather than a form of painting.[25] That is, in the after-life of Barker's invention, a catachresis—a violent inversion of signs and meanings—has occurred. Barker's stylized figuration of the panoramic vista for the purpose of commercial exhibition has become the natural sign of the landscape itself. In this respect at least, Wordsworth's anxieties in Book Seven were well founded. The panorama indeed succeeded in usurping Wordsworth's poetics of the natural sublime, employing a uniquely modern intersection of landscape art, commercialism, and visual technology to redefine popular understanding of landscape itself.

To summarize: Though its mode was mimetic, the primary effect of the panorama was de-naturalization. However absorbed in the thrill of the all-embracing view, the viewer remained aware of the spectacular, delusional nature of the panoramic image. Like Satan's Rome in *Paradise Regained,* its essential character was not as an illusion, but a technological wonder. As such, Wordsworth's critical description of the panorama in Book Seven of *The Prelude* constitutes a definitive episode of Romantic anxiety in the new visual culture of late Georgian London. For Wordsworth, the quintessential Romantic poet of Nature, the panorama symbolized the redirection of public taste away from the idealized evocation of natural landscape in poetry to its visual reproduction as a spectacular form of entertainment. At the panorama, Wordsworth finds his poetic prospects erased under the painter's "greedy pencil," his sublime sense of natural beauty reduced to a commercially driven, imaginatively impoverished shock of the "real."

But what did Wordsworth actually see? Philip Shaw departs from the usual presumption that the Book Seven panorama refers to an indetermi-

nate picturesque scene, or to the Rome panorama of 1802–3 as I have sug-
gested.[26] He proposes rather that the "mimic sights" passage recalls Barker's
"London from the Roof of Albion Mills," on display when Wordsworth
was in London in the autumn of 1791. An avid reader of newspapers,
Wordsworth would have seen advertisements for the show in the *Times:*

PANORAMA

The public are most respectfully informed that the subject of the
PANORAMA painted by R. Barker, Patentee for the invention, is a view-
at-a-glance of the CITIES OF LONDON and WESTMINSTER, compre-
hending the three bridges, represented in one Painting, containing 1479
square feet, which appears as large and in every respect the same as reality.
The observers of this Picture being by painting only deceived as to suppose
themselves on the Albion Mills from which the view was taken.[27]

Jonathan Wordsworth has introduced the alternative possibility that
Book Seven describes Wordsworth's visit to Thomas Girtin's 270° picture
of London in 1802, rather than Barker's full panorama in 1791. Charles and
Mary Lamb showed Wordsworth the sights of London in September 1802,
when Girtin's painting (as well as Reinagle's "Rome") was on show. Either
way, a panoramic idea of London may be said to inform the structure of
the book as a whole, in which "we are treated to a panorama of London
life, a word-painting. . . . "[28] The poet describes London variously as a
"picture," and a congregation of "unmanageable sights" that "weary" the
eye. In placing him before a reproduction of "London" within the greater
spectacle of London proper—a definitively modern, uncanny experience
of the double image—Wordsworth's panorama passage represents a
moment of maximum optical fatigue in Book Seven. At his first view of
London from the Cambridge coach (oddly placed at the end of Book
Eight, which he wrote before Book Seven), Wordsworth marveled "That
aught *external* to the living mind / Should have such mighty sway" (701–2).
A panorama of London could only magnify this effect. As Benjamin
remarks, "the interest of the panorama is in seeing the true city—the city
indoors."[29] At Barker's London panorama, Wordsworth's "interest" turns to
shock at the pure externality of the City-as-facsimile, where the outside
becomes inside, and the visible metropolis converts to a "spectacle / Within
doors."

One effect of situating Wordsworth's possible visit to a panorama of
London as a defining moment of Book Seven is that Barker's spectacular

facsimile becomes confounded with the poet's own panoramic descriptions of the city. The "prospect" of London Wordsworth putatively imagines at the book's opening incorporates elements of what he would have seen at Barker's panorama:

> Nor must we forget
> Those other wonders, different in kind
> though scarcely less illustrious in degree,
> The river proudly bridged, the giddy top
> And Whispering Gallery of St. Paul's, the tombs
> Of Westminster, the Giants of Guildhall,
> Bedlam and the two figures at its gates,
> Streets without end and churches numberless,
> Statues with flowery gardens in vast squares,
> The Monument, and Armoury of the Tower. (126-35)

Reading these lines with Barker's painting in mind, Wordsworth's "prospect" view of London does not represent a flight of the descriptive imagination, or an echo of *Paradise Regained*, as much as a literal transcription of details physically observed at the panorama in Leicester Square.

To pursue the suggestive possibilities raised by a London panorama, there are, I suggest, three "panoramic" views in Book Seven, not one. Together these constitute Wordsworth's sub-textual argument with the panorama's usurpation of the Romantic prospect. The first, just quoted, inventories the visual "wonders" of a London prospect: St. Paul's, Westminster, and the Tower. This description in turn alludes to Wordsworth's visit to Barker's panorama later in Book Seven where

> the painter—fashioning a work
> To Nature's circumambient scenery,
> And with his greedy pencil taking in
> A horizon on all sides—with power
> Like that of angels or commissioned spirits,
> Plant us upon some lofty pinnacle (356-61)

The third panorama is figurative: the celebrated Miltonic set-piece with which the book concludes. Here, Wordsworth again imagines himself elevated to a "lofty pinnacle," the better to assert a moral superiority over the

pandemonium of Bartholomew Fair (which he visited with the Lambs in 1802). He overlooks the scene from

> Above the press and danger of the crowd—
> Upon some showman's platform. What a hell
> For eyes and ears, what anarchy and din
> Barbarian and infernal—'tis a dream
> Monstrous in colour, motion, shape, sight, sound. (658-62)

In *The Prelude* Book Eleven, the prospect view for the young Wordsworth is an "empire for the sight" (l.192), a symbolic form of dominion, but here in Book Seven the privilege of that elevated station is a dubious one. Instead of a figurative space for the enactment of personal history, this urban panorama represents a visual "hell."

The overlapping sequence of prospect views of London in Book Seven raises the possibility that Wordsworth's memory of his stay has blurred the city itself with its reproduction as a "mimic sight" at the panorama. Thus, when at the conclusion of Book Seven the poet complains of

> Living amid the same perpetual flow
> Of trivial objects, melted and reduced
> To one identity by differences
> That have no law, no meaning, and no end (702-5),

his description may be applied equally to the *aesthetic* problem of the London panorama as well as a more general epistemological problem of life in the city itself. Both London and its panoramic simulation are full of "trivial objects" without "meaning." As I outlined in my introduction, Roland Barthes has characterized modern realist fiction in terms of this problematic relation between literal detail and thematic content. For Barthes, the deliberate accumulation of "useless details" in a story by Flaubert poses the central question of modern art: "is everything in the narrative [or painting] meaningful, significant? And if not, if there exist insignificant stretches, what is, so to speak, the ultimate significance of this insignificance?"[30] This is precisely the question Wordsworth asks of big city modernity in Book Seven of *The Prelude*. What, if anything, is the significance of London's "motley imagery," of those "trivial objects, melted and reduced / To one identity by differences / that have no law, no meaning"? The specter of modernity in Book Seven looms larger if we acknowledge that these lines might apply equally to Wordsworth's rejection of the London panorama on

aesthetic grounds, as to the wearying picture of London itself. The sheer "triviality" of London is compounded a hundredfold inside Barker's rotunda, where one can take in all the gratuitous details of the city "at a glance." Throughout Book Seven, the visual reality of London challenges the "wonder and obscure delight" (l.91) with which Wordsworth imagined the great city as a boy; but his most abject disappointment must surely come at the panorama, where London is reduced to a visual parody of itself.

Wordsworth subsequently escapes from London at the conclusion of Book Seven with a sense of "composure and ennobling harmony" intact.[31] He draws from the "blank confusion" of the "mighty city" the familiar moral of his own visionary election: as one "who sees the parts / As parts, but with a feeling of the whole." But we have arrived at an alternative to Wordsworth's self-fulfilling prophecies. Wordsworth's three iterations of the panoramic view of London in Book Seven—first as imagined, then as a commercialized facsimile, then as Hell—prompt a different set of questions concerning the poet's destiny. How can Wordsworth's panoramic visions as a Romantic landscape poet remain viable once that privileged station has become a trade name in the visual entertainment market? What consequences does the commodification of the "prospect" view at Barker's panorama have for the lyric poet as a trader in purely verbal prospects? We have seen that Wordsworth's response to the London panorama in Book Seven asserts the Romantic ideal of landscape poetics—Coleridge's "figured language of thought"—against the "lifelike mockery" of Barker's invention. If art is the humanization of nature, as Coleridge claimed and Wordsworth's poetry everywhere implies, then the panorama is its antithesis: the dehumanization of nature as a form of commodified spectacle. The elements of natural landscape in Wordsworth's poetry become emblems of a personal, internal "prospect of the soul"; by contrast, the panorama, as a wholly exteriorized landscape image reproduced in a public space, permits only what Benjamin has called a "distracted" form of visual comprehension.

Beyond Romantic ideology, however, Wordsworth's poetry of landscape and Barker's landscape panoramas do not necessarily appear so divergent. Putting the conventional opposition of idealism and *mimesis* aside, Wordsworth's poetry and Barker's paintings may be viewed as two highly artificial, de-naturalized landscape media competing for shares in public patronage. In this sense, the panorama's most serious threat for Wordsworth was to what Burke and Lessing had ordained as the superior referential power of the printed word, the poetic medium itself. If one was able, as Wordsworth did, to step off Cranbourne Street and see a comprehensive

view of "London" itself, or Rome, or the Swiss Alps, commercial visual technology had staked a claim to poetry's status, accorded by Lessing, as the natural vehicle of the imagination: "The wider sphere of poetry [commands] the infinite range of our imagination, and the intangibility of its images. These may stand side by side in the greatest number and variety without concealment or detriment to any, [unlike] the objects themselves or their natural symbols would in the narrow limits of time and space."[32] Traditional academic painting was restricted, in Lessing's terms, to representation of a single "pregnant moment" (*fruchtbare Augenblick*). But this was not so with the panorama, which, in abandoning narrative content in favor of documentary reproduction of an all-embracing world, transformed the scopic possibilities of the painting medium and consequently changed the terms of the sister arts debate entirely.

As W. J. T. Mitchell has noted, Lessing's *Laocoön* (1766) sides with English aesthetic theory, particularly Burke, in championing poetry's essential sublimity against the literary-pictorialist tendencies of eighteenth-century French criticism.[33] According to the Anglo-German view of Burke and Lessing, the phrase "sister arts" is a misnomer: poetry and painting, as media of representation, are estranged beyond even the synthesizing power of theory. English writers of the Romantic generation subsequently echoed Lessing's assertion of the imaginative superiority of the written word over the iconic image. "We may assume without much temerity that poetry is more poetical than painting," declared Hazlitt, "painting gives the object itself; poetry what it implies . . . this last is the proper province of the imagination."[34] Likewise, according to Coleridge's pseudo-anthropological history of language (borrowed from Rousseau), the symbolic power of graphic, alphabetic characters represents the consummate phase of cultural evolution:"in the lower degrees of civilization, [f]irst there is mere gesticulation; then rosaries or *wampum;* then picture-language; then hieroglyphics, and finally alphabetic letters."[35] The progress of civilization, suggests Coleridge, is synonymous with the abjection of "picture language" and "the visible" in general. Accordingly, for Wordsworth, the panorama's traffic in reproducible landscape images threatened no less than a wholesale cultural regression: the usurpation of "civilized" alphabetic language by a "savage" discourse in images, of nature poetry by a vulgar new visual landscape idiom, of poetic imagination by the "despotic" eye. As if to confirm the panorama's natural antagonism to poetry and poetics, its sole experiment with a literary theme, John Burford's "Pandemonium" (1829), which represented the opening scene from *Paradise Lost,* was a dismal failure with the public. Burford quickly withdrew "Pandemonium," returning to staple

panoramic views of Naples, Constantinople, and the Swiss Alps, scenes devoid of narrative or lyric suggestion, let alone direct poetical allusion. The strength of the panorama, Burford realized, lay in gratifying the sensibility of picturesque tourists, not readers of epic poetry.

Further to the same point: the eighteenth century had witnessed an emerging popular discourse of landscape exemplified by the picturesque guidebook and loco-descriptive poetry. After experiments with these genres in his early poems (notably "An Evening Walk" and "Descriptive Sketches," both from 1793), in which, as he relates in Book Eleven of *The Prelude,* "the eye was master of the heart" (l.171), Wordsworth conscientiously repressed the promiscuous touristic eye in favor of a more noumenal mode of intuition. The detailed landscape imagery of the early poems subsequently gives way to a set of sublime, nominal categories, such as "thought," "mood," "mind," "feeling," and "imagination," terms that circulate through his poetry in lieu of conventional visual description. As such, Wordsworth's mature poetry is already, at its origin, a reaction against Georgian popular visual culture, in particular picturesque tourism. But in Book Seven of *The Prelude,* Wordsworth encounters again the despotic picturesque gaze, this time in its commodified, socially descriptive form. At the panorama, William Gilpin's picturesque landscape formula has become a dominant pop-cultural phenomenon, symbolic of the "spectacular" nature of London itself.

In short, the panoramist's appropriation of the prospect view for the purposes of visual entertainment rather than lyric effusion marks an early step in the modern supersession of poetry by spectacle, and consequently a popular revolution in the traditional hierarchy of the sister arts. The clearest evidence that the panoramas were engaged against the traditional authority of verbal media in a struggle for the public imagination lies in the arguments of the panoramists themselves. Their most eloquent salesman was John Burford's son, Robert, whose puff for his 1834 Panorama of Niagara Falls includes the following claim:

> travellers speak of [the Niagara Falls] in terms of admiration and delight, and acknowledge that they surpass in sublimity every description which the power of language can afford; a Panorama alone offers a scale of sufficient magnitude to exhibit at one view (which is indispensable) the various parts of this wonderful scene, and to convey an adequate idea of the matchless extent, prodigious power, and awful appearance, of this stupendous phenomenon.[36]

Inverting the conventional sister arts hierarchy—a founding principle of Romantic aesthetics since Burke and Lessing—Burford makes an unam-

biguous claim for painting as the natural medium of the sublime, asserting its powers quite explicitly over verbal description. His panorama, he claims, "alone offers a scale of magnitude" to faithfully reproduce the experience of the Niagara Falls, and is superior to any literary evocation.

An even more revealing promotion, by James Jennings in 1818, abandons the rhetoric of the sublime altogether, to exult in the panorama's power to stage "reality" itself. Jennings invokes the literary tradition of the romance only to then proclaim, in a stunning hyperbole, the greater dramatic power of the panorama: as if the prospective customer's shilling was bound to gratify either the panoramist or the bookseller but not both. The panorama in question is "A Description of Lord Exmouth's Attack upon Algiers":[37]

> If, amidst the fables and fictions of the dark ages, those chivalrous exploits awaken our sympathy, excite our feelings, and command our approbation,— how much more, and in how much greater a degree, ought our feelings and our sympathies to be awakened, and our admiration to be arrested, at a story around which no historical or mythological halo hovers; around which no fiction is thrown; around which no lapse of time has lent its aid to veil the crudities of the pencil; where the LIVING SCENE, the vivid drama of REALITY, has just passed before us, in all the lineaments and strongest tints of Truth; in all the glory of genuine Heroism. . . . SUCH WAS THE ATTACK OF LORD EXMOUTH ON ALGIERS![38]

Cannier than Burford, Jennings bypasses the terms of the sister arts debate to light on the panorama's special appeal. Rather than a romanticization of the battle at Algiers, he offers the "REALITY" itself, in unashamed clarity. Jennings makes a virtue of the antitemporal immediacy of the panoramic image, "around which no historical or mythological halo hovers." The panorama's intent, he implies, is not to invite a Wordsworthian sublimation of the landscape image—to arouse the historicizing imagination evident in a landscape poem like "Tintern Abbey"—but simply to "arrest [the] admiration." The effect is exactly that Benjamin will later find in twentieth-century cinema, where spectators flocked to experience the "shock" of the "sight of immediate reality."[39]

A year after the panorama's sensational debut, William Gilpin reminded his readers how, on viewing a sufficiently evocative landscape, "the imagination becomes a *camera obscura,* only with this difference, that the camera represents objects as they really are; while the imagination, impressed with the

most beautiful scenes, and chastened by rules of art, forms its pictures, not only from the most admirable parts of nature; but in the best taste."[40] Gilpin first likens the visual imagination to a technological instrument of *mimesis*, a *camera obscura,* only to immediately distance his landscape aesthetics from any concern for "objects as they really are." In this sense, Gilpin's picturesque theory reinforces academic principles of idealist composition. The visual imagination, unlike the merely mechanical *camera obscura,* is capable of the tasteful re-arrangement of a landscape view. The problem of Barker's panorama for those, such as Wordsworth, tutored in the idealizing articles of picturesque composition, was that it accepted Gilpin's analogy of the visual imagination and the camera *without* the academic proviso he so carefully attached. The panoramist's "greedy pencil" reproduced scenes with a minute accuracy of detail entirely contradictory to academic codes of pictorial representation. But, at the same time, if the panoramas were not "picturesque" in letter, they were in spirit. The commercial potential of picturesque aesthetics was already evident in Gilpin's bestselling *Tours,* but reached an acme at the panorama where the scenic tourist, delivered of all the inconveniences of travel, simply paid for the instant thrill of a simulated prospect.

The possibility of a culture dominated by popular taste for technologically engineered documentation of the visible world—a culture we currently inhabit—was clearly evident at the panoramas of late Georgian England. As such, Wordsworth's hostility toward them, as a form of collective "outrageous stimulation," was not groundless. The panorama anticipates millennial visual media—from film, to theme park spectacles, to the virtual reality arcade—in which the conventional limits of visual representation have been entirely exploded (and the lyric poet permanently marginalized). Furthermore, if we imagine Wordsworth at a panorama of London itself, the effects of an incipient modernity in Book Seven intensify. For it is at the Panorama of London that the Georgian visual-cultural market moves beyond popular taste for picturesque landscape to a pictorial subject of even greater fascination for the bourgeoisie: themselves. The fastidious contemporaneity of panorama scenes whereby one might, for instance, locate the room where Byron stayed in Naples or even one's own house in Cheapside, effected what William Galperin has called a "theatricalization of the audience" itself.[41] As a popular destination for curiosity-seekers from all social levels, the panorama was a place not only to see and be seen, but to see oneself.

According to the prospect poem tradition, the panoramic view offered a commanding vantage point and, by a natural course of symbolic associa-

tion, cultural ownership.[42] It was a proof of the social as much as the aes-
thetic order of things that, as Sir Joshua Reynolds once stated, "A hundred
thousand near-sighted men, that see only what is just before them, make no
equivalent to one man whose view extends to the whole horizon round
him."[43] In *The Prelude,* his epic autobiography of poetic election,
Wordsworth sees himself as just that man among a hundred thousand.
Whether on Helvellyn, in the Alps, or at the summit of Mt. Snowdon, the
Wordsworthian "natural sublime" relies on the poet's studied ascent to
higher ground. As such, the fact that the panorama offered any Londoner
with a spare half-hour the same privileged "prospect" made his disapproval
of Barker's spectacular new medium inevitable. In a related figure of class
distinction we considered in chapter 2, Reynolds defined the educated
viewer as one able to look "upon the objects at large and . . . observe the
effect which they have on the eye when . . . it is employed upon the
whole, without seeing any of the parts distinctly." The uneducated opinion,
by contrast, could only ever be the "observation of a very narrow mind . . .
that sees with a microscopic eye . . . and thinks that small part which he
sees to be the whole."[44] Despite its representation of "the whole horizon,"
only a vulgar appetite for landscape could be satisfied at the panorama: a
"narrow" taste for life-like detail, for the purely mimetic surface of the vis-
ible object. Wordsworth's distrust of the panorama as a landscape medium
thus revisits Reynolds' rejection of *mimesis* in his *Discourses,* and likewise
echoes his class anxiety surrounding the rise of modern visual culture. At
the panoramas of the West End, England's elite poets and painters rubbed
shoulders with the hoi-polloi who, admitted at last to the privilege of a
prospect view, enjoyed a half-hour's dominion over Nature for the cost of a
shilling: dominion, that is, over a landscape perpetually contracting from
sublimity into servile delineation of the "real."

Chapter 4 ✑

RUINS AND MUSEUMS

Sentimental Distances in Schiller, Winckelmann, and Diderot

> *"People are rather fond of listening to declamations about the Greeks. But if someone were to come and say, here are some, then nobody is at home."*
>
> —F. Schlegel, *Athenaeum Fragments*

It is the fate of our modern sensibility, argued Friedrich Schiller, to be alienated from nature. In his 1795 essay, *Über naive und sentimentalische Dichtung,* Schiller describes how the modern poet "seeks nature, but as an ideal and in a perfection in which she has never existed, when he *bemourns* her at once as something having existed and now lost" (my emphasis).[1] Nature, for Schiller, is synonymous with classical art, called "naïve." Consequently, we experience our difference from antiquity as we do our estrangement from nature, in the form of personal loss: the ancients "are what we were." The psychological consequence of modernity *as* difference—as the alienation of modern European sensibility from its natural origins in antiquity—Schiller calls *die Sentimentalität,* "sentimentality." The affective symptom of sentimentality is *die Wehmut,* "melancholy," a particular affliction of eighteenth-century Grand Tourists. "Linger[ing] before the monuments of ancient times," according to Schiller, rendered one particularly vulnerable to sentimental symptoms. A generation after Schiller, William Hazlitt offered a vivid account of antiquarian melancholia. He observed that English students in Rome, confronted by "ancient greatness," experienced their "sinews of desire relax and moulder away, and the fever of youthful ambition [turn] into a cold ague-fit. There is a languor in the

air, and the contagion of listless apathy infects the hopes that are yet unborn."[2] For both Hazlitt and Schiller, the ancient ruin is an incomplete and ultimately inscrutable representation of antiquity. Through it, we sense "the limitation of our condition," namely modernity, in the form of a debilitating melancholia.

For later Hellenists such as Byron and Shelley, literal resurrection of the classical ideal was in some sense conceivable: "We are all Greeks," wrote Shelley in his 1821 closet drama, *Hellas*. In this positive construction, Hellenism marked the origins of modern historicism, consolidated in the diverse disciplines of archaeology, art history, and literary translation. The public museum, a natural institutional accompaniment of archaeology, emerged in Shelley's lifetime as a state-sponsored expression of antiquarian consciousness. But for Schiller in the 1790s, Hellenism's foundation lay not in the material, collectible achievement of Greek culture but its ideality: "nature and the ideal are an object of sadness . . . the first is treated as lost and the second as unattained."[3] According to Schiller's terms, the aesthetic form of an ancient ruin did not determine its value; rather the "reflecting intelligence" of the sentimental subject perceived its "beauty" as the hypostatization of his own difference from the vanished culture of antiquity. If the Romantic Hellenist thinks at all of "an external object," he claimed, "it must always be only an ideal, inner one; even if it grieves over some loss in actuality, it must first be transformed into an ideal loss."[4] Here Schiller theorizes the sentimental cult of antiquity as the interiorization of loss: what Sigmund Freud, a true late Romantic and archaeology aficionado, would clinically label "the work of mourning."

The practical conditions of eighteenth-century Hellenism enabled Schiller's negative definition of antiquity-as-loss in *On the Naive and Sentimental in Literature*. The excavations at Herculaneum (1738) and Pompeii (1748) introduced archaeology as the new historical science of the age, but political infighting paralyzed work at these sites for many decades. Moreover, very little archaeological work was undertaken in Greece itself. Joseph Spence (whose *Polymetis* was a well-thumbed volume in Keats' library) described the Hellenist scholar's predicament in plain terms: "As we lie so far north from this last great seat of empire, we are placed out of the reach of consulting these finer remains of antiquity so much, and so frequently, as one could wish. The only way of supplying this defect to any degree among us, is by copies, prints, and drawings."[5] Northern European Hellenists such as Spence and Schiller relied on "copies, prints, and drawings" until at least the first decade of the nineteenth century, when the Elgin Marbles arrived in London. As we shall see, public access to the Parthenon

sculptures transformed both the aesthetic and political implications of Hellenism. But for Schiller and his fellow philhellenes in the late eighteenth century, Ancient Greece constituted a radically underdetermined cultural object. They experienced a melancholy sense of historical and geographical remove, of being privy to no more than the "shadowy outline" of antiquity. This absence of an authentic classical object invited an inversely proportional abundance of substitute cultural forms to represent it. The dilettante fashion for copies, prints, and drawings depicting ancient sites, the eighteenth-century vogue for neo-classical architecture, as well as the European academies' devotion to classical themes and statuesque principles, represented a compensatory desire to reproduce lost antiquity in material form.

The most immediately influential of these Hellenist projects was Johann Winckelmann's critical writings on ancient art. Winckelmann's voluminous art-historical scholarship in the 1750s and 60s symbolized to the succeeding generation of Goethe and Schiller an emerging scientific phase of European Hellenism. But as Winckelmann made clear in his first major essay, *Gedanken über die Nachahmung der griechen Werke* (1755), his materialist approach was, in reality, severely compromised: the only examples of Greek art available to him were imitations (*Nachahmungen*) from the Roman Imperial period. "We have now the works of Phidias before our eyes," Goethe reminded Eckermann in 1826, "whereas in our youth nothing of the sort was to be thought of."[6] For instance, the sculpture that embodied for Winckelmann the combined perfections of the Greek tradition was the *Laocoön,* created in Rhodes no earlier than the first century B.C. and known to him only through poorly defined plaster reproductions. Winckelmann's lack of primary material would appear an insurmountable methodological weakness if we did not recognize the essential sentimentality of his scholarly enterprise. That he had access only to descriptions or copies of original Greek works was, in fact, the very spur of his Hellenist enthusiasm. For Winckelmann, Roman reproductions of Greek art were not mere "servile copies," but the perpetual signifiers of an absent original. They embodied the pathetic inspirations of loss itself: "we too have, as it were, nothing but a shadowy outline left of the object of our wishes, but that very indistinctness awakens only a more earnest longing for what we have lost, and we study the copies of the originals more attentively than we should have done the originals themselves, if we had been in full possession of them."[7] Here Winckelmann anticipates Schiller's sentimental poet, in love with the idea of antiquity rather than its material reality. The absence of an authentic material Greece, he argues, inspires our proportionally

greater response to it as an idea. Hence, paradoxically, we learn to love the Roman copy more than we would its Greek original. The more distant and indistinct our image of the Greeks, the greater our "longing for what we have lost." In this way, Hellenism, as the idealization of an imagined past, becomes a cipher of modernity itself and its pathologies. In Jacques Taminiaux's words, "the antithesis between Greece and modernity . . . shapes the space within which nostalgia [sentimentality] occurs."[8]

Winckelmann compensated for his lack of primary source material through a highly ingenious and improvised methodology. He synthesized volumes of archival documents related to Greece scattered in European libraries; examined uncatalogued artefacts strewn through the Baroque gardens and galleries of Dresden and Rome; and absorbed the aesthetic principles of Phidias and Polybius from sketchy descriptions of their work in Macrobius, Pliny, Pausanias, and others.[9] As for Greece itself, however, Winckelmann, the father of Romantic Hellenism, never visited it at all. He was never short of opportunities but preferred, it seems, to keep his sentimental distance. At the time of his murder in Trieste in 1767, he was returning home from yet another aborted journey to Greece. We have seen that, for Schiller, sentimental Hellenism was classical in spirit but modern in essence: "The feeling of which we here speak is therefore not that which the ancients possessed; it is rather identical with that which we have *for the ancients*. They felt naturally, we feel the natural."[10] Accordingly for Winckelmann, the preservation of distance, both literal and psychological, between the ancient and modern worlds was necessary to his enjoyment of an exquisite sentimental longing for Greece. As Alex Potts states, the artistic remains of antiquity constituted for Winckelmann "signs of a radical absence within the culture of his own time, the figurations of an ardently desired but impossible art and freedom."[11] Complete knowledge of or identification with the culture of antiquity would destroy that pleasurable melancholy.

In sum: it is the implication of Schiller's theory, and Winckelmann's practice, that whatever "scientific" projects the eighteenth-century cult of Greece might produce, Hellenism was essentially poetic, in the sense of *poesis*—a "making." Winckelmann's Hellenist scholarship did not recover Ancient Greece in a scientific, material sense, but invented it as the ideal locus of a peculiarly modern predicament. The psychological parameters of Romantic Hellenism were sadness associated with loss. Melancholia in turn became the very substance of aesthetic judgment. In other words, Winckelmann's perception of his cultural and historical difference from antiquity became indistinguishable from his recognition of beauty in its remains. It is

significant, in this respect, that Winckelmann built his highly influential theory of the "natural" beauty (*Die Schöne Natur*) of ancient art in *Gedanken über die Nachahmung der griechen Werke* without actually defining beauty itself. This is not an oversight or flaw in his theory, but its sentimental element. By leaving beauty undefined, Winckelmann represented it as an unattainable ideal, just as by refusing to visit Greece he preserved it as lost. Both are examples of sentimental distancing: a psychological resistance to the "real" Greece. For both Schiller and Winckelmann, sentimental distancing opened an ideal stage for their performance of Hellenist melancholia.

The antiquarian and *philosophe,* Denis Diderot, was among Winckelmann's most conscientious early readers. At a time when the French authorities had vigorously curtailed the publication of art criticism, Diderot's commission as *salonnier extraordinaire* to Europe's crowned heads presented a unique opportunity. His elite subscribers did not attend the exhibitions he described, which gave him unusual critical freedom to extend the possibilities of verbal response to visual art. As a result, Diderot largely abandoned *la méthode scientifique* in his criticism—a formal description of the artworks emphasizing technical aspects of composition—for a proto-Romantic approach focused on each picture's ability to evoke an emotional response in the viewer. This critical style is particularly evident in the *Salon de 1767,* written only months before Winckelmann met his violent end in Trieste, in which Diderot imaginatively projects himself into the scene of various paintings. He saunters across their landscapes and converses with their figures, crossing the line between viewer and painting, and between art criticism and literary romance.

In the *Salon de 1767,* Diderot comments at length on a series of four paintings of Roman ruins by the historical-landscapist Hubert Robert, which created a sensation in Paris that year. Combining a rectilinear vision of architectural form with serpentine rococo lines, Robert's paintings convey contemporary provincial Italy in a pastoral setting of decayed antiquity. In *La Passerelle* (figure 4.1), descriptively sub-titled *Un Pont, sous lequel on voit les campagnes de Sabine,* an old, gap-toothed Roman bridge, repaired in modern times with a purely functional wooden rampart, frames a Claudean twilight complete with a castle spire and vaguely delineated mountains in the distance. A woman rests on the stone rail of the bridge, while around her the evidence of rural industry is carefully staged. A horse and cart makes its way across the bridge, while a farmhand attends to cattle in the shadow of its base on the riverbank. What is missing from this bustling scene, however, is any sentimental awareness in these local inhabitants of the antiquity of their surroundings. For Diderot, Robert has failed to cap-

ture the necessary *poétique des ruines*. "You excel in your genre," he tells Robert, "but you miss the ideal. Don't you feel that there are too many fig- ures here? That you ought to scrub out three-quarters of them? You should keep only those which contribute to the solitude and silence."[12] Robert's mistake is to encourage the bourgeois viewer's complacent inter- est in the everyday doings of country folk, rather than the melancholy reflection proper to the dilapidated majesty of their setting. His scene is too busy by half. If there must be human figures at all, says Diderot, Robert should make sure to integrate them into the melancholy mood of the ruin: "A solitary man wandering in the shadows, with his arms crossed on his chest and head bowed, would have had a greater effect on me. The lonely obscurity, the majesty of the building, the grandeur of the workmanship, the expanse, the tranquility, and the muted echoes of the space would have made me tremble." Diderot's imaginary figure performs his melancholia with a desultory wandering through the ruins, intermittent sighing, and a grave registration, in expression and posture, of his own mortal frailty:

> The effect of these compositions, good or bad, is to leave you with a feeling of gentle *melancholia*. We let our eyes wander across the remains of a tri- umphal arch, a gate, a pyramid, a temple, a palace; and we reflect on our- selves; we anticipate the ravages of time; our imagination scatters the buildings we now inhabit on the ground. In an instant solitude and silence reigns over us. We remain alone, the last survivor of a forgotten nation. Here is the first line of the poetics of ruins.[13] (my emphasis)

By this point in his exposition, Diderot is not describing an ideal figure for Robert's painting as much as its ideal viewer, namely himself as sentimen- tal salonnier. The attitude of the imaginary figure in the painting serves as a model for Diderot's own melancholic response to it.

Guilty of the same generic infelicities as *La Passerelle,* according to Diderot, is Robert's *Grand Escalier qui conduit à un ancien portique.* In this painting, townsmen gather in idle clusters around an ancient building, con- versing together on the steps or sitting on fallen columns in contemplation of some unfinished labor. The composition's most startling element is the pedimental figures that look out from the walls. These have the effect of doubling the human figures, though their severe formal poses suggest an ironic rather than empathetic relation to the contemporary scene. These statues appear ready to join their living descendants in conversation at any moment, but nobody pays them any attention. As in the painting of the

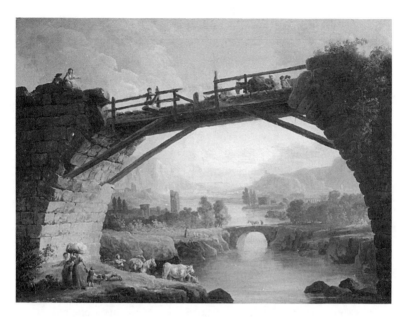

Figure 4.1 Hubert Robert, *La Passerelle [Un Pont sous lequel on voit les campagnes de Sabine]* (1767).

ancient bridge, it is as if the ruin were not there at all but for its convenience for lounging upon or the trafficking of goods. "All these insignificant groupings," remarks Diderot of the painting, "proves conclusively that the poetics of ruins is still left to do."[14]

Robert depicts the same washerwoman, heavy laden with a bundle on her head and an additional basket or child at her side, in *every* painting of the series. Her emphatic presence no doubt embodied, for Diderot, Robert's misrepresentation of the poetics of ruins, the antisentimental, quotidian quality of his classical vision. In terms offered by Michael Fried, Robert's figures are absorbed in their day-to-day business rather than theatrically displaying the morbidity proper to the ancient site.[15] Though both ruins and rural life are sentimental themes, Robert fails to harmonize them. The paintings are picturesque but lacking in sentiment. Once again, Diderot emphasizes that Robert's failure lies in the fatal incongruity of his figures and their setting: "You cannot bring ruins to life in this way. M. Robert, take care with your human figures! Do less of them, and do them better. Study especially the *spirit* of this type of figure; because only one

style will suit them. A figure among ruins is not the same as a figure placed somewhere else."[16] It is important to remember that Diderot constructs his *poétique des ruines* not amongst ruins themselves but from their representation in paintings. In the same way that Winckelmann's sentimentality compelled him to seek refuge in libraries, studiously avoiding Greece itself, Diderot displaces the authentic object of antiquity in favor of a pictorial representation. Diderot's Hellenism (mediated, like Winckelmann's, by its Roman "copies") is thus emblematic of the eighteenth-century classical revival in general, which consisted principally of literary translation, paintings and prints of ruins or mythological scenes, the travel writing of dilettantes, and, after Winckelmann, the new scholarly discipline of art history. The idealizing refractions of these media inspired the sentimental imagination of the eighteenth-century Hellenist.

For Diderot, the appeal of antiquity, properly aestheticized, was irresistible. "I would not be able," he wrote of Robert's historical landscapes, "to stop myself from going to dream under this vault, to sit among these columns, to enter into your tableau." By imaginatively entering Robert's painting, Diderot closes the distance between himself and his cultural object, namely antiquity. But this *rapprochement* is not attempted in the cause of final identification with the spirit of the ancients. Though Diderot imagines himself wandering beneath the broken vault and leaning against columns, he keeps his sentimental distance. He is not integrated into the scene as Robert's figures are through their self-absorbed and wholly functional attitude to their surroundings. For Diderot to preserve the psychological economy of Romantic Hellenism, the ekphrastic adventure he undertakes—incorporating himself into the painting—necessitates the hyperbolization of another form of estrangement, namely the difference in time. In Anne Janowitz's words, the pleasure we take in ancient ruins (*Ruinenlust*) depends upon their assuming "the aesthetically controlled shape of temporal transience."[17] As such, Diderot's poetics of ruins rewrite the medieval trope of *memento mori* with a characteristically eighteenth-century sentimental inflection. He experiences intimations of mortality among the ruins, but interprets them psychologically, not religiously. The relics of antiquity furnish not a moral lesson, but an elegiac mood: "Ruins evoke noble ideas in me. Everything is destroyed, everything perished, everything passed away. Only the world remains. Only time endures. How old the world is! I walk between two eternities." By figuratively entering Robert's ruin, Diderot, the elegiac critic/poet, occupies a liminal space of retrospection between the ancient and modern epochs. We recall that, for Schiller, modern sentimentality does not signify a decline in art from

ancient naiveté, only the historical difference between them. Diderot's sentimental art criticism consists in the thematization of that difference:"Time stops for those struck by amazement. How little I have lived! How brief my youth!" As "the solitary man wandering in the shadows, arms crossed on his chest and head bowed," Diderot writes himself into Robert's paintings as a figure of mourning by way of acute melancholia. Lurking in the shadows with his head lowered, Diderot assumes a posture of grief, thus redeeming the losses of history through an aestheticized image of mourning itself. As a posture, an attitude, a spectacle, mourning assumes the status of art. Diderot the critic has himself become (as will both the poet Keats and the collector Lord Elgin) a kind of ruin.[18]

Diderot's commentary on the paintings of Hubert Robert in his *Salon de 1767* exemplifies Schiller's definition of sentimentality. Reading Schiller, Winckelmann, and Diderot together, we find no "real" Hellenist object, only an imagined ideal. Their sentimental version of Hellenism does not constitute a body of knowledge about antiquity as much as a mode of personal and cultural self-invention. As Goethe told Eckermann of the effect of reading Winckelmann:"one does not learn anything, but one becomes somebody." The sentimental Hellenist mourns the past, and the poetry of the self emerges from that mourning. That said, Schiller's Romantic "lingering among the monuments of antiquity" appears more complicated, indeed paradoxical in Diderot's *Salon*. In his commentary on Robert, Diderot foreshadows the crisis in sentimental ideology precipitated in the early nineteenth century by the birth of museum culture. He defines the "poetics of ruins," unachieved by Robert's paintings, as a paradoxical encounter between ancient ruins and "the viewer, who *passes* by what is *past*." Compelled to stop, admire, and linger among ruins, instead of "passing" what is "past," the museum-goer is caught in a *contre-sens*. Diderot's serious play on *passer/passé* suggests that the romanticization of actual ancient relics in a museum contradicts the logic of representable experience. At this extremity, his *poétique des ruines* becomes an antipoetics. The modern museum-goer, Diderot predicts, unlike the sentimental, literary Hellenists of Schiller's generation, will be trapped in the *lieu péril* between the "two eternities" of antiquity and the modern world.[19] Confronted in the new century by the newly museumized Parthenon Marbles, the English poet John Keats indeed finds the safeguards of sentimental distancing unavailable to him. As his British Museum poems of 1817-19 record, the idealized Hellenism of Schiller, Winckelmann, and Diderot becomes impossible when presented with real objects of Greek antiquity in the public space of a state museum. As we shall see, the "perilous spot" Diderot

merely imagined at the 1767 Paris *Salon* represents for the Hellenist poet of Regency London a very real situation of crisis.

Keats and the Ruins of Imperialism

Looking back over two centuries of Hellenism, the critic Harry Levin mocks the affectations of Schillerian sentimentality. Antiquity "indulges our modern fondness for the fragmentary," he says, "we strike postures before its ruins." The nobility Schiller found in the sentimental pursuit of ancient naiveté has lost its gloss for Levin. By 1931, sentimentality is a dirty word:

> Whatever the Greek did (and it is injudicious to assume that his range of experience, over the course of centuries, varied widely from our own), the last thing he did was to muse among the ruins. . . . He used his buildings as long as he and they lasted; he ate, slept, wrestled, acted, and voted in them; and when they fell in ruins and he was buried in the earth, we came along and did the musing.[20]

As acute as Levin may be in his analysis of modern sentimentality, he doesn't question the historical truth of Greek naiveté. The ancients were not, like Schiller or Hazlitt's students in Rome, given to melancholic prostration in front of dilapidated buildings. Instead, Levin argues, they were pragmatic and utilitarian in the way that Nature herself is. Difficult as it is to believe that a culture enamored of the historical fantasies of Homer could be immune to nostalgia, Levin nevertheless makes an important point about ruins: they "are by their very nature modern." Wandering through a museum, we forget that classical ruins are not ancient at all, but have deteriorated into ruin from an original newness: their decrepitude is a diacritical sign of both great age and an intrinsic modernity. The idea of the ruin, as Schiller perceived, was quintessentially modern and sentimental.

Archaeology is thus a sentimental science, and the museum, as the natural repository of archaeological production, is the sentimental institution par excellence. The British Museum is the most important such institution in the history of Hellenism because it acquired, in 1816, the first major collection of Greek antiquities in Europe: the Elgin Marbles. Rebuilt in the Victorian age in Greek Revival style, with a variation at its entrance of the Parthenon pediment found within it, the British Museum is a monument to the contradictions of sentimentality.[21] That is, the museum aspires *in its very structure* to the naiveté of the Greek culture it memorializes, even as it performs its own historical difference from that culture through the idealization

of her remains as "art." As Carol Duncan has observed, "museums constitute one of those sites in which politically organized and socially institutionalized power most avidly seeks to realize its desire to appear as beautiful, natural, and legitimate."[22] In this sense, the foundation of the British Museum in 1753 helped "Britain"—a political concept not fifty years old—achieve a symbolic-aesthetic form. In his epic fragment "Hyperion" from 1818-19, John Keats described an "eternal law" of divine right: "that first in beauty should be first in might" (II:229). Keats' "law" captures the founding ideological principle of the modern museum, which enlists the aesthetic wonder of antiquity ("beauty") to bear the symbolic weight of imperial power ("might").[23] Essential to this symbolic capability is its interior blandness, which "represent[s] the museum experience as almost solely a series of encounters with discrete art objects."[24] With its open spaces and blank walls, the museum isolates ancient artefacts from their social and geographical origin, creating the sense of loss Schiller diagnosed in the modern subject's perception of antiquity. Ironically then, the British Museum, a product of Enlightenment historical consciousness, effectively de-historicizes its contents. As Dean MacCannell has explained, modern museums "are anti-historical and unnatural. They are not, of course, anti-historical and unnatural in the sense of their destroying the past or nature because, to the contrary, they preserve them, but as they preserve, they automatically separate modernity from its past and from nature and elevate it above them."[25] For example, the Parthenon frieze and pedimental statues, once removed from Athens to the British Museum, necessarily lose the greater part of their historical significance. Their subsequent renaming as the "Elgin" Marbles literally erases their origins. By separating art objects from their historical context in this way, argued Adorno, the museum age institutionalized culture under the trope of death: "Museum and mausoleum are connected by more than phonetic association. Museums are like the family sepulchres of works of art. They testify to the neutralization of culture."[26] If so, what benefits lay in possession of these alienated objects? As the new nation states of eighteenth- and nineteenth-century Europe discovered, nationhood is a transcendent idea. The state museum offered one means of conveying the idea of national identity in a material form. In the case of the so-called Elgin Marbles, the British Museum's "neutralization" of the Part henon ruins as cultural signs—through acquiring, institutionalizing, and finally renaming them—enabled their subsequent enlistment as symbols of national destiny.

My reading of Keats in this section presumes two non-discrete periods of Romantic Hellenism. The first century-long period, from approxi-

mately 1720 to 1816, witnessed a renewal of interest in the art of antiquity spurred by the beginnings of tourism to Italy and Greece and a boom in the translation of ancient texts. The popularity of travel journals and prints subsequently prompted quasi-scientific expeditions by private antiquarian organizations. For instance, the new Hellenist science of archaeology advanced significantly in the middle of the eighteenth century through the work of James "Athenian" Stuart who, at the behest of the Society of Dilettanti, undertook a taxonomy of Greek architectural styles based on rigorously accurate drawings made on the spot. (Notwithstanding the influence of Stuart's *The Antiquities of Athens* [1762], the relatively expressionless and pristine examples of *Roman* Hellenism such as the Apollo Belvedere and Farnese Hercules continued to determine popular perception of classical art through the first decade of the nineteenth century.) Succeeding the era of the individual collector, antiquarian, and private Hellenist society, was the age of the public museum. According to this historical schema, the arrival of the Elgin Marbles signals the second phase of Hellenism in Britain. The marbles produced, as Benjamin Haydon remarked, "an Aera in public feeling."[27] They transformed the educated person's fascination for ancient texts, sentimental travel to ancient lands, neo-classical painting, and sketches and studies on Hellenic themes in two ways. First, Elgin's collection represented ancient statuary in a far more deteriorated state than the Hellenic ideal testified to by literary accounts, prints and Roman collections. Second, the broad public fascination with and scandal surrounding the marbles effectively democratized Hellenism. That is, with the Parthenon relics installed for public view, Hellenism left the scholarly archive and dilettante's cabinet to enter the social sphere as an object of popular visual wonder.

In short, the Georgian sentimentalization of Ancient Greece through texts, tourism, prints, and interior decoration was interrupted in the early nineteenth century by the arrival of the Elgin Marbles. The installation of the marbles in the British Museum signified an intrusion of material reality into the idealist constructs of conventional Hellenism, in the form of actual, visible relics that seemed to both confirm and radically defy its principles. During the British Parliament's deliberation in 1816 over the fate of Elgin's collection, when the question of their authenticity and aesthetic merit dominated debate, the marbles remained, however briefly, *outside* antiquity, and thus outside Hellenism. Idealization, and hence appropriation of the statues was momentarily deferred. Keats' poems on the marbles from 1817–19 capture the instability, both aesthetic and ideological, of that historical moment. As my readings will show, the marbles were, for Keats, neither ideal

nor naturalistic, without form and beyond categorization. The Parthenon ruins signified for him the materiality of the past itself, the "real" of antiquity. As a poetic critique of the new museum age, Keats' Elgin Marbles sonnets and two *Hyperion* poems represent a *pre-aesthetic* moment in the history of the Parthenon sculptures: the moment before Imperial Britain absorbed them into the nationalist discourse of the museum—before their antiquity became "Hellenized." Even Haydon, an ardent patriot and champion of the marbles' purchase, expressed concern that the political motivations behind their institutionalization in the national museum would destroy their aura of ideality. "When bought," he advised, "the [Marbles] should be placed in a school of art, and not as a monument of National glory."[28] That the Elgin Marbles have since become the most intensely politicized symbols of Greek antiquity demonstrates that Haydon's fears were well founded, and opens the ideological view of Keats' Hellenism I wish to pursue here. When the Elgin Marbles first went on display at the British Museum in 1816, Regency Londoners, Keats notable among them, found their idealized view of antiquity confronted by the material reality of Greece and the political implications of cultural imperialism. If sentimental Hellenism is a work of mourning, as Schiller had suggested two decades before, then the arrival of the Elgin Marbles at the British Museum signaled nothing less than antiquity's return from the grave.

Keats' sometime friend Benjamin Haydon was a student at the Royal Academy when, one day in 1808, he visited Lord Elgin's Park Lane shed to examine the newly arrived antiquities from Athens. What he saw there summarily overthrew the academic ideals he had cherished since reading Reynolds' *Discourses* as a boy. With the example of the "true" Greek before him, Haydon prophesied a new era in European art and aesthetics:

> I felt the future, I foretold that they would prove themselves the finest things on earth, that they would overturn the false beau-ideal, where nature was nothing, and would establish the true beau-ideal, of which nature alone is the basis. I shall never forget the horses' heads—the feet in the metopes! I felt as if a divine truth had blazed inwardly upon my mind and I knew that they would at last rouse the art of Europe from its slumber in the darkness.[29]

The vivid physicality and expression of the marbles controverted academic principles, suggesting to Haydon that the Greeks, unlike his Royal Academy professors, devoted themselves to the scientific study of anatomy. The anti-academic implications of the marbles were likewise clear to Hazlitt,

for whom the marbles had "every appearance of absolute facsimiles or casts taken from nature." They represented, he claimed, "the best answer to Sir Joshua Reynolds' *Discourses,*" whose neo-classical orthodoxy continued to dominate high cultural taste a quarter-century after Reynolds' death:

> The Elgin Marbles give a flat contradiction to this gratuitous separation of design and exactness of detail, as incompatible in works of art, and we conceive that, with their whole ponderous weight to crush it, it will be difficult to set this theory on its legs again. In these majestic, colossal figures, nothing is omitted, nothing is made out by negation. . . . Therefore, so far these things, viz., nature, a cast from it, and the Elgin Marbles, are the same; and all three are opposed to the fashionable and fastidious theory of the *ideal*.[30]

For Hazlitt, there was "nothing made out by negation" in the marbles—that is, nothing of the ideal—only the positive representation of natural form. The arguments of both Hazlitt and Haydon rest on a simple distinction between nature and the ideal. As such, they anticipate naturalism, a dominant aesthetic in nineteenth-century art.[31]

The clearest testimony that the Elgin Marbles presaged the death of Baroque Classicism in Europe came, ironically, from its most illustrious practitioner, the sculptor Antonio Canova. Invited by Lord Elgin to submit an opinion on the marbles, Canova echoed Haydon and Hazlitt in his intuition of the sculptures' naturalistic quality, their total lack of neo-classical "pomp." The marbles conveyed, Canova declared, the "real" of nature: "everything about them breathes animation, with a singular truth of expression, and with a degree of skill which is the more exquisite as it is without the least affectation of the pomp of art, which is concealed with admirable address. The naked figures are *real* flesh, in its native beauty . . ." (my emphasis).[32] Canova, Hazlitt, and Haydon all perceive the "real" of antiquity in the Elgin Marbles, but articulate that effect in aesthetic terms, as exemplars of a new Romantic naturalism. For Haydon, it was a question of replacing one ideal—the "false beau-ideal" of the Royal Academy—with another: the "true beau-ideal" of Phidias himself. He subsequently puffed the marbles at every opportunity, abused Elgin's enemy Payne Knight in print, and offered his services to the Select Parliamentary Committee formed to consider the Government's purchase of Elgin's collection.

Thus it was in a heady climate of anti-academic feeling, parliamentary debates, and unprecedented public controversy on the cultural value of the arts—all inspired by Lord Elgin's marbles—that Keats finally went to have a look for himself in the spring of 1817. Haydon accompanied Keats to the

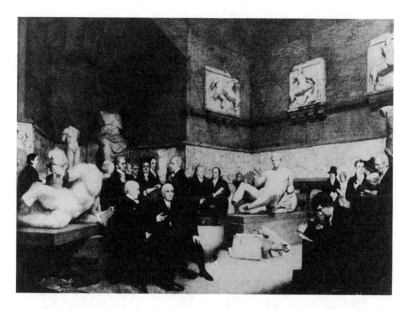

Figure 4.2 A. Archer, *The Elgin Marbles at the British Museum* (1819). © The British Museum.

temporary building housing the marbles (figure 4.2) at a time already redolent with feeling for the young poet. His first volume of poems was to appear the following day, March 3. The only first-hand account we have of Keats' visits to the Elgin Gallery is from a biography of Keats' portraitist Joseph Severn: "He [Keats] went again and again to see the Elgin Marbles, and would sit for an hour or more at a time beside them rapt in reverie. On one such occasion Severn came upon the young poet, with eyes shining so brightly and face so lit up by some visionary rapture, that he stole quietly away without intrusion."[33] Keats' rapturous attitude clearly made an impression on Severn. In his famous portrait of Keats from 1819 (figure 4.3), the poet appears just as he is here described: gaze transfixed, his face bathed by a luminous object beyond the frame. Severn has captured Keats' "museum" look.

Shortly after their visit to the British Museum, Keats sent off two new sonnets to Haydon.[34] Their respective opening lines established a familiar Romantic emphasis on the poet's psychological response to his subject in lieu of literal description. The sonnet "To Haydon" begins,

> Haydon! forgive me that I cannot speak
> Definitively of these mighty things;

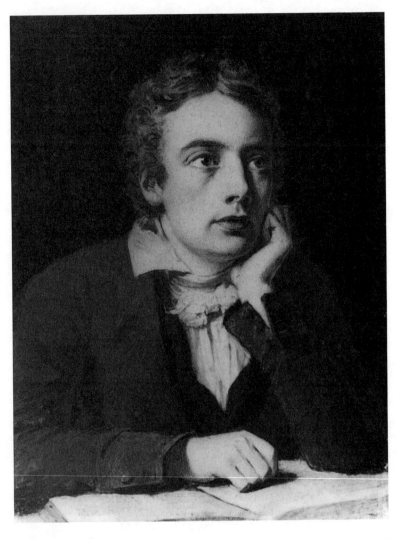

Figure 4.3 Joseph Severn, *Portrait of John Keats* (1819). By courtesy of the National Portrait Gallery, London.

Forgive me, that I have not eagle's wings,
That what I want I know not where to seek.

Keats' ironic opening gambit judges the Elgin Marbles worthy of sublime poetic tribute, but excuses the poet from the responsibility to make it. He pleads a lack of "ample strength":

And think that I would not be over-meek,
In rolling out upfollow'd thunderings
Even to the steep of Heliconian springs,
Were I of ample strength for such a freak.

"On Seeing the Elgin Marbles for the First Time" opens with the same regretful admission of incompetence before moving, as in its companion-poem, to a complicated identification with an eagle:

My spirit is too weak; mortality
Weighs heavily on me like unwilling sleep,
And each imagin'd pinnacle and steep
Of godlike hardship tells me I must die
Like a sick eagle looking at the sky.

The poet is thus by turns a disabled eagle, or not one at all. Either way Keats remains earthbound; but he regards the inaccessibility of the heavens not as a loss but a mercy. As Marjorie Levinson has observed, he "pointedly luxuriates in his deprivation."[35] The "godlike hardship" of artistic creation, represented by the marbles but applicable to himself, has about it an unbearable suggestion of death: "mortality / Weighs heavily on me." Immortality itself is an onerous servitude; he counts his escape from it a "gentle luxury."

By its end, "On Seeing the Elgin Marbles . . ." has run the full gamut of melodramatic affect: from weakness (1), to sleep (2), to sickness (5), to weeping (6), to "an indescribable feud" of the heart (10), to a "dizzy pain" (11). The marbles do not produce, for Keats, the gentle lassitude of Schillerian melancholia. We recall from the previous chapter that patrons of Barker's panorama reported feelings of nausea and confusion. Keats' symptoms here suggest an even more serious case of the shock of the real: his increasingly debilitated condition ultimately affects the structural and semantic order of his poem. The faculties of the poet buckle under the pressure of the poetic objective—a lyric response to the marbles—

precipitating a crisis of reference. By the end Keats, his grip on his subject fading, offers only the vaguest platitudes of sublimity: his confused vision

> mingles Grecian grandeur with the rude
> wasting of old Time—with a billowy main—
> A sun—a shadow of a magnitude.

Though Keats nominates the Elgin Marbles as the subject of his two sonnets, he refers to them directly only once in each. The marbles are "these mighty things" (2) in "To Haydon." In "On Seeing the Elgin Marbles . . . ," Keats deliberately avoids any literal performance of the "seeing" promised by the title. Even the single direct reference to the marbles, "these wonders" (11), is not a physical description but a transferred reference to his own awestruck reaction. Similarly in the second poem, Keats abjures visual engagement with the marbles through an increasingly desperate train of ellipses. He moves from the introspective "My spirit is too weak; mortality / Weighs heavily on me," to the purely associative or non-referential "with a billowy main— / A sun—a shadow of a magnitude."

For a poem not to deliver what it promises is not, of course, a lyric failure. The Romantic sublime specializes in rhetorical substitutions for the unrepresentability of objects. The aphasic dashes that stand in for hyperbole in "On Seeing the Elgin Marbles for the First Time" are hyperbolic gestures in themselves. But the sheer degree of Keats' defensiveness in the poem—the progressive and ultimately total emptying out of the sonnet's referential meaning—has provoked most critics to pronounce the poem an artistic failure on its own terms.[36] Levinson, Keats' most influential recent critic, restates the commonplace view of the poem's idealist susceptibilities: "Keats's initial logical swerve allows the sculptural full presence to survive not just intact but idealized."[37] Only Grant Scott has offered a solution to the poem's lack of descriptive reference, suggesting that the visual reality of the marbles returns in the very grammatical fragmentation thought to mark the poem's failure. "In disrupting syntactical relations and breaking down the poetic line," Scott argues, "Keats . . . enacts the marbles' process of decay in language . . . the poem remains in its own way as much a fragment as the statues."[38] What might otherwise appear to be a poetic capitulation to the challenge of *ekphrasis* represents in fact a triumphant return of the repressed. Canova and Haydon's ecstatic accounts of the marbles avoided reference to their deteriorated condition. From their descriptions we might not be looking at ruins at all; their rhapsodic response serves as a de facto restoration of the statues to an

imagined whole. Keats, by contrast, responds to the material condition of the ruins *as* ruins, rather than their formal aesthetic perfections. He eschews idealization in favor of a graphic allegory of the marbles themselves. To pursue the ideological implications of Scott's reading: the sonnets do not idealize their subject by a process of defensive avoidance, as Levinson claims, but rehistoricize them through a fascination with physical decay. They offer, in fact, a pre-aesthetic image of the Marbles that suspends the sentimentalizing designs of the museum. In so doing, Keats opens a door to the marbles' political meanings, otherwise obscured by their idealization as art.

To better prepare a political reading of Keats' final and most sustained meditation on the Elgin Marbles, "The Fall of Hyperion," I turn first to the early sonnet, "On First Looking into Chapman's Homer." Written at the height of the Elgin Marbles debate in October 1816, "Chapman's Homer" is the poem to which recent critics have traced the possibility of a politicized account of Keats' Hellenism. Daniel Watkins, for example, points to a repressed imperialist subtext in the poem: William Robertson's *The History of America* (1792), from which the schoolboy Keats had learned of the "glories" of Spanish conquests in the New World. According to Watkins, Keats ignores the plight of the indigenous peoples of the Americas by linking his reading of Chapman's Homer to the explorations of Cortez (whom Keats has confused with Balboa as the first European to see the Pacific). Keats has contrived the gorgeous rhetorical effects of his sonnet, Watkins contends, "at the expense of history itself."[39] The poem's ideological guilt, according to a similar critique put forward by Nicholas Roe, lies in its identification of the poetic imagination with imperial conquest:

> Keats's sonnet omits the human cost of Spanish activities in the new world, and celebrates Cortez (all struggles past) gazing over the Pacific in a moment of solitary personal triumph. Yet in doing so the sonnet has located imperial aggressiveness as a prerogative of the imagination "Which bards in fealty to Apollo hold" . . . Imagination and imperial power coincide in the appropriation of strange and marvellous new worlds.[40]

Attending closely to the poem, however, we find that it does not celebrate the poet's imagination per se but his discovery of antiquity, in the form of Chapman's translation of Homer. The theme of the sonnet is thus Hellenism in particular, not the Romantic imagination in general:

> Oft of one wide expanse had I been told
> That deep-brow'd Homer ruled as his demesne;

> Yet did I never breathe its pure serene
> Till I heard Chapman speak out loud and bold.

The image of the New World that follows does not ally Cortez and Keats, but Homer and the Americas. "[D]eep-brow'd Homer" is linked to the imperialist Cortez as the ancient poet who "ruled" the "wide expanse," but Keats remains on the sidelines as a *reader* who does not share in either's imperial "fealty." In the concluding lines, he invokes Cortez's act of discovery as an image not of imperial vision but readerly wonder:

> Then felt I like some watcher of the skies
> When a new planet swims into his ken;
> Or like stout Cortez when with eagle eyes
> He star'd at the Pacific.

Thus, Cortez's vision does not imply Keats' conquest. Moreover, if the poem begins with the "triumphant" exhilaration of discovery, as Roe suggests, it is difficult to see that mood sustained to the conclusion. Keats' poem ends at the moment before or—if we imagine Cortez/Balboa having already traversed the colonial space to arrive at the Pacific—*beyond* conquest. Cortez's companions, reminiscent of the gormless crew in Homer's *Odyssey,* are simply frightened, not looking at the sublime vista at all but at each other "with a wild surmise." The poem thus concludes, abruptly and strangely, not with the exercise of imperial imagination but with attitudes of pre-aesthetic wonder: "He star'd at the Pacific." As John Whale puts it, "Cortez's gaze remains peculiarly impenetrable to critical knowledge."[41] The pleasures of "Looking" announced by the poem's title, and with it the possibility of imperial vision, have disintegrated into the blankness of a stare.

We have seen that both sonnets to Haydon open with the sublime figure of an eagle, to which Keats unfavorably compares himself as "sick" or wingless. From there, each poem substitutes for the eagle a mythological deity whose power Keats equally cannot and does not want to match. In the figure of the eagle, Keats imagines the possibility of divine office, but not for himself. In both poems, he interrupts a conventional Hellenist *ekphrasis,* with its sentimental themes of mortality and sublimity, to emphatically declare his own unfitness for apotheosis. Similarly in "Chapman's Homer," the poet is "like stout Cortez when with *eagle* eyes / He star'd at the Pacific." Here, as in the sonnets, the positive nature of viewing diminishes through its figurative translation into "eagle" sight. Keats' enigmatic bird of prey makes a final appearance in the epic fragment of 1819,

"The Fall of Hyperion," when the hero, called to witness the pageant of mythic history conjured up by his guide Moneta, feels himself invested with an imperial confidence—"A power within me of enormous ken / To see as a god sees"—and sits himself "Upon an *eagle's* watch, that I might see, / And seeing ne'er forget." Before long, however, the poet's enthusiasm to witness the spectacle of divine Olympian power evaporates to the point where he longs for death:

> I prayed
> Intense, that Death would take me from the vale
> And all its burthens

As in the Elgin Marbles' sonnets and "Chapman's Homer," Keats in "The Fall of Hyperion" makes a *distinction* between the poet's destiny and imperial power, not an analogy. In the ambivalent figure of the eagle, which alights in all four poems, Keats' account of imperial subjectivity and its possible link to the poetic imagination could not be less "triumphant."

As "On First Looking into Chapman's Homer" suggests, Keats was from his days at Enfield School an avid reader of the classics. To his friend Richard Woodhouse, he appeared to have committed Lemprière's *Classical Dictionary* entirely to memory. The Hellenist poetry fostered by this adolescent enthusiasm falls into categories of both the naive and the sentimental. The "naive" poems— *Endymion,* "Lamia," and "Hyperion"—attempt to conjure antiquity as a living mythology: as, in A. W. Schlegel's terms, "the scene which is present."[42] There is no intrusion of subjective authorial filters in these poems: no recollection, hope, or desire. That said, they regularly lapse into sentimental formulae both through the introduction of poetic alteregos (Endymion, for example) that fracture the "living scene" of antiquity, and through the prevalence of chimeras and dream visions that repeatedly dissolve it. In short, these poems are faux-naive; necessarily so, as there can be no authentic modern naiveté. The late odes, by contrast, convey an *explicitly* sentimentalized distance from antiquity. In "Ode to Psyche," Keats identifies himself with the most belated of the ancient deities who, like the poet, enjoys "No voice, no lute, no pipe, no incense sweet." Neither Psyche nor Keats, the poem suggests, enjoys a secure and authentic relation to classical mythology. Likewise the poet of "Ode on Indolence," though "deep" in the study of the classics, feels estranged from antiquity in its material, museum form: "And they were strange to me, as may betide / With vases, to one deep in Phidian lore." Most famously, the Grecian Urn fails to

respond to Keats' insistent interrogation (seven consecutive questions in the first stanza). The pictorial relief on the urn presents a closed hermeneutic circle and "doth tease us out of thought / As doth eternity."

The pathos of these three museum odes from 1819 lies in the poet's failure to elicit significant meaning from Greek art. According to the same rhetorical inversion of value we saw in the Elgin Marbles sonnet, however, cognitive failure in Keats' odes represents poetic success. Where *Endymion* remained unfractured by the negative sublimity of sentimental longing, the odes embrace it. But "The Fall of Hyperion," I wish to argue, advances Keats' Hellenist intellect beyond the sentimentality of the odes. It does not rehearse the formulae of melancholy idealization we found in Winckelmann and Schiller, but rather takes the ironic form of a critique of sentimentality itself. In "Ode on a Grecian Urn," Keats examined the enigmatic union of truth and beauty in ancient art. In "The Fall of Hyperion," by contrast, antiquity presents less a moral or aesthetic problem than a physical condition of "living death." The museum odes are Keats' variations on intellectual Hellenism—they are ideal poems, about thought—while "The Fall of Hyperion" is more immediately felt. In this truncated epic-romance, Keats' focus shifts to the body, to the statuesque forms of the Titans and a ghostly, marmorealized image of the poet himself. As a poem of material contact with antiquity, "The Fall of Hyperion" explores the new nineteenth-century Hellenism of the "real."

In the first draft of his epic, called "Hyperion," Keats followed his own prescription to avoid the "deep and sentimental cast" that had brought such critical opprobrium on *Endymion*.[43] No poetic alter-ego is present and Keats' tone is majestically classical. Although this homage to the Miltonic tradition won a proportional amount of approval from critics, even from Byron, as a poetic style it proved unsustainable: "life to him [Milton] would be death to me," as Keats famously explained.[44] By abandoning "Hyperion," Keats rejected precisely what Haydon embraced in the Elgin Marbles, namely atavism: an opportunity to return to what Haydon called "the true beau-ideal." Keats is sufficiently sentimental to realize that a "true beau-ideal," like a "genuine antique," is a contradiction in terms: he perceives the impossibility of Haydon's project. Accordingly, as Tillotama Rajan has observed, his new draft of the epic "calls into question the possibility of a naive art."[45] Revising "Hyperion" as a romance, Keats recognized that after the glory of Athens, as after Milton, sentimentality was not a choice but a predicament. So, Keats abandons the naive "Hyperion" in April 1819 and attempts over that summer to integrate it into a more contemporary, sentimental idiom. As Geoffrey Hartman states, the transformation in style and

point of view between the two fragments—"Hyperion" and "The Fall of Hyperion"—marks the renewal of Keats'"feverish quest to enter the life of a pictured scene." Borrowing A.W. Schlegel's distinction between Romantic and classical poetics, Hartman defines Keats' lyric experience as "limited from the outset by the Greek and picturesque example. What perplexes his imagination is a mysterious picture rather than a mystery."[46] "The Fall" thus restores "Hyperion" to the ekphrastic mode of "On Seeing the Elgin Marbles for the First Time," the genre to which Keats returns also in the late museum odes.

In short, I read "The Fall of Hyperion," following Levinson and Scott, as an extended *ekphrasis* on the Elgin Marbles. "The Fall" is an epic museum dream-tour with the goddess Moneta as guide:

> "This temple, sad and lone,
> Is all spar'd from the thunder of a war
> Foughten long since by giant Hierarchy
> Against rebellion; this old Image here,
> Whose carved features wrinkled as he fell,
> Is Saturn's; I, Moneta, left supreme,
> Sole priestess of his desolation." (I:221-27)

In "Hyperion," the action unfolds in the dramatic present of the epic, with the poet set at an enchanted distance from his own text. In "The Fall," by contrast, the epic action is set back in an age "long since" passed. The fallen Titans become a museum exhibit, and the drama of the poem turns away from their heroic predicament to the modern romance of viewing them.[47] As Scott has explained, the frame narrative Keats introduces in "The Fall" effectively "museumizes" his own first attempt at the poem. The interpolations function as an ekphrastic commentary on the newly dismembered text:"The tableau that we first witnessed in *Hyperion* and that the poet failed to move into narrative is here memorialized, as if Keats has enshrined his own earlier text within the poem."[48] To reinforce this impression, the poem's action (or lack of it) unfolds through a sequence of loosely connected tableaux, as one might perambulate among sculpture exhibits in a museum:

> And still these two were postured motionless,
> Like natural sculpture in cathedral cavern;
> The frozen God still couchant on the earth,
> And the sad Goddess weeping at his feet
> .

> But for the main, here found they covert drear.
> Scarce images of life, one here, one there,
> Lay vast and edgeways. (I:85–88; II:32-34)

Keats gives the role of museum custodian to Moneta, who describes herself as the "sole priestess" of Titan "desolation." In Canto I, the frame narrative of the poet's dream and his meeting with Moneta occupy some 300 lines. Before the core text of the original "Hyperion" begins, we are told that Moneta keeps custody of Titan history in her brain. She will present the Olympian battle with the Titans to the poet through a process of cerebral projection not unlike a magic lantern show:

> "the scenes
> Still swooning vivid through my globed brain,
> With an electral changing misery,
> Thou shalt with these dull mortal eyes behold
> Free from all pain, if wonder pain thee not." (I:244-48)

The Elgin Marbles are "these wonders" in the sonnet "To Haydon," simply "wonder" here in "The Fall." In both instances, Keats associates the wonder of the marbles with pain: "So did those wonders a most dizzy pain"; . . . "if wonder pain thee not." Despite Moneta's promise, however, the poet *does* experience pain at the spectacle of the Titans' desolation. This outcome marks a revealing schism between expectation (Moneta's, that he shall be "free from all pain") and the event (the poet suffers great pain and prays for death). At this *dis*-junction, we have arrived at the defining psychological paradox of "The Fall of Hyperion." Why does the poet's experience of ancient myth at an imaginary museum produce a crisis of paralyzed wonder and pain? To answer this question, we need to follow Keats' allegorical museum tour ourselves.

The "chambers" of Moneta's skull conclude a series of ever diminishing architectural settings in "The Fall of Hyperion," contained within each other like Chinese boxes. The poet's account of his dream begins in a conventionally pastoral recess, "an arbour with a drooping roof" (25). The natural canopy of "trellis vines" and "larger bloom," complete with a "wreathed doorway," acquires a man-made solidity after the poet imbibes a "cool vessel of transparent juice," whereupon the fragrant bower is magically transformed into an "eternal domed monument":

> I look'd around upon the carved sides
> Of an old sanctuary with roof august,

Builded so high, it seem'd that filmed clouds
Might spread beneath, as o'er the stars of heaven.
So old the place was . . . (I:61-65)

For Schiller, historical consciousness distinguished modern, sentimental man from his ancient forebears. In this sentimental spirit, Keats here erects a symbol of post-lapsarian culture in the arcadian, *Endymion*-like present of the poem's beginning. The "domed monument" that emerges from the pastoral arbor marks the irruption of history itself into the hitherto undifferentiated time-continuum of the poet's dream. The hero is no longer a poet or "fanatic," but a modern historian eager to learn of the "high tragedy" of an ancient revolution. To do so, he enters a "temple" whose architecture suggests a nineteenth-century public building in Greek Revival style, such as the British Museum:

Turning from these with awe, once more I rais'd
My eyes to fathom the space every way;
The embossed roof, the silent massy range
Of columns north and south, ending in mist
Of nothing; then to eastward, where black gates
Were shut against the sunrise evermore.
Then to the west I look'd, and saw far off
An image, huge of feature as a cloud,
At level of whose feet an altar slept,
To be approached on either side by steps
And marble balustrade (I:81-91)

Passing then into the "dark secret Chambers" of Memory herself, the poet confronts a museum ensemble of "Image huge" and "fair statuary," "sculpture" and "large-limbed visions." After an initiation test reminiscent of chivalric romance, which requires him to ascend a marble staircase, he finds himself in the main gallery, "safe beneath this statue's knees."

The hero, for whom knowledge equals power, considers his "museum tour" nothing less than divine election. Initially, his expectations are fulfilled, as he gains visionary power similar to Apollo's in "Hyperion":

there grew
A power within me of enormous ken,
To see as a god sees, and take the depth

> Of things as nimbly as the outward eye
> Can size and shape pervade (I:302-6)

The poet identifies the visual, aesthetic intuition of "size and shape," such as one might have at a museum, with the experience of a godlike or imperial power. Against all expectations, however, an ekphrastic nightmare ensues. The poet finds himself the miserable captive of an unchanging dioramic exhibit:

> Long, long these two were postured motionless
> Like sculpture builded up upon the grave
> Of their own power. A long awful time
> I look'd upon them: still they were the same;
> The frozen God still bending to the earth,
> And the sad Goddess weeping at his feet,
> Moneta silent. Without stay or prop,
> But my own weak mortality, I bore
> The load of this eternal quietude,
> The unchanging gloom and the three fixed shapes
> Ponderous upon my senses, a whole moon. (I:382-92)

As we saw in the Elgin Marbles sonnets, the museum experience, for Keats, is not enlightening or liberating but oppressive. Here, the Parthenon sculptures suggest not life, breath, and animation but death itself:

> And every day by day methought I grew
> More gaunt and ghostly. Oftentimes I pray'd
> Intense, that Death would take me from the vale
> And all its burthens—Gasping with despair
> Of change, hour after hour I curs'd myself. (I:395-99)

Canova, Haydon, and Hazlitt were, in their rapturous approbation of the marbles, moved to elaborately aestheticized and anatomically precise descriptions. Keats finds in the statues an altogether different inspiration. The "Fall of Hyperion" contains not a critical account of statuary but impalpable images of muteness, paralysis, and blindness. The marbles represent not Haydon's new "beau-ideal" of Romantic naturalism but psychological crisis and interrupted cognition.

The poet's adventure begins with a deathly fantasy that is Keats' darkest ontological wish: marmorealization. He wishes to be turned to stone:

> suddenly a palsied chill
> Struck from the paved level up my limbs,
> And was ascending quick to put cold grasp
> Upon those streams that pulse beside the throat!
> I shriek'd, and the sharp anguish of my shriek
> Stung my own ears—I strove hard to escape
> The numbness, strove to gain the lowest step.
> Slow, heavy, deadly was my pace: the cold
> Grew stifling, suffocating, at the heart;
> And when I clasp'd my hands I felt them not. (I:122-31)

By risking and yet ultimately avoiding marmorealization, the poet at once desires and resists the inscription of his own body into the ruins. Following this near-death experience, however, his witness to the Olympian revolution in the theater of Moneta's brain degenerates from an exhilarating power-trip to a horrible bondage. He is literally teased out of thought and absorbed into the stony silence of the museum.

The florid excesses of *Endymion,* as Martin Aske has observed, served Keats as sculpturesque gestures of embellishment, as *literary* decoration of a virtual antiquity.[49] The "Fall of Hyperion," by contrast, is a product of Hellenism's visible, archaeological moment. Keats himself described the difference in a letter to Haydon in January, 1818: "In *Endymion* I think you may have many bits of the deep and sentimental cast—the nature of *Hyperion* will lead me to treat it in a more naked and grecian manner."[50] The sculptural metaphor Keats employs—whereby the *Hyperion* poems emerge as statuesque marble from the molded "cast" of *Endymion*—is highly suggestive of the development of his Hellenist poetics. Whereas classical texts in circulation since the Renaissance inspired Keats' imagery in *Endymion,* the two *Hyperion* poems belong to the archaeological Hellenism of the early nineteenth century. Its central characters, the fallen Titans, are museum pieces:

> remnants huge
> Of stone, or marble swart, their import gone
> Their wisdom long since fled. (I:281-83)

In short, if *Endymion* is a poem about love inspired by Keats' reading of Ovidian romance, the *Hyperion* poems are Phidian fragments inspired by his visits to the Elgin Gallery at the British Museum. Keats covers many similar episodes and psychological territory in the poems, but the thematic

emphases differ significantly. *Endymion*'s themes of love and longing are re-staged as power and dispossession in "The Fall of Hyperion." This reflects, I suggest, the reorientation of Hellenism in the Regency period from its private, literary, sentimental forms to a set of public visual-cultural icons symbolically charged with issues of imperial authority and ownership.

For Aske, Keats' Hellenist poetry out-sentimentalizes even Winckelmann with its arabesque substitutions for a lost antiquity. Contra Aske, I read "The Fall of Hyperion" as the stage on which Keats breaks out of sentimentalist ideology. Adopting the role of museum-goer and imperial subject, Keats abdicates his sentimental distance to confront antiquity as a material phenomenon rather than an imagined ideal. The prophetess Moneta, guiding the poet through a distinctly museum-like "cathedral cavern," promises him that "My power, which to me is still a curse / Shall be to thee a wonder" (I:243-44). The poet will experience "power" in the form of an aesthetic spectacle, a "wonder." Borrowing from the same logic, the British Parliament's purchase of Lord Elgin's collection in 1816 upheld the conviction that power is "more strong in beauty." His Majesty's Government, like Moneta in "The Fall of Hyperion," recognized the necessary substitution of "wonder" for "power" in the construction of imperial statehood. By placing this transaction under the threat of a "curse," however, Keats' failed epic challenges the ideological currency of the new, state-sponsored Hellenism whereby the British Empire claimed Greek art as a symbol of its manifest destiny. Moreover, the atmosphere of crisis in "The Fall of Hyperion" echoes the anti-visual culture sentiments of other Romantic writers I have explored in my first three chapters. As for Coleridge, who found his "mind become bewildered in the surrounding attractions" of the Regency theater, and Wordsworth trapped in the "lifelike mockery" of the panorama, the new visual-cultural space of the public museum is, for Keats, a scene of lyric "shock" that inspires misgivings about the future of the culture he inhabits, and with it the fate of poetry itself.

Keats proves consistent through his various poetic responses to the psychological impact of the marbles. The weight of mortality in "On Seeing the Elgin Marbles for the First Time" becomes the "burthens" of "Death" in "The Fall," where we find Keats anticipating Adorno's twentieth-century definition of the museum as a "sepulcher of works of art." In the de-historicized setting of the Elgin Gallery, Keats' marbles poems attempt to provide for the sheer emptiness of the ruins; their critical "desolation," as Moneta describes it; their sublime dearth of meaning. At the allegorical level of a guided tour, the narrative of "The Fall of Hyperion" describes how the modern museum's appropriation of ancient art objects comes at

the expense of a "curse." Keats shows that the experience of the imperial British subject at the national museum does not guarantee exhilaration but rather a melancholy anxiety deteriorating to paralysis and the throes of death. The relationship between the new visual-cultural Hellenism and imperialism, at least for Keats, hangs on these unforeseen affects. Preoccupied with the dissolution of sense and cognition, "The Fall" describes an ekphrastic encounter not with the glory of the past—or its idealization as art—but with *pastness* itself troped as Death. It evinces the potential of museum-going to degenerate from a diversionary exercise of the modern sentimental spirit to an annihilating encounter with historical difference. In "The Fall," the Elgin Marbles represent antiquity as a palpable, sensual, but unreadable object that "the outward eye / Can size and shape pervade" but the mind cannot comprehend.

The fragmented Parthenon statues, by virtue of their disaggregation from an original whole, disallow Keats the theoretical "restorations" of Winckelmann. In a parallel fracture of the idealist mold, the presence of actual Greek fragments in the British Museum proscribe for Keats the strategies of sentimental distancing we observed in Diderot and Schiller. Neither fantasy—be it the idealizing power of theory or romance—can be properly sustained by a museum observer of the Elgin Marbles in 1817. In terms suggested by Friedrich Schlegel, the museum-goer's constructive desire for unity and coherence in the art object—the frustration of which is the explicit subject of "Ode on a Grecian Urn"—breaks down in the face of the insistent, visible thinghood of the marble fragments, their resistance to formalization, their aura of the "real."[51] As the fragment of an epic whole in the classical Miltonic style, Keats' "Hyperion" assumed the iconic form of its ruined and dismembered subject. But "The Fall of Hyperion," as the romantic dramatization of a museum tour, draws us even deeper into the tensions endemic to modern institutional Hellenism. By examining the marbles' fate under the conditions of museum display, with himself as hero-narrator, Keats ventures upon the *lieu péril* Diderot described between antiquity and the modern world. In so doing, he transfers the pathetic spectacle of antiquity to himself, entering the museum display of Titan despair in order to experience their loss as his own.

As a critique of visual-cultural Hellenism, the poet's protracted mesmerization before the spectacle of antiquity in "The Fall of Hyperion" offers a counter-image to the sentimental "rapture" Joseph Severn memorialized in his portrait of Keats. For Severn, the transcendent quality of the poet's expression resonated powerfully with the Romantic spirit of the ruins. In "The Fall of Hyperion," by contrast, the poet resembles the mar-

bles not in beauty but in an attitude of deathly torpor: "And every day by day methought I grew / More gaunt and ghostly" (I:395-96). The poet's profound despondency before the Titan memorial ironizes the Romantic fascination for antiquity. It is also a negative image of the Hegelian idea of history circumscribed by the state and its institutions. The dreaming poet encounters the state museum not as a representation of national heritage or destiny, nor even of the dead, but as *the death of the living* in the experience of antiquity as an institutionalized object. In both the Elgin Marbles sonnets and "The Fall of Hyperion," Keats complains of the "pain" caused by the "wonder" of antiquity. The poet experiences the statues' implacable resistance to idealization as a kind of "curse" or shock, manifest not only in mental "anguish" but physical "pain" and disintegration. This anguish is most evident in the dreamer-poet's doomed fantasy of incorporation with the Parthenon marbles: his writing himself into the scene of Titan despair only reinforces his own. Allegorically speaking, "The Fall of Hyperion" shows how the imperial project of self-representation through an aestheticized Greece—which in Regency England took the form of a national museum of antiquities—produces at the same time its own critique. As Diderot perceived in the paintings of Robert, the ruins of antiquity foreshadowed the transience of all imperial dominion.

To conclude: the installation of the Elgin Marbles at the British Museum transformed the representation of antiquity in the Romantic mind. In the age of the museum, Ancient Greece was no longer an imagined, readerly ideal to be enjoyed in private—an experience Keats records in "On First Looking into Chapman's Homer"—but a material, visual reality displayed in a public space. Hellenism's shift from an academic pursuit of connoisseurs and scholars to an object of visible wonder in a public museum carried with it the political implications of state sponsorship. Chapman's translation of Homer might not have constituted cultural theft but, as Byron so persuasively argued, Lord Elgin's removal of antique statues to a foreign museum could properly be viewed that way. Keats' poetic responses to the Elgin Marbles never had the devastating political impact Byron's enjoyed, and continue to be misunderstood as conventionally idealist. But for Keats, the Elgin Marbles did not herald a new dawn in European civilization, as Haydon declared; they were, rather, empty of meaning—negative signifiers of modernity's radical difference from the ancient world. The enlightenment science of archaeology promised to make antiquity come alive for the Georgians, but by dramatizing the crisis of knowledge, identity, and political ethics endemic to the modern museum, Keats inserted death into the new Hellenist equation. Faced with

the immobility and muteness of archaeological ruins, Keats' marbles poems confront an antiquity void of sentimental possibility. The psychological affect of historical difference at the Elgin Gallery is not Schillerian melancholy, but the "shock" of antiquity's return from the grave: its incarnation as the visible, material "real" of Pericles' Athens.

With the arrival of the Elgin Marbles in England, Keats came to associate Hellenism less with literary romance and more with the visual experience of the museum. *Endymion's* pastoral flights of fancy subsequently give way to the historical project of "The Fall," where the poet is no longer an enchanted lover but a conscientious seeker of knowledge. Giving voice to Keats' change of attitude, Moneta condemns the Romantic dreamer who "venoms all his days" and "vexes" the world with poems like *Endymion*. But even in the epic-historicist mode of "The Fall of Hyperion," Keats' marbles fail to speak to a greater historical or aesthetic ideal. The descriptive category of "fragment" shared by both the poem and its subject renders them both potentially unreadable. The sentimental poet's hoped-for auratic exchange, whereby the ancient ruins return his romanticizing gaze, is not realized. Keats experiences instead the British Museum as a mausoleum: where the glory of antiquity neither returns as a sentimental ideal, nor symbolizes the imperial destiny of the nation, but tells a profoundly alien history and threatens, at any moment, to assume the powers of a Medusa.

Mourning the Marbles, or
The Strange Case of Lord Elgin's Nose

Keats scholars have customarily distinguished imagery from theme in "Hyperion," the one traceable to the British Museum, the other to Keats' reading list at the time: the enlightenment historicism of Gibbon and Voltaire. Stephen Larrabee's landmark study, *English Bards and Grecian Marbles* (1944), typifies the former. Larrabee relates the sculptural imagery of the poem to Keats' aesthetic interest in the Elgin Marbles. More recent readings, by contrast, nominate Oceanus' stirring apologia for Whiggish history in Book II of "Hyperion" as the thematic core of the poem.[52] This in turn has produced a number of programmatic "historical" readings. For Alan Bewell, Apollo in "Hyperion," Book III represents Napoleon. For both Bewell and Theresa Kelley, Keats' supposed aesthetic distinctions between Egyptian and Greek iconography in the poem, mapped onto the conflict between the Olympians and the Titans, translate to greater world-historical categories.[53] According to Kelley, a reformed and democratic

Europe, represented by the Olympians, replaces the feudal order of the
Titans in the same way that the Athenian *polis* superseded the primitivist
absolutism of Egypt: hence Hyperion's likeness to "the bulk / Of Mem-
non's image at the set of sun." As Oceanus states in Book II, "We fall by
course of Nature's law, not force / Of thunder, or of Jove" (181–82). The
sun is setting on the Titan epoch in "Hyperion" as it did on the Egyptians,
by a process of historical necessity. The difficulty for such a reading is the
question of where Keats' political sympathies lie. He seems improperly fas-
cinated with the fallen Titans, or "Egyptians." Either way, such readings
obscure the politics of the marbles themselves as cultural objects, granting
them ideological significance only insofar as they can be substituted for
familiar historical terms like the French Revolution, Napoleon, or the
Pharaohs. No critic has addressed the question raised in my reading of
"The Fall of Hyperion": namely, what the politics of Keats' looking at the
marbles, qua marbles, might be.

In "Hyperion," Keats takes up the mythological tale of war among the
Gods at its dénouement, focusing on the psychological abjection of the
vanquished Titans. A poem nominally about revolution becomes a post-
revolutionary epic: a meditation on statelessness. Thea tells Saturn,

> heaven is parted from thee, and the earth
> Knows thee not, thus afflicted, for a God;
> And ocean too, with all its solemn noise,
> Has from thy sceptre pass'd; and all the air
> Is emptied of thine hoary majesty. (I:55–59)

Keats subsequently lingers in the Titans' desolate vale for over seven hun-
dred lines. Everything in this first book of "Hyperion"—power, empire,
beauty, life, authority, identity—is longed for without being present:

> Upon the sodden ground
> His old right hand lay nerveless, listless, dead,
> Unsceptred; and his realmless eyes were closed (I:17–19)

The language of "Hyperion" implodes in the descriptive hollow of Sat-
urn's dispossession. Nerveless, listless, unsceptred, realmless . . . the
sequence of epithets, with their negative tags, do not paint a picture as
much as echo the dreadful emptiness of the scene. In the *Abgrund* of the
shady vale, power emerges as an idea by virtue of its absence. The poem

wanders through this vacuum recording the Titans' meditations on author-
ity—both their own that is lost and the Olympians' that is unseen:

> tell me, if this wrinkling brow,
> Naked and bare of its great diadem,
> Peers like the front of Saturn. Who had power
> To make me desolate? whence came the strength? (I:100-103)

With the arrival of the still-splendid Hyperion at the end of Book II, Keats
provides a formula for the hitherto obscure relation of knowledge and
power in the poem. Hyperion appears to the demoralized Titans as "a vast
shade / In midst of *his own brightness*" (my emphasis). Deep in the vale of
Titan defeat, power belongs to him who creates the light by which he sees.
Hyperion's enlightenment is a product of his power, not the other way
around. As we have seen, the same logic applies to the modern national
museum, a defining institution of the Enlightenment that claims the light
of knowledge as a natural symbol of state power.

In Book III of "Hyperion," Keats shifts attention from the Titans to the
Olympian Apollo, but in an unexpected vein. Most critics have identified
Keats himself with the "gifted," nascent God of the Sun in Book III.
Harold Bloom, in an influential reading, has linked Apollo's conflicted atti-
tude toward his apotheosis with Keats' anxieties over the legitimacy of his
own poetic ambitions.[54] Others have taken it less seriously. W. J. Bate, for
example, dismisses Apollo's "melancholy" self-doubt as an unfortunate
return to the effeminate mewling of *Endymion*. More recently, Marjorie
Levinson has organized an entire reading based on Book III's putative
"badness." Whatever its poetic merits, Book III announces Apollo as its
"golden theme"; but the subsequent mood is strangely despondent. The
incipient God finds himself inexplicably struck down by torpor and
melancholia. In *Endymion*, such symptoms derived from lovesickness; here
the themes are power and dispossession:

> For me, dark, dark,
> And painful vile oblivion seals my eyes:
> I strive to search wherefore I am so sad,
> Until a melancholy numbs my limbs;
> And then upon the grass I sit, and moan,
> Like one who once had wings.—O why should I
> Feel curs'd and thwarted, when the liegeless air

Yields to my step aspirant? why should I
Spurn the green turf as hateful to my feet? (86-94)

At first blush, Apollo's feeling "curs'd" and "thwarted" suggests a frus-
trated expectation of apotheosis. But this proves not to be the case. The
reader confronts instead the barely credible scene of Apollo's "melancholy"
at the prospect of divinity. The idea of apotheosis is "hateful" to him and
he "spurn[s]" it. Apollo's demoralized state in Book III of "Hyperion"
echoes Keats' chariness toward god-like privilege in the Elgin Marbles son-
nets. But what are we to make of Apollo's dire lassitude in "Hyperion" and
the paradoxical conjunction he embodies: divine election and the enerva-
tion of a curse? Apollo's ill-omened coronation culminates in a near-death
experience, in which he crosses and re-crosses the boundary between life
and oblivion:

Soon wild commotions shook him, and made flush
All the immortal fairness of his limbs;
Most like the struggle at the gate of death;
Or liker still to one who should take leave
Of pale immortal death, and with a pang
As hot as death's is chill, with fierce convulse
Die into life: so young Apollo anguish'd (124-30)

Apollo's dying into life is profoundly paradoxical: he attains immortality
through the humanizing instruction of death. Inevitably, given Apollo's (and
Keats') misgivings, the moment of divine investiture is interrupted. Keats
rejects the spectacle of imperial election except in a virtual state where it
resembles death. He is interested in the Hyperion myth, as he was in
Endymion, only so far as it embraces his preferred psychological territory:
loss, self-dissolution, visionary limits, and the nature of human feeling in
extremis. That is, the story of Apollo's election in Book III provides Keats
another opportunity in his poetry to explore the borders of life and death, in
particular the impalpable notion of the dead crossing into life. When called
upon to describe Apollo as an incarnate Olympian divinity, however, the epic
task is suddenly no longer to Keats' taste (or within his power) and he leaves
off, abandoning Book III and "Hyperion" as a whole after some 130 lines.

Apollo's desperate appeal to discover the locus of authority among the
post-revolutionary ruins—"Where is power?"—clarifies the link I have
suggested between Keats' Elgin Marbles sonnets and the two *Hyperion*
poems. Like the museum-going poet of the sonnets, Apollo in "Hyperion"

undergoes a crisis of confidence in which the prospect of godlike power is deflating and appalling. Significantly, Apollo never becomes a God. As in the Elgin Marbles sonnets, where Keats resisted the "godlike hardship" of engineering the sublime, there are no legitimate divinities in "Hyperion," only once and future gods. In short, Keats identifies with Apollo not as a poet, as Bloom claims, but as a frustrated imperial subject. Apollo's deathly apotheosis marks an ambivalent understanding of worldly power, and the price of dominion, for Keats in "Hyperion," is self-identity. Apollo remains uncreated and his imperial subjectivity is measured by that incomplete transformation. Mnemosyne puts the problem to the languishing Apollo: "Is't not strange / That thou shouldst weep, so gifted?" This affective paradox—the disjunction between what *should be* and what *is* the experience of imperial election—is "Hyperion's" great ideological problem. The implication of Mnemosyne's query is that power, not knowledge, is the poem's first and final term, and its most intangible commodity. Knowledge is verifiable, but power cannot be finally authenticated.

With the paradox of Apollo's imperial election in "Hyperion" in mind, this final section of my chapter on Romantic Hellenism proposes a connection between poetry and history: between Keats' melancholic account of the British Museum in his two *Hyperion* poems, and the psychological history of the man who acquired the Parthenon marbles as its prize and defining exhibit. Lord Elgin's antiquarian career in Athens resonates suggestively with my speculative reading of Keats' marbles poems, in particular the link between imperialism and pathology that they propose. The confounding mixture of imperial power and psychological crisis we find in the figure of Apollo in "Hyperion" Book III is echoed in Elgin's troubled quest for souvenirs of Athenian glory, and will shed new light on his disputed place in the British imperialist legacy. In short, Elgin *is* Apollo, a real-life Regency figure of Keats' melancholy god in "Hyperion." As Byron perceived, and dramatized so devastatingly in his satire "The Curse of Minerva," Lord Elgin, British Special Ambassador to the Ottoman Empire from 1799-1803, likewise experienced the "gift" of imperial power as a form of "curse." Furthermore, in his implacable desire to acquire fragments of the Acropolis for himself, Elgin follows Keats in abdicating the sentimental distance so studiously preserved by Winckelmann, Diderot, and Schiller. In place of their critical fantasy of a lost Hellenic ideal, Elgin substitutes the imperial-bourgeois fantasy of possession. By crossing the boundaries of Romantic Hellenism (as it was then constituted), Elgin the collector, like Keats the poet, moved into an untheorized space, toward an encounter with the material "real" of antiquity itself. As in Keats' marbles poems, we

will discover that the price Elgin pays for transgression beyond the safe-guards of Schillerian sentimentality is high. In the strange case of Lord Elgin, the pleasurable, even exquisite melancholy enjoyed by Schiller, Winckelmann, and Diderot in their meditations on antiquity—as some-what rarefied excursions of the Hellenist intellect—transforms itself into a more visceral work of mourning, experienced through the body. For Keats in "The Fall of Hyperion," the nightmarish fate of the modern museum subject was marmorealization, a turning to stone. Lord Elgin, as we shall see, suffers a similar fate in Byron's "The Curse of Minerva"; but beyond the merely fictional theater of poetic allegory, he experienced also a real-life curse of emasculation, concluding in his very personal, bodily "ruin."

In the winter of 1808, Lord Elgin was better known as a cuckold than a col-lector of antiquities. His wife, Mary, faced the Edinburgh courts on a charge of adultery, with their compatriot and neighbor, Robert Fergusson, named as co-respondent.[55] According to witnesses at the trial, Elgin's busy diplo-matic schedule as ambassador to the Ottoman Empire from 1799-1803, securing British interests against Napoleon in the Near East, had put great strain on the marriage. But it was not this neglect, common enough in a man of Elgin's class and position, which determined his wife's disaffection. Elgin's ill-health, specifically a degenerative infection concentrated in his nose, prompted Lady Elgin to refuse her husband's conjugal privileges and ultimately leave him. The court transcripts make for interesting reading:

—Mr. Hamilton, would you say that this withdrawal [of affection] on the part of Lady Elgin was due to a definite reason?
—Yes. While in Constantinople, Lord Elgin contracted a severe ague which consequently resulted in the loss of his nose.
—Mr. Hamilton, would you say that her Ladyship's interest in Lord Elgin began to wane at this point?
—Yes.[56]

The uproar in the public gallery at this revelation was repeated when the prosecutor asked Elgin's secretary, John Morier, to describe the change in Lady Elgin:

—In the beginning she was a most affectionate wife and mother.
—Do you mean to say that her Ladyship's conduct changed?
—Yes.
—When exactly?

—As Lord Elgin's affliction became more serious.
—You are referring to the loss of his lordship's nose?
—I am.[57]

Unsurprisingly, there are no portraits of Lord Elgin in later life, and we can rely only on Lady Elgin's letters and a few inconclusive doctors' reports for our assessment of Elgin's condition. It seems sure, however, that a wasting disease of dubious origin had eaten away a considerable portion of his face.

A clue to Elgin's malaise emerges some years after the Elgin Marbles were installed in the British Museum, and the furor surrounding their purchase had died down. Thomas Medwin, in the margins of his own copy of the *Conversations,* records the following couplet related to him by Byron:

> Noseless himself, he brings home noseless blocks,
> To show what time has done and what—the [pox]. [58]

To attribute Elgin's condition to syphilis accorded with popular medical notions of the time. Without any means of verifying Byron's diagnosis, I nevertheless wish to pursue his insinuation that Elgin's personal problems—his bad health and bad marriage—constituted a central motive for his extravagant passion for antiquities while British Special Ambassador to the Turkish Empire.

It was Byron's attacks on Elgin in 1811-12 that first set the terms for contemporary debates over British cultural imperialism. In canto II of *Childe Harold's Pilgrimage* and "The Curse of Minerva," he established a connection between the aesthetic and the political, between the aristocratic Hellenism of the Society of Dilletanti and British political interests in the Mediterranean:

> Then thousand schemes of petulance and pride
> Dispatch her scheming children far and wide,
> Some East, some West, some everywhere but North,
> In quest of lawless gain they issue forth.
> And thus, accursed be the day and year!
> She sent a Pict to play the felon here! ("Curse" 143-48)

Using the recently arrived Elgin Marbles as a political symbol, Byron sought to expose Elgin's professed curatorial concern for Athenian antiquities as a fraud. For Byron, the idea of an enlightened mission to "save" the marbles simply rationalized the avaricious exercise of British political

power. It was not the ravages of time or war that was antiquity's nemesis in this case, but imperial greed:

> here thy temple was
> And is, despite of war and wasting fire,
> And years, that bade thy worship to expire:
> But worse than steel, and flame, and ages slow,
> Is the dread sceptre and dominion dire
> Of men who never felt the sacred glow
> that thoughts of thee and thine on polish'd breast bestow. (3-9)

Representatives of the British Empire, such as Elgin, lacked aesthetic sensibility—they "never felt the sacred glow"—and in a cutting ironic inversion, Byron condemns these self-appointed agents of civilization as the worst of barbarians.

Byron's polemical powers notwithstanding, it was the prospect of the investment of taxpayer's money that generated intense public interest in the marbles in 1815-16. Because of the huge debts he had incurred in transporting them to England, Lord Elgin found he could not afford to preserve the marbles as a private collection, nor was his asking price within reach of other connoisseurs. His only recourse was the public purse.[59] With Elgin's application to the Parliament, the line between public and private interest in the arts, a historically forbidding one in Britain, was crossed. The anxiety of that transgression is evident in the 1816 Select Parliamentary Committee Report on the marbles. Influenced by Byron's criticisms of Elgin, the committee agonized over the circumstances under which he had acquired the collection, now available for purchase by the state: Were Lord Elgin's adventures as a connoisseur of antiquities facilitated by his position as Special Ambassador? Could he have convinced the Turks to allow him to dismantle large sections of the Parthenon without this authority? In short, did he act as a British emissary or private collector? If the former, was he guilty of abusing his privileges as a representative of His Majesty's Government? And if the latter, under what obligation did the government now lie to buy his marbles?

In ultimately vindicating Elgin, the Select Committee Report represented the Periclean golden age as the model for Britain's own cultural destiny, and by extension Elgin as a servant of that destiny:

> In contemplating the importance and splendour to which so small a republic as Athens rose, by the genius and energy of her citizens . . . we learn from history and experience that free governments afford a soil most suitable to

the production of native talent, to the maturing of the powers of the human mind and the growth of every species of excellence, by opening to merit the prospect of reward and distinction, no country can be better adapted than our own to afford an honourable asylum to these monuments of the school of Phidias, and of the administration of Pericles; where secure from further injury and degradation, they may receive that admiration and homage to which they are entitled, and serve in return as models and examples to those, who by knowing how to revere and appreciate them, may learn first to imitate, and ultimately to rival them.[60]

The Select Committee Report effectively nationalizes the Parthenon sculptures. The imperial aspirations of the British state discover, in the Elgin Marbles, the form of ancient glory. That is, the Hellenist enthusiasm of the committee represents not an enlightened discovery of Ancient Greece as much as its invention as a cultural metaphor, an ideal to which the British state might then lay claim as the natural heir and custodian of Athenian "genius." The "admiration and homage" accorded the Athenian republic reflect Britain's own entitlement "to imitate and ultimately rival" it.[61] In *Childe Harold,* however, it was precisely this aesthetic-historical exchange between the "free governments" of Periclean Athens and Regency England that Byron exposed as the imperial fantasy of those who understood neither aesthetics nor history—"of men who never felt the sacred glow." For Byron, the state-sponsorship of Hellenism was a license for cultural exploitation.

Although Elgin was ultimately disappointed, indeed ruined, by the remuneration Parliament offered him (the thirty-five thousand pound payment was less than half the expenses he incurred bringing the marbles to England), the Select Committee resolved the dispute over the aesthetic merit of the Parthenon sculptures. In the Regency period, fragmented and decayed structures were established elements of landscape aesthetics. No fashionable estate could be without its picturesque ruin. But in 1816, stylized deterioration was not a *sculptural* aesthetic. Icons of neo-classical taste such as the Apollo Belverdere and Laocoön, largely pristine and intact, were the unchallenged masterpieces of the art. At the Select Committee hearings, the connoisseur Richard Payne Knight accordingly invoked the example of these Roman sculptures when criticizing the Parthenon marbles' "state of preservation [which] is such I cannot form a very accurate notion; their surface is gone mostly . . . they are so mutilated I cannot say much about them."[62] A similar preoccupation with the "mutilated" state of the marbles is evident in Elgin's own testimony to the Select Committee, in which he claimed that his interest in the Parthenon had at first been purely

academic. He intended only to have sketches done and plaster molds made, to be put at the disposal of the Royal Academy for the encouragement of a British school of neo-classical art. Only when he observed the apparent desecration of the marbles at the hands of the Turks, Greeks, and European (mostly British) tourists did Elgin decide to remove them. "Every traveller coming," he explained to the committee,

> added to the general defacement of the statuary in his reach: there are now in London pieces broken off within our day. And the Turks have been continually defacing the heads. . . . It was upon these suggestions and with these feelings, that I proceeded to remove as much of the sculpture as I conveniently could; it was no part of my original plan to bring away anything but my models.[63]

The sincerity of Elgin's conservationist concern is questionable. But beyond the familiar debate over conservation versus imperial avarice lies a more unfathomable set of questions. While the Acropolis was a well-marked site on the grand tours of the early nineteenth century, it did not enjoy the exalted cultural reputation it later acquired. Why then would Elgin sacrifice his career, marriage, and endowment for little known statues Byron dismissed as "Phidian freaks?" Why would a newly married man with responsibility for a large estate, a rising star in the Foreign Office with a reputation for careful dealing, sign away notes for thousands of pounds he knew he could not cover, all for what many considered inconsequential rubble?

So tenacious was Elgin's commitment to the marbles that over ten years of diplomatic wrangling with the Turks, quarreling and sabotage among his archaeological team, and spiraling costs, he never showed any sign of giving up the whole improbable enterprise. The nationalist-political arguments that still swirl around rightful ownership of the marbles have never addressed this personal question of Elgin's motives: why a middle-ranking British peer with no association with any artistic society and no previous interest in connoisseurship would develop such a passion for imperiled antiquities. It is an especially confounding case because Elgin enjoyed no official support, either financial or logistical, for his excavations. "I have not failed to write at various times," his lieutenant in Athens, Lusieri, wrote to him in 1806,

> according to Milord's instructions to all the persons who had ought to be interested, but without the least profit. For the last two years there has been a very considerable cargo, which is steadily increasing, and amounts to 40 cases, ready to be put on board. . . . They ought to be exported from here.

I have advised it many times to the ministers, to the British ambassadors at the Porte, I have written about it often to Mr. Ball at Malta, to Mr. Hamilton, but so far nobody takes any interest. It seems to me that all these gentlemen who ought to favour this acquisition, do not want to take part in it.[64]

John Galt's mock-heroic trifle, the "Atheniad," which Byron saw in manuscript form while in Greece in 1810, exploits the official embarrassment over Elgin's mania for collecting. He has Elgin ("Brucides") turned mad by a vengeful Minerva, and fired from the Foreign Service. His diplomatic correspondence filled with antiquarian jabberings, Elgin loses his post as well as his mind:

> Revenge she seeks by various means and ways,
> Inspires his pen, and strikes his brain with craze.
> Delirious fancies that were never thought,
> Helpless Brucides innocently wrote.
> From the charm'd pen a strange perversion springs,
> He thinks of statues and it writes down kings;
> Basso-relievos occupy his brain,
> While towns and armies fill the paper plain:
> His doom at length the froward pen provokes,
> For British statesmen, writing marble blocks . . .
> With canvas wings the fiat leaves the shore—
> The man exists, the minister's no more. [65]

When critics of Elgin refer to his motives at all, it is presumed, following Galt, that they were typical of a fashionable delirium for antiquities or, following Byron, that they belonged to a systematic policy of cultural imperialism sponsored by the British government. But Elgin's lack of antiquarian credentials, as well as the persistent refusal of the Foreign Office to support him, suggests that he was neither a typical collector of antiquities nor a creature of Britain's dark imperial designs.

Even Byron's first response to Elgin's adventures in Athens, from 1809, was not the moral outrage of Childe Harold II and "The Curse of Minerva," but scorn and bewilderment at the sheer quixotry of his enterprise:

> Let Aberdeen and Elgin still pursue
> The shade of fame through regions of Virtu;
> Waste useless thousands on their Phidian freaks,
> Mis-shaped monuments, and maimed antiques;

And make their grand saloons a general mart
For the mutilated blocks of art. ("English Bards and Scotch Reviewers"
 l.1027-32)

The emphasis here is not on the political questions raised by Elgin's activities but on his huge financial outlay, which for Byron and most other observers bordered on lunacy. There was no precedent for the scale of what Elgin had undertaken in Athens and no obvious compelling reason for the marbles' removal. According to one biographer, even after Elgin's return to London in 1808 he "seemed to have no clear idea of what he actually wanted to do with his Marbles."[66] Indeed, it was Elgin's own lack of purpose as much as government indifference that determined the marbles' forlorn and transient residency in London from 1808 to 1816.

Elgin only began to claim the rewards due to a patriot and cultural benefactor when he realized that he was bound to give up his prize for sale. Initially, he intended his collection of antiquities to furnish his new mansion at Broomhall. Writing to Luisieri in 1801, Elgin first instructs him only "to look out for some different kinds of marble that could be collected together in course of time, to decorate the hall (in the manner of the great Church at Palermo) with columns all different one from another, and all of fine marble."[67] As yet, Elgin is not fixated on the Parthenon; Lusieri is to undertake only a desultory kind of collecting, carried out "in course of time." Just fifteen months after this letter, however, Elgin has developed a far more serious passion for the marbles: "If I had still three years, and all the resources I have had, I would employ them all at Athens. I beg you to convince yourself fully of this impression—especially in relation to objects that can be transported . . . pursue as far as you can the digging all round the temple, to find some further fragments of frieze, and some ornament. . . . I beg you therefore to put some on board ship. To sum up, the slightest object from the Acropolis is a jewel."[68] One of the many setbacks Elgin faced in the transportation of the marbles to England was the loss of his brig, the *Mentor,* off Cerigo in September 1802. It cost six thousand pounds and many months to retrieve the marbles from the bottom of the Mediterranean. In a letter to the British consul in Cerigo at that time, Elgin makes a startling admission: "the cases contain *stones of no great value in themselves,* but it is of great consequence to me to salve [sic] them." (my emphasis)[69] In 1802, it seems, the marbles had not yet assumed the powerful cultural-symbolic status Byron will grant them a decade later in *Childe Harold* II. Nor is their market value certain. They are still very much Elgin's *personal* obsession; but exactly what kind of value they have for

him—aesthetic, symbolic, or emotional—is unclear. Seven years later in 1809, after imprisonment in France and a traumatic divorce, and with his debts mounting beyond all hope of recovery, Elgin's antiquarian fever had still not abated. At news of a delay in the shipment of yet another load of sculptures, Elgin, writing again to Lusieri, appears desperate:

> Heavens! Why the delay? How, at a time like the present, can you believe in the possibility of a lasting peace? What is the use of the cruel experience we have had already? For the love of God, don't lose another instant, *whatever the cost*. Take any ship you can possibly get either from Smyrna or Malta, to get the things into a place of safety. When you have once made them secure, then we will go forward with more confidence and calmness. But remember all I have suffered for the last six years. . . . I [will] send you all the means you can desire, or that I can procure for you.[70] (my emphasis)

Elgin's archaeological enthusiasm now takes on the rhetoric of martyrdom, of "suffering" and the lessons of "cruel experience." The artworks themselves are only items to be "secured." The noble ideal of cultural salvage has all but disappeared, replaced by a desperate fear of loss and betrayal. The dilettante project of interior decoration has likewise given way to a far more psychologically vital mission.

For Elgin to have become obsessed with Greek statues is not unusual in the history of archaeology, nor is his courting opprobrium and disaster in pursuit of them; but that his obsession appears to have had no clear origin, purpose, or bounds, even to Elgin himself, merits examination. Elgin's modern biographer, William St. Clair, takes Elgin at his word: his motives were the preservation of the marbles in equal measure with a patriotic "ambition of improving public taste." Karl Meyer, in his sympathetic account of Elgin in *The Plundered Past* (1973), attributes mixed motives to his excavations, a "blend of disinterest and avarice."[71] Richard Cottrell also thinks Elgin's motives "curiously mixed: part sentiment, part science, and part private emotion. The intended destination was Scotland—the family's Broomhall estate in Fife; and the emotional element was the desire to please a wayward wife, a young lady who already had everything, and was shortly to enjoy even more in the form of another husband."[72] To acknowledge the "emotional element" behind his antiquarian career, particularly the effect of his marital problems on its dramatic intensification after 1802, is to restore the personal history of Lord Elgin to the politics of the marbles affair. That is to say, viewing Elgin's professional and personal travails together, a suggestive historical coinci-

dence emerges. The eight years between the first and last of the above-quoted letters to Lusieri span the period of Lord Elgin's estrangement from his wife: from the initial appearance of his "syphilitic" nose ague to their divorce on the grounds of adultery. Significantly, Elgin's health and marriage problems arise after the 1801 letter with its modest antiquarian agenda, but prior to the later correspondence detailing his radically enlarged designs on the Parthenon.

Elgin's public humiliation at the sensational divorce trial of 1808 provided the fodder for Byron's assault in "The Curse of Minerva" and canto II of *Childe Harold's Pilgrimage*. These poems dramatize Elgin's dismantling of the Parthenon according to a characteristically Byronic brand of sexual politics, with Elgin cast as the ravisher from the North satisfying his impoverished desires on a helpless arcadia:

> Cold is the heart, fair Greece! that looks on thee,
> Nor feels as lovers o'er the dust they lov'd;
> Dull is the eye that will not weep to see
> Thy walls defac'd, thy mouldering shrines remov'd
> By British hands, which it had best behov'd
> To guard those relics ne'er to be restor'd.
> Curst be the hour when from their isle they rov'd,
> And once again thy hopeless bosom gor'd,
> And snatch'd thy shrinking gods to northern climes abhorr'd. (127-35)

This is archaeology as bad sex, for Byron the most damning of indictments. Later in the poem, he unfavorably compares the sexual credibility of the collector with the massive virility of his prize:

> While many a languid maid, with longing sigh,
> On giant statues casts the curious eye:
> The room with transient glance appears to skim,
> Yet marks the mighty back and length of limb;
> Mourns o'er the difference of now and then,
> Exclaims, "these Greeks indeed were proper men!" (185-90)

In "The Curse of Minerva," Elgin's divorce trial plays a more direct part in Byron's political allegory of the marbles affair. He characterizes Elgin's loss of his wife to his neighbor Ferguson as a revenge on the private man

exacted by Venus, goddess of love, for the sins of his public career, wrought
on Minerva's temple:

> Yet still the Gods are just, and crimes are crost
> See here what Elgin won, and what he lost!
> Another name with his pollutes my shrine:
> Behold where Dian's beams disdain to shine!
> Some retribution still might Pallas claim,
> When Venus half aveng'd Minerva's shame. (117-22)[73]

The most explicit reference to Elgin's marital scandal lies in the Latin
addendum to the poem: "Tu statuam rapias, Scote, sed uxor abest," which,
liberally translated, reads: "You may abscond with the statues, Scotchman,
but your wife has absconded too." For Byron, as for the public at large,
Elgin's prominence as an antiquarian was directly linked to his publicity as
a cuckold. In short, the Elgin of Childe Harold II and "The Curse of Mi-
nerva" is not the antiquarian knight-errant who appeared before the Select
Committee. Byron's Elgin instead plays the villain of a miniature revenge
tragedy in which his punishment, fitted to his crime of cultural rape, is to
pass his sexual and psychological corruptions onto his heirs:

> First on the head of him who did this deed
> My curse shall light, on him and all his seed:
> Without one spark of intellectual fire,
> Be all the sons as senseless as the sire. (163-66)[74]

As the *coup de grace,* Elgin is himself figured as an ancient ruin: "So let him
stand through ages yet unborn, / Fix'd statue on the pedestal of Scorn"
(207-8).

To erect Elgin as a degraded monument to those he has plundered is a
clever Byronic turn: he pre-empts the institutionalization of the marbles in
the British Museum by "museumizing" Elgin himself in a gallery of shame.
John Galt's "Atheniad" has as its climax a similarly Ovidian transformation of
Elgin into stone. After a veiled reference to Elgin's marital problems, Venus
commissions Cupid to attack Elgin as he sleeps and burn off his nose. As in
Byron's violent sexualization of the Elgin affair, the rapist becomes the raped:

> Malignant Cupid, glorying in his power,
> Follow'd Brucides to the secret bower,

And, in the crisis of extatic joy—
O direful woe! that Cupid should destroy,
Full at his forehead dash'd the flaming torch;
The nose defenceless perish'd with their scorch.
Like dead Patroclus on the funeral pyre,
His friends lamenting as the flames aspire.
The mortal feature was resolv'd to dust,
And left Brucides like an antique bust.

This scene of symbolic castration echoes the Byronic conceit of Elgin's transformation into a marble statue, and reinforces a thematic link between Elgin's antiquarian fervor, a sexual crisis, and his facial disfigurement. Emasculated by the god of love, Elgin is transformed into a mutilated "antique bust" from his own collection. Byron originally conceived a similar image for Elgin in *Childe Harold* II.13, as a "man distinguished by some monstrous sign." This may have been a pair of cuckold's horns, but more likely Elgin's grievously ruined face: the "perish'd" nose of Galt's poem, and signifier of Elgin's sexual disablement from syphilis.

With Galt's poem as a model, and the physical similarity between Elgin and the Parthenon sculptures in mind ("Noseless himself, he brings home noseless blocks"), Byron's statuary metaphor of Elgin "on the pedestal of Scorn" suggests a complex chain of psychological causes leading from Elgin's private humiliation to his public disgrace, from the loss of his nose through venereal disease to the sexual crisis of his wife's rejection and eventual adultery. By the irresistible logic of physical resemblance, Elgin's ruinous passion for Grecian statues in turn becomes an expression of these personal crises. The defaced Parthenon marbles find their living image in Elgin himself: "The mortal feature was resolv'd to dust / And left Brucides [Elgin] like an antique bust." We recall that Elgin emphasized to the Select Committee the statues' abused condition: "every traveller coming added to the general defacement of the statuary in his reach: there are now in London pieces broken off within our day. And the Turks have been continually defacing the heads. . . . " In the context of the Byron and Galt poems, Elgin's emphasis on the words "defacing" and "defacement" are at least as suggestive as his argument for rightful salvage. Elgin's overnight obsession with the "de-faced" statues of Phidias—inspired some time in 1802 by the trauma of his disintegrating nose and the sexual revulsion it provoked in his wife—suggests neither disinterest nor avarice, but a specific pathology.

We saw earlier that Schiller's definition of sentimentality—as the interiorization of loss—resonates suggestively with the terms of psychoanalysis.

The Hellenist passions of Lord Elgin, I suggest, may likewise be viewed retrospectively through a Freudian lens, as a "work of mourning." Following Freud's schema, the personal object-loss suffered by Lord Elgin—his nose and his wife—becomes an ego-loss, a crisis of identity. Elgin subsequently finds a symbolic mirror for his newfound deficiencies in the "de-faced" Parthenon marbles. In short, the affliction to his nose signified, both clinically and figuratively, Elgin's emasculation: the loss of sexual authority over his wife. Acquisition of the marbles—"noseless blocks" depicting idealized Greek manhood—was to compensate for his misfortune. As Freud defines it, mourning represents a split in the ego between its diminished present state and the shadow of its former wholeness. In Elgin's case, possession of the Parthenon statues promised a healing of this split—a reunion with his own marble "shadow"—and an end to the crisis of confidence brought on by his venereal affliction and broken marriage. Following this psychopathological model, Elgin's passion for the rescue of endangered antiquities is no longer for the objects themselves as much as for the act of recovery. For Elgin, acquisition of the Parthenon marbles promised to make good the loss of his nose and the series of other personal losses that overtook him as a consequence: his wife, his fortune, his career and even, as a final indignity, his seat in the House of Lords.

Further evidence of Elgin's pathological motives for collecting antiquities lies in his curatorial plans for the marbles. Though his final intentions for them were never thought through, Elgin was clear on one issue: he wanted the statues restored. The limbs and broken noses were to be replaced, the surfaces cleaned and planed. In March 1803, Elgin met with Antonio Canova in Naples for advice on restoration. Though Canova was horrified at the idea, his objections didn't deter Elgin from consulting the English sculptor, John Flaxman, on the same account four years later. Flaxman repeated Canova's profound misgivings over restoring the marbles, and threw out a figure of twenty thousand pounds as a projected cost, which he may well have thought to be the only way of putting Elgin off.[75] In short, Elgin included restoration of the marbles, in addition to their ownership, in his pathological working through of the disasters of his personal life. He would restore the marbles and through them, himself (ironically, the privileges of both ownership and restoration were ultimately denied him). In light of the psychologically loaded, symbolic value of the marbles for Elgin, his application to the British Parliament for recovery of his expenses represents far more than a mere tabling of accounts. Noseless and bankrupt, the "figure" of loss Lord Elgin presents to the Select Committee is not the financial outcome of his archaeological enterprise, but its psycho-

logical cause. Elgin's noselessness represents not only his sexual disablement and the cause of his broken marriage, but a pathological origin for his relentless pursuit of those antique statues he so closely resembled.

The Select Committee Report on the marbles acknowledged the singular nature of Elgin's situation in Greece. The British rout of Napoleon from Egypt in 1801 had made the Turks, as the traditional power there, "beyond all precedent propitious to whatever was desired in behalf of the English nation; they readily, therefore, complied with all that was asked by Lord Elgin. He was an Englishman of high rank, he was also Ambassador from our Court: they granted the same permission to no other individual."[76] As Ambassador in the Levant at a time of British ascendancy, Elgin enjoyed broad authority to pursue his newfound antiquarian passion. When his marriage began to fall apart, political opportunity converged with emotional need to inspire an "aesthetic" obsession with the Acropolis. Five years earlier or later, and Elgin would never have had his marbles. In short, a unique combination of personal crisis and historical chance—a particular man, time, and place—brought the Parthenon marbles to the British Museum. This Elgin is not Byron's imperial rapist, nor the enlightened cultural benefactor of Elgin's own imagining, but a British emissary whose emotional misfortunes found their consolation in a passion for antiquities and their expression in the arrogant exercise of imperial privilege.

Like Keats' Apollo in "Hyperion," Lord Elgin experienced his imperial "gift" in the form of a curse: "the curse," as Byron called it, "of Minerva," patron-goddess of the subject city of Athens. Viewing Elgin's career through the lens of "Hyperion" Book III, the British imperial fantasy of *becoming* Athens, expressed in the Select Committee Report of 1816, follows the trajectory of a failed apotheosis. Equally, like the poet-tourist of "The Fall of Hyperion," Elgin's empathetic fantasy of ancient statuary takes the form of bodily incorporation, visible to his contemporaries Byron, Medwin, and Galt as an uncanny physical resemblance: "Noseless himself, he brings home noseless blocks." In seeking to physically *possess,* rather than merely sentimentally admire the Parthenon marbles, Elgin transgressed the psychological parameters of Romantic Hellenism established by Schiller, crossing into an untheorized space—modernity's *lieu péril*—that no one on either side of the two-centuries old Elgin Marbles debate, excepting Keats, has charted. Beyond the sentimental pleasures of classical ruins, for both Elgin and Keats, lies the specter of ruin itself. Together, Elgin's story and Keats' poems constitute a cautionary critique of the museum's role in modern visual culture. The temptation to embrace antiquity as a symbol of one's own destiny, they suggest, represents a mor-

tal psychological danger to the Romantic Hellenist, who may just get what he wishes for.

Ultimately, the personal and the political in the Elgin affair must resist unraveling. In his decade-long obsession with the removal of the Parthenon marbles to Britain, Elgin sought to put a face to his melancholy condition, both physical and emotional. But he found in the disfigured statues he so coveted only the image of his own loss, a reflection of his emasculated self that he nevertheless set about, with an implacable will, to redeem, whatever the cost: "See here what Elgin won, and what he lost!" Today, there is little mention of Lord Elgin in the British Museum or any of its publications.[77] The gallery devoted to his ambiguous posterity, the Elgin Room, was renovated and renamed the Duveen Gallery in 1939. The political erasure brought about when the British Parliament decreed the statues to be no longer Phidian or Greek but "Elgin's Marbles" is now itself barely visible. Less visible, indeed not recognized since Byron, is the personal image of Lord Elgin himself among the ruins: a "fix'd statue on the pedestal of Scorn."

Chapter 5 ◡ゆ

ILLUSTRATION TOURISM PHOTOGRAPHY

Courons vers l'horizon, il est tard, courons vite,
Pour attraper au moins un oblique rayon!
 —Baudelaire, "Le Coucher du Soleil Romantique" (1862)

"So Late in the Season":
Turner, Fox Talbot, and the Illustration of Scott

In December 1833, Charles Lamb received a volume of poems by his friend Samuel Rogers. Entitled *The Pleasures of Memory,* it featured illustrations by the most eminent book artists of the day, J. M. W. Turner and Thomas Stothard. Lamb delighted in the poetry but balked at the accompanying pictures. In chapter 1, we saw that Lamb rated the aesthetic experience of *reading* a Shakespeare play above its representation at the theater. Reading Rogers' poems, the intrusion of visual images on the poetic text likewise upset his Romantic sensibility. In a sonnet he subsequently published in the *Times,* Lamb deplored the degrading effect of illustration on the "moral heart" of Rogers' text:

> thy gay book hath paid its proud devoirs,
> Poetic friend, and fed with luxury
> The eye of pampered aristocracy
> In flittering drawing-rooms and gilt boudoirs,
> O'erlaid with comments of pictorial art
> However rich or rare, yet nothing leaving

> Of healthful action to the soul-conceiving
> Of the true reader . . . [1]

Lamb deploys the rhetoric of puritan outrage against pictorial additions to literature. He contrasts the book-buyer's decadent gazing on illustrations—a "luxury" granted to the "pampered aristocracy" in "gilt boudoirs"—with the "healthful" and "soul-conceiving" effects of reading unadorned text. Lamb later sent a conciliatory letter to Rogers in which he outlined his general prejudice against illustration. In it, Lamb gave the example of Boydell's Shakespeare Gallery project, which, he charged, had sought to "confine the illimitable" dimensions of Shakespeare's genius and the reader's imagination. To read *Romeo and Juliet* with a print in view was "to be tied down to an authentic face of Juliet!" Actors offended Lamb by presenting Shakespearean characters in a single, visible form. In the same way, book illustration reduced the sublime suggestiveness of a Shakespearean play (and Rogers' poetry) to a framed visual particularity. The sister arts, he concluded, should "sparkle apart." The marriage of word and image in books could only end unhappily for the reader.[2]

Lamb may have tempered his sentiments in his 1833 poem out of regard for Rogers, but Wordsworth felt no constraint on his antipictorial feeling in the 1845 sonnet, "Illustrated Books and Newspapers." Echoing Lamb, the aged poet laureate warns against the popular taste for book illustration as a "vile" reverse of civilization's progress from cave-painting to modern print culture:

> Now prose and verse sunk into disrepute
> Must lacquey a dumb Art that best can suit
> The taste of this once-intellectual Land.
> A backward movement surely have we here,
> From manhood—back to childhood; for the age
> Back towards caverned life's first rude career. (6-11)

In bombastic strains, Wordsworth contrasts the glory of pure "prose and verse," with its "enlarged command / For thought—dominion vast and absolute / For spreading truth, and making love expand," to the illustrator's "vile abuse of pictured page!" Wordsworth's image of British culture returning to its primitive state or "childhood" through the influence of illustrated books echoes a *Quarterly Review* article from the previous year. "A natural effect of [illustrated books]," warned the *Review*, "is that those means, which at first were called in to aid, now bid fair to supersede much

of descriptive writing: certainly they render the text of many books sub-sidiary to their so-called illustrations. In this partial return to baby litera-ture—to a second childhood of learning—the eye is often appealed to instead of the understanding."[3] The opinions of Lamb, Wordsworth, and the conservative *Quarterly Review* show that, as late as the 1840s, the literary elite continued to actively resist the cultural influence of new visual media. Like the public spectacles of the theater and the panorama, the increasingly pop-ular illustrated book engaged the eye rather than the mind and imagination. For Romantic writers, it symbolized the spread of an infantilizing visual medium to the domestic sphere and, more seriously still, the encroachment of the visual arts onto literature's sovereign domain, the printed book.

Until the 1760s books were rarely illustrated. But with the boom in English engraving (see chapter 2), illustrated publications became a lucra-tive extension of the print trade. The publisher John Bell led the field in the late eighteenth century with illustrated editions of Shakespeare and the English poets. The industry broadened rapidly in the Romantic age to the point where "readers came to expect that collections of poems, plays, and novels would contain well-executed engravings."[4] For example, Robert Cadell's illustrated editions of Scott's works, to be considered in this chap-ter, were a major factor in his sustained mass appeal through the early Vic-torian period. The role of illustrations in the publication of English fiction, hitherto limited to a frontispiece and vignette, was turned on its head with the first installment of *Pickwick Papers* in the spring of 1836. After the unanticipated success of Dickens' new mixed media narrative (neither the author, his publishers, nor the reviewers called it a "novel"), a generous variety of pictorial dramatizations of scenes and characters became indis-pensable to any new successful work of fiction. Aside from Dickens' illus-trated serials, two further innovations in the first decade of Victoria's reign were to spectacularly increase the role of illustrated text in British culture. In 1842, the *Illustrated London News* published its first issue to record sales; and by 1845, the year Wordsworth composed his sonnet condemning illus-trated newspapers, a new image technology of which he was only dimly aware—photography—threatened to supplant the traditional forms of engraved illustration altogether.[5]

The first part of this chapter centers on the Romantic attitude toward textual illustration in the period prior to the *Pickwick Papers* and *Illustrated London News,* specifically the illustration of Sir Walter Scott. As John Har-vey has suggested, "Scott may [best] represent the attitude of the earlier three-volume novelist to illustration. None of his Waverley novels had any pictures when they first came out."[6] Following an analysis of Turner's

revolutionary illustrations of Scott's poetry in the early 1830s, my focus shifts to the Victorian period proper and a comparison of Turner's designs for Scott with the pioneer photographer Fox Talbot's 1845 tribute to the same author. The contemporary response, and lack thereof, to Fox Talbot's *Sun Pictures in Scotland* will subsequently enable us to examine the late Romantic encounter with photography in its various nascent shapes: as a form of illustration, as a documentary medium allied to the new tourist industry, and as the latest "infernal" agent of the "real."

Sir Walter Scott was indifferent to art, but in the first decades of the nine-teenth century the indigenous mythology of his novels and verse romances revitalized British history painting and its tired classical subjects.[7] "Never" averred the *Quarterly Review,* "has the analogy between poetry and painting been more strikingly exemplified than in the writings of Mr. Scott."[8] Artists from the Royal Academy adapted his work with great energy, pro-ducing a body of work that resembles Scott's literary legacy in being both prolific and currently unfashionable. "Between 1805 and 1870," relates Catherine Gordon, "Scott's subject matter attracted over three hundred painters and sculptors who exhibited more than a thousand 'Scott' works at the Royal Academy and British Institution." But Scott's visual-cultural influence extended beyond high art: "commercial concerns such as Minton and Wedgwood made pottery and profit from the Scott mania; publishers issued numerous illustrated books, travel guides and keepsakes associated with the author of *Waverley.*"[9] So diverse were the products of this Waver-ley industry that it becomes difficult to distinguish the popularity of his writings from the plethora of Scott-related art and sub-artistic merchandis-ing. These tribute industries—sightseeing at Scott locales, and the collec-tion of Waverley paintings, prints, and even crockery—blurs our perception of Scott the author with "Scott" the visual media brand name.

 This confusion is most evident in the illustrated editions of the late 1820s and 1830s. Initially, artistic interpretation of Scott was the exclusive purview of academic painters such as Richard Westall. But when the inno-vative publisher Robert Cadell took over the Scott copyright in 1825, book illustrators aggressively entered the field. Cadell saw a gold mine in the Waverley author and championed his popular, visually adaptable literary style: it was exemplary, he said, of "the age of graphically illustrated Books."[10] Whatever the attitude of his publisher, Scott himself, as a mem-ber of the Regency literary elite, shared Lamb's and Wordsworth's distaste for the commercial union of word and image. He memorably compared an

illustrated text to "a faded beauty [who] dresses and lays on a prudent touch of rouge to compensate for her want of juvenile graces."[11] When Westall had proposed a set of illustrations in 1809, Scott confided to Joanna Baillie his conviction that they would be "execrable" and likely to make a mockery of his poems: "I expect to see my chieftan Sir Rhoderick Dhu in the guise of a recruiting sergeant of the Black Watch and his Bard the very model of Auld Robin Grey upon a japand tea-tray."[12] For Scott, painting could never faithfully illustrate his poetry, only parody it. His resentment of book illustration—a visual medium's trespass on the traditional privileges of literature—echoes Romantic iconophobia from Lessing's *Laocoön* to Shelley's *Defence of Poetry* (see chapter 3), as well as directly reinforcing the anti-illustration sentiments of Lamb and Wordsworth. Given that the illustration of pre-*Pickwick* novels was limited to at most two images—a frontispiece and vignette on the title page—it is a measure of the acute sensitivity of the literary class to the intrusion of images on text that Cadell had difficulty persuading Scott to allow even so small an amount of visual decoration. But after his publisher Constable collapsed in 1825, effectively bankrupting him, Scott had no choice but to agree to the most lucrative marketing of his work, which meant illustrated editions.

The list of contributors to Scott's "Magnum Opus" (Cadell's nickname for the collected *Waverley* edition, 1829-34) reads like a *Who's Who* of late Georgian painting. Edwin Landseer, John Martin, David Wilkie, and Charles Leslie contributed to a total of ninety-six plates: a frontispiece and title-page vignette for each of the forty-eight volumes. All are "illustrative" in the strict sense: they represent characters and scenes from the novels they adorn. For example, John Martin's illustration of *Ivanhoe* (figure 5.1) depicts the tense confrontation between Rebecca and the tragic villain, Bois-Guilbert, with a narrative formality reminiscent of the Renaissance masters. In a genre piece more typical of the series as a whole, David Wilkie's illustration for *Old Mortality*, "Bothwell Surprising the Family at Milnwood," exemplifies his compositional mastery of the domestic ensemble. Bothwell enters from the side, the better to capture the astonishment of the family ranged before him at the dinner table: one half-risen from his chair, another's soup spoon arrested in midair. [13] Despite the rare quality of this work for the "Magnum Opus," and the edition's subsequent strong sales, Scott was still reluctant to concede the popular appeal of illustration. Cadell bluntly set him straight. "Without plates," he told Scott, "5,000 less of the Waverley Novels would have sold."[14]

Eager to extend this promising success, Cadell was soon urging on Scott

Figure 5.1 John Martin, "Ivanhoe," frontispiece illustration to Sir Walter Scott, *Waverley Novels* (London: Robert Cadell, 1830), vol. 16.

an illustrated edition of his poetry. Because the collected poetry would be a smaller project (a mere twelve volumes), Cadell decided to enlist a single artist, a decision that simplified matters but set great stakes on his choice. In 1831 there was only one real option, however. Turner was already the most sought-after illustrator in Britain when, the year before, he had rescued Rogers' *Italy* with a spectacular illustrated edition. Turner transformed a lit-

Figure 5.2 J. M. W. Turner, "Melrose," frontispiece illustration to Sir Walter Scott, *Poetical Works* (London: Robert Cadell, 1832-34), vol. 6.

erary mediocrity into a popular sensation, the illustrated *Italy* selling four thousand copies in its first two weeks. Turner's successful career as an illustrator is often ignored by scholars, according to the same anticommercial ideology that inspired both Lamb and Wordsworth's disdain for book illustration and, a half-century earlier, Reynolds' for engraving in general. But in the rapidly changing book culture of 1830s Britain, Turner's success with Rogers' *Italy* impressed no less a critical conservative than Scott himself, who judged the collaborative project "a rare specimen of the manner in which the art of poetry can awaken the Muse of painting."[15]

Scott had worked with Turner before. In 1818, Turner contributed twelve designs to Scott's *Provincial Antiquities and Picturesque Scenery of Scotland,* a partnership that even then, given the established popularity of Turner's annual illustrated *Tours,* was considered to the professional advantage of both parties. Though demonstrating Turner's trademark concern for the intangible landscape elements of light and air, the illustrations for *Provincial Antiquities* were stodgily conventional—complete with lofty castles and foreground peasantry—compared to the modern, documentary approach he would adopt for Scott's *Poetry* a dozen years later. The *Provin-*

Figure 5.3 Turner, "Loch Coriskin," frontispiece illustration to Scott, *Poetical Works,*
vol. 10.

cial Antiquities volume had not sold well, but Cadell nevertheless judged
Turner's participation in *The Poetical Works* a commercial imperative: "With
Mr. Turner's pencil I can ensure the sale of 8000 of the Poetry," he told the
still doubtful Scott, "without not 3000." Turner was subsequently hired at
the handsome fee of 25 guineas a plate.[16]

In the summer of 1831, Turner traveled to Abbotsford to gather
sketches for *The Poetical Works,* with Scott and Cadell accompanying him to
picturesque sites of the Border and Lowland regions.[17] The illustrations
Turner produced constitute a visual record of these expeditions. The fron-
tispiece to *The Lay of the Last Minstrel* in volume six, for example, shows
Scott, Cadell, and Turner enjoying a picnic lunch overlooking a prospect of
Melrose (figure 5.2). Melrose Abbey itself, the setting for Canto II of
Scott's poem, is no more than an ill-defined smudge in the distance. The
poem is, quite literally, relegated to the background. In a similar spirit, the
vignette to volume twelve depicts the vacationers making their way across
the Tweed toward Abbotsford in an open carriage. Another illustration

remembers a pleasant day at Bemerside Tower: Cadell and Scott converse with a Miss Haig while, in the background, Turner sketches a tree. In volume seven, Cadell hauls Turner and his gear up Blackford Hill; and in the vignette to volume two the sightseeing party crosses a bridge beneath Johnny Armstrong Tower. Viewed as a series, these images offer a pictorial narrative of Turner's 1831 Scottish tour. Unlike the "Magnum Opus" pictures—I gave the example of Martin's *Ivanhoe* design—they do not *illustrate* Scott's poetry: their references are not literary or historical but contemporary and none of Scott's characters appear. In essence, this new image-text relationship anticipates the twentieth-century captioned newspaper photograph in which, as Roland Barthes has described, "the image no longer illustrates the words; it is now the words which, structurally, are parasitic on the image."[18] That is, Turner's designs refer not to the characters and incidents of Scott's fictional narratives, but to their real-world settings. Instead of pictorially dramatizing Scott, the illustrations effectively document the Romantic tourist industry, with the author, artist, and publisher—the triumvirate of the illustrated book trade—as emblematic consumers of trademark Waverley landscapes.

Scott's day trips with Turner and Cadell in the Lowlands proved to be enjoyable, productive, even moving experiences. Gerald Finley has suggested that the personal objectives of Turner's 1831 northern tour—to record his association with the dying Scott—meant as much to him as the artistic possibilities it offered. The artist "perceived that his illustrations for the 'Poetry' might be perceived as memorials."[19] Scott's declining health—he had recently suffered a mild stroke—set a sentimental, almost elegiac tone for the visit (reminded of his mortal frailty, Turner redrafted his will prior to setting out for Scotland). After three weeks sketching Scott, Cadell, and himself touring the countryside around Abbotsford, Turner separated from his companions. Scott was fit to be a Lowlands guide but not a Highlands tourist. For the designs of Loch Coriskin and Loch Katrine, Turner set out on his own.

Turner's vignette for *Lord of the Isles* (figure 5.3), an evening view of Loch Coriskin on the Isle of Skye, is his most ambitious design for the "Poetry" series.[20] Stylistically speaking, it more resembles a Turner seascape from the 1830s than his generic neo-classical illustrations for Rogers and Byron in that period, anticipating *Waves Breaking on a Shore* (1835) and the radically impressionistic *Snow Storm* and *Deluge* paintings of the early 1840s.[21] In accordance with Turner's new documentary approach, the Loch Coriskin drawing does not commemorate the historic moment in Scott's poem where Bruce and his men climb to the verge of the loch, but rather the artist's own visit to the spot in 1831.

Turner is nevertheless faithful to Scott's meteorological prescription in *Lord of the Isles:*

> The evening mists, with ceaseless change,
> Now clothed the mountains' lofty range,
> Now left their foreheads bare,
> And round the skirts their mantle furl'd,
> Or on the sable waters curl'd,
> Or on the eddying breezes whirl'd,
> Dispersed in middle air (III.15)

In Turner's design, the atmospheric elements of Scott's scene—darkening sky and swirling mist—are almost indistinguishable from the permanent presence of the mountains and "the dread lake." As Ruskin observed, Turner defines the dramatic extrusions of rock, which rise from the bottom of the vignette and ascend step-like to a lofty consummation with the roiling sky, by the materiality of their bodily presence rather than dimensional outline. The mountain is not a shape but a mass: "Looking at any group of the multitudinous lines which make up this mass of mountain, they appear to be running anywhere and everywhere; yet the whole mass is felt at once to be composed. . . . "[22] For Ruskin, Turner's Loch Coriskin illustration was a triumph of observation beyond the reach of empirical science. Each carefully rendered stratum of rock suggested not a bland topographical fact but a dramatic and still reverberating event in geological time. Cleaving and surging like waves through the right of the picture, the ruptured vortices of Loch Coriskin recall the Alpine snowstorm enveloping Hannibal and his men in Turner's 1812 masterpiece. As in that landmark painting, Turner implodes the formal Claudean divisions of the landscape:

> that primeval earthquake's sway
> Hath rent a strange and shatter'd way
> Through the rude bosom of the hill,
> And that each naked precipice,
> Sable ravine, and dark abyss,
> Tells of the outrage still. (III.14)

Turner intensifies the psychological impact of the scene by including himself and his guide crouching quietly on a ledge in the foreground. As in the drawings of Melrose and elsewhere, Turner's self-referential approach transforms a mere landscape study into a proto-photographic souvenir. These

are Romantic tourists playing their role in a choreographed drama of the sublime. Their tininess suggests majesty of scale, their exposed position a mortal vulnerability to the elements of nature.

From Loch Coriskin and *Lord of the Isles,* Turner turned his attention to Scott's most celebrated poem, *The Lady of the Lake,* and returned south to Loch Katrine: "as exquisite . . . a scene of stern beauty," Scott had recorded in his journal from 1814, as Loch Coriskin was "savage."[23] The original publication of *The Lady of the Lake,* volume eight of Cadell's 1832-34 edition, had been a breakthrough for both Scott and Scottish tourism. The first genuine summer blockbuster, it went through five editions in 1810 alone, selling in excess of 20,000 copies—the best-selling poem in history.[24] As Robert Cadell himself recorded, Scott's sentimental romance brought great crowds "to view the scenery of Loch Katrine, till then comparatively unknown; and as the book came out just before the season for excursions, every house and inn in the neighbourhood was crammed with a constant succession of visitors. It is a well-ascertained fact, that from the date of the publication of *The Lady of the Lake,* the post-horse duty in Scotland rose to an extraordinary degree. . . ."[25] In the Abbotsford edition of *Rob Roy,* the author remembered his first sight of the Loch's spectacular southern vista "of which," he modestly conceded, "he may perhaps say he has somewhat extended the reputation." As James Holloway has suggested, the dreamy retirees of Scott's poem—Allan, Ellen, and her noble father—were themselves models of touristic pleasure and a tremendous publicity coup for the Highlands. Scott's Romantic exiles represented an ideal of seclusion and idleness for those English urbanites, Queen Victoria among them, determined to "shed their professional and social identities for the sake of the spiritually restorative effects of natural beauty."[26] But the birth of Scottish mass tourism required the means of travel as well as the motive. Crucial to the commercial development of the Highlands after 1810 was the establishment of a coach linking Edinburgh and Inverness. A Scotland tour that, only seven years before, had offered the Wordsworths no public coaches or post-horses and the perilous negotiation of lochs by rickety ferries, could now be safely undertaken in a day. Thousands of English and Lowland tourists took advantage of the new ease of domestic travel, and by the 1830s the Highlands were a veritable playground of the Sassenachs.

For his illustration of *The Lady of the Lake* (figure 5.4), Turner followed guidebook recommendations in choosing the prospect immortalized in Scott's opening Canto, where the hunter-king, lost in pursuit of a deer, stumbles upon the northern extremity of Loch Katrine:

> gleaming with the setting sun,
> One burnish'd sheet of living gold,
> Loch Katrine lay beneath him roll'd,
> In all her length far winding lay,
> With promontory, creek, and bay,
> And islands that, empurpled bright,
> Floated amid the livelier light,
> And mountains, that like giants stand,
> To sentinel enchanted land.
> High on the south, huge Benvenue
> Down on the lake in masses threw
> Crags, knolls, and mounds, confusedly hurl'd,
> The fragments of an earlier world . . .
> From the steep promontory gazed
> the stranger, raptured and amazed. (Canto XIV-XV)

From the point of view of historical plausibility, such rapture at a High-land view rings false in a sixteenth-century Scotsman, but for an English tourist of the Regency age, James evinces a familiar, indeed programmatic awe.[27] For his design, Turner decided upon a subtle but important varia-tion to the poem's account. The view he takes is actually impossible from the ground: it imagines a vantage-point some thirty yards in the air. This alteration creates a more dramatic downward plane in the foreground, which in turn allows for a felicitous spatial organization of the main fea-tures. The loch lies in the middle distance, the fabled "Ellen's Isle" floating serenely on it, with the eastern fells at eye level on the left, and the smoky eminence of Benvenue on the horizon, picturesquely off-center to the right.[28] Turner visited Loch Katrine alone, but made sure to include in the design his now standard signifier of Romantic tourism: the well-populated foreground. A solitary Scott enthusiast looks out over the loch from the shade of a grove of trees; another group haul themselves through the scrub to a higher lookout point nearby; while a couple strolls arm in arm along the eastern side on an invitingly commodious pathway. The whole conveys a mood of domesticated sublimity. Unlike the Loch Coriskin illustration there is no apocalyptic distress of the elements, no threat to the viewer's tranquil contemplation. Turner's pilgrims to the loch are both intrepid and at play, circulating in a charmed intersection of adventure and leisure designed to appeal to the city-bound reader of Scott.

After publication of Scott's illustrated *Poetry,* the *Quarterly Review* recog-nized that Turner's designs called for a critical distinction between histori-

Figure 5.4 Turner, "Loch Katrine," frontispiece illustration to Scott, *Poetical Works,* vol. 8.

cal and contemporary style in illustration, between the "ideal" designs of the "Magnum Opus" edition and the "real" impressions of Turner. The critic favors Turner's documentary approach, emphasizing the Victorian reader's touristic desire to enjoy the Scottish landscape over the need for pictorial description of Scott's verse narrative:

> if that wish be strong in our minds with regard to Byron, whose interests lie abroad—in fact are foreign—how far stronger is it in the case of Scott, whose thoughts, and words, and scenes come home to ourselves—to England—to Scotland. . . . It is this minute illustration, this transporting of ourselves to the actual locality of the scene that interests us.[29]

The reviewer's choice of words—his concern to be "transported" to the "actual locality of the scene"—is strongly reminiscent of the panorama advertisements I examined in chapter 3. In appealing for verisimilitude in illustration, he rejects the academic, narrative depiction of medieval

romance in Martin's *Ivanhoe* design in favor of something "*real* . . . ready made for the million" (my emphasis).[30] Cadell's *Athenaeum* advertisement for the *Poetry* edition in 1832 sought to take advantage of this shift in popular taste toward the topicality and verisimilitude of Turner's *Poetry* illustrations.[31] He stressed that Turner, like the panoramists of Leicester Square, had recorded his designs *on the spot,* thereby guaranteeing their fidelity to the actual scene. In Cadell's puff, the commercial lineage of and market for the Turner illustrations are clear. Scott's poetry takes a back seat to the picturesque scenery it evokes. To the urban middle class, illustrated books, like the panoramas, offered a kind of virtual tourism.

For eighteenth-century readers of *Ossian* and Gilpin's *Tours,* Scotland had represented an unspoiled and rudely picturesque wilderness inhabited by an alien, pre-industrial culture. But in the first decades of the nineteenth century, the opportunities for exotic contact on a Scottish tour receded northward at a rapid pace. Already by 1818, Scott's mythic tales appeared dated to John Keats, who complained in a letter to his brother that "the border inhabitants are quite out of keeping with the romance about them, from a continual intercourse with London rank and fashion."[32] For both Wordsworth and Keats, however, Scotland was not Scott but Burns country, a rugged and challenging landscape analogically linked to the incipient tragedy of poetic self-creation (a link Keats himself perpetuated by developing the first strains of terminal illness while on Mull). As Keats wrote to his friend Reynolds during his Scotland tour, the specter of Burns put a chill on lyric inspiration:"His Misery is a dead weight upon the nimbleness of one's quill—I tried to forget it—to drink Toddy without any Care—to write a merry Sonnet—it won't do."[33]

By contrast with these disappointed expectations and poetic failures, the Scotland of Turner's *Poetry* illustrations represents an uncomplicated and inviting landscape in which the figure of the artist becomes indistinguishable from the tourist masses whose company he has joined. As such, Turner's illustrations dispel the lyric gloom of Wordsworth and Keats while anticipating the democratizing, lowbrow role of the camera, where standard tourist "sights" are not subject to artistic interpretation, but act as a backdrop to the documentary image of family and friends. For the modern tourist, the inclusion of familiar faces in the photograph (oneself included) individuates the experience of generic tourist locales but, equally importantly, the presence of other tourists in the frame, real or implied, is a necessary guarantee of the desirability of the site "consumed." The landscape dominates Turner's illustrations of Scott, as the Romantic sublime dictates, but these fundamental aspects of modern souvenir photography are never-

theless there *in embryo.* Considered as a whole, Turner's illustrations for Scott's "Poetry" represent the cult of the picturesque in its late, ironic phase. Academic illustrators of Scott's "Magnum Opus" edition, such as Martin and Wilkie, remained faithful to Scott's historical narratives, creating an idealized world of *Waverley* legend. By contrast, Turner's 1831 *Poetry* designs rendered the Scott tourist industry more visible than its literature. The references to Scott's works were, to that extent, a given. The greater imperative of literary tourism, for Turner, was to be able to visually document one's recreational travels, as with a camera.

Further evidence for the proto-photographic modernity of Turner's illustrations for Scott's *Poetry* lies in their direct influence on the pioneer photographer William Henry Fox Talbot, whose *Sun Pictures in Scotland* from 1845 records much of the same Scottish landscape, and constitutes the first photographic travelogue in the history of the medium. Some months before Wordsworth wrote his iconophobic sonnet, "Illustrated Books and Newspapers," Fox Talbot had dutifully followed Turner's trail from Abbotsford to Loch Katrine with a camera in hand and a new genre of illustrated book in mind: the text-less volume of photographs. Although never strictly a professional photographer, Fox Talbot, like so many Victorian landed gentry, was cash poor, and he sought profit from the commercial sale of his photographs. As such, he "was the first to realize the potential rivalry of the photographic print to engravings and to make capital out of their sale. His sun pictures of views of towns, scenes from nature, and copies of works of art, were sold by all the leading stationers and print-sellers in the United Kingdom from the mid-1840s on."[34] Fox Talbot scored a hit with his first volume of photographs, *The Pencil of Nature,* published in installments between 1842 and 1846; but he interrupted that series for his Scott project, seeking to take commercial advantage of the contemporary fashion for all things "Waverley."[35]

As a marketing proposition, Fox Talbot's 1845 volume *Sun Pictures in Scotland,* which advertised "scenes connected with the life and writings of Sir Walter Scott," could not have been more timely. To mark the opening of the Scott Monument that year, Edinburgh played host to a "Waverley summer" of tributes, parades, and society balls. The so-called Waverley Balls featured Scott-inspired tableaux: guests, in theatrical costume, would take turns representing their favorite scenes from Scott's novels. David Octavius Hill, a founding member of the Scottish Royal Academy, attended the Balls and later recorded a number of "Waverley tableaux" with his camera. Photography had made its social debut.[36] In contrast to Hill's conventional notion of

photographing staged scenes from Scott's works—a style of photographic illustration analogous to that of the "Magnum Opus" edition—Fox Talbot's rival tribute to Scott, like Turner's a dozen years earlier, took the form of a picturesque travelogue. Included in his twenty-three plates were images of the nearly completed Scott Monument, views of the author's Abbotsford home, and his tomb at Dryburgh Abbey. For all the historical interest of these photographs, however, the volume is most significant for its landscape studies, the first in the history of photography. Employing three cameras, one with an experimental curved lens, Fox Talbot included seven calotypes of Loch Katrine, the site made famous by Scott's *The Lady of the Lake* (1810), and further romanticized by Turner's illustration for volume eight of Cadell's *Poetry* edition. Fox Talbot's choice of subject proved an inauspicious beginning for landscape photography, however, and for photographic illustration. Less than one hundred copies of *Sun Pictures in Scotland* were sold, far less than the celebrated *Pencil of Nature* series.

Where did Fox Talbot go wrong? How could a photographic tribute to Scott fail at the height of Waverley mania in 1845? First, subscribers complained that the pictures didn't appear to be photographs at all but old-fashioned engravings. More revealingly, Lady Elisabeth Talbot wrote to her son that she found the "clearness" of the images disturbing, an effect she attributed to him having "been in Scotland so late in the season."[37] Uppermost in Lady Talbot's mind would have been an unfavorable comparison between *Sun Pictures in Scotland* and Turner's celebrated designs for the Cadell edition. Their projects were of the same scope (twenty-three photographs by Fox Talbot as against twenty-four drawings by Turner); both likewise sought to represent "scenes connected with the life and writings of Sir Walter Scott" rather than episodes from the writings themselves. The similarity of the two illustration projects ends there, however. While Turner's designs, although documentary in approach, strove to suggest the "enchanted land" of Scott's picturesque verse, Fox Talbot seemed intent on breaking that spell. The images of *Sun Pictures in Scotland* provide no foreground figures as models of consumer gratification, no implied community of leisure, and no concessions to picturesque taste.[38] In so doing, Fox Talbot successfully alienated the market audience established by Turner and Cadell, whose desire to see images of literary landscapes made famous by Sir Walter Scott was exceeded only by their desire to see themselves. As a consequence, while Turner's Scott series is considered the high point of his career as a book illustrator, Fox Talbot's *Sun Pictures in Scotland* has never enjoyed critical or commercial favor. Historians of early photography have almost entirely neglected it in favor of *The Pencil of Nature,* whose histori-

cal significance has been compared to the Gutenberg Bible.[39] But failure can be as "illustrative" as success. An analysis of Fox Talbot's ill-fated tribute to Scott, set against the commercial success of Turner's illustrations for Cadell, will tell us much about the role of two competing visual media—book illustration and photography—in the late Romantic cult of Waverley, and their connection to the rapidly expanding literary tourism industry.

On a visit to picturesque Lake Como in 1833, Fox Talbot had been frustrated at his inability to preserve images of the lake with a *camera obscura*. As he relates in the text to *The Pencil of Nature,* he returned from his continental tour determined to find a means "to cause these natural images to imprint themselves durably, and remain fixed upon the paper." Fox Talbot's subsequent experiments with photochemical paper resulted in his invention of the negative print. British photography originated, to this extent, from a tourist's desire for a better quality souvenir. This incidental historical link between Romantic tourism and the invention of photography has been overlooked.[40] With his seminal 1833 tour of the Italian lakes in mind, Fox Talbot's excursion to Loch Katrine a decade later takes on great personal and historical resonance: a return to the picturesque scene of photography's conception.

By the time Fox Talbot followed in Turner's footsteps to Loch Katrine, new engineering had rendered the Scottish Highlands even more accessible to Waverley tourists. In 1831, Turner had made the arduous trip by coach, but in 1844 Fox Talbot took the train (at least part of the way). Turner's apocalyptic *Rain, Steam and Speed*, painted that year, celebrated the new engine of modernity, boring out of an otherwise serene landscape in a convulsion of steam and fiery light. The summer of 1844 also marked the second of Queen Victoria and Prince Albert's Scottish tours, the greatest publicity for the Highlands since *The Lady of the Lake* was published in 1810. But 1844 was a year of antitourist reaction as well. Down in the Lake District, Wordsworth submitted two letters to the *Morning Post* decrying the proposed construction of a rail link between Kendal and Windermere. "Artisans and labourers," he protested, "should not be tempted to visit particular spots which they have not been educated to appreciate."[41] Echoing Wordsworth, Lord Cockburn complained that the infernal "angel of mechanical destruction" had vulgarized domestic tourism beyond endurance, attracting a veritable "asylum of railway lunatics" to his beloved Highlands (the steam-train, in this sense, threatened to do for the democratization of travel what photography threatened for visual culture).[42] The disgruntled peer had no doubt headed home in disgust long before Fox Talbot made his belated trip to the Highlands in October.

Figure 5.5 William Henry Fox Talbot, "View of Loch Katrine." *Sun Pictures in Scotland,* plate 10 (1845). Hans P. Kraus, Jr. Fine Photographs, New York.

Immediately evident in Fox Talbot's photographs of Loch Katrine from 1844 is an inflexibility of viewpoint and composition. Unable to launch his apparatus into the air with any confidence, thereby matching Turner's elevated vantage, Fox Talbot avoided the celebrated southward vista altogether, taking his chances on the eastern side of the Loch. His choice of unorthodox vantage points, combined with the lateness of the season, produced photographs strangely devoid of human presence. In *The Pencil of Nature,* Fox Talbot admitted to a lack of faith in the camera's capacity to represent figures, especially large ensembles: "at present we cannot well succeed in this branch of the art without some previous concert and arrangement." Apparently, no arrangements for models were made for Fox Talbot's Scotland tour. His desire to avoid the tourist crowds may even have determined the lateness of his journey. Whatever the case, the twenty-three plates of *Sun Pictures in Scotland,* taken at sites that might expect many thousands of visitors a year, include a total of two human figures. The self-referentiality of Turner's designs—in which commemorating his sketching

Figure 5.6 Fox Talbot, "View of Loch Katrine." *Sun Pictures in Scotland,* plate 11. Hans P. Kraus, Jr. Fine Photographs, New York.

tour with Sir Walter and Robert Cadell took precedence over pictorially dramatizing Scott's poetry—is entirely absent from *Sun Pictures in Scotland.* In fact, Fox Talbot's desolate images bear no trace either of the Scott literature or its sightseeing industry, conforming neither to the "ideal" interpretations of the "Magnum Opus" designs nor Turner's "real" illustrations for Scott's *Poetry.* From the eerily bereft scenes of Scott's home at Abbotsford to the photographs of Loch Katrine as a wilderness unreclaimed by mythology or tourism, *Sun Pictures in Scotland* withdraws the social and historical context for which appreciation of Scott had, by 1844, become indispensable.

Plate twelve of *Sun Pictures,* for example, resembles Turner's illustration of Loch Katrine in that it offers an elevated view, with foreground trees establishing an interior frame to direct the eye over the water to the mountains beyond. But the foreground itself is the merest scrub, without figures or even the suggestion of a pathway. Plate ten (figure 5.5) offers the distant image of a figure sitting in a boat, but he has the appearance of a local who

has wandered into the frame, not a bourgeois tourist from London for whom the loch is a stage of conspicuous touristic consumption. Neither photograph makes reference to Loch Katrine's Romantic literary presences—Ellen, Allan the Bard, and Roderick Dhu—nor to its contemporary touristic appropriation. Scott himself, who "always liked to have a dog with him in his walks, if for nothing else but to furnish a living object in the *foreground of the picture,*" would have been highly discomfited by this almost total absence of life.[43] Taken "so late in the season," Fox Talbot's seven images of Loch Katrine suggest a landscape beyond history itself. They repress the breathtaking hospitality of the scene to which the hunter-king of Scott's poem, and the annual floods of Romantic tourists after him, had been drawn as to a siren song. In place of a romanticized historical landscape, Fox Talbot's photographs suggest the *pre*history of Loch Katrine, and are as uninviting as that remoteness would suggest. Fox Talbot has deconstructed the landscape of Scott romance into "fragments of an earlier world" without human accommodation. In short, the uncompromising "clearness" of Fox Talbot's images, which Lady Talbot deplored, effectively de-romanticizes the myth of Waverley. If the *Quarterly Review* considered Turner's *Poetry* illustrations "real" by virtue of their contemporary references, Fox Talbot's photographs represent *the* "real" of the Scottish Highlands, devoid not only of historical or narrative reference, but all Romantic aura. Rather than evoking its mythic-historical associations, Fox Talbot insists on the sheer facticity of a landscape where, for Scott, by contrast, "every valley ha[d] its battle and every stream its song."[44]

The effect of clarity in *Sun Pictures in Scotland* contrasts dramatically with the dynamic confusion of line and form in Turner's illustrations. Where Turner's landscapes appear to tonally unfold, Fox Talbot's are essentially immobile. The members of the cultural elite who subscribed to Fox Talbot's volume, trained in the coloristic impalpabilities of Gainsborough and Constable, and confused by the precedent of Turner's Scott designs, naturally recoiled at the banal objectivism of *Sun Pictures in Scotland*. In 1853, Sir William Newton, a founder of the Royal Society of Photography, conceded the camera's inability to capture the "atmospheric veil" of nature that had inspired so much modern landscape painting (most notably Turner himself):

> Who has not studied nature so much as to observe how beautifully she throws her atmospheric veil, detaching each object, while producing that harmony and union of parts which the most splendid specimen of chemical photography fails to realize! Consequently, at present, it is in vain to look

for that true representation of light and shade in Photography, which is to be found in a work of art.[45]

Certainly, the limits of the early photographic medium are evident in *Sun Pictures in Scotland*. The tonal elements of Fox Talbot's calotypes, even allowing for their current faded condition, collapse into two broad categories: off white and murky black. In plate eleven (figure 5.6), for example, the sky, like the loch itself, is a dirty white color, while the surrounding cliffs merge with their own shadows in the water in a monochromatic gloom. Unlike the Turner *Poetry* designs, where indistinctness of line creates a compensatory dynamism of form, the overlapping tones of the Fox Talbot photographs largely ruin all compositional effect.

To compensate for the unromantic clarity of images such as those of Loch Katrine in *Sun Pictures in Scotland,* Newton advocated taking photographs "a little out of focus." In this respect, his argument for the artistic capability of photography depended upon the erasure, in the image itself, of the technology used in its production. Newton considered photography capable of high art only insofar as it could reproduce the effects of an oil painting or watercolor. (The fact that the first President of the Royal Society of Photography, Sir Charles Eastlake, was also President of the Royal Academy confirmed the academic aspirations of Britain's early photographers. Fox Talbot's refusal of the honor likewise suggests his own aversion to academic appropriation of his "scientific" invention). But as we shall see later in this chapter, a significant body of critical opinion considered photography permanently inimical to High Art. Charles Baudelaire, most notably, conceived the camera as a purely descriptive, naturalistic medium, incompatible with Romantic idealism. In his paper to the Royal Society, Newton clearly wished to forestall criticism, such as Baudelaire's, that the camera was a purely scientific apparatus incapable of creative invention or artistic effects. Newton's "blurred focus" technique was an attempt, in effect, to save photography from itself and redeem it for art. But as R. W. Buss observed to the Royal Society, Newton's argument for "breadth of effect" against "minute detail" in photography did no more than employ "the camera to do what is recorded as the practice of Sir Joshua Reynolds."[46] That is, the debate over early photography, as represented by the likes of William Newton, simply rehearsed the argument between *mimesis* and ideal beauty in Reynolds' *Discourses* (see chapter 2). To the extent that Buss was correct, photography in the 1850s existed in a material sense, but not as a theorized object. Its capabilities were judged only in terms of pre-existing media.

The art critic Lady Eastlake likewise perceived the camera's incompatibility with Romantic vision. She could well have had *Sun Pictures in Scotland* in mind when she pointed to "the falling off of artistic effect" in early landscape photography. "The sharp perfection of the object which stands out against the irreproachably speckless sky," she observed, "is exactly as detrimental to art as it is complimentary to science."[47] Following Sir William Newton, Lady Eastlake championed the production of "accidental blurs and blotches" in the darkroom as the best means of capturing Turneresque effects (she would find a brilliant acolyte in Julia Margaret Cameron in the 1860s). As we have seen, Fox Talbot's Scotland calotypes rejected this contrived Romantic effect entirely in favor of a realist visual account. In his commentary to *The Pencil of Nature*, Fox Talbot insisted that camera technology allowed for no human intervention: photographic images "impressed by Nature's hand . . . have been formed or depicted by optical and chemical means alone." In keeping with this scientific philosophy of the camera, his Scotland calotypes do not resemble Turner's carefully orchestrated depictions of a landscape appropriated by Scott and Scottish tourism. Without text or tourists, Fox Talbot's denuded landscape images dissolve the Romantic aura of Scott mythology, giving us the Highlands as the "real."

Fox Talbot's epigraph to *Sun Pictures in Scotland* reinforces his quietly iconoclastic attitude toward aesthetic tradition:

> Juvat ire jugis qua nulla priorum
> Castaliam molli devertitur orbita clivo . . .
> (What joy to travel to the springs of Parnassus,
> where none before has made their track.)[48]

Fox Talbot perceived himself primarily as a pioneer of science, and the camera as nothing less than a revolution in visual experience. Whereas his rival D. O. Hill crafted his photographs like academic paintings, Fox Talbot clearly felt no indebtedness to art history. Given his explicit non-conformism, in what terms should we rate Fox Talbot's Scottish landscapes? As an artistic failure? Or a deliberate challenge to Romantic landscape and its idealized mode of seeing? In Mary Warner Marien's words, pioneer photographers "proclaimed the truth of the senses and of the palpable world" to a public already infatuated with panoramas, souvenir prints, and illustrated newspapers—that is, with visual reproduction of real places and events.[49] Photography's commercial success was accordingly never in doubt. Debates over its artistic potential, however, raged throughout the

remainder of the nineteenth century. For Fox Talbot, a gentleman mathematician and linguist, the artistic scope of photography was an open question. What he did claim for the camera, however, was its "own sphere of utility," which lay in an ability to provide "completeness of detail and correctness of perspective." The achievement of photography, he announced, was "to introduce into our pictures a multitude of minute details which add to the truth and *reality* of the representation" (my emphasis). The strength of the camera lay, that is, in empirical observation, as his *Pencil of Nature* photographs stunningly demonstrated. Furthermore, because it would record the image of "a chimney sweeper with same impartiality as it would the Apollo of Belvedere," the camera also promised an age of radical social leveling. Fox Talbot's choice of imagery here is significant. His comparison of the Apollo Belvedere, darling of generations of aristocratic Grand Tourists, with a chimney sweeper, perennial symbol of the downtrodden, should be taken as a broadly inclusive gesture: an invitation to the masses from the inventor of the camera. Fox Talbot's combination of objectivist aesthetics and implicitly democratic social goals naturally appeared subversive to the cultural elite (I will consider the Romantic backlash against photography in the second part of this chapter). "To idealists," states Warner, photography "was reductive, presenting a false picture of a demystified and totally material nature . . . photography became an important proxy for the effects of science, technology and popular democracy."[50] In other words, Fox Talbot defied academic orthodoxy, feeding a popular craving for the "real" of material nature. The commercial failure of *Sun Pictures in Scotland* notwithstanding, he anticipated our longstanding quotidian use of the camera as a documentary device and its cultural role as the universal, middlebrow visual medium.

The first decade of British photography was defiantly amateur, due largely to Fox Talbot's calotype patent. The club of British photographers was small, select, and catered only to a leisure class of aficionados. But with the expiration of Fox Talbot's patent in the early 1850s, the development of visually sharper and more efficient chemical processes, and the explosion of commercial photographers throughout Europe, the camera trade in Britain mushroomed almost overnight. By the mid-1850s, the elite's monopoly over photographic production had come to an end. Lady Eastlake observed that the number of registered commercial photographers in the 1852 London Directory "did not amount to more than seven. In 1855 the expiration of the patent and the influence of the Photographic Society swelled them to sixty-six—in 1857 photographers have a heading to themselves and stand at 147."[51] The significance of this growth for photographic aesthetics

was immense. *Sun Pictures in Scotland* clearly did not satisfy its highbrow subscribers of the mid-1840s like Lady Talbot, William Newton, and Lady Eastlake, who had been educated in picturesque aesthetics and steeped in the Romanticism of Turner. With the rapid democratization of camera technology in the 1850s, however, the market for photography expanded beyond those with any experience of or taste for such luxuries. The result was the formation of "a natural alliance," in Baudelaire's jaundiced terms, "between photography and the stupidity of the masses."[52] By 1860, the descriptive realism of Fox Talbot's calotypes, adapted to the utilitarian, commercial forms of the *carte de visite* and family portrait, was entrenched as the standard commercial style of the medium.

Whatever Fox Talbot's influence on the later commercial development of photography, his 1845 Scotland volume nevertheless represented a premature challenge to Romantic aesthetic ideology. Fans of Scott, swept up in the unveiling of the Edinburgh Monument and the lavish Waverley Balls, were in no mood for a realist critique of their icon. Unlike the middle-class patrons of the panoramas, who delighted in pictorial verisimilitude, Fox Talbot's aristocratic subscribers blanched at the shock effect of photographic realism. In short, *Sun Pictures in Scotland* anticipated Romanticism's demise at the hands of photography but did not effect it. Fox Talbot's failed Scotland travelogue is still a tribute to the Romantic cult of *Waverley,* however remote and equivocal. Not until the end of the next decade, with camera technology established in the mass market, could Félix Nadar more convincingly compose a photographic eulogy to Romanticism.

Adieu Bohème: Nadar, Baudelaire, and *la vision fugace*

To the chagrin of English photographers, the French pavilion at the 1851 Great Exhibition in London demonstrated the clear superiority of French camera technology. The work of the landscapist Gustave le Gray in particular outstripped the hosts in clarity, depth, and detail. The reason for the disparity between English and French photography was simple: Fox Talbot's jealous guarding of his patent. Fox Talbot and the Frenchman J. M. Daguerre had produced unique and distinct photographic processes within weeks of each other in 1839. But in the 1840s, through Fox Talbot's retarding influence, the production of English "calotypes" remained a strictly controlled amateur affair while the French "daguerrotype," open to technological innovation and capital investment, created a thriving commercial market in photography. The sheer technical difficulty of the photographic process to some extent counteracted this commercial trend in France. As

long as photographic technology (principally collodion-on-glass after 1851) demanded a virtuosic craftsmanship unadaptable to the mass market, the new medium maintained its avant-garde cachet. The 1850s subsequently witnessed, in Benjamin's words, "the flowering of photography . . . which preceded its industrialization."[53]

Two innovations that revolutionized the marketing possibilities of photography brought this golden age to an abrupt end around 1860: first, the development of albumenized paper for mass production; and second, A. A. E. Disdéri's adaptation of the photograph to the visiting card. Twenty years after the first invention of the daguerrotype, commercial studio photography as we know it today had arrived. One consequence of Disdéri's innovations was that France's first great artist in the photographic medium, Félix Nadar, enjoyed only a very short career. After 1860, his meticulous and unhurried studio practices became commercially impracticable. He soon lost interest in his bourgeois clientele and the abbreviated studio techniques the new industry of mass production demanded. The plain, beautifully sculpted style of Nadar's 1850s portraits, his subjects cast majestically against a flat and shadowless background, gave way to generic studio images in which clients surrounded themselves with the clutter of domestic bourgeois affluence. The photograph had become a signifier of social status rather than a radical medium of artistic inquiry and personal disclosure. After six intense years as a pioneer in photography, Nadar abandoned the camera, returning to his studio (which continued to publish thousands of commercial photographs under his name for the next four decades) only for special clients like Sarah Bernhardt or old friends like George Sand.

After a roller coaster career in the 1860s and 70s as an inventor, aeronaut, and public celebrity, Nadar devoted his declining years to nostalgic memoirs of his youth. Interestingly, the greater portion of his "millions of memorializing words" concerned not the photographic oeuvre for which he is remembered today but his life in Paris in the late 1830s and 1840s, when he belonged to a loose community of young artists in the *Quartier latin*. His friend, Henri Murger (who, at the age of forty, would breathe his last breath in Nadar's arms), had immortalized Nadar's circle in his best-selling *Scénes de la Vie de Bohème* (1845-49).[54] Murger's fond depictions of an artistic brotherhood struggling against penury and bourgeois ignorance became the basis for Puccini's opera a half-century later and are the stereotype of romantic urban youth still today. His bohemians rarely discuss politics, which is curious given the extraordinary concentration of radical French thought in that period (Proudhon, Fourier, Blanqui, etc.). Nadar, however, remembered the 1840s in the *Quartier latin* as a socialist utopia: "It

is necessary to insist on the character, the essence of our bohemian clans in those days, which in fact realized the 'phalansteries' and communes dreamt of by Saint-Simon, Fourier and my beloved visionary prophet, Jean Journet. These would astound today's generation."[55]

The climactic moment for the bohemian socialists of the July Monarchy came with what Nadar's friend, Charles Baudelaire, called the "intoxication" of 1848. Baudelaire himself was at the barricades, while Nadar marched with Prince Czartoryski on his quixotic campaign to liberate Poland from the Russians. But the troubled career of the Second Republic, culminating in the restoration of imperial rule in 1852, brought an abrupt end to "building Utopia." With government constraints on the French radical press, Nadar's early career as a political cartoonist was over. Even more seriously for Baudelaire, the new authoritarian regime would bring him to trial for obscenity in 1857. The poet duly "rage[d] at the *coup d'Etat*. To how many bullets I exposed myself! Another Bonaparte! what a disgrace!"[56] His 1862 poem, "Le Coucher du Soleil Romantique," implicitly connects the twilight of Romanticism with the advent of the Second Empire:

> L'irresistible Nuit établit son empire,
> Noire, humide, funeste et pleine de frissons
> [The irresistible Night establishes its empire,
> Black, humid, deadly, and filled with trembling].

For Baudelaire and Nadar, the repressive reign of Napoleon III signaled the end of the politicized Parisian Bohemia that had flourished under Louis-Philippe. Both subsequently abandoned politics: Baudelaire retreated into dandyish cynicism—"1848 was charming only by reason of the very excess of its absurdity"—while Nadar remade himself into an icon of Second Empire modernity and industrial progress.[57] The ultimate compliment to Nadar's mainstream celebrity came in 1865, when Jules Verne mythologized him as the daring balloonist and *homme du monde* of *De la Terre à la Lune*.

Aside from its artistic and technical achievement, Nadar's career as a portrait photographer offers documentary insight into the period of political disenchantment following the 1851 *coup d'état*. Prince Czartoryski appears broken and embittered in his portrait; Michelet's expression, as if reflecting on his ruined academic career, is equal parts pain and philosophy. The younger veterans of 1848, Nadar's own generation, make for even more revealing subjects. The studies of Champfleury, Murger, Chenevard, and others are so many "Portraits of the Artist in Middle Age." The cocky,

resilient twenty-year olds of Murger's *Scènes de la Vie de Bohème* have either become respectable, in the case of the civil servant Chennevières, or bitterly disillusioned, such as the poet Nerval, photographed only weeks before his suicide. By contrast, the radical activist figure Eugène Pelletan (figure 5.7), friend of Sand and Michelet and student of Saint-Simon, is heroically defiant, signifying Nadar's unrepentant political sympathies. The military cut of Pelletan's coat, the furl of his brow and unflinching gaze all suggest a Romantic martyr in whom the visionary gleam still burns. The portrait of the "utopian prophet" Jean Journet (figure 5.8) has a similar subtext: wrapped in an acolyte's robe, Journet uplifts his eyes toward the long-overdue angels of French socialism.

Nadar's best work suggests wry observation rather than the stagey visual aphorisms of his portrait of Journet. In his study of another Romantic celebrity, Théophile Gautier, Nadar eschews earnest physiognomic inquiry for a Balzacian description of the poet's eccentric uniform. In one portrait Gautier wears a rumpled artist's smock and open-collared white shirt, immediately placing him in the charmed Bohemian circle. Our eye is drawn to the carelessly tied check scarf that sits atop his belly as a mock-Byronic accent. In the second photograph (figure 5.9), Gautier's old wool coat of unclassifiable style recalls the famously capacious garment worn by Colline in Murger's *Bohème*. The poet's floral-patterned damask cap likewise accentuates the self-mocking attitude we find in Murger's stories: the bohemian's extravagant dress belies the seriousness of his air. With Gautier, as elsewhere, Nadar plays a double game. He pays photographic homage to the icons of French Romanticism while at the same time sending them up (see George Sand in a ludicrous wig!). His portraits celebrate the salad days of bohemian Paris, but in a way that emphasizes its passing into disillusionment (Nerval the suicide) or self-parody (Gautier in dress-up).

Nadar's bohemian subjects—leftists, actresses, painters, critics, writers, and anonymous grisettes—constitute a representative gallery of his famously large social circle. He once estimated the number of his friends at five thousand, and came to treat his photography studio less as a business than a theater in which to memorialize these friendships. To this extent, Nadar's relaxed and intimate approach to studio sessions owed much to the great society painters of the past, such as Van Dyck and Reynolds (see chapter 1). His portraits suggest not the studied "pose" of a client, but a pause in the conversation of intimates. Consequently, Nadar's portrait oeuvre does more than simply chronicle his bohemian friends and the icons of French Romanticism such as Berlioz and Delacroix. It marks an attempt to revive or, at the least, to memorialize the spirit of 1840s Bohemia itself, which, for

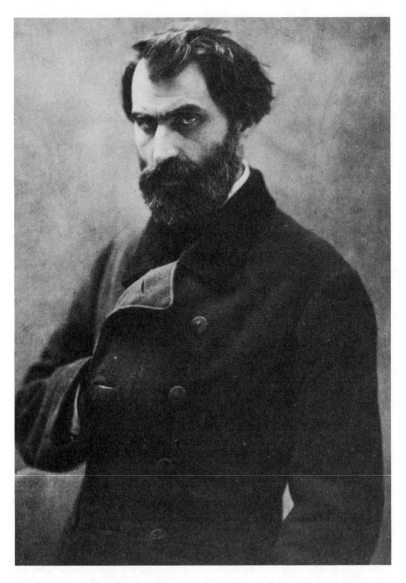

Figure 5.7 Félix Nadar, *Portrait of Eugene Pelletan* (ca.1855). The Metropolitan Museum of Art, The Howard Gilman Foundation Gift and Rogers Fund, 1991.

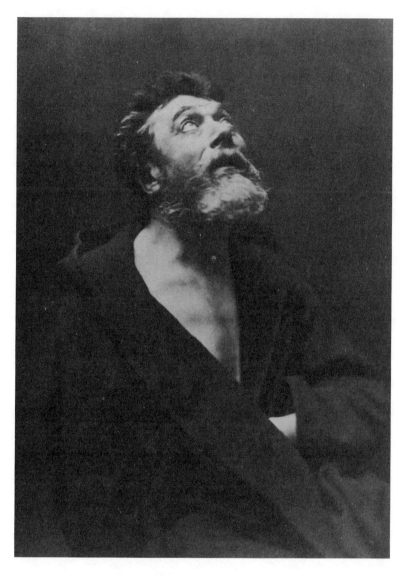

Figure 5.8 Nadar, *Portrait of Jean Journet* (ca.1856). Cliché Bibliothèque nationale de France, Paris.

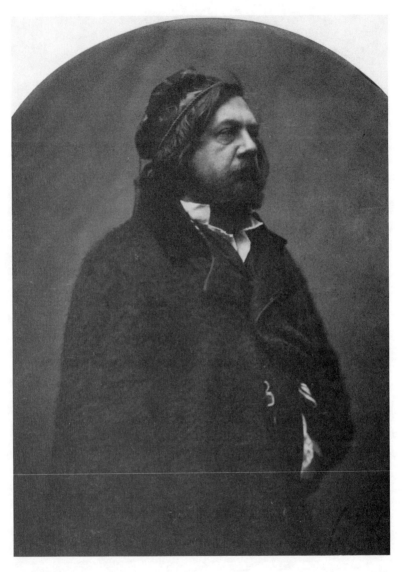

Figure 5.9 Nadar, *Portrait of Théophile Gautier* (1854). The J. Paul Getty Museum, Los Angeles.

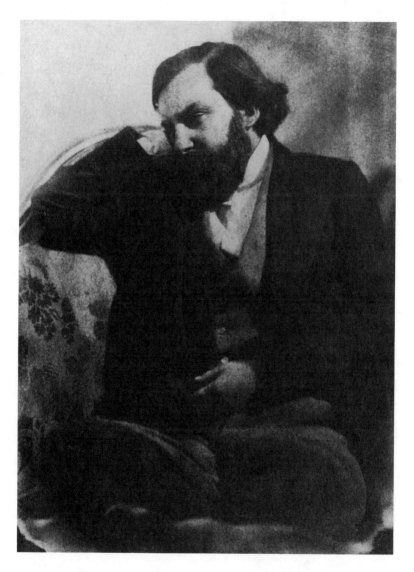

Figure 5.10 Nadar, *Portrait of François Asselineau* (1855). © Photo RMN – Réunion des musées nationaux.

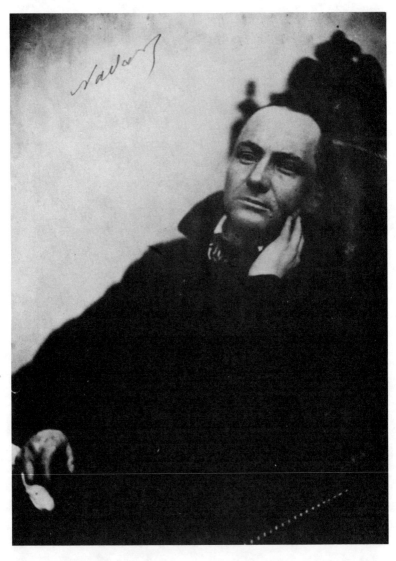

Figure 5.11 Nadar, *Portrait of Charles Baudelaire* (1855). © Photo RMN – Réunion des musées nationaux.

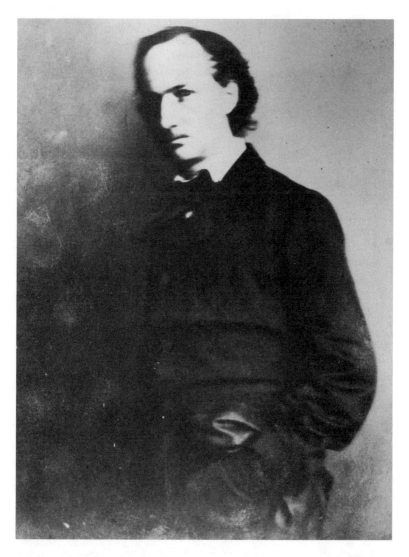

Figure 5.12 Nadar, *Portrait of Charles Baudelaire* (ca.1856). ©Photo RMN – Réunion des musées nationaux.

Nadar, lay not in a devotion to art but to friendship, to the exhilaration of absolute confidence. "Sharing all, without reserve or secrets," he mistily recalled, "our individual existences formed a single whole; we lived in perfect clarity, as if under a dome of glass, in an intimacy which filled every hour and every minute, and where nothing escaped notice."[58] Nadar's portrait of his lifelong friend François Asselineau (figure 5.10), for example, captures the critic in an unguarded but dignified meditation. The soft light and elevated camera angle do not expose his face to undue scrutiny, but rather allow it to recede into its characteristic gentleness (a quality Théodore de Banville memorably contrasted with Baudelaire's intensity).[59] The language Nadar later used to characterize bohemian friendship—clarity, intimacy, sharing without reserve—are all vividly suggested by the portrait. Nadar's sensitivity to Asselineau's most characteristic pose suggests the quasi-sacred amity of *la vie bohème*. His use of salt prints and a less than perfect lens guaranteed that this would be no warts-and-all memoir, but an affectionate representation of his friend's character. The misty camera lens symbolized Nadar's "glass dome" of perfect trust, with the photographer himself as the ideal confidant, honest but generous.

In his memoirs, Nadar endows his first encounter with Baudelaire in 1842 with a characteristic aura of holy intimacy: "We immediately confided everything to each other because, in this corner of bohemia, there was nothing to hide."[60] To Baudelaire in turn, Nadar was "the most amazing expression of vitality": an invaluable champion of his work in print and companion in the dark days of his decline.[61] The poet appears to have been a regular visitor to Nadar's studio on the Rue Saint-Lazare in the halcyon years. Portraits of Baudelaire from 1855-56 show him in a great assortment of costumes and poses. Two stand out: Baudelaire the dandy (figure 5.11), reclined in a high-backed chair, fastidiously dressed, with one hand drawn carelessly to his cheek; and Baudelaire the *poète maudit* (figure 5.12), diffident and out of focus against a blank wall, as if caught stalking a prostitute in Montmartre. Deathly pale and stark-eyed, the Baudelaire of the Nadar portraits suggests almost too well the humid sensibility of *Les Fleurs du mal*. But Baudelaire's published opinions on photography upset any simple reading of these portraits as character studies. As Walter Benjamin has observed, "To Baudelaire, there was something profoundly unnerving and terrifying about daguerrotypy."[62] And it was no ordinary camera shyness. Baudelaire despised photography for its vulgarization of French culture, a position he laid out in an astounding jeremiad in his *Salon de 1859*. With Baudelaire's disdain for photography in mind, we are led to interpret his

expression of distrust in the Nadar portraits—here a sidewards glance, there his lips pursed tight—not as an essential element of his character revealed by the camera, but a specific discomposure before Nadar's lens. There is no record of a conversation much less a dispute on the aesthetics of photography between the two friends, so it is left for us to speculate from the 1859 *Salon* essay to the mood of the Baudelaire sessions at Nadar's studio a few years earlier. One point is certain: Nadar's portraits of Baudelaire are necessarily complex images. They are Nadar's tribute to a celebrated bohemian comrade on the one hand; but one who was, at the same time, a sworn enemy of the medium in which he chose to memorialize their friendship.

The rapid popularization of photography in France coincided with the overthrow of the Republic in 1851-52. Consequently, the camera became synonymous in Baudelaire's mind with the ascendance of bourgeois taste in the Second Empire. The ubiquity of photographic images represented an industrialized modernity and mass culture he loathed. "Photography," he wrote in his *Salon de 1859,* "has helped in no small way to confirm fools in their faith, and to ruin what vestige of the divine might still have remained in the French mind."[63] In the world of the camera, he argued, "external reality" triumphs over "the intangible and the imaginary," technology over genius, and trade over art: "I am convinced that the badly applied advances of photography, like all purely material progress for that matter, have greatly contributed to the impoverishment of French genius. . . ." In Roland Barthes' terms, the photograph presents "the Real in its indefatigable expression."[64] For Baudelaire, the explosion of commercial photography in the mid to late 1850s foreshadowed the mass media culture Barthes would subsequently inhabit in the twentieth century. Unless checked, the cultural influence of photography, he claimed, would rapidly corrupt aesthetic standards. Photographic images of the "real"—in newspapers, shop windows, and the home—would crowd the imagination, inhibiting poetic sensibility. In a culture of reproductions and replicas, future artists would inevitably lose all faculty of sublime invention as one might lose the use of a limb for lack of exercise. "Can it legitimately be supposed," demanded Baudelaire, "that a people whose eyes get used to accepting the results of a material science as products of the beautiful will not, within a given time, have singularly diminished its capacity for judging and feeling those things that are most ethereal and immaterial?"[65] For the French Academy and its bohemian fringe-dwellers (Murger's Marcel, we recall, is a struggling history painter), ordinary visual experience implied the material, the earthly, and hence the unredeemed. It followed that, as a mere replicator of visual phenomena, the camera stood guilty of asserting a homogenizing "truth"

over the subjective ideality necessary to the appreciation of fine art. Daumier's academic opinion echoed Baudelaire's: "Photography imitates everything and expresses nothing—it is blind in the world of the spirit."[66]

Baudelaire's objections to photography originate in the Romantic precepts of elected genius and the imagination: the former threatened by the democratizing potential of camera technology, the latter by the popular appeal of photographic verisimilitude. The detrimental effects of photographic realism on painting were already apparent, he argued, in the fashionability of artists such as Courbet:

> More and more, as each day goes by, art is losing its self-respect, is prostrating itself before external reality, and the painter is becoming more inclined to paint, not what he dreams, but what he sees. . . . Will the honest observer declare that the invasion of photography and the great industrial madness of today are wholly innocent of this deplorable result?[67]

Baudelaire concedes a role for photography in the material sciences—as a tool of biologists or astronomers, and in the custodial sciences of the museum and archive—but, to the artist, it represents a "mortal enemy." The camera might classify and record, but never create. For the lyric poet, the photograph is not a figure of the death of the imagination, but its literal image. A Romantic trope has become a historical reality; a photo exists where the imagination used to be.

This characterization of Baudelaire as an unreconstructed Romantic will confuse those accustomed to reading him solely through the prism of his 1859 essay on the newspaper sketch artist, Constantin Guys, where Baudelaire celebrates the fugitive and ephemeral medium of newspaper illustration as representative of an essentially modern artistic consciousness. Read alongside his essay on photography from the same year, however, Baudelaire's analysis of Guys in "The Painter of Modern Life" becomes less a tribute to the evanescent, mass-produced images of illustrated newspapers than a reassertion of the sovereign power of Romantic genius. That is, Baudelaire's concern is less with what Guys produces, or the machinery of its distribution, than the spectacle of the sketch artist's feverish inspiration:

> Monsieur G. is bending over his table, darting onto a sheet of paper the same glance that a moment ago he was directing towards external things, skirmishing with his pencil, his pen, his brush, splashing his glass of water up to the ceiling, wiping his pen on his shirt, in a ferment of violent activity, as though afraid that the image might escape him, cantankerous though alone,

elbowing himself on. And the external world is reborn upon his paper, natural and more than natural, beautiful and more than beautiful, strange and endowed with an impulsive life like the soul of its creator.[68]

Guys' sketches are "modern" at only the most superficial level of their subject matter. Baudelaire concentrates rather on the conventional signifiers of Romantic art: beyond its merely documentary surface, Guys' work is "more than natural," "strange," and animated by "the soul of its creator." As a dandy, a "man of the crowd," "a kaleidoscope gifted with consciousness," Guys is not an *ur*-modernist but a proxy for Baudelaire's own Romanticized self-image and the operations of his urban lyric imagination. Thus Baudelaire's essay, its title and general reception notwithstanding, is essentially conservative. His principal concern in celebrating Guys is to preserve the auratic status of Romantic genius within the new industry of mass-circulated image production. Ironically, it was Baudelaire's nemesis, photography, that ultimately usurped this privileged status of the daily newspaper illustrator. The advent of photojournalism in the years after World War I meant that the marriage of "painting" and "modern life," embodied for Baudelaire in the career of the mercurial sketch artist Guys, was short-lived.

Whatever the reasons for Baudelaire's attraction to the new popular medium of newspaper illustration, it did not extend to photography. The almost demonic energy of Guys in the act of artistic creation would have contrasted favorably in Baudelaire's mind with the disengaged manner of the studio photographer, the peak of whose animation lay in coolly replacing a plate before disappearing silently beneath the hood. Having one's photograph taken in the 1850s was indeed an alienating ordeal. The protracted exposure time required the subject to remain absolutely still for longer than a minute, gazing unblinkingly into the lens. Benjamin relates that "what was inevitably felt to be inhuman, one might even say deadly, in daguerrotypy was the (prolonged) looking into the camera, since the camera records our likeness without returning our gaze."[69] For their more fidgety clients, photographers employed head braces and back supports to ensure immobility, literally trapping them in the frame. Baudelaire lamented photography's sacrifice of an auratic exchange between artist and subject in favor of this crude mechanical process. The interposition of the machine was a "startling" and "cruel" rupture of the protocols for conventional portraiture and exemplified, in Benjamin's terms, the "shock" effect of human interaction with modern visual technology.

Given Baudelaire's deeply felt antipathy to photography, we return to his

portraits by Nadar with a wary eye. The "glass-dome" intimacy of bohemian brotherhood—so apparent in the portraits of Asselineau, Gautier, and others—is fractured in these images. We cannot escape the resentment of the poet's unrequited gaze. Baudelaire's suspicious eye lights upon Nadar and us as if to determine the true object of our loyalty: technology or the imagination? More than a decade earlier, in his *Salon de 1846,* Baudelaire had declared that "to call oneself a romantic and to fix one's gaze systematically on the past is contradictory . . . romanticism is the most recent, the most up-to-date expression of beauty."[70] Years later, in his final programmatic statement on Romanticism, Baudelaire once more rejected the family of affects associated with Romantic retrospection, namely nostalgia, sentimentality, and a melancholy longing for the past:

> *Romanticism:* When we ponder on the days of our youth, we think of them as a manifestation of ourselves. We are, in fact, resurrecting ourselves—and, around us, an epoch. Reconstructions of bygone ages are false in this respect, that there is no life at their centre—everything has the same depth: the result is inevitably a chromolithograph.[71]

Baudelaire's definition, through its strict discrimination of the Romantic and the sentimental, implies a critique of Nadar's nostalgic enterprise as both a photographer and memoirist. Romanticism is "the most up-to-date expression of beauty," insists Baudelaire, while nostalgia seeks only "to reconstruct . . . bygone ages." The suggestion is that, like the chromolithographer, Nadar, as self-appointed memoirist of *la vie de Bohème,* is destined not to reconstruct the "glass dome" of past friendships through photography. His camera does not reveal its subject, only the direction of his own sentimental gaze. As examples of a "false" Romanticism, Nadar's nostalgic memories of bohemian Paris will inevitably lack "life" and "depth." According to this logic, his portraits do not represent a living document of his charmed youth but its "reconstruction" as allegory. In their shallow lifelessness, Nadar's photographic memories signify precisely the absence of what they present.

In his memoir *Quand J'Etais Un Photographe* (1900), Nadar responds to Baudelaire's critique of photography with mock seriousness. It was, he noted, a curious brand of heroism that prompted the French Romantics— Balzac, Baudelaire, Gautier—to protest the *terreur* of photography, and at the same time submit to it so regularly at his studio (presumably they

wished to test their fears). Baudelaire's distrustful expression comes irresistibly to mind in Nadar's whimsical account of the "disquiet" and "trepidation" he encountered among his earliest clients, which amounted to a "hesitant defiance" of photography among "the most exquisite spirits." He recalls their impression of his Saint-Lazare studio as "a place of election reserved for the Prince of Darkness. It needed but little to make our filters into philters."[72] Balzac, not Baudelaire, however, serves as Nadar's immediate example of antiphotographic sentiment, on account perhaps of the gothic appeal of his reasoning. "Each natural body is composed of a series of specters," Balzac solemnly informed Nadar, "and with each successive Daguerrian operation, one of these specters, that is, one part of its constitutive essence, is lost."[73] Balzac's distinctly Romantic objection to photography, based on a "spectral" notion of human identity, stood only a half-step removed from more conventional criticisms of the new medium. The English critic Robert Hunt exemplified a deeper, religious iconophobia central to the early Victorian argument against photography. "Works of High Art," insisted Hunt, "are not to be executed by a mechanical contrivance. The hand of man, guided by the heaven-born mind, can alone achieve greatness in this direction."[74] Hunt's true artist reminds us of Michelangelo's Adam ("the hand of man, guided by the Heaven-born mind") reaching upward to receive the divine spark, literally touched with genius. A photographer hunched beneath a black hood fiddling with shutters clearly didn't belong to this iconography of artistic production.

It is typical of Nadar's mercurial relationship to French Romanticism that he both makes fun of Balzac—who "could afford to squander a great many specters"—while using Balzac's own rhetoric of spectrality for an impassioned defense of photography. For Nadar, the magic of camera technology

> seems at last to have given Man the power to create in his turn. He can materialize the impalpable *specter* that vanishes as soon as it is seen without leaving a shadow on the crystal of the mirror, or a ripple on the bowl of water. How could Man not think himself a creator when he seized, grasped, fixed the intangible, preserving the fugitive vision [*la vision fugace*] of light, inscribing it now on the toughest bronze?[75] (my emphasis)

Balzac and Baudelaire dreaded precisely this power of the camera to "fix the intangible," to materialize the evanescent specters of visual experience. But Nadar's Promethean ambitions make no concession to such fears. In

place of Balzac's gothic alarmism, he employs the triumphalist rhetoric of nineteenth-century industrial utopianism, in which photography stands out as "the most extraordinary of that constellation of inventions that make of our yet unfinished century the greatest for science."[76]

The capture of *la vision fugace,* for Nadar the scientific achievement of photography, is precisely what Baudelaire's poetics disavow. In his famous sonnet, "A Une Passante," Baudelaire recalls the spectacle of a beautiful woman passing on a crowded street:

> La rue assourdissante autour de moi hurlait
> Longue, mince, en grand deuil, douleur majesteuse
> Une femme passa, d'une main fasteuse
> Soulevant, balançant le feston et l'ourlet;
> [Around me, the street was a deafening roar.
> A woman passed by, willowy slender, in deep mourning,
> Majestic in her sorrow—with a luxuriant hand
> She lifts and swings her embroidered hem.]

The woman's subsequent disappearance into the crowd symbolizes for the poet the essence of the Romantic condition, in which nothing is truly appreciated or defined except in longing:

> Un éclair . . . puis la nuit!—Fugitive beauté
> Dont le regard m'a fait soudainement renaitre,
> Ne te verrai-je plus dans l'éternité?
> Ailleurs, bien loin d'ici! Trop tard! Jamais, peut-etre!
> Car j'ignore ou tu fuis, tu ne sais ou je vais,
> O toi que j'eusse aimée, o toi qui le savais!
>
> [A flash of light . . . then darkness!—Fugitive beauty,
> Your one glance made me suddenly reborn,
> Will I never see you again for all eternity?
> Somewhere else, far from here, and too late! Perhaps never!
> I don't know where you are fleeing to, nor you me,
> You whom I might have loved—You who knew it too!]

While Nadar considers *fugitive beauté* within the documentary grasp of photography, for Baudelaire in "A Une Passante" beauty is essentially and necessarily fugitive. According to Benjamin's unforgettable gloss of the poem: "the delight of the urban poet is love—not at first sight, but at last

sight."[77] The aspirations of the photographer and lyric poet are at odds. The photographer's object is the capture of *la vision fugace* while, for the poet, its possession would mean no lyric performance of desire, and hence no poem.

Nadar's scientific goal to "fix the intangible" in a photographic image is evident in his experiments in the Paris Catacombs in 1861, eventually published under the title *Paris Souterrain*. Before 1861, all photographers, studio and *plein-air,* had relied on natural light for their "sun pictures." Seeking a technological breakthrough in artificial illumination, Nadar intended the three-month underground project to advance the understanding of photographic exposures: "The subterranean world presented infinite possibilities for [photographic] operations no less interesting than on the earth's surface. We were going to penetrate and reveal the mysteries of the deepest, most secret caverns."[78] Nadar's desire to "penetrate and reveal" the "mysteries" of subterranean Paris marks him, as Baudelaire suspected, an enemy of Gothic impalpability.

But the Paris Catacombs, as it turned out, fell far short of the ghoulish majesty of their ancient Roman counterpart. They were old subterranean quarries, recently converted to accommodate the contents of cemeteries demolished to make way for the city's expansion. In this respect, the development of the Paris Catacombs belonged to the modernizing vision of Baron Haussmann, town planner of the Second Empire and architect of modern Paris.[79] As Nadar wistfully recalled in his memoir of Baudelaire, he and his bohemian friends, in pre-Haussmann days, had inhabited an essentially medieval city:

> The great boulevards, Saint-Michel and Saint-Germain, did not yet exist. Walled up within an arterial maze of muddy streets, Cluny would be choking, sections of columns and broken gargoyles strewn in the garden . . . as a kind of repose there was an intersection to our right, a little plaza with asymmetrical corners called the Cloister of Saint-Benoit. In front of us we would find the ancient Church of the Cordeliers, long abandoned, its blackened structure set apart from the tumbledown cottages nearby. . . .[80]

The bohemians even had their own pseudo-medieval language, a brand of French pig latin (its sophistication may be judged by the corruption of the photographer's family name, Tournachon, in his untraceable nom de plume, Nadar).[81] By the mid-1850s, however, much of the old *Quartier latin* had already disappeared and its bohemian culture along with it. Haussmann systematically leveled the cloistered streets and old one and two-

story dwellings of Nadar's youth to make way for his great signature boule-
vards (designed specifically to prevent the erection of barricades). As
Baudelaire lamented in "Le Cygne":

> Le vieux Paris n'est plus (la forme d'une ville
> Change plus vite, hélas! que le coeur d'un mortel)
>
> [The old Paris is no more (the shape of a city
> Changes faster, alas, than the human heart)].

In the building sites of Second Empire Paris, Baudelaire discovered a
figure for his own psychological excavations, and a theater for Romantic
memory—

> Paris change! mais rien dans ma mélancolie
> N'a bougé! palais neufs, échafaudages, blocs,
> Vieux faubourgs, tout pour moi devient allégorie,
> Et mes chers souvenirs sont plus lourds que des rocs.
>
> [Paris changes! But nothing in my melancholy mood
> Has altered! I see in the new palaces, scaffolding,
> Rubble, and old neighborhoods an allegory of my self,
> And cherished memories heavier than stone.]

—but visitors to the Catacombs found its atmosphere ruined by the signs
of Haussmann's ordering hand. The Goncourt brothers, who visited the
Catacombs in 1862 in the company of Flaubert, were disappointed by the
complete lack of ghoulish ambiance: "There is an administrative orderliness
that removes all the drama from this library of skulls. . . . To create the
proper effect one would need chaotic piles, mountains of bones, not
shelves. Bones should rise all along the immense vaults and fade up into the
night, as all these heads fade into anonymity and dust." Lacking the sugges-
tive neglect of the graveyard (the better to represent death's power over our
worldly rage for order), the Catacombs conveyed, for the Goncourts, some-
thing like the bureaucratization of death. No *frisson* of otherworldly com-
munion greeted the Romantic tourist, who felt instead only the numbness
of the alienated citizen confronted by the collectivizing apparatus of the
modern state. Worse yet, because the Catacombs were now a popular
tourist attraction (as they still are), the Goncourts found themselves a cap-

tive audience to "those Parisian jokers who go underground on veritable pleasure parties and amuse themselves by hurling taunts into the mouth of Nothingness; it makes one cringe."[82] In their amused contempt for the Catacombs, the Parisian hoi-polloi show their indifference to a quintessential Romantic *topos:* the gloomy subterranean vault of bones. The Catacombs hold no terrors for the Goncourts' fellow tourists because Baron Haussmann, in destroying medieval Paris, has de-mystified the Gothic. The ghostly terrors of death itself have been absorbed into the "real," and Romantic visitants to the Catacombs feel the dull shock of that loss.

Nadar's typically breezy account of his Catacombs project appeared in the 1867 *Paris Guide* (a companion to the *Exposition Universelle*).[83] This initial publication of *Paris Souterrain* in a tourist guide rather than a photographic journal (of which there were dozens in Europe and North America by this time) may be explained by the Catacombs' growing celebrity. Characteristically, Nadar had found a means to combine science and self-promotion. In the text of *Paris Souterrain,* he assumes the role of tour guide, addressing himself to a young female companion: "You are not acquainted with the Catacombs, Madame; allow me to be your guide. Please take my arm, and *suivons le monde!*" What follows is a supercilious parody of Dante's *Inferno,* with Nadar in the role of the mentor Virgil and the timorous lady his Florentine poet-pupil. Like the Goncourts, the two modern pilgrims find their expectation of medieval horror at the Catacombs deflated by the *ennui* of municipal data: ". . . . the postern gate opens. Each of us is swallowed up little by little by the tightly spiraling stair. It might please you to know that this entrance, the most practical, is one of sixty to the Paris Catacombs, and that this stairwell has ninety steps. No doubt these statistics interest you no more than they do me."[84] For Stendhal in 1823, Dante was "le poète romantique par excellence." By mid-century, however, allusions to the *Inferno* had become, in Michael Pitwood's words, one of "the clichés of Romanticism." [85] Nadar treats it as such. He and his companion enact the crossing of the Styx: "A massive, square-shaped boat received us . . . towing us across the sordid stream . . . toward the stinking Seine," and follow the legendary spiraling path downward beyond redemption: "the path descends and descends still. . . ."[86] Unlike the *Inferno,* however, there is no hierarchy of sinners to greet these Second Empire tourists to the Paris Catacombs, no epic dramatis personae of Hell, only an "egalitarian confusion of death" that leaves them cold. The Romantic inferno of the imagination loses everything in its visual realization. A literary Hell, concludes Nadar, is a visual bore. "One's curiosity is soon satisfied," he announces to his compan-

ion as if anticipating her disappointment, "this is one of those places where everyone wants to go but no-one ever comes back again."[87]

The question arises: do Nadar's Catacombs photographs echo his textual commentary in proclaiming the end of the Parisian Gothic, or do the images of *Paris Souterrain* challenge the ironizing power of Haussmann's bureaucratized mausoleum, reclaiming the Catacombs as a site for Romantic, Baudelairean imagination?

The paucity of light in the Catacombs necessitated the employment of powerfully bright magnesium flares. Moreover, because Nadar needed an exposure time of a quarter-hour or more for each photograph, he used mannequins instead of human models to enliven the scene. The images of dummies dressed in working clothes (figure 5.13) hauling carts or leaning on shovels, lend a cartoonish quality to the Catacombs series. On occasion, Nadar dispenses with the dummies and attempts to discover a formal beauty in the arrangement of the bones and skulls (figure 5.14). In one particularly arresting image, Nadar captures a wall of bones stacked in an architecturally delicate curve, like the interior of a church dome (figure 5.15). The effect is abstract rather than descriptive: we are looking at a pattern or tapestry, not human remains. The overall impact of the Catacombs series, however, reflects the disappointed reviews of Nadar and the Goncourts. As a photographic advertisement aimed at the would-be Romantic tourist, *Paris Souterrain* lacks the seductive gloss of the modern travel brochure or its later, weightier cousin, the coffee-table book of exotic sights. Instead of evoking the Romantic aura of the mausoleum, Nadar's images show bones and skulls literally filed away against the walls. Classical quotations, inscribed on the dividing columns, function as so many collective toe-tags. These Catacombs are not an ancient, Romantic graveyard but a municipal warehouse of the dead, a skeletal archive where human identity is shelved and homogenized. In other words, the images of *Paris Souterrain* take on the de-romanticized character of their subject. Their unusual blandness typifies what Benjamin has described as the historical destruction of the aura in the mid-nineteenth century: a gradual supersession of Romantic idealism under the cultural conditions of urban industrial modernity. According to Benjamin's terms, Romanticism is no longer a choice for Nadar. His Catacombs project represents Haussmann's Paris, not Dante's Hell—the "real," not the ideal—because it is Haussmann's Paris Nadar inhabits. His Catacombs series bears witness to the highly bureaucratized and increasingly impersonal character of Parisian life in the industrial boom years of the Second Empire. The unnamed stacks of bones and skulls elicit for Nadar, the Goncourts, and the aging bohemians of

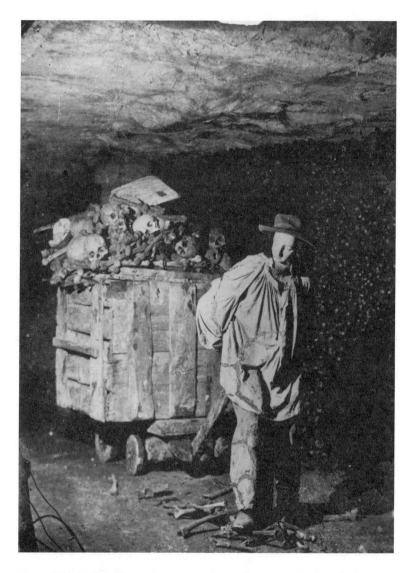

Figure 5.13 Nadar, *Mannequin tirant un chariot d'ossements*. From *Paris Souterrain* (1861). Felix Nadar/© Arch. Phot. Paris/Caisse nationale des monuments historiques et des sites, Paris.

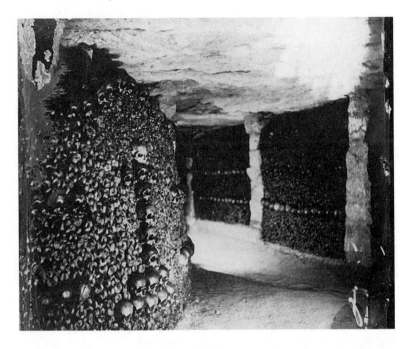

Figure 5.14 Nadar, *Un élément de lumière artificielle.* From *Paris Souterrain.* Felix Nadar/© Arch. Phot. Paris/Caisse nationale des monuments historiques et des sites, Paris.

their generation, the very specter of France's modernity. They are, in effect, negative images of Nadar's bohemian "glass dome": the medieval quarter of 1840s Paris where, instead of these anonymous skeletons, one might have five thousand friends.

To conclude, Nadar's parody of Dante in *Paris Souterrain,* like his send-up of Balzac in his memoirs, shows a keen sensitivity for Romantic cliché. His ironic instincts were most in evidence, naturally, in his career as a cari-caturist, where not even his most esteemed friends escaped mockery. One cartoon from 1858, entitled "Charles Baudelaire Discovering Carrion in the Undergrowth of *Les Fleurs du mal,*" shows Baudelaire, his head comi-cally enlarged, tripping over the carcass of a dog. Nadar's image is typically insouciant: he makes light of perhaps Baudelaire's most shocking poem, *Une Charogne.* Complicating our notion of Nadar as a mere parodist, how-ever, is his self-appointed role as historian of French Romanticism. Both as

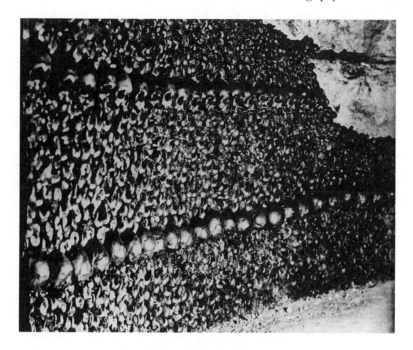

Figure 5.15 Nadar, *Façade de tibias avec ornamentation horizontale de crânes.* From *Paris Souterrain.* Felix Nadar/©Arch. Phot. Paris/Caisse nationale des monuments historiques et des sites, Paris.

a photographer in the 1850s and later a prolific memoirist, Nadar typically looks back to pre-Haussmann Paris: to the bohemian years of the July Monarchy. In his famous Saint Lazare portraits of 1854-60, he memorializes the great French Romantics of that earlier generation—Delacroix, Berlioz, Michelet—as well as his old bohemian companions, Asselineau, Murger, and Baudelaire. In a similar spirit, Nadar's photo-documentary of the Catacombs in 1861, as an implicit representation of the new authoritarian and bureaucratized social order of the Second Empire, symbolizes the disappearance of gothic Paris and the bohemian neighborhoods of his youth.

When judging both Nadar's famous portraits and the lesser-known Catacombs series, however, we are reminded of Baudelaire's warnings of the shallowness of sentimentality, the "false" Romanticism of nostalgia. Both the cadaverous reserve of the Baudelaire portraits and the merely clinical

morbidity of his Catacombs images suggest that Nadar, as a photographer, was in no position to resurrect Romanticism as "the most up-to-date form of beauty." Like Turner's proto-photographic memorial to the dying Sir Walter Scott, which documented their tour of the Scottish Lowlands in 1831, Nadar's photographic oeuvre is riven by a pre-emptive retrospection. As he himself perceived, photography, unlike painting, necessarily lives in the past. A photographic image captures its subject not as it "really" is, but only the fugitive moment of its own production—a *vision fugace*. By composing a photographic eulogy to French Romanticism, Nadar thus anticipated mainstream use of the medium in its subsequent hundred and fifty year history—as a form of sentimental *souvenir*.

Afterword ∿

VISUAL CULTURE 2000

My aim in *The Shock of the Real* has been to present a history of the Romantic period debate over visual and verbal media. To do this, I have traversed the landscape of late Georgian visual culture: from Reynolds' Royal Academy to the Panorama of Leicester Square; from Garrick's Drury Lane to the British Museum; and from the tourist treks of the Highlands to Nadar's studio in Second Empire Paris. Each episode of Romantic anxiety we encountered at these sites highlighted a specific "shock" effect of modern visual culture on literary sensibility. This shock effect was found to be particularly acute when inspired by media devoted to mimetic recreation of the visible world. In chapter 3, for example, Wordsworth blamed the "mimic sight" of the panorama for its debilitating effect on the autonomous poetic imagination. Likewise for Lamb at the theater, Keats at the Elgin Gallery, and Baudelaire caught in Nadar's pitiless lens, *The Shock of the Real* has sought to dramatize how innovations in the forms and forums of visual media in the late eighteenth and early nineteenth centuries posed a mortal threat to the Romantic view of art and nature. Implicit in this conclusion is a challenge to both popular and academic understandings of visual-cultural history. That is, a central argument of this book has been that the enduring trend in visual technology toward the more faithful reproduction of "reality"—what Benjamin ironically termed "the theory of 'progress' in the arts"—predates the invention of photography by the better part of a century. The wide variety of media I have discussed collectively demonstrate that the basic framework of our visual culture—its emphasis on verisimilitude, its commercial foundation in mass production, and its invention of "entertainment" as the

commodity form of leisure—can be identified from the late eighteenth century.

What benefits accrue to this realization? The problems faced by a literary sensibility in a visually saturated cityscape—the psychologically "unmanageable sights" Wordsworth described in 1790s London—are more than familiar to us two hundred years later (Wordsworth feared for the fate of poetry, and indeed it has retreated within the walls of the Academy). In the iconophobic rhetoric of Romantic writers such as Lamb, Wordsworth, and Baudelaire, we observe a certain violence attending the rise of the visual culture we currently inhabit from a more literary age that we are now inclined to sentimentalize. The much-anticipated demise of literate culture at the hands of visual mass media may yet prove to be just another exaggerated millennial prediction; but whatever the future *agon* of word and image in Western culture, the Romantic period offers an indispensable account of its origins.

Class issues have been central to my investigation of Romantic ideology and popular visual culture. Art galleries (exclusively private) and Grand Tours (very expensive) were, through the first half of the eighteenth century, the province of the moneyed elite. As I have shown, however, visual culture in the long Romantic period came increasingly under the patronage of the bourgeoisie and thus, for the connoisseur class, under the taint of commercialism. We saw that, as a consequence of the Georgian commercialization of art, those involved in academic production sometimes resorted to a professional double identity. Sir Joshua Reynolds, for example, protected his elitist credentials through conservative academic lectures, while at the same time securing a lucrative slice of the booming popular market in prints. More broadly, this book has examined how the high/low sensitivities in aesthetic ideology between 1760 and 1860 produced fierce debates over every aspect of the new visual culture: from whether to charge admission for art exhibitions (thus "commercializing" them), to the aesthetic merit of panoramas, to the politics of museums, to the relation of theatrical production to dramatic text, to the social consequences of book illustration and photography. The class schism over visual culture remains clearly visible today: between so-called independent cinema and Hollywood; between Greek revival art galleries and Disneyworld; between the latest Soho video-art installation and the commercial media world it attempts to critique. The Romantic writers I have discussed habitually identified popular taste with commercialism, bad art, and a taste for simulated reality. The educated elite of today continues to reinforce this associ-

ation through regular denouncements of visual media entertainment and its fascination for the "real." For the editorialists of the highbrow press, special effects Hollywood movies, simulated action video games, and confessional TV talk shows have created a parallel world of pseudo-experience that, increasingly, only they themselves care to distinguish from *real life* and its proper distillation in the older forms of art.

Visual culture from 1760 to 1860 incorporated both public and private spheres, albeit in unequal proportion. Prints, illustrated books, and later photographs were produced for collection and display in the home; but the sheer variety and scope of public visual entertainment overshadowed these domestic media. Theaters, art galleries, panoramas and dioramas, museums, cabinets of curiosities, and sightseeing tours all catered to a seemingly insatiable popular appetite for visual recreation. The two hundred years of visual media since the age of Wordsworth, however, have seen the relative significance of public and domestic spheres reversed. Where Georgian urbanites roamed from West End theaters to the Scottish Highlands in search of visual novelty, the private home is now the dominant site of visual culture. That is, whereas the media marketplace of the Romantic period was primarily dependent on public venues and thus collective consumption, visual culture now largely takes place in atomized domestic spaces—"living" rooms—where the technology of visual entertainment is kept and its rituals performed. The progressive miniaturization of twentieth-century visual technologies into cheap, compact, portable units has facilitated the domestication of visual media. What we candidly describe as our "home entertainment system" includes the venerable TV set, the indispensable VCR, and now the interactive genii of the Internet and CD-ROM with their increasingly sophisticated graphic components. One consequence of this reversion to the domestic space is that the visual culture industry is no longer run by theater managers like Garrick, impresarios like Bullock, and individual media innovators like Barker and Boydell, but by film and TV production companies, web site engineers, and software conglomerates. Though traditional public forums persist—theaters and art galleries maintain a loyal if stubbornly marginal constituency—the wild cornucopia of public visual culture, as it was in the Romantic age, has been almost entirely reduced to popular cinema and the circus spectaculars of made-for-TV professional sports.

An exception to the entrenched high/low cultural paradigm in contemporary visual culture is tourism. Since its origins in the Grand Tours and picturesque sightseeing of the eighteenth century, recreational travel has seen its class hierarchies progressively elided to the point where tourists

now represent a more or less homogenous mass. Foreign travel has become a broadly middle-class phenomenon, and domestic tourism is available to all but the very poor. (The only residual class distinction is between those who cling to the Romantic origins of tourism—as a form of improvised self-invention through exotic contact—and those drawn to the comfort and convenience of resorts and organized package tours). From the point of view of visual technology, the tourist industry today is inseparable from its documentary images. Whereas, in the Georgian era, no Grand Tourist was without a journal in which to record her impressions, modern travelers carry camera equipment. Here, as everywhere, the literary accessory (the travel journal) has given way to a substitutive visual form (the photo album or videotape). The tourist's worst nightmare is, after all, to return home to find the camera unloaded. My study has touched upon the origins of this close, often suffocating embrace of tourism and visual media. In Turner's illustrations for Scott's *Poetry* (chapter 5), we discovered an embryonic form of the visual media accessories—postcards, travel magazines, souvenir snapshots—long since indispensable to the modern tourist.

The implication of the preceding paragraphs, and my book as a whole, is that the late Georgian fascination for replicating the visible world—be it a natural image (a landscape reproduced as a panorama or photograph) or a pre-figured aesthetic form (a portrait by Reynolds reproduced as a print)—constitutes the template of our own popular tastes and expectations in visual culture in the new millennium. This includes the sometimes violent minority reaction *against* visual culture, for which, I suggest, Romantic aesthetic ideology continues to provide the conceptual vocabulary. It is near-impossible, for example, to open a current periodical devoted to educated cultural commentary (*Harper's,* say, or *The Atlantic Monthly*) without encountering a lament on the failure of literacy in a visual age, or a high-minded defense of the pleasures of reading, that could have been written by a Wordsworth, a Lamb, or a Baudelaire. This book is intended to provide necessary historical context for this familiar and now all-too-respectable discourse of resistance to popular visual culture. *The Shock of the Real* demonstrates that, whatever our feelings of awe, apprehension, or "shock" at the latest wave of recreational and informational visual media, our response to the new relies heavily on the workings of cultural memory. In short, our millennial anxiety over visual media is an essentially Romantic phenomenon, and has not advanced much beyond the terms the Romantics set around 1800. Without an understanding of the *long* history of critical reactions to modern visual culture—the origins of which I have explored in this book—we cannot examine its prejudices or our own. Such

understanding matters because an unexamined adoption of Romantic prejudice against popular visual media is potentially more damaging to the future of literate culture than the unconditional embrace of our so-called visual age. Indeed, the day is fast approaching when the standard literary critique of visual media—staged as a perennial rematch of aging heavy-weights, the Imaginary and the Visible, the Ideal and the Real—will appear every bit as numbing and empty as the culture it condemns.

NOTES ∽

Introduction

1. *A Saunter Through the West End* (London, 1861), 43.
2. For a history of William Bullock and the Egyptian Hall, see Richard Altick, *The Shows of London* (Cambridge, MA: Harvard University Press, 1978), 236-41.
3. The most authoritative of the recent biographies of Belzoni, from which I draw the following account, is Stanley Mayes, *The Great Belzoni* (New York: Walker and Co., 1961), 257-62. John Whale offers a more critical treatment of Belzoni's place in the history of cultural imperialism in "Sacred Objects and the Sublime Ruins of Art," *Beyond Romanticism,* ed. John Whale and Stephen Copley (London: Routledge, 1992), 227-35.
4. *The Times,* 30 April 1821.
5. "The Reality Effect," *French Literary Theory Today,* ed. Tzvetan Todorov (Cambridge: Cambridge University Press, 1982), 15.
6. The Greek painter Zeuxis' rendering of grapes was so lifelike that, as Pliny relates, birds would strive to alight on the painting to sample the fruit. *Natural History,* trans. D. E. Eicholz (Cambridge, MA: Harvard University Press, 1962), 9: lib.XXXV.10.
7. *Camera Lucida: Reflections on Photography,* trans. Richard Howard (New York: Farrar, Straus, and Giroux, 1981), 4.
8. "The Reality Effect," 16.
9. As Norman Bryson has explained, "The real needs to be understood not as a transcendent and changeless given, but as a production brought about by human activity within specific cultural constraints. . . . It is in relation to this socially determined body of codes, and not in relation to an immutable 'universal visual experience,' that the realism of an image should be understood." *Word and Image: French Painting of the Ancien Régime* (Cambridge: Cambridge University Press, 1981), 8.

10. "Lecture 13 (On Poesy or Art)," *The Literary Remains of Samuel Taylor Coleridge,* ed. H. N. Coleridge (London: William Pickering, 1836; rpt. New York: AMS Press, 1967), 1:220-21. I draw from the two published versions of this lecture for my quotations and analysis in this section. The first, cited above, is a through-written version of Coleridge's lecture, reconstituted by Henry Nelson Coleridge from the "Sibylline leaves" of Coleridge's notes and memoranda, and from audience accounts. The other text, from the Bollingen edition, reprints only Coleridge's original notes (and carries no subtitle). *The Collected Works of Samuel Taylor Coleridge* (Princeton: Princeton University Press, 1969-), 5(2):217-25. See especially page 218 for Coleridge's exposition on imitation and copy.

11. *Essai sur la nature, le but et les moyens de l'imitation dans les beaux-arts* (Paris, 1823; rpt. Brussels, 1980), 104 (my translation).

12. [*Description de la rotonde des panoramas élevée dans les Champs-Elysées: Précédé d'un aperçu historique sur l'origine des panoramas et les principales constructions auxquelles ils ont donné lieu*]. *Revue générale de l'architecture et des travaux publics* (Paris, 1841), 2:504 (my translation).

13. *Illuminations,* ed. Hannah Arendt (New York: Schocken Books, 1968), 232-38.

14. "Romanticism, the Self, and the City: *The Secret Agent* in Literary History," *Boundary 2* 9 (Fall 1980): 78. The most important recent study to challenge this historical paradigm is Jonathan Crary's *Techniques of the Observer: On Vision and Modernity in the Nineteenth Century* (Cambridge, MA: MIT Press, 1990). Crary situates photography in a history of *seeing,* not simply as a material item in the evolution of technology or the pictorial arts.

15. "1800 Preface," *Wordsworth and Coleridge: Lyrical Ballads,* ed. R. L. Brett and A. R. Jones (London: Routledge, 1991), 248-49.

16. *The Arcades Project,* trans. Howard Eiland and Kevin McLaughlin (Cambridge, MA: Harvard University Press, 1999), 530.

17. Comment, *The Panorama,* trans. Ann-Marie Glasheen (London: Reaktion Books, 1999), 132.

18. "What is Visual Culture?" 4.

19. Emily Apter, *October* 77 (Summer 1996): 27.

20. James Heffernan, *Museum of Words: The Poetics of Ekphrasis from Homer to Ashbery* (Chicago: University of Chicago Press, 1993), 1.

21. *Literary Gazette* (9 March 1822): 153; "The Curse of Minerva" l.181-82.

22. Kurt Andersen, *The New Yorker* (12 July 1999): 82.

23. See especially *Understanding Media* (New York: McGraw-Hill, 1964).

Chapter 1

1. Thomas Davies, *Memoirs of the Life of David Garrick,* ed. Stephen Jones (New York: Benjamin Blom, 1969), 1:41.

2. "Translation, a Poem," by Dr. Franklin, in *Memoirs of the Life of David Garrick,* 2:437.

3. Sir Joshua Reynolds, *Portraits,* ed. Frederick Hilles (New York: McGraw Hill, 1952), 112.

4. The historical evolution of acting style proposed by Alan Downer in two highly influential papers has never seriously been questioned in the half-century since their publication. "Nature to Advantage Dressed: Eighteenth-Century Acting," PMLA 58 (1943): 1002-37; "Players and Painted Stage: Nineteenth-Century Acting," PMLA 61 (1946): 522-76. But there are serious limits to the utility of Downer's broad-stroke understanding of the distinctions between realism and classicism. For example, Downer's analysis of the "return" to classicism in the performances of Siddons and Kemble lacks an appreciation of the permanent effects of Garrick's reformation of technique. That is, Garrick established a threshold of expectation among audiences for naturalistic performance beneath which not even the most "classical" interpretation in the early nineteenth century could fall. Garrick thus represents not one style among a variety of oscillating preferences, as Downer contends, but an irreversible paradigm shift in the interpretation of dramatic character.

5. Thomas Davies, *Dramatic Miscellanies* (London, 1785), 3:264-65.

6. *The Complete Works of William Hazlitt,* ed. P. P. Howe (New York: AMS Press, 1967), 4:247.

7. "On the Tragedies of Shakspeare [sic] Considered with Reference to their Fitness for Stage Representation," *The Complete Works and Letters of Charles Lamb* (New York: The Modern Library, 1935), 298.

8. *A Satirical View of London at the Commencement of the Nineteenth Century* (London, 1801), 238.

9. *The Collected Works of Samuel Taylor Coleridge,* ed. R. A. Foakes (Princeton: Princeton University Press, 1969-), 5(1):350.

10. *Collected Works,* 5(1):564.

11. *Collected Works,* 5(1):228.

12. "A Defence of Poetry," *Shelley's Poetry and Prose,* ed. Donald H. Reiman and Sharon B. Powers (New York: Norton, 1977), 490.

13. *The Long Revolution: An Analysis of the Democratic, Industrial, and Cultural Changes Transforming Our Society* (New York: Columbia University, 1961), 264.

14. The Licensing Act gave broad censorship powers to the lord chamberlain and granted the two patent theaters, Drury Lane and Covent Garden, a monopoly over "spoken drama" in London. One effect of the monopoly was to promote the proliferation of alternative forms of dramatic entertainment, including opera, circuses, and the pantomime, all of which were well-established rivals of traditional "literary" drama by the Romantic period.

15. Marilyn Gaull, "Romantic Theater," *Wordsworth Circle* 14 (1983): 257.

16. *The Romantic Theater: An International Symposium,* ed. Richard Allen Cave (Totowa, NJ: Barnes and Noble, 1986), 9-46.

17. In a paper delivered at the "Romanticism and Visual Culture" conference at Oxford in June 2000, Sophie Thomas demonstrated how Coleridge's *Remorse* stages its own distrust of visual-theatrical tricks. By casting his hero, Alvar, as a painter, and making the exhibition of a painting of his attempted assassination the climax of dramatic revelation in the play, Coleridge foregrounds conventional art as an antidote to the vulgar scenic effects of the Regency theater. As such, *Remorse* constitutes a classic compromise-formation between the antitheatricality of the Romantics and their desire to renew poetic drama.

18. See Alan Richardson, *A Mental Theater: Poetic Drama and Consciousness in the Romantic Age* (University Park: Pennsylvania State University Press, 1987), 1-3, 191. The tone for critical reception of Romantic drama was set by contemporary critics, who declared that "of all literary productions the most uninteresting, because the most unnatural, is the *closet drama*" (*British Critic* 21, April 1824: 403). The last decade, however, has seen a raft of critics attempt to rehabilitate the plays. In the spirit of post-80s excavation at the margins of the canon, Richardson, Jeffrey Cox, Frederick Burwick, Daniel Watkins, Julie Carlson, and Michael Simpson have all devoted monographs to Romantic drama.

19. *Byron's Letters and Journals,* ed. Leslie Marchand (Cambridge: Harvard University Press, 1973-82), 8:186-87; 5:170. *Manfred* was produced successfully several times after Byron's death, most notably by Alfred Bunn at Covent Garden in 1835. But as Sherwyn Carr has documented, Bunn's production exploited the luridly melodramatic and supernatural elements of the play over its literary possibilities, ruthlessly cutting Byron's complex Faustian lyric monologues in favor of "spectacular scenic effects and liberal doses of music." Henry Crabb Robinson attended the production, taking no "pleasure except from the splendid scenery." In this sense, Bunn's "adaptation" of *Manfred* constitutes a characteristic example of rather than an exception to the dilemma faced by the Romantics, as purveyors of traditional verse drama, in the new culture of theatrical spectacle. Sherwyn Carr, "Bunn, Byron and *Manfred*." *Nineteenth Century Theatre Research* 1 (Spring 1973): 19; Robinson, *The London Theatre, 1811-1866: Selections from the Diary of Henry Crabb Robinson,* ed. Eluned Brown (London: Society for Theatre Research, 1966), 144-45. In another revealing example of the Romantics' mixed, sometimes contradictory attitude toward the stage, Wordsworth originally submitted *The Borderers* to the managers of both Covent Garden and Drury Lane, but later insisted in notes to the text that he was actually relieved at its rejection. "It was first written," Wordsworth averred in 1842, "and is now published, without any view to its exhibition upon the stage." *The Borderers,* ed. Robert Osborn (Cornell: Cornell University Press, 1982), 813.

20. *Byron's Letters and Journals,* 8:90.

21. *Essays on Chivalry, Romance and the Drama* (London, n.d.), 224. Scott did compose some five verse dramas, but these constitute a tiny and mostly neglected portion of his literary output. Scott's personal antipathy to writing for the stage didn't deter others from adapting his extraordinarily popular novels, however. In 1819, for example, a production of *Heart of Midlothian* ran for 170 performances.

22. *Collected Works,* 5(1):563.

23. *Collected Works,* 5(1):319.

24. Lamb, *Complete Works and Letters,* 298; *Medwin's Conversations of Lord Byron,* ed. Ernest J. Lovell, Jr. (Princeton: Princeton University Press, 1966), 93. Whatever his misgivings regarding the staging of his own dramas, the theater star system did not bother Byron, who kept a screen of prints in his Cambridge rooms displaying famous English actors, including Garrick, in their signature roles. See Henry Angelo, *Reminiscences* (London: Henry Colburn, 1828), 2:100.

25. From "A View of the English Stage," *Complete Works,* 5:222.

26. *Complete Works,* 4:248.

27. *Complete Works and Letters,* 289-302. I will forego further citation of individual page numbers in the detailed discussion of this essay that follows.

28. Joan Coldwell, "The Playgoer as Critic: Charles Lamb on Shakespeare's Characters," *Shakespeare Quarterly* 26 (1975): 193-95; Janet Ruth Heller, *Coleridge, Lamb, Hazlitt, and the Reader of Drama* (Columbia: University of Missouri Press, 1990), 25; Greg Kucich, "'A Haunted Ruin': Romantic Drama, Renaissance Tradition, and the Critical Establishment," *Wordsworth Circle* 23 (Spring 1992): 67.

29. Jonathan Arac, "The Media of Sublimity: Johnson and Lamb on *King Lear.*" *Studies in Romanticism* 26 (Summer, 1987): 210-11. Heller argues that modern critics of film adaptations of literature, from Kracauer to Iser, borrow Lamb's terms in arguing that cinematic versions of novels lack the psychological texture and depth of characterization of the literary original. *Coleridge, Lamb, Hazlitt, and the Reader of Drama,* 115-16.

30. The statue, by Henry Webber, depicts Garrick taking a curtain call with the muses of the theater at his feet. It was erected in 1797 in the south transept of the Abbey with the verse inscription by S. J. Pratt.

31. *Dissertation on the Theaters* (London, 1759), 73.

32. *The History of the Theatres of London and Dublin from the Year 1730 to the Present Time* (London, 1761), 1:61-62.

33. *Memoirs of the Life of David Garrick,* 1:44; Paul Hiffernan, *Dramatic Genius* (London, 1770), 71.

34. James Ralph, *The Case of the Authors Stated* (London, 1758), 25.

35. *The Herald* 15 (22 December 1757). In a further symptom of the theater's broadening cultural significance, the *Gentleman's Magazine* regularly pub-

lished notes on acting technique, and some twenty instructional handbooks on acting appeared in the half-century after Garrick's debut in 1741.

36. This tradition has continued through the twentieth century, with Richardson, Gielgud, Olivier, and more recently Kenneth Branagh.

37. It is the ultimate index of fame in our age to be granted a single, universally recognized moniker: Marilyn, Evita, Elvis etc. John Kemble and Sarah Siddons—as "Mr. K" and "Mrs. S"—appear to have enjoyed equivalent status in Regency England.

38. "Images to Light the Candle of Fame," *Nadar/Warhol, Paris/New York: Photography and Fame,* ed. Gordon Baldwin and Judith Keller (Los Angeles: J. Paul Getty Museum, 1999), 15.

39. *Society of Spectacle,* trans. Donald Nicholson-Smith (New York: Zone Books, 1994), 38.

40. *The Complete Works of William Hazlitt,* 17:129-30.

41. *Memoirs of the Life of David Garrick,* 1:328.

42. See Charles Gildon, *The Life of Mr. Thomas Betterton, the Late Eminent Tragedian. Wherein the Action and Utterance of the Stage, Bar, and Pulpit are Distinctly Considered* (London: Robert Gosling, 1710).

43. Anthony Aston, *A Brief Supplement to Colley Cibber* (London, 1747), quoted in *Actors on Acting,* ed. Toby Cole and Helen Chinoy (New York: Crown Publishers, 1970), 114.

44. *The Museum: or, the Literary and Historical Register* 25 (28 February 1747): 382.

45. *The Prompter* 99 (21 October 1735).

46. *Memoirs* (London, 1806), 59-60.

47. *Memoirs of the Life of David Garrick,* 1:45.

48. *Actors on Acting,* 132.

49. William Whitehead, *Poems* (London, 1788), 3:65.

50. *Lichtenberg's Visits to England,* trans. Margaret L. Mare and W. H. Quarrell (New York: Benjamin Blom, 1969), 30.

51. John Alexander Kelly, *German Visitors to English Theaters in the Eighteenth Century* (New York: Octagon Books, 1978), 40.

52. D. C. Stuart, *The Development of Dramatic Art* (New York: Appleton & Co., 1928), 440.

53. John Galt, *The Lives of the Players* (London: Hamilton, Adams & Co., 1886), 147.

54. John Genest, *Some Account of the English Stage from the Restoration in 1660 to 1830* (London, 1832), 4:14.

55. *Memoirs of the Life of David Garrick,* 1:349; John Knowles, *Life and Writings of Henry Fuseli* (London, 1831), 1:39.

56. For an analysis of the evolution of Cartesian philosophy in the writings of Le Brun and Hill, see Joseph R. Roach, *The Player's Passion: Studies in the Science of Acting* (Newark: University of Delaware Press, 1985), especially chapter 2.

57. *The Prompter* 64 (20 June 1735); 66 (27 June 1735).

58. Francis Gentleman, *The Dramatic Censor* (London: J. Bell, 1770), 482.

59. *Some Account of the English Stage,* 4:14

60. Joseph Bertram, *The Tragic Actor* (London: Theater Arts Books, 1959), 109.

61. Joseph Pittard, *Observations on Mr. Garrick's Acting* (London, 1758), 6.

62. *The Actor* (London, 1755), 265.

63. *A General View of the Stage* (London, 1759), 114.

64. *Complete Works,* 5:222.

65. "The Paradox of Acting," in *Actors on Acting,* 168.

66. *Dramatic Miscellanies,* 1:320.

67. *Memoirs of the Life of David Garrick,* 2:463.

68. *Dramatic Miscellanies,* 2:150.

69. *A General View of the Stage,* 248.

70. *Lichtenberg's Visits to England,* 15.

71. *Works* (London, 1753), 4:368.

72. "I am not therefore blind to his studied tricks, his overfondness for extrav-
agant attitudes, frequent affected starts, convulsive twitchings, jerkings of the
body, sprawling of the fingers, slapping the breast and pockets:—A set of
mechanical motions in constant use, the caricatures of gesture, suggested by
pert vivacity; his *pantomimical* manner of acting every word in a sentence;
his unnatural pauses in the middle of a sentence; his forced conceits . . . "
Theophilus Cibber, *Dissertation on the Theaters,* 56 (my emphasis).

73. "The Rosciad" l.1055-62. *The Poems of Charles Churchill,* ed. James Laver
(New York: Barnes and Noble, 1970), 46.

74. *Gentleman's Magazine* 12 (October 1742): 527.

75. Gary Taylor, *Reinventing Shakespeare* (New York: Weidenfeld & Nicolson,
1989), 120. See also Lance Bertelsen, "David Garrick and English Painting,"
Eighteenth Century Studies 11 (1978): 308-24.

76. Ellis Waterhouse, *Reynolds* (London: Phaidon Press, 1941), 21.

77. "David Garrick and English Painting," 310.

78. Garrick to Draper, 1 December 1745. *The Letters of David Garrick,* ed. David
M. Little and George M. Kahrl (Cambridge, MA: Harvard University Press,
1963), 1:70.

79. *Letters,* 2:443.

80. *Dramatic Miscellanies,* 3:432.

81. *British Theatre and the Other Arts, 1660-1800,* ed. Shirley Kenny (Washing-
ton: Folger Books, 1984), 20-21.

82. *Lichtenberg's Visits to England,* 29.

83. Kalman Burnim, "Looking upon his Like Again: Garrick and the Artist," in
British Theatre, 185.

84. *Observations on Mr. Garrick's Acting,* 8.

85. *Portraits,* 98.

86. *Letters,* 2:788.

87. See John Brewer, *The Pleasures of the Imagination: English Culture in the Eighteenth Century* (New York: Farrar, Straus and Giroux, 1997), 338-39.

88. *The Case of the Authors Stated,* 24-25.

89. *The Herald* 28 (23 March 1758): 210-12.

90. *A Bone For Chroniclers to Pick On* (London, 1758), 6-8.

91. *Dissertation on the Theatres,* 26.

92. "Philippe James de Loutherbourg and the Early Pictorial Theatre: Some Aspects of its Cultural Context," in *The Theatrical Space,* ed. James Redmond (Cambridge: Cambridge University Press, 1987), 110.

93. *Morning Chronicle,* 23 December 1774, quoted in Russell Thomas, *Spectacle in the Theatres of London from 1767 to 1802* (Ph.D. diss.: Chicago University, 1942), 30.

94. *Morning Chronicle,* 16 February 1776.

95. Richard Altick, *The Shows of London* (Cambridge, MA: Harvard University Press, 1978), 119-27.

96. Frontispiece to Sir Nicholas Nipclose [pseud.], *The Theatres: a Poetical Dissection* (London, 1772).

97. *Reminiscences,* ed. William Van Lennox (Cambridge, MA: Harvard University Press, 1942), 8.

98. *Dramatic Criticism 1808-1831,* ed. Lawrence Huston Houtchens and Carolyn Washburn Houtchens (New York: Columbia University Press, 1949), 47-48. In addition to elevating visual spectacle over dramatic text, the democratic nature of the Regency theater threatened to marginalize another literary genre: dramatic criticism. The access of the lower classes to all forms of leisure and entertainment, Hunt argued, had "giv[en] them an increase in all sorts of intellectual pleasures, previous to their having anything like a critical knowledge of them, or care for criticism." Writing in 1831, Hunt remains hopeful that "ten years hence, perhaps, the trade of a theatrical critic will be better than it is now," but the projection only reinforces Hunt's current impression of the declining audience for educated literary journalism. *Dramatic Criticism,* 282.

99. *Collected Works,* 5(1):564; Sir Walter Scott, *Letters,* ed. H. J. C. Grierson (London: Constable, 1932-37), 4:720.

100. Coleridge, *Complete Poetical Works,* ed. E. H. Coleridge (Oxford: Clarendon Press, 1912), 1:817.

101. *German Visitors to English Theaters,* 140.

102. "An Enquiry into the Present State of Polite Learning in Europe," in *Collected Works of Oliver Goldsmith,* ed. Arthur Friedman (Oxford: Clarendon Press, 1966), 1:325.

103. This definitive tautology of modern celebrity was first formulated by Daniel Boorstin in *The Image: What Happened to the American Dream* (New York: Atheneum, 1962), see especially chapter 2.

104. *Collected Works,* 5(1):228.

105. *Dramatic Miscellanies,* 3:264-65.

106. "A Defence of Poetry," *Shelley's Poetry and Prose,* 489.

107. *Lichtenberg's Visits to England,* 7; Henry Crabb Robinson, *Diary, Reminiscences, and Correspondence,* ed. Thomas Sadler (Boston: Fields, Osgood & Co., 1870), 1:214-15.

108. *Treatise of Human Nature* (New York: Penguin, 1984), 299-311.

109. *Masquerade and Civilization* (Stanford: Stanford University Press, 1986), 5. Public masquerades were officially banned in 1756 for moral reasons, but continued to flourish through the remainder of the century as privately hosted entertainments.

110. "An Essay on the Knowledge of the Characters of Men," *Miscellanies,* ed. Henry Knight Miller (Oxford: Oxford University Press, 1972), 1:155.

111. *The Letters of Charles and Mary Anne Lamb,* ed. Edwin W. Marrs, Jr. (Ithaca: Cornell University Press, 1975), 1:267.

112. From "Retaliation: A Poem," quoted in *Memoirs of the Life of David Garrick,* 2:164.

113. *Masquerade and Civilization,* 79.

114. Shearer West, *The Image of the Actor: Verbal and Visual Representation in the Age of Garrick and Kemble* (New York: St. Martin's Press, 1991), 89.

115. "Autobiographical Notes" to *The Analysis of Beauty,* ed. Joseph Burke (Oxford: Clarendon Press, 1955), 209.

116. *Letters and Journals,* 9:36-37.

117. Richard Altick, *Painting from Books* (Columbus: Ohio University Press, 1985), 27. Mixing portraiture and allegory had its precedents in European painting—the huntress-virgin Diana was a particularly popular guise for aristocratic ladies to adopt—but before Reynolds no one had undertaken this hybrid genre with such serious zeal. Reynolds met with critical resistance to his historical portraits from the outset. Goldsmith satirized the fashionability for grand-style portraiture in *The Vicar of Wakefield,* while Johnson regretted his friend's pollution of the domestic art of portraiture with "empty splendour" and "airy fiction" (*The Idler* 45, 1759). The Victorians pronounced "Three Ladies Adorning a Term of Hymen" an "absurdly artificial" conceit, and twentieth-century critics have largely concurred. F. G. Stephens, *English Children as Painted by Sir Joshua Reynolds* (London, 1867), 9.

118. Richard Wendorf, *The Elements of Life: Biography and Portrait Painting in Stuart and Georgian England* (Oxford: Clarendon Press, 1990), 243; *Sir Joshua Reynolds: The Painter in Society* (Cambridge, MA: Harvard University Press, 1996), 128; David Piper, *The English Face* (London: Thames and Hudson, 1957), 200.

119. *Reminiscences,* 16-17.

120. In Sheridan's *The School for Scandal* (IV.i), the gadabout hero Charles Surface sells off his stock of family portraits to raise capital, unaware the buyer is his uncle in disguise. With characteristic sarcasm, he refers to their embodying

"the true spirit of portrait painting . . . all stiff and awkward as the originals." He goes on to compare the "inveterate likeness" of these old-fashioned portraits to the "volunteer grace" of the "modern Raphaels," a reference to Reynolds. Notorious for his neglect of likeness in his portraits, Reynolds was nevertheless the more popular for it. The vagaries of resemblance did not deter those English gentry eager to be immortalized in the style of the Old Masters.

121. *Portraits,* 118-19.
122. *Discourses on Art,* ed. Robert R. Wark (New Haven: Yale University Press, 1997), 238.
123. *Discourses,* 240.
124. *Theatre and Disorder in Late Georgian London* (Oxford: Clarendon Press, 1992), 10.
125. *Absorption and Theatricality: Painting and Beholder in the Age of Diderot* (Berkeley: University of California Press, 1980), 4.
126. Judith Pascoe has argued that literary women's "theatrical modes of self-representation" constitute an important corrective to normative masculinist views of Romantic antitheatricality. *Romantic Theatricality: Gender, Poetry, and Spectatorship* (Ithaca: Cornell University Press, 1997). The exclusively female subjects of Reynolds' historical portraits likewise suggest that theatricality, at the level of social identity, was a predominantly female preserve. On feminine masquerade as a form of pathology, see Joan Rivière's seminal case-study, "Womanliness as Masquerade." *Psychoanalysis and Female Sexuality,* ed. Hendrik Ruitenbeck (New Haven: College and University Press, 1966), 209-20. The notion of the theatricality or, more strictly, "performativity" of gender identity has featured prominently in recent feminist theory. See in particular Judith Butler, *Gender Trouble* (New York: Routledge, 1990).
127. "Women in Disguise: Likeness, the Grand Style and the Conventions of Feminine Portraiture in the work of Sir Joshua Reynolds," *Femininity and Masculinity in Eighteenth-Century Art and Culture,* ed. Gill Perry and Michael Rossington (Manchester: Manchester University Press), 23.
128. Kimberley Crouch, "The Public Life of Actresses: Prostitutes or Ladies?" *Gender in Eighteenth Century England: Roles, Representations, and Responsibilities,* ed. Hannah Barker and Elaine Chalus (London: Longman, 1997), 75-76.
129. "Reynolds's Theory and Practice of Imitation," *Burlington Magazine* 80 (1942): 45.
130. *Discourses,* 88.
131. *Strategies for Showing: Women, Possession, and Representation in English Visual Culture* (Oxford: Oxford University Press, 1997), 60.
132. *Reynolds,* ed. Nicholas Penny (New York: Harry N. Abrams, 1986), 29.
133. *Strategies for Showing,* 190.
134. *Sir Joshua Reynolds: The Subject Pictures* (Cambridge: Cambridge University Press, 1995), 3, 36-38.

135. *Reynolds,* 211.
136. Arthur Marwick, *Beauty in History* (London: Thames & Hudson, 1988), 153.
137. "Talking of Mrs. Siddons, Lady Inchiquin said that Sir Joshua Reynolds had often declared that she was an Actress who never *made Him feel*" (emphasis in original). Joseph Farington, *Diary,* ed. Kenneth Garlick, Angus Macintyre, and Kathryn Cave (New Haven: Yale University Press, 1978), 4:1297.
138. *Lichtenberg's Visits to England,* 34.
139. For biographical information I rely, with obvious reservations, on John Haslewood's contemporary *Secret History of the Green Room* (London, 1795), 41-58, and John Fyvie, *Comedy Queens of the Georgian Era* (London: Archibald Constable & Co., 1906), 200-230.
140. *Secret History,* 53-54.
141. "The Public and Private Roles of Sarah Siddons," *A Passion for Performance: Sarah Siddons and her Portraitists,* ed. Robyn Asleson (Los Angeles: J. Paul Getty Museum, 1999), 3.
142. "The Public Life of Actresses," 73.
143. *Comedy Queens,* 222.
144. *Lichtenberg's Visits to England,* 33.
145. *The Meridian Anthology of 18th and 19th Century British Drama,* ed. Katherine Rogers (New York: Penguin, 1979), 312.
146. *Lichtenberg's Visits to England,* 33.
147. *Memoirs of the Life of David Garrick,* 2:177.
148. *Diary, Reminiscences, and Correspondence,* 2:214-15.
149. For an alternative reading of the portrait see Joseph Musser, "Mrs. Abington as 'Miss Prue,'" *South Atlantic Quarterly* 83 (1984): 176-92.
150. Charles Robert Leslie and Tom Taylor, *The Life and Times of Sir Joshua Reynolds* (London, 1865), 1:226-27, 2:115.
151. *Dramatic Miscellanies,* 3:394.
152. "Stage Drama as a Source for the Pictorial and Plastic Arts," *British Theater,* 60.
153. "Mrs. Abington as 'Miss Prue,'" 180.

Chapter 2

1. *Collected Letters,* ed. Earl Leslie Griggs (Oxford: Clarendon Press, 1956), 3:501.
2. *The Collected Works of Samuel Taylor Coleridge,* ed. R. A. Foakes (Princeton: Princeton University Press, 1987), 5(2):277.
3. *Collected Works,* 7(2):23.
4. *The Complete Works of William Hazlitt,* ed. P. P. Howe [after the Centenary Edition] (New York: AMS Press, 1967), 10:8.
5. Richard Sha, *The Visual and Verbal Sketch in British Romanticism* (Philadelphia: University of Pennsylvania Press, 1998), 52.

6. *Illuminations,* ed. Hannah Arendt (New York: Schocken Books, 1966), 220–21. For a discussion of the English print trade informed by Benjamin's "Mechanical Reproduction" essay, see John Brewer, *The Pleasures of the Imagination: English Culture in the Eighteenth Century* (New York: Farrar, Straus, Giroux, 1997), 449–63.

7. Earl of Shaftesbury, *Second Characters; or, The Language of Forms,* ed. Benjamin Rand (New York: Columbia University Press, 1914), 121.

8. David Solkin, *Painting for Money: The Visual Arts and the Public Sphere in Eighteenth Century England* (New Haven: Yale University Press, 1992), 274.

9. See Reynolds, *Discourses on Art,* ed. Robert Wark (New Haven: Yale University Press, 1997), 320-36. Wark has dutifully included a transcript of Blake's embittered commentary in the Yale edition of the *Discourses,* but Lawrence Lipking has warned against the critical tendency to read Reynolds solely through the lens of Romantic reaction against him. It is a consequence of Blake's canonization by twentieth-century literary critics, Lipking contends, that we "perceive Reynolds' *Discourses* through the screen of Blake's famous marginalia," not because Blake's opinions had any impact on Reynolds' reputation at the time. *The Ordering of the Arts in Eighteenth-Century England* (Princeton: Princeton University Press, 1970), 164.

10. *The Idler* 79 (1759).

11. *Sir Joshua Reynolds: The Painter in Society* (Cambridge, MA: Harvard University Press, 1996), 88.

12. *Discourses,* 117.

13. *Discourses,* 290.

14. Louise Lippincott, *Selling Art in Georgian London* (New Haven: Yale University Press, 1983), 144.

15. Timothy Clayton, *The English Print, 1688-1802* (New Haven: Yale University Press, 1997), 177. I am indebted to Clayton's original and comprehensive research for a considerable portion of the historical material in this chapter.

16. *Reynolds,* ed. Nicholas Penny (New York: Harry N. Abrams, 1986), 35.

17. *Discourses,* 107.

18. A single engraving might be used as an illustration in a book as well as sold separately as an individual print. Both forms were often available in the same shop.

19. "The way for a little-known painter to reach a public that ranged from the patrons of taverns to the private collector was through reproductive engraving." *Pleasures of the Imagination,* 303.

20. From the engraver Sir Robert Strange's *Inquiry into the Rise and Establishment of the Royal Academy of Arts* (London, 1775), 71-75; see also Sidney C. Hutchinson, *The History of the Royal Academy, 1768-1968* (London: Chapman & Hall, 1968), 40. Among the "auctioneers" alluded to by Strange was James Christie, whose association with the building "no doubt reinforced

Reynolds's need to rigidify lines between art and commerce." *Visual and Verbal Sketch in Romanticism*, 43.

21. *The English Print*, 167.

22. Established in 1754, the Society successfully applied for a royal charter in 1765, and thereafter became the Incorporated Society of Artists of Great Britain. After the secession of its elite members, however, the Society lost favor with the King and fell into a rapid decline.

23. After a public outcry at their exclusion, engravers were granted associate membership in 1770, but even then with such limited privileges that willing candidates were difficult to find.

24. Desmond Shawe-Taylor, *The Georgians: Eighteenth-Century Portraiture and Society* (London: Barrie and Jenkins, 1990), 26.

25. *Discourses*, 102.

26. *Discourses*, 100. Blake angrily dissents from Reynolds' view on the practice of copying: "The difference between a Bad Artist & a Good one Is: the Bad Artist Seems to Copy a Great deal. The Good one Really Does Copy a Great deal." "Annotations to Reynolds' *Discourses*," in *Discourses*, 294.

27. *Inquiry*, 117-18.

28. *Inquiry*, 112. Another sub-textual example of Reynolds' anti-engraving prejudice is his use of the word "mechanical," which suggests both the sensibility required for simple visual replication of a subject and the technological process of image reproduction. When Reynolds refers to "the intellectual dignity" of academic painting "that ennobles the painter's art; that lays the line between him and the mere mechanic," he distinguishes Academy painters from the artisans of the fine arts industry, which includes not only the perennially maligned journeymen portraitists but engravers as well. *Discourses*, 43.

29. The theme of servility in the *Discourses* echoes other, more immediately political unpleasantness. The Society of Arts brought a charge of servility against Reynolds for his part in applying to the King for patronage of a rival Academy. The diatribe from the Wilkite *Middlesex Journal* in 1770, under the pseudo-academic pen-name "Fresnoy," was typical of the fury roused by Reynolds'—a provincial cleric's son—perceived class treachery: "I cannot sufficiently express my abhorrence of the indefatigable pains, the illiberal advantages you have taken to alienate many of the members of the Society of Artists of Great Britain from a legal charter to the support of a factious and arbitrary institution. . . . Your proceedings, from first to last against the Society . . . have been uniformly iniquitous.—'Tis from high life high characters are drawn'—but all your efforts served only to display your own servility." Some part of Reynolds' derogatory emphasis on imitation in the *Discourses*, it might be argued, belonged to a reflex need to distance himself from all servile associations, both painterly and political.

30. "A skilled painter ought not be a slave to Nature, but rather its arbiter." *Dialogue sur le coloris* (Paris, 1699), 8.

31. "One must do more than copy Nature in a servile manner if one is to give each passion its proper character." *Réflexions critiques sur la poésie et sur la peinture* (Paris, 1719), 1:200. The attitude toward trade of these authors set the tone for Reynolds. The French Academy was notoriously jealous of its superiority to the commercial Artists' Guild. For example, they forbade the display of any academician's work in his studio window.

32. *Inquiry,* 121.

33. Ellis Waterhouse, *Reynolds* (New York: Phaidon Press, 1973), 20.

34. *Reynolds,* ed. Penny, 35.

35. Richard Godfrey, *Printmaking in Britain* (Oxford: Oxford University Press, 1978), 48, quoted in Martin Postle, *Sir Joshua Reynolds: The Subject Pictures* (Cambridge: Cambridge University Press, 1995), 42.

36. *A Review of the Polite Arts in France, at the time of their Establishment under Louis XVI, compared with their Present State in England* (London, 1782), 51.

37. *The Works of Sir Joshua Reynolds,* ed. Edward Malone (London, 1797), 2:51-53.

38. *Inquiry,* 60.

39. *Discourses,* 13.

40. *The English Print,* 202.

41. *Discourses,* 13.

42. *The Autobiography and Memoirs of Benjamin Robert Haydon,* ed. Tom Taylor (London: Peter Davies, 1926), 1:212-13.

43. James Barry, *Works* (London: T. Cadell and W. Davies, 1809), 177.

44. "The Curse of Minerva," l.175-76.

45. *An Inquiry into the Requisite Cultivation and Present State of the Arts of Design in England* (London, 1806), 221-22.

46. For a comprehensive account of Boydell's career, together with larger issues he represents—namely, the failure of academic history painting and the rise of a commercial art market in Britain—see Morris Eaves, *The Counter-Arts Conspiracy: Art and Industry in the Age of Blake* (Ithaca: Cornell University Press, 1992). This is the first important study to recognize the late eighteenth century as the "Boydell" era, in which "the histories of painting and engraving are inextricable one from the other" (1).

47. *The Counter-Arts Conspiracy,* 3-8.

48. "Whether the Fine Arts are Promoted by Academies," *The Complete Works,* 9:409.

49. *The Pleasures of the Imagination,* 208.

50. Richard Altick, *The Shows of London* (Cambridge, MA: Harvard University Press, 1978), 106.

51. C. H. Watelet and P. C. Léveque, *Dictionnaire des Arts de Peinture, Sculpture et Gravure* (Paris, 1792), 2:109, quoted in Clayton, 282.

52. *Classical Literary Criticism,* trans. T. S. Dorsch (London: Penguin, 1965), 35.

53. *Discourses,* 232-33.

54. For important background to my discussion of class and taste in the *Discourses*, see John Barrell, *The Political Theory of Painting from Reynolds to Hazlitt* (New Haven: Yale University Press, 1986), 77.

55. *Painting for Money*, 259.

56. See Thomas E. Crow, *Painters and Public Life in Eighteenth-Century Paris* (New Haven: Yale University Press, 1985).

57. For an illuminating treatment of the class anxieties surrounding the formation of a public for British art, see Solkin, 254-76.

58. *Discourses*, 233.

59. *Works*, 162, quoted in James Northcote, *The Life of Sir Joshua Reynolds* (London: Henry Colburn, 1818), 78.

60. *A Review of the Polite Arts,* 57.

61. Edward Edwards, *Anecdotes of Painters* (London, 1808), xxv, quoted in *Sir Joshua Reynolds,* 5.

62. *English Art 1800-1870* (Oxford: Clarendon Press, 1959), 21.

63. "William Blake's Annotation to Reynolds' *Discourses,*" *Discourses,* 304; Marilyn Gaull, *English Romanticism: The Human Context,* (New York: Norton, 1988), 333.

64. *Correspondence and Table-Talk,* ed. F. W. Haydon (London: Chatto and Windus, 1876), 1:185.

65. *Autobiography,* 1:19.

66. In the 1760s, the Archbishop rejected an application from the Society of Artists to decorate St. Paul's with religious paintings in the style of the great European cathedrals. Fifty years later, Haydon continued to pursue history painting with, if anything, less official encouragement.

67. *Literary Gazette* (9 March 1822): 153.

68. *The Shows of London,* 413.

69. *Correspondence and Table-Talk,* 2:293.

70. *The Diaries of Benjamin Robert Haydon,* ed. Walter Bissell Pope (Cambridge, MA: Harvard University Press, 1960), 2:218.

71. Robert Woof et al., *Benjamin Robert Haydon* (Grasmere: The Wordsworth Trust, 1996), 113-15.

72. *The Examiner* (8 March 1819): 157.

73. *Autobiography,* 2:810-12.

74. *The Counter-Arts Conspiracy,* 23.

75. *A Review of the Polite Arts,* 50; see also *The Counter-Arts Conspiracy,* 27-28.

76. *The Shows of London,* 187.

77. *Autobiography,* 1:293.

78. "The Barrenness of the Imaginative Faculty in the Productions of Modern Art," *Complete Works and Letters* (New York: Modern Library, 1935), 203.

79. *The Shows of London,* 187.

80. *The Republic,* trans. Allan Bloom (New York: Harper Collins, 1961), 285-86.

81. *Discourses*, 232.
82. *Complete Works*, 205.

Chapter 3

1. Morris Eaves, *The Counter-Arts Conspiracy: Art and Industry in the Age of Blake* (Ithaca: Cornell University Press, 1992), 52. For a comprehensive account of the gallery's history and contents, see also *The Boydell Shakespeare Gallery*, ed. Frederick Burwick and Walter Pape (Bottrop: Peter Pomp, 1996).

2. *Works* (London: T. Cadell and W. Davies, 1809), 318.

3. There are only some half-dozen panoramas from the golden age of 1790-1830 still in existence, most of them of smaller dimensions than the typical commercial panorama, and none of them British. Perhaps the best known is Carucciolo's "Panorama of Rome" (1824), which hangs in the Victoria and Albert Museum.

4. Richard Altick's *The Shows of London* (Cambridge, MA: Harvard University Press, 1978) is the most comprehensive of these, but other important archival sources include Ralph Hyde's *Gilded Scenes and Shining Prospects: Panoramic Views of British Towns 1575-1900* (New Haven: Yale Center for British Art, 1985), and from the same author, *Panoramania!: the Art and Entertainment of the All-Embracing View* (London: Trefoil Publications, 1988). A monumental survey by German scholar Stephan Oettermann (Munich, 1980) has recently appeared in an English translation, as has Bernard Comment's *Panorama* (Paris, 1993). These important studies, in addition to a lesser-known title, *The Panorama Phenomenon*, ed. Evelyn Fruitema and Paul Zoetmulder (The Hague, 1981), promise to serve as a definitive resource for future, much-needed comparative work on the panoramas. The interest of Anglo-American literary scholars in British panoramas originated with Marilyn Gaull's *English Romanticism* (New York: W. W. Norton, 1988), 84-85, followed in the 1990s by a succession of MLA panels and the stimulating analyses of William Galperin and Ross King (see bibliography).

5. *Reflections*, ed. Peter Demetz (New York: Schocken Books), 150.

6. As far as I have been able to determine, Barker and his successors commissioned three separate panoramas of the Alps, the first in 1821.

7. *The Arcades Project*, trans. Howard Eiland and Kevin McLaughlin (Cambridge, MA.: Harvard University Press, 1999), 532.

8. *Repertory of Arts and Manufactures 4* (London, 1796), 166. The very fact of Barker's patenting the panorama points both to its status as a technological innovation and its potential as commercial property.

9. C. R. Leslie, *A Handbook for Young Painters* (London: John Murray, 1855), 4, quoted in *The Shows of London*, 134.

10. See *The Shows of London*, 132. James Northcote relates that Reynolds "was a prodigious admirer of the inventions and striking effect of the Panorama in

Leicester-Fields, and went repeatedly to see it. He was the first person who mentioned it to me, and earnestly recommended me to go also, saying it would surprise me more than anything I had ever seen in my life." *The Life of Sir Joshua Reynolds,* 2nd ed. (London: Henry Colburn, 1818), 2:242. Reynolds' reaction contrasts to the profound ambivalence of Wordsworth and Constable. It must be said, however, that Reynolds was quite blind by 1789 and never lived to see the type of clientele the panorama ultimately attracted.

11. "Panorama." *Dictionnaire historique de l'architecture* (Paris, 1832), 2:200 [my translation].

12. *The Panorama,* 7.

13. Charles Leslie, *Memoirs of the Life of John Constable, R.A.,* ed. Andrew Shirley (London: Phaidon Press, 1937), 24n.

14. *John Constable: Correspondence,* ed. R. B. Beckett (Ipswich: Suffolk Records Society, 1964), 2:34.

15. *Discourses on Art,* ed. Robert Wark (New Haven: Yale University Press, 1997), 42.

16. "Lecture 13 (On Poesy or Art)," *The Literary Remains of Samuel Taylor Coleridge,* ed. H. N. Coleridge (London: William Pickering, 1836; rpt. New York: AMS Press, 1967), 1:220.

17. Burke's claim that "we have a pleasure in imitating, and in whatever belongs to imitation merely as it is such, without any intervention of the reasoning faculty" may be traced to chapter 4 of the *Poetics. A Philosophical Enquiry into the Origin of our Ideas of the Sublime and Beautiful* (Oxford: Oxford University Press, 1990), 45. For Plato's contrary opinion, which Reynolds and Wordsworth echo, see chapter 2.

18. For example, see *The Shows of London,* 184. In text accompanying the display of Carucciolo's "Panorama of Rome" at the Victoria and Albert Museum, the curators unaccountably invoke Wordsworth as a fan of the medium, describing his response to it as "mild." The tone of the passage in Book Seven may be restrained, but Wordsworth's rejection of the panorama is unequivocal.

19. *Three Essays: On Picturesque Beauty, On Picturesque Travel, On Sketching Landscape, with a Poem, "On Landscape Painting"* (London, 1791), 56.

20. "Preface" to *Lyrical Ballads* (1800), *Wordsworth and Coleridge: Lyrical Ballads,* ed. R. L. Brett and A. R. Jones (London, Routledge, 1991), 249.

21. John Barrell, *Poetry, Language, and Politics* (Manchester: Manchester University Press, 1988), 156.

22. Karl Kroeber, *Romantic Landscape Vision: Constable and Wordsworth* (Madison: University of Wisconsin Press, 1975), 29, 106.

23. *The Panorama,* trans. Anne-Marie Glasheen. (London: Reaktion Books, 1999), 8.

24. *Wordsworth and the Figurings of the Real* (London: Macmillan, 1982), 59.

25. *The Panorama,* 5.

26. "'Mimic sights': A Note on the Panorama and Other Indoor Displays in Book 7 of *The Prelude*," *Notes and Queries* (1993): 462-64.

27. 10 January 1792; quoted by Hubert J. Pragnell, *The London Panoramas of Robert Barker and Thomas Girtin circa 1800* (London: Topographical Society, 1968), 12.

28. *William Wordsworth: The Borders of Vision* (Oxford: Clarendon Press, 1982), 29.

29. *The Arcades Project*, 532.

30. "The Reality Effect," *French Literary Theory Today*, ed. Tzvetan Todorov (Cambridge: Cambridge University Press, 1982), 12.

31. Critics have found fault with Wordsworth's concluding diatribe against the city, suggesting its sentiments are at odds with the clear evidence, through the rest of the book, that he has taken great pleasure in London's "great tide of human life." For Lucy Newlyn, the lines beginning "O, blank confusion . . ." are "extraneous" to the book and "astonishing in [their] apparent insensitivity to the claims that have gone before." *Charles Lamb Bulletin* 47-48 (July/October 1984): 181-82. See also Jonathan Wordsworth, *The Borders of Vision*, 304-5. The key point, however, is that Wordsworth, owing to his natural education, is able to turn from the "rueful prospect" of London with a sense of "purity inviolate" (VIII.811, 814). Like Milton's Christ, he successfully resists the tempting vision of a "vast metropolis," namely London, that is, for Wordsworth, as Rome formerly was, "the destiny of earth itself" (VIII.746, 748).

32. Gotthold Lessing, *Laocoön*, trans. Ellen Frothingham (Boston: Little, Brown, and Company, 1910), 43 [translation modified].

33. *Iconology: Image, Text, Ideology* (Chicago: University of Chicago, 1986), 105-6; Burke, *A Philosophical Enquiry*, 158-61.

34. "On Poetry in General," *The Complete Works*, ed. P. P. Howe (New York: AMS Press, 1967), 5:10.

35. *Literary Remains*, 1:217; see also the celebrated passage from Shelley's "Defence of Poetry": "For language is arbitrarily produced by the Imagination, and has relation to thoughts alone; but all other materials, instruments and conditions of art, have relations among each other, which limit and interpose between conception and expression. The former is as a mirror which reflects, the latter as a cloud which enfeebles, the light of which both are mediums of communication. Hence the fame of sculptors, painters and musicians, although the intrinsic powers of the great masters of these arts, may yield in no degree to that of those who have employed language as the hieroglyphic of their thoughts, has never equalled that of poets." *Shelley's Poetry and Prose*, ed. Donald H. Reiman and Sharon B. Powers (New York: W. W. Norton, 1977), 483.

36. *A Collection of Descriptions of Views Exhibited at the Panorama, Leicester Square, and Painted by H. A. Barker, Robert Burford, John Burford and H. C. Selous, London, 1798-1856* (London: British Library).

37. A panorama was rarely promoted simply as the "Panorama of . . . " Rather, the pamphlets that came with the price of admission invariably offered a

more impressive and revealing title such as, in the prior case, "Description of a View of the Falls of Niagara." This formulaic title was borrowed from eighteenth-century loco-descriptive poetry and travel writing, pointing again to the panorama's origins in picturesque tourism. It also carried the weight of scientific authenticity, of empirically "described" phenomena. In the case of "Lord Exmouth," the panorama functioned in a distinctly journalistic vein, anticipating among other things the newsreels of the Second World War. The painting depicted a famous action of 1816, in which a fleet of British and Dutch gunships, under the command of Rear-Admiral Edward Pellew (thereafter Lord Exmouth), demanded the release of Christian slaves from the Dey of Algiers. In the subsequent battle, brought to life by the panorama, English firepower overcame the land-battery and reduced much of the city to ruins.

38. *Descriptions of Views* (unpaginated).
39. *Illuminations,* ed. Hannah Arendt (New York: Schocken Books, 1966), 233, 238.
40. *Three Essays,* 52.
41. William Galperin, *The Return of the Visible in British Romanticism* (Baltimore: Johns Hopkins University Press, 1993), 94.
42. John Barrell, *The Political Theory of Painting from Reynolds to Hazlitt* (New Haven: Yale University Press, 1986), 69-81.
43. Sir Joshua Reynolds, *Portraits,* ed. F. R. Hilles (New York: McGraw-Hill Book Company, 1952), 145.
44. *Works,* ed. Edward Malone (London, 1798), 162, quoted in James Northcote, *The Life of Sir Joshua Reynolds* (London: Henry Colburn, 1818), 78.

Chapter 4

1. *On the Naive and Sentimental in Literature and On the Sublime,* trans. Julius A. Elias (New York: Frederick Ungar, 1966), 127. My work on Romanticism and Hellenism was first inspired by a seminar with David Ferris at the CUNY Graduate Center in New York. Though his subsequent book, *Silent Urns: Romanticism, Hellenism, Modernity* (Stanford: Stanford University Press, 1999) was published too late for close consideration in this study, I owe much to David for the development of my readings in this chapter, those of Winckelmann and Keats in particular.
2. "English Students at Rome," *The Complete Works of William Hazlitt,* ed. P. P. Howe (New York: AMS Press, 1967), 17:141.
3. *On the Naïve and Sentimental in Literature,* 48.
4. *On the Naïve and Sentimental in Literature,* 127.
5. *Polymetis, or An Enquiry Concerning the Agreement between the Works of the Roman Poets and the Remains of the Antient* [sic] *Artists* (London: R. Dodsley, 1747), 3.

6. *Conversations with Eckermann,* trans. John Oxenford (San Francisco: North Point Press, 1984), 110.

7. *The History of Ancient Art,* trans. G. Henry Lodge (Boston: J. R. Osgood, 1872), 4:292.

8. *Poetics, Speculation, Judgment: The Shadow of the Work of Art from Kant to Phenomenology,* trans. Michael Gendre (Albany: State University of New York Press, 1993), 89.

9. E. M. Butler, *The Tyranny of Greece over Germany* (Boston: Beacon Press, 1935), 11-48.

10. *On the Naive and Sentimental in Literature,* 105.

11. Alex Potts, *Flesh and the Ideal: Winckelmann and the Origins of Art History* (New Haven: Yale University Press, 1994), 66.

12. *Ruines et paysages: salons de 1767,* ed. Else Marie Bukdahl, Michel Delon, Annette Lorenceau (Paris: Hermann, 1995), 338 (my translation).

13. *Ruines et paysages,* 335.

14. *Ruines et paysages,* 344.

15. *Absorption and Theatricality: Painting and Beholder in the Age of Diderot* (Berkeley: University of California Press, 1980).

16. *Ruines et paysages,* 336.

17. *England's Ruins: Poetic Purpose and the National Landscape* (New York: Basil Blackwell, 1990), 1.

18. Marc Eli Blanchard, "Writing the Museum: Diderot's Bodies in the *Salons,*" in *Diderot: Digression and Dispersion,* ed. Jack Udank and Herbert Josephs (Lexington, KY: French Forum Press, 1984), 31-33.

19. *Ruines et paysages,* 335.

20. *The Broken Column: A Study in Romantic Hellenism* (Cambridge, MA: Harvard University Press, 1931), 13-14. Other general surveys in English on Romantic Hellenism include Butler's *The Tyranny of Greece over Germany;* B. H. Stern, *The Rise of Romantic Hellenism in English Literature, 1732-86* (Menasha, WI: George Banta, 1940); Timothy Webb, *English Romantic Hellenism 1700-1824* (Manchester: Manchester University Press, 1982); and *Rediscovering Hellenism,* ed. G. W. Clarke (Cambridge: Cambridge University Press, 1989).

21. The pediment above the main entrance, "The Progress of Civilization" (designed by Richard Westmacott in 1853), embodies the Whiggish theory of history that was the ideological foundation of the museum. Its iconography signifies Britain's rightful place at the vanguard of civilization's progress.

22. *Civilizing Rituals: Inside Public Art Museums* (New York: Routledge, 1995), 6.

23. As was most evident in this century at the Fascist rallies of the 1930s and in the public erections of Hitler's architect Albert Speer, the modern state requires not only bureaucratic institutions and a police force to maintain its authority, but a material, aesthetic form to *represent* it.

24. *Civilizing Rituals,* 1.

25. *The Tourist: A New Theory of the Leisure Class* (New York: Schocken Books, 1976), 84.

26. "Valéry Proust Museum," *Prisms,* trans. Samuel and Shierry Weber (Cambridge, MA: MIT Press, 1981), 175.

27. *The Diary of Benjamin Robert Haydon,* ed. Walter Bissell Pope (Cambridge, MA: Harvard University Press, 1960), 2:76.

28. *Diary,* 2:520.

29. *The Autobiography and Memoirs of B. R. Haydon,* ed. Tom Taylor (London: Peter Davies, 1926), 67.

30. *The Complete Works of William Hazlitt,* 18:100, 147.

31. In their emphasis on natural form, Hazlitt and Haydon denigrate sentimental idealizations of ancient art, and advocate a return to the naiveté of antiquity itself. But the logic of sentimentality is circular and co-optive. In their call for a return to the naive, Hazlitt and Haydon re-inscribe their own belated relation to the original naiveté of the ancients.

32. *Report from the Select Committee of the House of Commons on the Earl of Elgin's Collection of Sculptured Marbles &c.* (London: John Murray, 1816) [addendum].

33. William Sharp, *The Life and Letters of Joseph Severn* (London: Sampson Low, Marston & Co., 1892), 32.

34. Keats' Elgin Marbles sonnets and the late Hellenist odes are products of the Regency fashion for ekphrastic poetry. By the time Keats published the marbles sonnets—first in *The Examiner* (9 March 1817) and later, at Haydon's behest, in the *Annals of the Fine Arts* (vol. 3, April 1818)—the subject of ancient sculpture was a commonplace in the popular literature of the day and had a well-established set of conventions. For example, in 1805, both Oxford and Cambridge inaugurated poetry competitions on the theme of antique sculpture: a symbolically resonant moment in the historical shift from literary classicism in England to its modern, material-visual phase. See Grant Scott, *The Sculpted Word: Keats, Ekphrasis and the Visual Arts* (Hanover, NH: University Press of New England, 1994), chapter 2.

35. *Keats's Life of Allegory: The Origins of a Style* (Oxford: Basil Blackwell, 1988), 249.

36. W. J. Bate calls the poem "almost comic" in his critical biography, *John Keats* (Cambridge, MA: Harvard University Press, 1963), 147. Judgments on the Elgin Marbles sonnets reached a nadir in the late 1960s: from "half-inarticulate" (Douglas Bush, *John Keats* [New York: Macmillan, 1966], 39); to "disappointing" (Ian Jack, *Keats and the Mirror of Art* [Oxford: Oxford University Press, 1967], 35); to "dismally thin" (John Jones, *Keats' Dream of Truth* [London: Chatto & Windus, 1969], 162).

37. *Keats's Life of Allegory,* 250.

38. *The Sculpted Word,* 66.

39. *Keats' Poetry and the Politics of the Imagination* (Rutherford, NJ: Fairleigh Dickinson University Press, 1989), 28.

40. *Keats and History* (Cambridge: Cambridge University Press, 1995), 13.

41. "Sacred Objects and the Sublime Ruins of Art," in *Beyond Romanticism,* ed. Stephen Copley and John Whale (London: Routledge, 1992), 226. Paul Fry has suggested *Paradise Lost* as an intertext for these lines. *A Defense of Poetry: Reflections on the Occasion of Writing* (Stanford: Stanford University Press, 1995), 147–52. According to Fry's reading, Keats' "pure serene," already a reference to the world of the blind poet Homer, echoes the "drop serene" that leaves Milton in "dim suffusion veiled" (*Paradise Lost* III:25–26). This intertextual blindness further ironizes the positive visual expectations established by the sonnet's title, and anticipates the "universal blank" of Cortez's vision in the concluding lines. It is, as Fry suggests, a "non-epiphanic" moment.

42. *Lectures on Dramatic Art and Literature,* trans. John Black (New York: AMS Press, 1973), 27.

43. Although the lost manuscript of Keats' second poem on Hyperion reportedly bore the new title "The Fall of Hyperion: A Dream," Keats in his letters appears to have considered the two fragments on Hyperion as independent versions of the same epic project, rather than as drafts of a single poem. To make this distinction clear, I have italicized the title *Hyperion* when referring to the two fragments as part of Keats' greater unfinished poetic enterprise. The two fragments, taken individually, will be referred to in quotation marks.

44. *The Letters of John Keats, 1814–21,* ed. H. E. Rollins (Cambridge, MA: Harvard University Press, 1958), 2:212.

45. *Dark Interpreter: The Discourse of Romanticism* (Ithaca: Cornell University Press, 1980), 163.

46. *The Fate of Reading* (Chicago: Chicago University Press, 1975), 83.

47. The sculptural character of the imagery in the *Hyperion* poems is not a recent insight. Thomas De Quincey compared Keats' epic fragments to "a Grecian temple enriched with Grecian sculpture." For Leigh Hunt, the poems were "like a ruin in the desert"; for George Gilfillan, "the most magnificent of poetical Torsos"; and for Richard Woodhouse, "that in poetry which the Elgin and Egyptian Marbles are in sculpture." Almost no commentary on the poems since the Victorian era has neglected to reiterate the comparison. De Quincey, *Collected Writings,* ed. David Masson (Edinburgh, 1889–90), 11:389; Hunt, quoted in Theodore Redpath, *The Young Romantics and Critical Opinion, 1807–24* (New York: St. Martin's Press, 1973), 499; Gilfillan, *A Gallery of Literary Portraits* (Edinburgh: W. Tait, 1845), 372; Woodhouse, quoted in *Keats and the Mirror of Art,* 161.

48. *The Sculpted Word,* 151.

49. Martin Aske, *Keats and Hellenism* (Cambridge: Cambridge University Press, 1985), 53–72.

50. *Letters,* 1:207.

51. "Many a work of art whose coherence is never questioned is, as the artist knows quite well himself, not a complete work but a fragment, or one or more fragments, a mass, a plan." *Philosophical Fragments,* trans. Peter Firchow (Minneapolis: University of Minnesota Press, 1991), 12.

52. For example: Tillotama Rajan, *Dark Interpreter,* 143-203; and Thomas Reed, "Keats and the Gregarious Advance of Intellect in *Hyperion,*" *ELH* 55 (1988): 195-232.

53. Alan Bewell, "The Political Implications of Keats's Classicist Aesthetics," *Studies in Romanticism* 25 (1986): 220-29; Theresa Kelley, "Keats, Ekphrasis, and History," *Keats and History,* 212-37.

54. *The Visionary Company* (New York: Doubleday, 1961), 388.

55. The trial transcripts are at the Scottish Records Office in Edinburgh. Here I rely on the generous transcript of the proceedings in Theodore Vrettos, *A Shadow of Magnitude: The Acquisition of the Elgin Marbles* (New York: G. P. Putnam's Sons, 1974), 188-217.

56. *Shadow of Magnitude,* 195.

57. *Shadow of Magnitude,* 201.

58. *Medwin's Conversations of Lord Byron,* ed. Ernest J. Lovell, Jr. (Princeton: Princeton University Press, 1966), 211. Medwin attributes the couplet to Martin Archer Shee's *Rhymes on Art,* which went through four editions from 1805-21. But the couplet does not appear in any of these editions. Furthermore, in a footnote in the 1809 edition, now bearing the title *Elements of Art,* Shee, a one-time president of the Royal Academy, describes himself as "one of those who think that the noble proprietor deserves well of the Arts for their [the marbles'] introduction to this country" (120). Given that Elgin had enemies enough among the art establishment, it is difficult to believe a venereal joke would come from his own corner. Any number of factors could explain the confusion: Medwin's gift for fanciful recollection, or Byron's habit of baiting Medwin with misinformation— there is probably no final answer.

59. Moving into the public sphere with his collection, Elgin surrendered any control he might have had over the political stakes attending their acquisition. As a consequence, the historical disinclination in England to contribute public money to the arts, added to the debt crisis the government faced in the aftermath of the wars against Napoleon, and the scandalous example of cultural thievery set by the French emperor, made his application to the parliament in 1816 a poor bet indeed. Notwithstanding, Elgin was confident that the British Museum, flushed with the recent endowment of Lord Townley's Greco-Roman collection, offered a logical repository for the marbles and an opportunity for him to recoup his losses.

60. *Report,* 26-27.

61. In her poem "Modern Greece," Felicia Hemans employed the same cultural metaphor of England as a latter-day Athenian republic. Writing in the year of the parliamentary debate on the Elgin Marbles, she naturally turned to them to exemplify her patriotic feeling:

> And who can tell how pure, how bright, a flame
> Caught from these models, may illumine the West?
> What British Angelo may rise to fame,
> On the free isle what beams of art may rest?
> Deem not, O England! that by climes confined,
> Genius and taste diffuse a partial ray.
> No! thou hast power to be what Athens e'er hath been.
>
> (1.990-96, 1000)

62. *Report,* 92-93. The irony is that Payne Knight had plenty to say about the marbles, most of it the prejudicial opinion one would expect from the Society of Dilettanti's champion in an emergent bourgeois museum culture. Most damaging was his challenge over dinner at Lord Stafford's: "You have lost your labour, milord Elgin. Your marbles are not Greek at all, but from the time of Hadrian." Sydney Checkland, *The Elgins 1766-1917: A Tale of Aristocrats, Proconsuls and their Wives* (Aberdeen: Aberdeen University Press, 1988), 82. The ignorance of this remark did not disqualify Payne Knight's influence with the Select Committee nor the meanness of the financial settlement ultimately offered to Elgin, as he had many friends in Parliament.

63. *Report,* 41.

64. Smith, "Lord Elgin and his Collection," *Journal of Hellenic Studies* 36 (1916): 262.

65. Though written prior to Byron's poems, and undoubtedly an influence on them, Galt's parody was not published until 1820 (*The Monthly Magazine* 49: 51-54), and even then in expurgated form. Another version appears in his autobiography (London: Cochrane & McCrone, 1933), 160-69.

66. *The Elgins,* 83.

67. "Lord Elgin," 162.

68. "Lord Elgin," 234.

69. "Lord Elgin," 245.

70. "Lord Elgin," 276.

71. *The Plundered Past* (New York: Atheneum, 1973), 174-75.

72. "Mme. Mercouri and Elgin's Marbles," *Encounter* 64 (1985): 74.

73. The "other name" is Mary Elgin's, boldly inscribed next to her husband's on a column in the summer of 1801. As William St. Clair records, Lord Elgin's name was soon erased, though Mary's was still legible in 1826. *Lord Elgin and the Marbles* (Oxford: Oxford University Press, 1967), 198.

74. This is perhaps the cruelest insinuation in a poem full of cruelties; it was widely known that Elgin's eldest son suffered from epilepsy.

75. "Lord Elgin," 298.

76. *Report,* 6.

77. Despite the Museum's efforts to suppress his memory, popular interest in Lord Elgin and his marbles remains strong. In addition to numerous symposia and hearings on the fate of the Parthenon collection, three books on the subject of their acquisition were re-issued in the late 1990s: William St. Clair's definitive *Lord Elgin and the Marbles;* Theodore Vrettos' *A Shadow of Magnitude,* revised and re-titled *The Elgin Affair;* and Christopher Hitchens' polemical essay, *The Elgin Marbles: Should They be Returned to Greece?* Amid fin de siècle anxiety over the legacies of empire, these new editions help restore the marbles to their historical role as Britain's most controversial national symbol. In terms of their specific politics, however, they show the intractability of the Elgin controversy as much as its topicality. As Mary Beard's review in the *Times Literary Supplement* attests (12 June 1998: 5-6), the three authors add little to the parliamentary debates of 1816: St. Clair essentially defends Elgin, while Hitchens and Vrettos restate the Byronic critique.

Chapter 5

1. *Complete Works and Letters* (New York: Modern Library, 1935), 1098.

2. *Complete Works,* 1018-19.

3. "Illustrated Books," *The Times* (July 1844): 171.

4. John Brewer, *The Pleasures of the Imagination* (New York: Farrar, Straus, Giroux, 1997), 462.

5. The first issue of *The Illustrated London News* appeared on 14 May 1842. It consisted of sixteen pages with two illustrations per page, and sold 26,000 copies. As well as current political and society news, the inaugural issue contained a survey of current visual-cultural offerings, including an account of a Royal Academy exhibition and an advertisement for yet another revival of the Waterloo panorama at Burford's in Leicester Square. Christopher Hibbert, *The* Illustrated London News: *A Social History of Victorian Britain* (London: Angus and Robertson, 1975), 11-13.

6. *Victorian Novelists and their Illustrators* (London: Sidgwick and Jackson, 1970), 8.

7. In his *Autobiographical Reflections,* Charles Leslie recalled visits to Abbotsford where Scott "talked of scenery as he wrote of it—like a painter; and yet for pictures, as works of art, he had little or no taste, nor did he pretend to any. To him they were interesting merely as representing some particular scene, person or event; and very moderate merit in their execution contented him." Quoted in Adele Holcomb, "Scott and Turner" in *Scott Bicentenary Essays,* ed. Alan Bell (Edinburgh: Scottish Academic Press, 1973), 202.

8. May 1810, quoted in *The Poetical Works* (Edinburgh: Robert Cadell, 1832-34), 8:19n.

9. "The Illustration of Sir Walter Scott: Nineteenth-Century Enthusiasm and Adaptation," *Journal of the Warburg and Courtauld Institutes* 34 (1971): 297.

10. "Notice" to the *Waverley Novels* (Edinburgh: Robert Cadell, 1844).

11. *Letters,* ed. H. J. C. Grierson (London: Constable, 1932-37), 11:7.

12. *Letters,* 2:321.

13. An illustration by Charles Leslie for *The Antiquary,* not for Cadell's edition, appealed to the popular market for Hogarthian ribaldry. In "The Intrusion of the Sanctum Sanctorum" (1823), Leslie depicts the unfortunate chambermaid caught cleaning under his desk by the Antiquary, to whom she unwittingly presents her generous rump. The disposition of the figures creates a bawdy visual pun: whose "Holy of holies" has been intruded upon, the Antiquary's or the chambermaid's?

14. *Letters,* 11:485n. [Cadell to Scott].

15. *Letters,* 11:459-60.

16. See note 14. Having worked with Turner before, both Cadell and Scott were accustomed to Turner's ill-kempt appearance and general "cockney" vulgarity. But his refusal to assume his share of the losses incurred by poor sales of *The Provincial Antiquities of Scotland* had earned the artist a more serious demerit: an ungentlemanly preoccupation with money. In a letter from April 1819, Scott describes Turner as "almost the only man of genius I ever knew who is sordid in these matters." cf. A. J. Finberg, *The Life of J. M. W. Turner, R. A.,* 2nd ed. (Oxford: Oxford University Press, 1961), 257.

17. Some of these sketches, as well as drawings made by Turner on previous visits, became the basis of designs for Cadell's edition of Scott's *Prose Works* (1834-36). Because these illustrations lack the self-referential, touristic quality of the *Poetry* series, I have not included them in my analysis.

18. *A Barthes Reader,* ed. Susan Sontag (New York: Hill and Wang, 1982), 204.

19. *Landscapes of Memory: Turner as Illustrator to Scott* (Berkeley: University of California Press, 1980), 157-58. I am indebted to Finley's study for the history of Turner's relationship, both personal and professional, to Scott and Cadell.

20. In August 1814, Scott visited the Loch he calls "Corriskin" (its "proper name") in his journal and "Coriskin" in *Lord of the Isles.* It is universally known today as Loch Coruisk, a popular scenic site at the south end of Skye.

21. Adele Holcomb, "Scott and Turner," *Scott Bicentenary Essays,* 212. The convergence of Turner's illustrative and painterly styles in his work for Scott's "Poetry" can be explained, at least in part, by the circumstances of publishing technology. The introduction of high quality steel plates in the late 1820s, which offered the possibility of finer, more brilliant lines and greater subtlety of tone than copper plates, excited the artist's imagination. Later in

the 1830s, the use of wood engraving ushered in a new era of cheap, mass produced, but inferior illustration. When Cadell approached Turner at that time to illustrate another edition of Scott using wood engraving, he refused, citing the stylistic limitations of that technology. It is clear from this that Turner took the artistic value of illustration seriously. Given the direct relation between technology and aesthetic quality, Turner's *Poetry* illustrations, undertaken during the brief reign of the steel plate in commercial publishing houses, emerge as a singular artistic high point in the history of illustrated books (see Finley, 186–88).

22. *Modern Painters* (London: J. M. Dent & Co., 1923), 2:23.

23. *Memoirs of the Life of Sir Walter Scott,* ed. J. G. Lockhart (Edinburgh: Cadell, 1839), 4:313.

24. "The Illustration of Sir Walter Scott," 298n.

25. Quoted in David Daiches, *Sir Walter Scott and his World* (London, 1971), 41–42.

26. James Holloway, *The Discovery of Scotland* (Edinburgh: National Gallery of Scotland, 1978), 109. As a besieged local resident, Scott himself was ambivalent toward the unforeseen consequences of his poem's success. "Every London citizen," he lamented in 1810, "makes Loch Lomond his washpot and throws his shoe over Ben Nevis." (*Memoirs,* 190).

27. Scott's essentially modern, lowland viewpoint was no better in evidence than during his Highland tour after the grand success of *The Lady of the Lake.* The tributes of a gathering of Highlanders nominated him "the great *Saxon* poet," and offered an extended encomium in his honor, in Gaelic, of which he understood not a word. This episode illustrates how the cult of Scott, in the tradition of Macpherson's *Ossian,* belonged to a form of Romantic primitivism that pretended to recover an authentic, heroic, pre-industrial kingdom to the north, a culture almost as alien to a lowland Scotsman as to an Englishman. The irony was that, at Loch Katrine, the Lowlander Scott found himself a tourist in the very land to which he had presumed to give a voice. See James Buzard, "Translator and Tourism: Scott's *Waverley* and the Rendering of a Culture," *Yale Journal of Criticism* 8:2 (1995): 31–59.

28. Horatio McCulloch's grandiose academic production of the same view in 1866, often thought to replicate Turner's, is in fact a more literal account, with an immediate foreground, the eastern fells elided, and Benvenue more imposingly featured.

29. "Illustrated Books," 196–97. See Martin Meisel, *Realizations: Narrative, Pictorial and Theatrical Arts in Nineteenth-Century England* (Princeton, NJ: Princeton University Press, 1983), 30–31.

30. "Illustrated Books," 175.

31. *Athenaeum,* 17 March 1832.

32. *The Letters of John Keats,* ed. H. E. Rollins (Cambridge, MA: Harvard University Press, 1958), 1:299.

33. *Letters,* 1:325.

34. Helmut and Alison Gernsheim, *L. J. M. Daguerre: The History of the Diorama and the Daguerrotype* (New York: Dover Publications, 1968), 55.

35. Unlike the landscape studies of *Sun Pictures of Scotland, The Pencil of Nature* was indebted to the Dutch tradition of still life. Three of its most famous compositions—"The Open Door (broom in a doorway), "Scene in a Library" (bookshelves), and "lace" (close-up of tablecloth pattern)—share a fascination with formal beauty in the everyday, domestic world while radically extending the repertoire of still-life subjects. Only one of the twenty-four images in *The Pencil of Nature*—a view of Fox Talbot's Lacock Abbey estate outside Bath—could remotely qualify as picturesque.

36. Hill's Waverley tableaux were, in fact, stylized imitations of well-known academic treatments of Scott dating from the first decade of the century, most notably the dramatic illustrations to the Cadell "Magnum Opus" edition. Baudelaire would later single out the fashion for photographic "tableaux" as among the worst degradations of the new medium. Photographers, he speculated, "must have seen in [tableaux] a cheap means of spreading the dislike of history and painting amongst the masses, thus committing a double sacrilege, and insulting, at one and the same time, the divine art of painting and the sublime art of the actor." *Art in Paris 1845-1862: Salons and Other Exhibitions,* trans. Jonathan Mayne (Oxford: Phaidon Press, 1965), 295. Baudelaire's opinion echoes the current critical consensus: Hill's Waverley "tableaux" are conspicuously absent from the canon of early British photography.

37. Unpublished correspondence quoted in Graham Smith, "Views of Scotland," *Henry Fox Talbot: Selected Texts and Bibliography,* ed. Mike Weaver (Oxford: Clio Press, 1992), 117.

38. The anxiety of influence evident in the Turner-Fox Talbot relation, whereby Fox Talbot responds to (or, as I will argue, rejects) Turner's canonical precedent, contradicts the received art-historical understanding of photography's influence on nineteenth-century art. According to this analysis, the precision of detail and perspective available to the camera motivated an inexorable trend in painting from mid-century on toward non-naturalistic, impressionistic, and ultimately abstract figuration. In the British context, this account fails, first of all, to explain the post-1850s realism of Millais or the hyper-naturalism of the Pre-Raphaelites. But the most serious chronological anomaly is, as Susan Sontag has pointed out, Turner himself: "as photography was entering the scene, painting was already, on its own, beginning its long retreat from realistic representation—Turner was born in 1775, Fox Talbot in 1800—and the territory photography came to occupy with such rapid and complete success would probably have been depopulated anyway." *On Photography* (New York: Dell Publishing, 1973), 94.

39. Beaumont Newhall, "Introduction," *W. H. Fox Talbot's* The Pencil of Nature (New York: DaCapo Press, 1969) [unpaginated]. Helmut Gernsheim, for example, the doyen of modern photography historians, dismisses *Sun Pic-*

tures in Scotland as "uninspired," and devotes barely a half-dozen lines to it in his 600 page *History of Photography* (New York: McGraw-Hill, 1969), 173.

40. Tourism aside, a more general Romantic influence on the first generation of British photographers is clearly evident. In essence, British photography enters art history in the form of parody, a symptom of the Victorian failure of taste in the aftermath of Romanticism. D. O. Hill apes Henry Raeburn, Julia-Margaret Cameron invents the pseudo-romantic "blur," and Henry Peach Robinson emulates the genre style of Wilkie. Fox Talbot largely avoided the trap of derivativeness, but in his photographic tribute to Scott showed an equally unresolved relation to Romantic landscape art.

41. *The Illustrated Wordsworth's Guide to the Lakes,* ed. Peter Bicknell (New York: Congdon & Weed, 1984), 22.

42. *Circuit Journeys* (London: 1888), 268, 308, quoted in *The Discovery of Scotland,* 103.

43. C. R. Leslie, *Autobiographical Reflections,* ed. Tom Taylor (London: J. Murray, 1860), 60 [original emphasis].

44. *Letters,* 11:459.

45. "Upon Photography in an Artistic View, and in its Relations to the Arts," *Journal of the Photographic Society* 1 (3 March 1853). Newton's paper was the very first delivered to the Royal Society at its inaugural meeting, immediately after Sir Charles Eastlake's installation as President and Roger Fenton's first report as secretary.

46. "On the Use of Photography to Artists," *Journal of the Photographic Society* 1 (21 June 1854): 75-76. The traces of Reynolds in early photographic theory demonstrate the tendency of aesthetic debates to revert to old terms, irrespective of the novelty of the medium. "There is," as Benjamin remarks in his *Passagenwerk,* "an effort to master the new experiences of the city within the framework of the old traditional experiences of nature." *The Arcades Project,* trans. Howard Eiland and Kevin McLaughlin (Cambridge, MA: Harvard University Press, 1999), 447. The greatest setback for the photography-as-art lobby came in 1862 when officials of the Great International Exhibition chose to classify the camera as a machine and photographers as mechanical "operators." Their reasoning contained familiar echoes of the *Discourses,* namely a clear, hierarchical opposition between the technology of verisimilitude and the arts of invention, between imitation and imagination, and between the real and ideal.

47. "Photography," *Quarterly Review* 101 (April 1857): 462. Lady Eastlake's (neé Elizabeth Rigby) anonymous *Quarterly Review* article elucidates both technical developments in and the aesthetic implications of photography. It is among the most important early critical pieces on the medium.

48. From Virgil, *Georgics* III: 293 [my translation]. This is also Fox Talbot's epigraph to *The Pencil of Nature.* His attachment to Virgil's lines raises them to the order of an artistic creed.

49. *Photography and its Critics: A Cultural History, 1839-1900* (Cambridge: Cambridge University Press, 1997), 72.

50. *Photography and its Critics,* 73.

51. "Photography," 443.

52. *Art in Paris,* 297 (translation modified).

53. "A Small History of Photography," *One-Way Street and Other Writings* (London: Verso, 1979), 240.

54. Maria Morris Hambourg, "A Portrait of Nadar," *Nadar,* ed. M. M. Hambourg, Françoise Heilbrun, and Philippe Néagu (New York: Metropolitan Museum of Art, 1995), 31. The two Nadar memoirs central to this discussion are *Quand J'Etais un Photographe* (1900) and the posthumously published *Baudelaire Intime* (1911).

55. *Charles Baudelaire Intime* (Paris: La Bibliothéque des Arts, 1994), 129.

56. *My Heart Laid Bare and Other Prose Writings,* ed. Peter Quennell (London: Soho Book Company, 1986), 178.

57. *My Heart Laid Bare,* 180.

58. *Baudelaire Intime,* 129.

59. "On voit le doux Asselineau / Près du farouche Baudelaire," quoted in *Nadar,* 228.

60. *Baudelaire Intime,* 43.

61. *My Heart Laid Bare,* 193.

62. *Illuminations,* ed. Hannah Arendt (New York: Schocken Books), 186.

63. *Art in Paris,* 295.

64. *Camera Lucida: Reflections on Photography,* trans. Richard Howard (New York: Farrar, Straus, and Giroux, 1981), 4.

65. *Art in Paris,* 298.

66. Quoted in Heinrich Schwarz, *Art and Photography: Forerunners and Influences,* ed. William E. Parker (Layton: Peregrine Smith Books, 1985), 114. Nadar considered Daumier a giant among French caricaturists and a personal mentor. For Daumier's part, he appeared to rate Nadar more highly as a photographer than a caricaturist. A cartoon from 1862, "Nadar élevant la Photographie à la hauteur de l'Art," shows Nadar in his unusual new studio—a balloon floating above a Paris skyline filled with billboard advertisements for photographers. Daumier's drawing commemorates Nadar's first aerial photographs of Paris from his balloon "Le Géant" in the summer of 1863, but it operates also as a compliment: Nadar, both literally and symbolically, soars high above his competition.

67. *Art in Paris,* 297-98. Four years earlier, in his review of the *Exposition Universelle,* Baudelaire had mocked "the heroic sacrifice . . . performed by M. Courbet on behalf of external, positive and immediate Nature."

68. *Art in Paris,* 12.

69. *Illuminations,* 188.

70. "What is Romanticism?" *Art in Paris,* 52. Like Schiller in *On the Naive and Sentimental in Literature,* Baudelaire defines Romanticism negatively, according to its difference from classicism. Contra Schiller, he rejects antiquarian sentimentality (see chapter 4).

71. "Years in Brussels," in *My Heart Laid Bare,* 224.

72. *Nadar: Dessin et Ecrits,* ed. Philippe Néagu (Paris: Arthur Hubschmid, 1979), 1:977; my translations throughout.

73. *Dessins et Ecrits,* 978.

74. *Art Journal* (April 1858): 21.

75. *Dessins et Ecrits,* 976.

76. *Dessins et Ecrits,* 974.

77. *Illuminations,* 168-69.

78. *Dessins et Ecrits,* 1088.

79. Haussmann served as prefect of the Seine Department of Public Works from 1853 to 1870.

80. *Baudelaire Intime,* 2.

81. "A Portrait of Nadar," *Nadar,* 6.

82. Edmond and Jules de Goncourt *Journal: Mémoires de la vie littéraire,* ed. Robert Ricatte (Paris, 1989), 1:783; quoted by Sylvie Aubenas, "Beyond the Portrait, Beyond the Artist" in *Nadar,* 99-100.

83. It was republished as part of Nadar's memoir, *Quand J'Etais Un Photographe* (1900).

84. *Dessins et Ecrits,* 1074-75.

85. *Dante and the French Romantics* (Geneva: Librarie Droz, 1985), 217.

86. *Dessins et Ecrits,* 1094-96.

87. *Dessins et Ecrits,* 1083.

BIBLIOGRAPHY

Ades, John I. "Charles Lamb, Shakespeare, and Early Nineteenth-Century Theater." *PMLA* 85 (1970): 514-26.

Adorno, Theodor. "Valéry Proust Museum." Trans. Samuel and Shierry Weber. *Prisms.* Cambridge, MA: The MIT Press, 1981: 173-86.

Altick, Richard D. *Painting from Books.* Columbus: Ohio University Press, 1985.

————. *The Shows of London.* Cambridge, MA: Harvard University Press, 1978.

Andrews, Malcolm. *The Search for the Picturesque: Landscape, Aesthetics, and Tourism in Britain, 1760-1800.* Aldershot: Scholar Press, 1989.

Arac, Jonathan. "The Media of Sublimity: Johnson and Lamb on King Lear." *Studies in Romanticism* 26 (Summer 1987): 209-20.

————. "Romanticism, the Self, and the City: The Secret Agent in Literary History." *Boundary 2* 9 (Fall 1980): 75-90.

Aske, Martin. *Keats and Hellenism.* Cambridge: Cambridge University Press, 1985.

Asleson, Robyn, ed. *Sarah Siddons and her Portraitists.* Los Angeles: The J. Paul Getty Museum, 1999.

Baer, Marc. *Theatre and Disorder in Late Georgian London.* Oxford: Clarendon Press, 1992.

Barish, Jonas. *The Anti-theatrical Prejudice.* Berkeley: University of California Press, 1981.

Barrell John, ed. *Painting and the Politics of Culture, 1700-1850.* Oxford: Oxford University Press, 1992.

————. *Poetry, Language, and Politics.* Manchester: Manchester University Press, 1988.

————. *The Political Theory of Painting from Reynolds to Hazlitt.* New Haven: Yale University Press, 1986.

Barry, James. "Inquiry into the Real and Imaginary Obstructions to the Acquisition of the Arts in England." London, 1774.

————. *Works.* London: T. Cadell and W. Davies, 1809.

Barthes, Roland. *A Barthes Reader*. Ed. Susan Sontag. New York: Hill and Wang, 1982.

———. *Camera Lucida*. Trans. Richard Howard. New York: Farrar, Straus and Giroux, 1981.

———. *Mythologies*. Trans. Annette Lavers. New York: Farrar, Straus and Giroux, 1972.

———. "The Reality Effect." *French Literary Theory Today*. Ed. Tzvetan Todorov. Cambridge: Cambridge University Press, 1978.

Baudelaire, Charles. *Art in Paris 1845-1862: Salons and other Exhibitions*. Trans. Jonathon Mayne. Oxford: Phaidon Press, 1965.

———. *Les Fleurs du mal*. Paris: Gallimard, 1971.

———. *My Heart Laid Bare and Other Prose Writings*. Ed. Peter Quennell. London: Soho Book Co., 1986.

Baudrillard, Jean. *Simulations*. Trans. Paul Foss, Paul Patton and Philip Beitchman. Semiotext(e), 1983.

Baugh, Christopher. "Philippe James de Loutherbourg and the Early Pictorial Theatre: Some Aspects of its Cultural Context." *The Theatrical Space*. Ed. James Redmond. Cambridge: Cambridge University Press, 1987.

Benjamin, Walter. *The Arcades Project*. Trans. Howard Eiland and Kevin McLaughlin. Cambridge, MA: Belknap Press of Harvard University Press, 1999.

———. *Illuminations*. Ed. Hannah Arendt. New York: Schocken Books, 1966.

———. *Reflections*. Ed. Peter Demetz. New York: Schocken Books, 1978.

———. "A Small History of Photography." *One-Way Street and Other Writings*. London: Verso, 1979.

Bertelsen, Lance. "David Garrick and English Painting." *Eighteenth Century Studies* 11 (1978): 308-24.

Bertram, Joseph. *The Tragic Actor*. London: Theater Art Books, 1959.

Bewell, Alan J. "The Political Implications of Keats's Classicist Aesthetics." *Studies in Romanticism* 25 (1986): 220-29.

Blanchard, Marc Eli. "Writing the Museum: Diderot's Bodies in the Salons." *Diderot: Digression and Dispersion*. Ed. Jack Udank and Herbert Josephs. Lexington, KY: French Forum Press, 1984.

Bloom, Harold. *The Visionary Company*. New York: Doubleday, 1961.

Boase, T. S. R. *English Art 1800-1870*. Oxford: Clarendon Press, 1959.

Bourdieu, Pierre. *Photography: A Middle-Brow Art*. Trans. Shaun Whiteside. Stanford: Stanford University Press, 1990.

Brewer, John. *The Pleasures of the Imagination: English Culture in the Eighteenth Century*. New York: Farrar, Straus, Giroux, 1997.

———. Neil McKendrick, and J. H. Plumb. *The Birth of a Consumer Society: The Commercialization of Eighteenth-Century England*. London: Europa Publications, 1982.

Bryson, Norman. *Word and Image: French Painting of the Ancien Régime*. Cambridge: Cambridge University Press, 1981.

Burke, Edmund. *A Philosophical Enquiry into the Origin of our Ideas of the Sublime and Beautiful*. Oxford: Oxford University Press, 1990.

Burnim, Kalman. *David Garrick, Director*. Pittsburgh: University of Pittsburgh, 1961.

Burwick, Frederick and Walter Pape, eds. *The Boydell Shakespeare Gallery*. Bottrop: Peter Pomp, 1996.

Buss, R.W. "On the Use of Photography to Artists." *Journal of the Photographic Society* 1 *(21 June 1854): 75-76.*

Butler, E. M. *The Tyranny of Greece over Germany*. Boston: Beacon Press, 1935.

Buzard, James. "Translation and Tourism: Scott's Waverley and the Rendering of a Culture." *Yale Journal of Criticism* 8:2 (1995): 31-59.

Byron, Lord. *The Complete Poetical Works*. Ed. Jerome McGann. 3 vols. Oxford: Clarendon Press, 1980.

Byron's Letters and Journals. Ed. Leslie Marchand. 12 vols. Cambridge: Harvard University Press, 1973-82.

Castle, Terry. *Masquerade and Civilization*. Stanford: Stanford University Press, 1986.

Checkland, Sydney. *The Elgins, 1766-1917: A Tale of Aristocrats, Proconsuls and their Wives*. Aberdeen: Aberdeen University Press, 1988.

Churchill, Charles. *Poems*. Ed. James Laver. New York: Barnes and Noble, 1970.

Cibber, Theophilus. *Dissertation on the Theatres*. London, 1759.

Clarke, G. W., ed. *Rediscovering Hellenism*. Cambridge: Cambridge University Press, 1989.

Clayton, Timothy. *The English Print, 1688-1802*. New Haven: Yale University Press, 1997.

Coldwell, Joan. "The Playgoer as Critic: Charles Lamb on Shakespeare's Characters." *Shakespeare Quarterly* 26 (1975): 184-95.

Cole, Toby and Helen Chinoy, eds. *Actors on Acting*. New York: Crown Publishers, 1970.

Coleridge, Samuel Taylor. *Collected Letters*. Ed. Earl Leslie Griggs. 6 vols. Oxford: Clarendon Press, 1956.

———. *Collected Works*. Ed. Kathleen Coburn. 16 vols. Princeton: Princeton University Press, 1969- .

———. *The Literary Remains of Samuel Taylor Coleridge*. Ed. H. N. Coleridge. 4 vols. London: William Pickering, 1836. Rpt. New York: AMS Press, 1967.

"A Collection of descriptions of views exhibited at the Panorama, Leicester Square: painted by H. A. Barker, Robert Burford, John Burford and H. C. Selous, 1798-1856." London: British Library.

"A Collection of descriptions of views exhibited at the Panorama, The Strand: painted by R. R. Reinagle, T. E. Barker, H. A. Barker, J. Burford and R. Burford, 1802?-31." London: British Library.

Comment, Bernard. *The Panorama*. Trans. Anne-Marie Glasheen. London: Reaktion Books, 1999.

Constable, John. *Correspondence*. Ed. R. B. Beckett. 2 vols. Ipswich: Suffolk Records Society, 1964.

Copley, Stephen and Peter Garside, eds. *The Politics of the Picturesque*. Cambridge: Cambridge University Press, 1994.

Cottrell, Richard. "Mme. Mercouri and Elgin's Marbles." *Encounter* 64 (1985): 73-75.

Crary, Jonathan. *Techniques of the Observer: On Vision and Modernity in the Nineteenth Century*. Cambridge, MA: MIT Press, 1990.

Crouch, Kimberley. "The Public Life of Actresses: Prostitutes or Ladies?" *Gender in Eighteenth-Century England: Roles, Representations, and Responsibilities*. Ed. Hannah Barker and Elaine Chalus. London: Longman, 1997.

Crow, Thomas E. *Painters and Public Life in Eighteenth Century Paris*. New Haven: Yale University Press, 1985.

Davies, Thomas. *Dramatic Miscellanies*. 3 vols. London, 1785.

———. *Memoirs of the Life of David Garrick*. Ed. Stephen Jones. 2 vols. New York: Benjamin Blom, 1969.

Debord, Guy. *The Society of the Spectacle*. Trans. Donald Nicholson-Smith. New York: Zone Books, 1994.

Diderot, Denis. "The Paradox of Acting." *Actors on Acting*. Ed. Toby Cole and Helen Chinoy. New York: Crown Publishers, 1970.

———. *Ruines et paysages: salons de 1767*. Ed. Else Marie Bukdahl, Michel Delon, and Annette Lorenceau. Paris: Hermann, 1995.

Downer, Alan S. "Nature to Advantage Dressed: Eighteenth-Century Acting." *PMLA* 58 (1943): 1002-37.

———. "Players and Painted Stage: Nineteenth-Century Acting." *PMLA* 61 (1946): 522-76.

Duncan, Carol. *Civilizing Rituals: Inside Public Art Museums*. New York: Routledge, 1995.

Eastlake, Lady [Elizabeth Rigby]. "Photography." *Quarterly Review* 101 (April 1857): 443-68.

Eaves, Morris. *The Counter-Arts Conspiracy: Art and Industry in the Age of Blake*. Ithaca: Cornell University Press, 1992.

Ferris, David. *Silent Urns: Romanticism, Hellenism, Modernity*. Stanford: Stanford University Press, 1999.

Finley, Gerald. *Landscapes of Memory: Turner as Illustrator to Scott*. Berkeley: University of California Press, 1980.

Fisher, Philip. "A Museum with One Work Inside: Keats and the Finality of Art." *Keats-Shelley Journal* 33 (1984): 85-102.

Fox Talbot, William Henry. *The Pencil of Nature* [1842-46]. Rpt. New York: DaCapo Press, 1969.

———. *Selected Texts and Bibliography*. Ed. Mike Weaver. Oxford: Clio Press, 1992.

———. *Sun Pictures in Scotland*. London, 1845.

Freud, Sigmund. "Mourning and Melancholia." *The Complete Psychological Works of Sigmund Freud*. Ed. James Strachey. London: Hogarth Press. 14: 237-58.

Fried, Michael. *Absorption and Theatricality: Painting and Beholder in the Age of Diderot*. Berkeley: University of California Press, 1980.

Fruitema, Evelyn J. and Paul Zoetmulder, eds. *The Panorama Phenomenon.* The Hague: Foundation for the Preservation of the Centenarian Mesdag Panorama, 1981.

Galassi, Peter. *Before Photography.* New York: Museum of Modern Art, 1981.

Galperin, William. *The Return of the Visible in British Romanticism.* Baltimore: Johns Hopkins University Press, 1993.

Galt, John. "The Atheniad." *Monthly Magazine* 49 (1820): 51-54.

Garrick, David. *Letters.* Ed. David M. Little and George M. Kahrl. 3 vols. Cambridge, MA: Harvard University Press, 1963.

Gaull, Marilyn. *English Romanticism: The Human Context.* New York: W. W. Norton, 1988.

Genest, John. *Some Account of the English Stage from the Restoration in 1660 to 1830.* 10 vols. London: T. Rodd, 1832.

Gentleman, Francis. *The Dramatic Censor.* London: J. Bell, 1770.

Gernsheim, Helmut. *History of Photography.* New York: McGraw-Hill, 1969.

Gilpin, William. *Three Essays: On Picturesque Beauty, On Picturesque Travel, On Sketching Landscape, with a Poem "On Landscape Painting."* London: R. Blamire, 1792.

Glendening, John. *The High Road: Romantic Tourism, Scotland, and Literature, 1720-1820.* New York: St. Martin's Press, 1997.

Godfrey, Richard. *Printmaking in Britain.* Oxford: Oxford University Press, 1978.

Goethe, J. W. von. *Conversations with Eckermann.* Trans. John Oxenford. San Francisco: North Point Press, 1984.

Goldstein, Laurence. *Ruins and Empire.* Pittsburgh: University of Pittsburgh Press, 1977.

Gombrich, Ernst. "Reynolds's Theory and Practice of Imitation." *Burlington Magazine* 80 (1942): 40-45.

de Goncourt, Edmond and Jules. Journal: *Mémoires de la vie littéraire.* Ed. Robert Ricatte. Paris, 1989.

Gordon, Catherine. "The Illustration of Sir Walter Scott: Nineteenth-Century Enthusiasm and Adaptation." *Journal of the Warburg and Courtauld Institutes* 34 (1971): 297-317.

Green, Valentine. *A Review of the Polite Arts in France, at the time of their Establishment under Louis XVI, compared with their Present State in England.* London: T. Cadell, 1782.

Green-Lewis, Jennifer. *Framing the Victorians: Photography and the Culture of Realism.* Ithaca: Cornell University Press, 1996.

Hagstrum, Jean. *The Sister Arts: The Tradition of Literary Pictorialism and English Poetry from Dryden to Gray.* Chicago: University of Chicago Press, 1958.

Hambourg, M. M. et al. *Nadar.* New York: The Metropolitan Museum of Art, 1995.

Hamilton, Paul. "'A Shadow of a Magnitude': The Dialectic of Romantic Aesthetics." *Beyond Romanticism.* Ed. John Whale and Stephen Copley. London: Routledge, 1992.

Hartman, Geoffrey. *The Fate of Reading.* Chicago: Chicago University Press, 1975.

Harvey, John. *Victorian Novelists and Their Illustrators*. London: Sidgwick and Jackson, 1970.

Haslewood, John. *Secret History of the Green Room*. London, 1795.

Haydon, Benjamin. *The Autobiography and Memoirs of Benjamin Robert Haydon*. Ed. Tom Taylor. 2 vols. London: Peter Davies, 1926.

———. *Correspondence and Table-Talk*. Ed. F. W. Haydon. 2 vols. London: Chatto and Windus, 1876.

———. *The Diary of Benjamin Robert Haydon*. Ed. Walter Bissell Pope. 5 vols. Cambridge, MA: Harvard University Press, 1960.

———. "Enquiry into the Causes which have Obstructed the Advance of Historical Painting for the Last Seventy Years in England." London, 1829.

Hayter, Althea. *A Sultry Month: Scenes of London Literary Life in 1846*. London: Robin Cook, 1965.

Hazlitt, William. *The Complete Works*. Ed. P. P. Howe [after the Centenary Edition]. 21 vols. New York: AMS Press, 1967.

Heffernan, James. *Museum of Words: The Poetics of Ekphrasis from Homer to Ashbery*. Chicago: University of Chicago Press, 1993.

Heller, Janet. *Coleridge, Lamb, Hazlitt, and the Reader of Drama*. Columbia: University of Missouri Press, 1990.

Hill, Aaron. *Essay on the Art of Acting*. London, 1745.

———. *The Prompter* (1734-1736). Ed. William W. Appleton and Kalman A. Burnim. New York: Benjamin Blom, 1966.

Hill, John. *The Actor; or, a Treatise on the Art of Playing*. London, 1755.

Hitchens, Christopher. *The Elgin Marbles: Should They be Returned to Greece?* London: Chatto & Windus, 1987.

Hittorf, Johann Ignaz. [Description de la rotonde des panoramas élevée dans les Champs-Elysées: Précédé d'un aperçu historiques sur l'origine des panoramas et les principales constructions auxquelles ils ont donné lieu]. *Revue générale de l'architecture et des travaux publics*. 2 vols. Paris, 1841.

Hoare, Prince. *An Inquiry into the Requisite Cultivation and Present State of the Arts of Design in England*. London, 1806.

Holcomb, Adele. "Scott and Turner." *Scott Bicentenary Essays*. Ed. Alan Bell. Edinburgh: Scottish Academic Press, 1973.

Holloway, James. *The Discovery of Scotland*. Edinburgh: National Gallery of Scotland, 1978.

Hume, David. *Treatise of Human Nature*. New York: Penguin, 1984.

Hunt, Leigh. *Dramatic Criticism, 1808-31*. Ed. Lawrence Huston Houtchens and Carolyn Washburn Houtchens. New York: Columbia University Press, 1949.

———. *A Saunter Through the West End*. London, 1861.

Hutchinson, Sidney C. *The History of the Royal Academy, 1768-1968*. London: Chapman & Hall, 1968.

Hyde, Ralph. *Gilded Scenes and Shining Prospects: Panoramic Views of British Towns 1575-1900*. New Haven: Yale Center for British Art, 1985.

———. *Panoramania!: The Art and Entertainment of the All-Embracing View.* London: Trefoil Publications, 1988.

"Illustrated Books." *Quarterly Review,* July 1844: 168-99.

Jack, Ian. *Keats and the Mirror of Art.* Oxford: Oxford University Press, 1967.

Jackson, J. R. de J. "Coleridge on Dramatic Illusion and Spectacle in the Performance of Shakespeare's Plays." *Modern Philology* 62 (August 1964): 13-21.

Jacobus, Mary. "'That Great Stage Where Senators Perform': Macbeth and the Politics of Romantic Theatre." *Studies in Romanticism* 22 (Fall 1983): 353-87.

Janowitz, Anne. *England's Ruins: Poetic Purpose and the National Landscape.* New York: Basil Blackwell, 1990.

Keats, John. *Complete Poems.* Ed. Jack Stillinger. Cambridge, MA: Belknap Press of Harvard University Press, 1982.

———. *The Letters of John Keats.* Ed. H. E. Rollins. 2 vols. Cambridge, MA: Harvard University Press, 1958.

Kelly, John Alexander. *German Visitors to English Theaters in the Eighteenth Century.* New York: Octagon Books, 1978.

Kelsall, M. M. *Byron's Politics.* Brighton: Harvester Press, 1987.

Kenny, Shirley, ed. *British Theatre and the Other Arts, 1660-1800.* Washington, DC: Folger Books, 1984.

King, Ross. "Wordsworth, Panoramas, and the Prospect of London." *Studies in Romanticism* 32 (1993): 57-73.

Kroeber, Karl. *British Romantic Art.* Berkeley: University of California Press, 1986.

———, ed. *Images of Romanticism: Verbal and Visual Affinities.* New Haven: Yale University Press, 1978.

———. *Romantic Landscape Vision.* Madison: University of Wisconsin Press, 1975.

Kucich, Greg. "'A Haunted Ruin': Romantic Drama, Renaissance Tradition, and the Critical Establishment." *Wordsworth Circle* 23 (Spring 1992): 64-75.

Lamb, Charles. *Complete Works and Letters.* New York: Modern Library, 1935.

———. *The Letters of Charles and Mary Lamb.* Ed. Edwin Marrs, Jr. Ithaca: Cornell University Press, 1975.

Larrabee, Stephen. *English Bards and Grecian Marbles.* New York: Columbia University Press, 1944.

Leslie, Charles. *Memoirs of the Life of John Constable, R. A.* Ed. Andrew Shirley. London: Phaidon Press, 1937.

Lessing, Gotthold. *Laocoön.* Trans. Ellen Frothingham. Boston: Little, Brown, and Company, 1910.

Levin, Harry. *The Broken Column: A Study in Romantic Hellenism.* Cambridge, MA: Harvard University Press, 1931.

Levinson, Marjorie. *Keats's Life of Allegory.* New York: Blackwell, 1988.

Lichtenberg's Visits to England. Trans. Margaret L. Mare and W. H. Quarrell. New York: Benjamin Blom, 1969.

Lipking, Lawrence. *The Ordering of the Arts in Eighteenth-Century England.* Princeton: Princeton University Press, 1970.

Lippincott, Louise. *Selling Art in Georgian London.* New Haven: Yale University Press, 1983.

Lockhart, J. G. *The Life of Sir Walter Scott.* London: J. M. Dent & Co., 1893.

MacCannell, Dean. *The Tourist: A New Theory of the Leisure Class.* New York: Schocken Books, 1976.

Marien, Mary Warner. *Photography and Its Critics: A Cultural History, 1839-1900.* Cambridge: Cambridge University Press, 1997.

Mayes, Stanley. *The Great Belzoni.* New York: Walker and Company, 1961.

Medwin's Conversations of Lord Byron. Ed. Ernest J. Lovell, Jr. Princeton: Princeton University Press, 1966.

Meisel, Martin. *Realizations: Narrative, Pictorial and Theatrical Arts in Nineteenth-Century England.* Princeton: Princeton University Press, 1983.

Meyer, Karl. *The Plundered Past.* New York: Atheneum, 1973.

Mirzoeff, Nicholas, Ed. *The Visual Culture Reader.* New York: Routledge, 1998.

Mitchell, W. J. T. *Iconology: Image, Text, Ideology.* Chicago: Chicago University Press, 1986.

———. *Picture Theory: Essays on Verbal and Visual Representation.* Chicago: Chicago University Press, 1994.

Moore, Robert E. "Reynolds and the Art of Characterization." *Studies in Criticism and Aesthetics.* Ed. Howard Anderson and John Shea. Minneapolis: University of Minnesota Press, 1967.

Murger, Henri. *Scènes de la vie Bohème.* Trans. Elizabeth Ward Hugus. Salt Lake City: Peregrine Smith Books, 1998.

Musser, Joseph F., Jr. "Sir Joshua Reynolds's 'Mrs. Abington as Miss Prue'." *South Atlantic Quarterly* 83 (1984): 176-92.

Nadar, Felix. *Baudelaire Intime.* Paris: La Bibliothéque des Arts, 1994.

———. *Nadar: Dessins et Ecrits.* Ed. Philippe Néagu. Paris: Arthur Hubschmid, 1979.

———. *Nadar: Photographies.* Ed. Philippe Néagu. Paris: Arthur Hubschmid, 1979.

———. *Nadar/Warhol, Paris/New York:* Photography and Fame. Ed. Gordon Baldwin and Judith Keller. Los Angeles: J. Paul Getty Museum, 1999.

———. *Le Paris souterrain de Felix Nadar, 1861: des os et des eaux.* Paris: Caisse nationale des monuments historiques et des sites, 1982.

Newlyn, Lucy. "Lamb, Lloyd, London: A Perspective on Book Seven of The Prelude." *Charles Lamb Bulletin* 47-48 (July/October 1984): 169-75.

Newton, Sir William. "Upon Photography in an Artistic View, and in its Relations to the Arts." *Journal of the Photographic Society* 1 (3 March 1853).

Nipclose, Sir Nicholas [pseud.]. *The Theatres: A Poetical Dissection.* London, 1772.

Northcote, James. *The Life of Sir Joshua Reynolds.* 2 vols. London: Henry Colburn, 1818.

Oettermann, Stephan. *The Panorama: History of a Mass Medium.* Trans. Deborah Lucas Schneider. New York: Zone Books, 1997.

Pascoe, Judith. Romantic *Theatricality: Gender, Poetry, and Spectatorship.* Ithaca: Cornell University Press, 1997.

Penny, Nicholas, ed. *Reynolds*. New York: Harry N. Abrams, 1986.

Perry, Gill. "Women in Disguise: Likeness, the Grand Style and the Conventions of Feminine Portraiture in the Work of Sir Joshua Reynolds." *Femininity and Masculinity in Eighteenth-Century Art and Culture*. Ed. Gill Perry and Michael Rossington. Manchester: Manchester University Press, 1994.

Piper, David. *The English Face*. London: Thames and Hudson, 1957.

Pittard, Joseph. *Observations on Mr. Garrick's Acting*. London, 1758.

Pointon, Marcia. *Strategies for Showing: Women, Possession, and Representation in English Visual Culture*. Oxford: Oxford University Press, 1997.

Postle, Martin. *Sir Joshua Reynolds: The Subject Pictures*. Cambridge: Cambridge University Press, 1995.

Potts, Alex. *Flesh and the Ideal: Winckelmann and the Origins of Art History*. New Haven: Yale University Press, 1994.

Pragnell, Hubert J. *The London Panoramas of Robert Barker and Thomas Girtin*. London: London Topographical Society, 1968.

Pugh, Simon, ed. *Reading Landscape: Country, City, Capital*. Manchester: Manchester University Press, 1990.

de Quincy, Quatremère. *Essai sur la nature, le but et les moyens de l'imitation dans les beaux-arts*. Paris, 1823. Rpt. Brussels, 1980.

———. "Panorama." *Dictionnaire historique de l'architecture*. 2 vols. Paris, 1832.

Rajan, Tillotama. *Dark Interpreter: The Discourse of Romanticism*. Ithaca: Cornell University Press, 1980.

Ralph, James. *The Case of the Authors Stated*. London, 1758.

Rauth, Eric. *The Work of Memory: Ekphrasis, Museums, and Memorialism in Keats, Quatremère de Quincy, Balzac, and Flaubert*. Ph.D. diss. Princeton University, 1991.

Reed, Thomas A. "Keats and the Gregarious Advance of Intellect in Hyperion." *ELH* 55 (1988): 195-232.

Report from the Select Committee of the House of Commons on the Earl of Elgin's Collection of Sculptured Marbles &c. London: John Murray, 1816.

Reynolds, Sir Joshua. *Discourses on Art*. Ed. Robert Wark. New Haven: Yale University Press, 1997.

———. *Portraits*, ed. F. R. Hilles. New York: McGraw-Hill Book Company, 1952.

———. *Works*, ed. Edward Malone. London: T. Cadell and W. Davies, 1798.

Richardson, Alan. *A Mental Theater: Poetic Drama and Consciousness in the Romantic Age*. University Park: Pennsylvania State University Press, 1987.

Roach, Joseph R. *The Player's Passion: Studies in the Science of Acting*. Newark: University of Delaware Press, 1985.

Robinson, Henry Crabb. *Diary, Reminiscences, and Correspondence*. Ed. Thomas Sadler. 2 vols. Boston: Fields, Osgood & Co., 1870.

———. *The London Theatre, 1811-1866: Selections from the Diary of Henry Crabb Robinson*. Ed. Eluned Brown. London: Society for Theatre Research, 1966.

Roe, Nicholas, ed. *Keats and History*. Cambridge: Cambridge University Press, 1995.

A Satirical View of London at the Commencement of the Nineteenth Century. London, 1801.

Schiller, Friedrich. *On the Naive and Sentimental in Literature (1795), and On the Sublime.* Trans. Julius A. Elias. New York: Frederick Ungar, 1966.

Schlegel, A.W. *Lectures on Dramatic Art and Literature.* Trans. John Black. New York: AMS Press, 1973.

Schlegel, Friedrich. *Philosophical Fragments.* Trans. Peter Firchow. Minneapolis: University of Minnesota Press, 1991.

Schwarz, Heinrich. *Art and Photography: Forerunners and Influences.* Ed. William E. Parker. Layton: Peregrine Smith Books, 1985.

Scott, Grant. *The Sculpted Word: Keats, Ekphrasis and the Visual Arts.* Hanover: University Press of New England, 1994.

Scott, Sir Walter. *Letters.* Ed. H. J. C. Grierson. 12 vols. London: Constable, 1932-37.

———. *Poetical Works.* 12 vols. London: R. Cadell, 1832-34.

———. *Waverley Novels.* 48 vols. London: R. Cadell, 1829-33.

Sha, Richard. *The Visual and Verbal Sketch in British Romanticism.* Philadelphia: University of Pennsylvania Press, 1998.

Shaw, Philip. "'Mimic sights': A Note on the Panorama and Other Indoor Displays in Book 7 of The Prelude." *Notes and Queries* (1993): 462-64.

Shawe-Taylor, Desmond. *The Georgians: Eighteenth-Century Portraiture and Society.* London: Barrie and Jenkins, 1990.

Shelley, Percy Bysshe. *Shelley's Poetry and Prose.* Ed. Donald H. Reiman and Sharon B. Powers. New York: W. W. Norton, 1977.

Shirley, William. *A Bone for Chroniclers to Pick On.* London, 1758.

Siddons, Sarah. *Reminiscences.* Ed. William Van Lennox. Cambridge, MA: Harvard University Press, 1942.

Simpson, David. *Wordsworth and the Figurings of the Real.* London: Macmillan, 1982.

Smith, A. H. "Lord Elgin and his Collection." *Journal of Hellenic Studies* 36 (1916): 163-372.

Solkin, David. Painting for Money: *The Visual Arts and the Public Sphere in Eighteenth Century England.* New Haven: Yale University Press, 1992.

Sontag, Susan. *On Photography.* New York: Delta, 1973.

Spence, Joseph. *Polymetis; or, An Enquiry Concerning the Agreement between the Works of the Roman Poets and the Remains of the Antient Artists.* London: R. Dodsley, 1747.

Stafford, Barbara. *Artful Science: Enlightenment Entertainment and the Eclipse of Visual Education.* Cambridge, MA: MIT Press, 1994.

St. Clair, William. *Lord Elgin and the Marbles.* Oxford: Oxford University Press, 1967.

Stern, Bernard. *The Rise of Romantic Hellenism in English Literature, 1732-1786.* Menasha, WI: George Banta Publishing, 1940.

Stone, George Winchester, Jr., and George M. Kahrl. *David Garrick: A Critical Biography.* Carbondale: Southern Illinois University Press, 1979.

Strange, Sir Robert. *Inquiry into the Rise and Establishment of the Royal Academy of Arts.* London, 1775.

Sweet, Nanora. "History, Imperialism, and the Aesthetics of the Beautiful: Hemans and the Post-Napoleonic Moment." *At the Limits of Romanticism: Essays in Cultural, Feminist, and Materialist Criticism.* Ed. Mary A. Favret and Nicola J. Watson. Bloomington: Indiana University Press, 1994.

Taminiaux, Jacques. *Poetics, Speculation, Judgment: The Shadow of the Work of Art from Kant to Phenomenology.* Trans. Michael Gendre. Albany: State University of New York Press, 1993.

Taylor, Gary. *Reinventing Shakespeare.* New York: Weidenfeld & Nicolson, 1989.

Taylor, George. "'The Just Delineation of the Passions': Theories of Acting in the Age of Garrick." *The Eighteenth Century English Stage.* Ed. Kenneth Richards and Peter Thomson. London: Methuen, 1972.

Thomas, Russell. *Spectacle in the Theatres of London from 1767 to 1802.* Ph.D. diss.: Chicago University, 1942.

Victor, Benjamin. *The History of the Theatres of London and Dublin from the Year 1730 to the Present Time.* 2 vols. London, 1761.

Vrettos, Theodore. *A Shadow of Magnitude: The Acquisition of the Elgin Marbles.* New York: G. P. Putnam's Sons, 1974.

Walker, Carol Kyros. *Walking North with Keats.* New Haven: Yale University Press, 1992.

Watelet, C. H., and P. C. Léveque. *Dictionnaire des Arts de Peinture, Sculpture et Gravure.* 5 vols. Paris, 1792.

Waterhouse, Ellis. *Reynolds.* London: Phaidon Press, 1941.

Watkins, Daniel. *Keats' Poetry and the Politics of the Imagination.* Rutherford, NJ: Fairleigh Dickinson Press, 1989.

Webb, Timothy. *English Romantic Hellenism 1700-1824.* New York: Manchester University Press, 1982.

Wendorf, Richard. *The Elements of Life: Biography and Portrait Painting in Stuart and Georgian England.* Oxford: Clarendon Press, 1990.

———. *Sir Joshua Reynolds: The Painter in Society.* Cambridge, MA: Harvard University Press, 1996.

West, Shearer. *The Image of the Actor: Verbal and Visual Representation in the Age of Garrick and Kemble.* New York: St. Martin's Press, 1991.

Whale, John. "Sacred Objects and the Sublime Ruins of Art." *Beyond Romanticism.* Ed. John Whale and Stephen Copley. London: Routledge, 1992.

Wilkes, Thomas. *A General View of the Stage.* London, 1759.

Winckelmann, Johann. *History of Ancient Art* [1762]. Trans. G. Henry Lodge. 4 vols. Boston: J. R. Osgood, 1872.

———. *Reflections on the Imitation of Greek Works in Painting and Sculpture* [1755]. Trans. Elfrieda Heyer and Roger C. Norton. Rpt. La Salle, IL: Open Court, 1987.

Woof, Robert, David Blayney Brown, and Stephen Hebron. *Benjamin Robert Haydon.* Grasmere: The Wordsworth Trust, 1996.

Wordsworth, Jonathan. *Wordsworth: The Borders of Vision*. Oxford: Clarendon Press, 1982.

Wordsworth, William. *The Poetical Works of William Wordsworth*. Ed. Ernest de Selincourt. Oxford: Oxford University Press, 1936.

———. *The Prelude: 1799, 1805, 1850*. Ed. Jonathan Wordsworth, M. H. Abrams, and Stephen Gill. London: W.W. Norton, 1979.

———. *Wordsworth and Coleridge: Lyrical Ballads*. Ed. R. L. Brett and A. R. Jones. London: Routledge, 1991.

INDEX ✌